KU-456-773

Contents at a Glance

Acknowledgements xi

Introduction xiii

Chapter 1: The art of animation in Flash 8 2

Chapter 2: Planning and production 26

Chapter 3: Character animation 54

Chapter 4: Facial animation and lip syncing 80

Chapter 5: Sound and dialog 102

Chapter 6: Titling, pixel fonts and typography 138

Chapter 7: Flash mobile and Flash Lite 2 164

Chapter 8: Introduction to video 192

Chapter 9: Flash Professional and video for broadcast 218

Chapter 10: Advanced video techniques 242

Chapter 11: 3D animation in a 2D environment 258

Chapter 12: Flash Professional tips and tricks 282

Showcase 310

Appendix A: Fonts 380

Appendix B: Flash Lite 2 scripting 391

Appendix C: Shooting terms 397

Appendix D: Animation terms 403

Contents at a Glance

Appendix E: Animation software 410

Appendix F: TV organizations 415

Appendix G: CD content 418

Index 421

Contents in Summary

Introduction

Chapter 1: The art of animation in Flash 8
Animators and designers have used Flash, animations and other Flash authored content on web sites for many years now. While the content provided a rich experience for users, large file sizes often meant long download times. In response, Macromedia has introduced several advances in Flash 8 that allow for even richer content while also lowering the file size of the finished Flash project. Using a very basic character with minimal detail I have put together in Chapter 1 a simple tutorial that looks at a basic walk. Applying the principles you learn in this chapter to your own characters will be effortless. Once you've mastered this basic walk, then you can give your character your own style and characterization.

Chapter 2: Planning and production
The traditional large team's sole responsibility was to track who is doing what and when. To some extent all this can be done with Flash 8 by one person. Before we go into the depth of animation we need to plan our processes. This chapter looks at the process. It is broken up into three parts.

The first section looks at planning and storyboarding the traditional way but using Flash 8.

The middle section demonstrates *a simple design methodology that plans out all the assets required for a game or animation.*

The final section at productivity tips to *improve your workflow and organize your workspace while using Flash 8.*

Chapter 3: Character animation
We start this chapter by looking at simple techniques of drawing. When you were a child your teacher taught you how to draw the basic shapes like; the triangle, the square, the circle. Things do not really get any more complicated than that. Everything in the known universe can be drawn using combinations of two or more basic geometric shapes. The animator must have the ability to draw or pose characters, but also have an acute sense of timing, of observation, mannerisms and movement. This chapter covers all the major techniques for drawing and producing realistic character animations, and includes hands-on examples and a number of tips and tricks.

Chapter 4: Facial animation and lip syncing
If you've ever animated a character and you have wanted to make it talk or sing, then you will have touched on the art of lip syncing. This is the art of taking a pre-recorded

dialog, and making a character move its lips as if to speak this dialog. This involves figuring out the timings of the speech (breakdown) as well as the actual animating of the lips/mouth. In addition making the actual setup or mouth positions needed can also be considered a part of the entire lip sync process. Creating speech may appear to be difficult. This chapter looks at the art of lip syncing using eight basic mouth expressions to represent English speech. We also look at the process of scrubbing. "Scrubbing" is a preview of the sound when moving the playhead along the timeline. You need to set your voice over audio file to Stream. Not only will this preserve the lip sync, but it will also allow you to "Scrub" back and forth across the timeline to hear your sound frame by frame.

Chapter 5: Sound and dialog

This chapter outlines how you can use sound to make your animations more fun and exciting. You will learn how to edit sound effects and how to integrate these sounds into Flash 8. The chapter also covers compressing sounds for optimal playback and descriptions of the different digital sound formats. I hope the Sound Object is demystified with tutorials that explore the construction of the sound object and its implementation into a movie.

Chapter 6: Titling, pixel fonts and typography

Although this book is about animation it seems unlikely that the animator or designer will not encounter a situation where type is needed in the project. The Internet has changed the nature of type. What at one time was solid and made of lead and had its rules is now reduced to dots on a screen completely in the designer's control. This chapter takes a look at using typography effectively in a number of common situations in your animation. It first covers the art of animated para and then moves on to look at pixel fonts. In Appendix A we have a potted history of typography for the budding typorgrapher. The closing tutorial looks at the different fonts used in our game and looks at the different tools and decisions that affect the final style.

Chapter 7: Flash mobile and Flash Lite 2

This chapter is an overview of developing content for Mobile Phones and the Pocket PC. In this chapter I spend some time explaining the Macromedia Flash Lite 2 new features as well as describing some best practices for creating content for these mobile devices.

You will be taken through essential issues such as interface design, movie size and format and optimum movie size for playback on handheld devices. This chapter discusses in depth the importance of mobile communications as we look into the future, and how they will change the multimedia industry. On a practical point I feature two products with all the source code and a template for all mobile development including running video on mobile.

Chapter 8: Introduction to video

When people talk about broadcast quality they are usually referring to NTSC/PAL/ SECAM standards. This chapter looks at the production of video and the issues around it. The focus is around development for television and video, and how to optimize your Flash movies for publishing on video, film and DVD. I start by demystifying this world and then move on to explaining the basic principles of exporting your movie to other formats preparing the way for the more advanced chapter on Flash Video. At the core of Flash Video is the Flash for Video (FLV) file format. FLV files include encoded audio and video data that is optimized for delivery through the Flash Player. This keeps the Flash Player footprint as small as possible by using a single video rendering format.

Chapter 9: Flash Professional and video for broadcast

Macromedia Flash Video easily puts video on a web page in a format that almost anyone can view. This chapter provides an introduction to Flash Video, including information on how to create and publish Flash Video. Flash Video is based on the technology behind the Flash Player – so it's ready to play in almost all of PCs worldwide. This means:
No more massive player installations.
No lengthy registration forms.
No ads attempting to upsell you to other players.

Chapter 10: Advanced video techniques

In addition to explaining the process of live video, I will, in this chapter, look at keying effects using the Final Cut Pro keying process and a walk through using Adobe After Effects. Once we have created our video content I produce a cue movie. The way you provide the video stream for live video is by using a source of live video, which must be encoded in real time as it is captured. Unlike the procedure for on-demand video, with live video the capturing, encoding and publishing steps all happen at the same time. Because of the need to setup a streaming service I look at am not going to do a tutorial on live streaming video. But I am going to get you started and in addition I will point you to services on the web that offer the Flash Media Server for the streaming video.

Chapter 11: 3D animation in a 2D environment

So the first thing you should know about 3D and Flash is that there is no 3D in Flash. So to attempt to make things look 3D in Flash you need to fake it. Animation is basically one trick after another. Whatever it takes to get your vision on screen is the right way. Regardless of the software, whatever you produce will finally be judged on its appeal and quality. Creating a real 3D scene in a program outside of Flash and bringing in a pre-rendered 3D animation which is to be displayed frame-by-frame as though a movie is one approach. Using mathematically calculated 3D from Actionscript requires an understanding programming and we touch on this and offer a number of examples for the animator to play with.

Chapter 12: Flash Professional tips and tricks

This chapter is all about those little snippets that can make the difference to an animation production. They are very loosely split into Animation, Flash 8 application and ActionScript. Sometimes the difference is purely that you organized a large project well or you spell checked the title. It is unlikely that even the most ardent of Flash animators developer will not find something interesting in this chapter. The features I cover in this chapter will save you countless hours by reducing mouse clicks. It has been compiled from best practices from a number of different sources and then worked on in real situations over a number of years and then finally adapted to Flash 8.

Showcase

A vibrant showcase of work and games covering animation, typography, mobile content all using Flash.

Appendix A: Fonts

Appendix B: Flash Lite 2 scripting

Appendix C: Shooting terms

Appendix D: Animation terms

Appendix E: Animation software

Appendix F: TV organizations

Appendix G: CD content

Index

Acknowledgements

I would like to give Kay Siegert special thanks for all his help in putting this book together. His efforts in both making sure that we are covering Flash 8 correctly and his creative input cannot be rewarded enough.

I would also like to thank the team at Focal Press and at Sprite Interactive for putting up with me the last two years of writing this book.

A special thanks goes to Liz, Ellen and Alex for their patience and support.

Introduction

Who this Book is for

If you want to learn how to create quality professional animation using Flash and deploy it across platforms varying from computer screens, PDAs to cell phones, then this is the book for you. Whether you are a designer who hasn't yet used Flash, or a professional animator who wants to create digital animation for the first time, this book will take you from your first drawing and animation project in Chapter 1, through to a strong foundation for animation techniques that are just as applicable to the animation world as they are to the world of the Flash user. This book is thorough and practical, and tutorial-led, where each chapter helps to build up an understanding through case studies and example projects reinforcing what you've learnt in that section and how it can be applied in real projects. By having working examples to follow, difficult animation can become understandable, even easy. However, even if you are not an animator, but want to learn about enhancing your web presentation by using animation, then you can, from the material we provide.

Free Commercial Games

I have included a PC Flash game and five (mobile) Flash Lite 2 application in the showcase and on the CD. The purpose here is not to take you through streams of code but to allow you to practice your animation skills in a multi-platform environment animating very basic button through to full character design. In addition to the games, I have also featured a number of useful code-driven animation that you might find useful as effect.

There are plenty of great sources for learning Flash basics. In this book we focus on those aspects of Flash that facilitate animation and sound for multi-platform playback. We start with the principles of animation and go through to the advanced features. We also examine animation that takes advantage of the playback device and its limitations. The intention is that the animator understands the restrictions of different devices and how to compensate for those devices. If you have never animated before, persevere as the art of animation is very accessible and Flash can take your spontaneous doodle and, with creativity and care, turn it into a compelling piece of animation.

Figure I.1 *Commercial site retailing games from this book*

What is Flash?

Flash is one of the most significant applications in the web creation process. It has become a "killer app" that has been embraced by a wide spectrum of developers. Flash has a large community with developers freely sharing tips, tricks and processes with each other, and also contributing to the development of the application itself.

Before Flash, creating animated web sites (complete with sound) involved large files, which required equally large bandwidth. Flash files are vector based and in contrast, can be very small, making bandwidth and loading times less of a concern. Furthermore, Flash has brought a level of advanced animation and interactivity previously unavailable using traditional Internet technology. Though Flash is predominantly used for the Internet it is also used outside of the web, for kiosks, for presentations and CD-ROMs, among other things.

You work in Flash by creating a movie by drawing or importing artwork, arranging it on the Stage, and animating it with the Timeline. You make the movie interactive by using actions to make the movie respond to events in specified ways.

The Flash Player

When the movie is complete, you export it as a Flash Player movie to be viewed in the Flash Player, or as a Flash stand-alone projector to be viewed with a self-contained Flash Player included within the movie itself. In this book you will learn how to do all this.

The Flash Player functions as either a stand-alone player or as a web-browser plug-in, which is available for the two most popular web browsers, Netscape and Internet Explorer.

Movie Formats

Flash files are often referred to as movies, whether in the authoring environment or in the final playable form. You create animation and interactivity in Flash-format files, whose file extension is .fla. To create viewable movies you convert these to Flash Player format, whose extension is .swf.

Flash is the foremost application for creating the swf format files. The swf files need the Flash Player plug-in from Macromedia to playback the swf animation. But Flash is not the only application for creating swfs. Throughout the book I will highlight the different tools available for building Flash Applications for both Flash and swf playback. Also, if you need to download the application, Macromedia offers a free 30-day trial of the software on its site.

The Flash Player is now available to create animation for all kinds of devices from Internet pages on computers through to mobile devices such as PDAs and phones. So now we can watch rich animation using Flash on PDAs whilst on the move. We can watch and play Flash games in the interactive TV environment from the comfort of our sofa and we can use Flash to build clear focused interfaces for business products.

This book will teach you the process of animating, using Flash for deployment across all platforms from cell phones through to PDAs and computers. By looking at detailed examples provided on the CD, I will take the reader through each stage of creation, build and deployment. We will look at the complexities of the interfaces and how we cater for them. Animators can now realize their vision with just an idea and talent, or just pure enthusiasm and drive.

Flash Professional 8

Flash Professional 8 is the industry's most advanced authoring environment for creating interactive web sites, digital experiences and mobile content. For most of the mobile applications that we have included on the CD and all the Flash Lite scripting you will need the Flash Professional 8 version and not the standard version.

Flash Professional 8 and Video

Take advantage of the most widely deployed video platform on the Internet. Flash, originally a web site animation tool, has emerged as a potentially formidable competitor in the race to build powerful web-based applications and could challenge Microsoft, RealNetworks and Apple and up-end the web video market with Flash 8. The software's video capabilities that are stirring the most interest, particularly among those who think the new version's improved codec, which is its particular video compression format, and various other advantages could make it a significant threat to Microsoft's Windows Media technology, RealNetworks' Real format and Apple Computer's QuickTime format.

Many of the big changes in Flash 8 centre on its video capabilities. Flash 8 boasts a new codec, On2 Technologies' VP6, that both companies claim will provide dramatically improved quality over the Flash 7 video codec. Flash 8 also supports alpha transparency, which lets authors combine Flash video with text, vector graphics and other Flash elements.

Macromedia published its specification for the swf format allowing numerous alternatives to Flash for creating swfs. In the world of 2D we have LiveMotion, Illustrator, After Effects, Fireworks and Freehand. In the 3D world, every 3D application of note

has the facility to export content in the swf format. In this book we will look at both Swift 3D and Poser 6.

There is no shortcut for skills and knowledge, so before you get too involved in looking at the different tools available, you need to consider and plan your animation. This is thinking about the project, identifying the right tools and deciding on the right resources for the right approach.

About Bitmaps and Vectors

Computers display graphics in either vector or bitmap format. Understanding the difference between the two formats can help you work more efficiently. Flash lets you create and animate compact vector graphics. It also lets you import and manipulate vector and bitmap graphics that have been created in other applications.

The data that creates vector and bitmap graphics is similar, they are both mathematical instructions, but bitmaps are more complex, and result in less manageable graphics. Vectors are compact and fully scaleable, but are less complex graphically. Bitmap instructions break the graphic into little dots and have to tell the computer where to place each dot; vector graphics describe graphics as a series of lines and arcs. If you zoom in on

Figure I.2 *A vector image scaled up*

Figure I.3 *A bitmap graphic with a close-up of the detail*

a bitmap you will start to see the image reduce to its dot or pixel structure. If you zoom in on a vector image you will see that the quality of the line work is maintained. You will read more about vectors throughout the book.

The tradition of drawn animation is an art form that has only developed in this century. Film has been the vehicle for this great technology. Traditionally, an animator needed a large team of artists to produce any moving image. The industry had to standardize itself; in this standardization, the craft of animation was born. Animation is an art form that has no limitations but is a discipline that needs to be studied and tailored for whatever format or environment you are creating content.

Character Development

I have not covered the process of character design in this book, but for me everything starts with the drawing. Drawing on paper still offers the most spontaneous creative results. The design of a character is explored by sketching from different angles. This evolves into a clearer character that is then thoroughly worked out in the

rough stages. It may take hours of frustration to get to this part but if you persevere here you will have a solid foundation for a character that might end up living longer than you.

I tend to sketch with Chromacolor blueline, as the duck drawing shown on the top left-hand side (Figure I.4). This is my "work in progress" rough. It's a rough because it still needs color and shading. As the line work becomes more visible we move onto the "clean" drawing. I start to add color in pastels. Working in blueline is the way I have been shown how to do it and I believe that it is still the way of both traditional and computer animators. All the animators I know draw their roughs in blue pencil. Specifically Col-erase blue no.1276 from Chromacolor.

The rough is scanned as a JPG and imported into Flash.

The aim now is to recreate classic comic book style lines that look as if they have been done by drawing with a brush. Brushed lines tend to start off thick and taper to a point. Ink brushed lines have direction they add weight, depth and subtle perspective to the drawing. Even in the most modern technical "Managa" style you find this type of line work. It gives the drawing a dynamic feel. Keep the shapes nice and smooth and keep the file size down by keeping the anchor points down to a minimum.

I tend to keep all my roughs on Layer 1 and then I lock it. This is to stop it being accidentally selected and moved about.

On Layer 3, I build up all the ink lines.

Layer 2, I usually put down all the color work and shading. Although to be honest this usually ends up around a dozen layers.

The final duck image shows the ink lines colored and grouped as required with Flash shading. Highlighting around the edges helps to give the drawing depth.

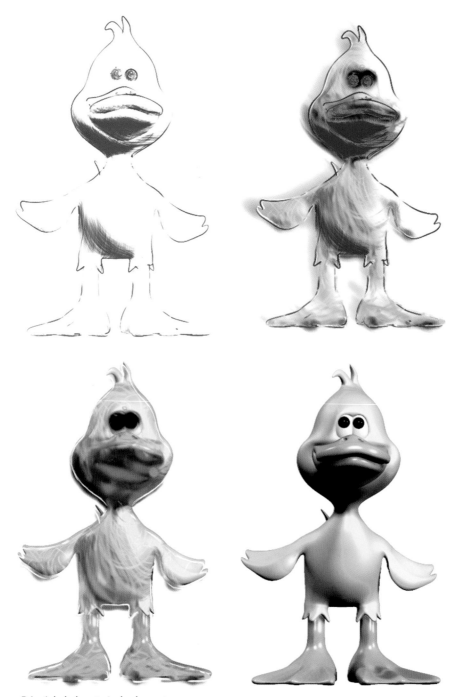

Figure I.4 *A duck character in development*

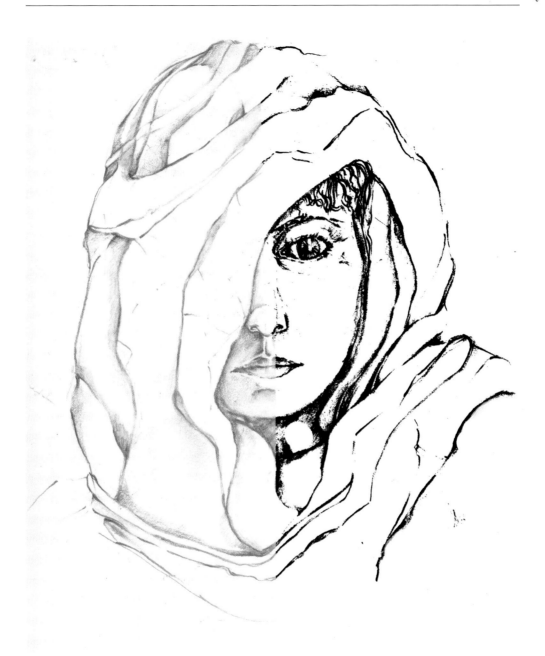

Figure I.5 *Drawings can be scanned and auto traced and then tidied up for sharp finished line work. Compare the two halves of this figure*

A Breakdown of the Book

The first part of this book looks at some of the basics of animation which includes applications for quick animation prototyping (Poser 6), lip-syncing and sound, as well as other helpful animation tips. We also look at the process or science of animation. This takes us from in-betweening to walks, runs and exaggeration in the animated body.

We then move on to bringing sound into the animation. This starts initially with some basic principles of interactivity and continues through to some complex sound editing. All the tutorial material is provided with clear explanation on its usage as well as how to edit it. Although I do not go into the code of the commercial games as that is beyond the scope an animation book, it is all there for the budding programmer. All examples throughout the book are contained on the accompanying CD.

The final part of the book looks at the delivery of a completed animation, for computers that have varied resolution, television screens, PDAs and cell phones that have only 140×220 pixels with which to play.

Throughout, the chapters are supported by complete FLA files containing all the elements you need to build your own version of the examples. Also included are games where you can redraw the characters testing out your new computer-based animation skills in games development. I recognize the importance of ActionScript and so I have introduced both basic concepts and complex routines that can be used in the animation process. This will save time and money. The level of ActionScript we present is geared to give confidence to the animator to amend and customize code.

Figure I.6 *Game image from one of the tutorial files on the CD*

Chapter 1

The Art of Animation in Flash 8

Flash Professional 8 is the industry's most advanced authoring environment for creating interactive animations, digital experiences and mobile content.

Animators and designers have used Flash, animations and other Flash authored content on web sites for many years now. While the content provided a rich experience for users, large file sizes often meant long download times. In response, Macromedia has introduced several advances in Flash 8 that allow for even richer content while also lowering the file size of the finished Flash project.

One of the great things that Macromedia did with Flash 8 authored content is to offload much of the rendering work to Flash Player 8. Using tags in the Flash project, the player can now render filters in real-time as the user interacts with the project.

But all this technology cannot make an animation work unless the ingredients are there in the first place. So in the following chapters, I hope to build up a knowledge of professional animation that is then applied to the Flash environment and not just any Flash environment but Macromedia Flash 8.

Throughout the book, we will apply some of our newfound knowledge to a game which we will develop with the chapters. The game has a lot of code that drives it which you are welcome to use in your own commercial situations. But there will be minimal reference to the code with just the basics to allow the animator to customize the graphics and no more. More focus will be given on the techniques of using Flash in a professional environment to produce animations. We will also look at the art/science of animation.

Making a character's walk look realistic is a long-lost, and long-cherished, secret of animation. There's no simple magical way of doing this but the steps can be broken down into easily digestible bites that are easy to understand and recreate.

Probably, the most basic yet the most difficult animation is the simple walk cycle. Not only do you have to decide on the angles of viewing but also you need to think of pace, gait and at the same time you need to draw this. To help in this process you can use many different aids, the simplest is your own body. You can watch yourself move and record this. You can ask a friend to do a walk cycle and grab that. Apart from this, I use the character modeler Poser 6. The following Figure 1.1 is a screen grab of a top-down animation for a Power Rangers game where I use single frame output from Poser and redraw the frames in FreeHand for final import into Flash 8. You can also see the original shot of a helmet from a Power Ranger model.

Throughout the book we will be working up a version of this game. Although it is a top-down view of the game, the issues of movement, frame rate and the animated game play are all the same.

Before you even begin to create animations, there are several important aesthetic issues to take into account. You need to consider some basic questions, such as:

What is its purpose?

What kind of audience do you want to attract?

Figure 1.1 *The red circle is the final version of a single frame from the character*

What are you trying to say?

It is also important to remember, not to overwhelm your audience with moving images. Make sure that the animation is beneficial to your web site, otherwise you will lose your audience. Animations that cycle endlessly can quickly become annoying. Design your animation with a finite number of loops, so that it eventually stops.

Once you've decided to create an animated sequence, you need to start with the fundamentals. Of these, a crucial step is the creation of the storyboard. Here, you detail the animation in a precise fashion with sketches, scripts, transitions, timing, etc. It is with the storyboard that you can workout many creative difficulties. More on storyboards is described in Chapter 2.

When objects are in motion, the eye is not able to discern information one would normally see in a still image and is much more forgiving. This means that detail can be reduced and made simpler.

Using a very basic character with minimal detail, I have put together a simple tutorial that looks at a basic walk. Later in Chapter 3 there is a more in-depth analysis of over 20 different styles of movement with added personality with exaggerated positions, or different speeds, or crazy walks. In theory you need only a basic knowledge of Flash 8; applying the principles you learned

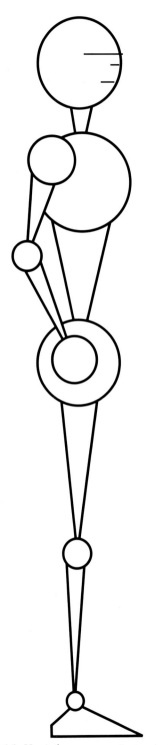

Figure 1.2 *Here is the guy we are going to animate*

here to your own designs will be effortless. Once you've mastered this basic walk, then you can give your character your own style and characterization.

Let's start building our character using simple shapes.

Starting with launching man.fla project.

Create a new symbol. From the main menu, go to the Insert menu, then choose New Symbol. A new window will open. Click on the graphic and name the new symbol "Man". Symbols allow you to use the same asset more than once without storing multiple copies of it in your FLA file. You store the symbol in the Library panel, and drag instances of the symbol to the Stage when you need them. Think of symbols as a set of boxes that fit into each other, you'll always find a smaller one inside. This nested hierarchy allows you to have several levels of animation cycles. For example, let's say you have a symbol of a character walking, inside of which you have another symbol with the body going up and down, inside which you have the symbol of the arms moving. Inside the arm symbol, you could have a hands symbol, inside which you could have a fist clenching.

I use three levels for this:

- head, torso and front arm layers for the "Top"
- 2 legs layers "Legs"
- with the back arm layer "Back Arm"

This is significant because, as you will see later, the two halves of the body complement each another. The legs swing one way while the upper body swings the other way. The back arm should stay behind the legs and the body, which is why it's on its own layer, obscured from full view.

The Top

Select the first layer in the layer palette, and rename it "Top". Either using the predrawn assets or using the shape tools, create a circle for the head and a small square for the nose, like in Figure 1.3, below. When using your shape tool, be sure to select the stroke color as black and use white for your fill color. Later, you can recolor your walking man as you choose, but for now this will keep things clear and easy.

Dragging the selected shapes with your mouse, arrange the nose on the head so the whole assembly resembles a profile. To select one shape, use the Arrow tool and double-click the fill.

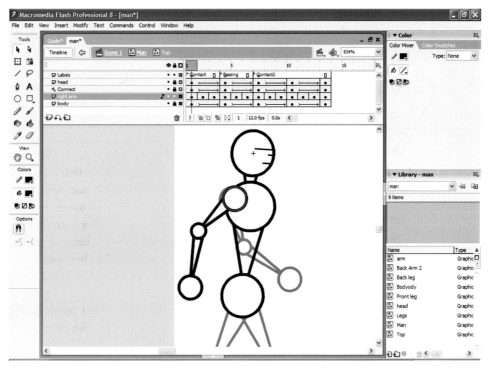

Figure 1.3

When your creation looks like a face, select the two shapes, go to the Insert menu and choose "Convert to Symbol" and name the symbol "Top". Also, make sure to choose "Graphic Behaviors", as this will make previewing the animation easier. Now double-click on the "Top" symbol you just created. Select the layer where the head is, then double-click on it and name it "head".

The Body

Add a new layer with the Insert menu, or click the Add Layer button at the bottom of the Timeline. Name this new layer "body". You can build the body using the polygon tool or you can use the predrawn shapes in man.fla.

Select the torso and convert it to a symbol by using the Insert menu. When the symbol dialog appears, name the symbol "body" and choose "Graphic Behaviors".

Add a second layer underneath using the Insert menu. A shortcut for this is simple – just click the Add Layer button at the bottom of the Timeline.

Layers are like transparent sheets of acetate stacked on top of each other to help you organize the artwork in your document. You can draw and edit objects on one layer without affecting objects on another layer. Layers are totally transparent. Only one layer can be active at a time, even though more than one layer can be selected at a time.

To draw onto a layer or folder, you select the layer in the Timeline to make it active. A pencil icon next to a layer or folder name in the Timeline indicates that the layer or folder is active.

When you create a new Flash document, it contains only one layer. You can also hide, lock or rearrange layers.

Layer folders allow you to organize and manage layers by placing layers in them. You can expand or collapse layer folders in the Timeline without affecting what you see on the Stage. In addition, you can use special guide layers to make drawing and editing easier, and mask layers to help you create sophisticated effects.

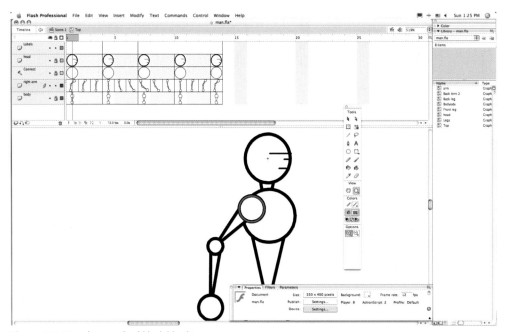

Figure 1.4 *Your character should look like this*

The Flash tutorials that come with Flash 8 have a great overview of layers. Here is how to find it; select Help > Flash Tutorials > Basic Tasks > Work with Layers.

The new layer appears higher than the "head" layer in the layer palette, drag it underneath the "head" layer with your mouse. We need to keep the head as the highest layer in the hierarchy right now.

Name the new layer "right arm". We're calling it "right arm" because a "left arm" will be added later. Build the arm by drawing two long rectangles and a small polygon for the hand, as shown in the illustration. Select the arm and convert it to a symbol using the Insert menu. When the symbol dialog appears, name the symbol "right arm" and choose "Graphic Behaviors".

Now that we've built the symbols for the upper body, make sure that each symbol is on its own layer, and that the layers are in the following order:

1. "head"
2. "right arm"
3. "body"

You can always change the order of the layers by dragging them around the Layer palette with your mouse.

The Legs

Click on "Walk" in the top left-hand-corner of your window to go back to the first symbol we created.

Add a new layer from the Insert menu and name it "Legs". Build a basic outline of a leg or use the library image as shown in Figure 1.5. It's easiest to use two long rectangles for the two different sections of the leg, and then add a triangle for the foot.

Select all of the elements in the leg and convert the leg to symbol.

Name the symbol "Legs", and remember to choose "Graphic Behaviors". Next, change the name of the "Legs" layer, renaming it "Front leg".

Copy this leg by selecting the symbol and choosing "Copy" from the Edit menu. Add a new layer using the Insert menu and name it "Back leg". Select the new layer and choose "Paste in Place" from the Edit menu.

To be able to animate each leg separately, we need to create a different instance symbol for each leg. When we built the back leg, we used the same instance of the symbol as the front leg. Unless we change this, we will end up with two front legs going through the same motions.

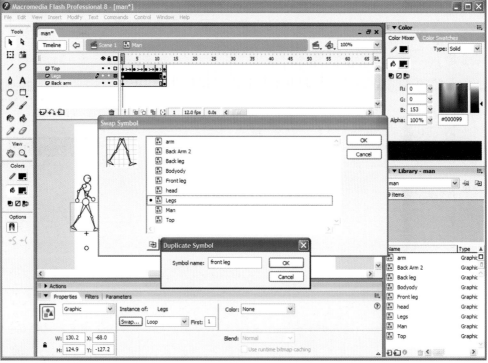

Figure 1.5

Select the leg on the "Front leg" layer. In the property panel there is a "swap" button, that opens the pop-up. With the pop-up open, click on the duplicate button. This will cause a symbol window to open. Change the name to "front leg" before clicking OK. Do the same process for the back leg as well, just be sure to name the symbol "Back leg" before clicking OK.

Now you have 3 leg symbols, 2 of them on Stage as instances and one backup in the library. Whatever you do to the instanced symbols will not affect the backup one.

We have two layers in our "Legs" symbol

• A top layer called "Front leg"
• A second layer called "Back leg"

We are going to add a guideline to animate his legs more easily. By placing a guiding circle in the walk symbol, we won't risk having it in the way during animation, but we'll still be able to see it with onion skinning turned on.

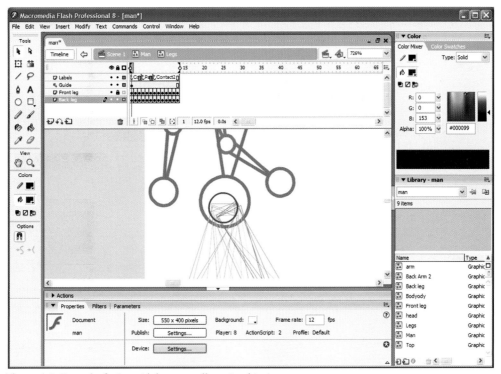

Figure 1.6 *Example of using guide layers as well as onion skinning*

Onion Skinning

Flash displays one frame of the animation sequence at a time on the Stage. To help you position and edit a frame-by-frame animation, you can view two or more frames on the Stage at once. The frame under the playhead appears in full color, while surrounding frames are dimmed, making it appear as if each frame were drawn on a sheet of translucent onion-skin paper and the sheets were stacked on top of each other. Dimmed frames cannot be edited.

Add a layer from Insert menu and keep it selected. Click on Modify in the menu bar and then on "Timeline" and a pop window will open. Mark this layer as a guide by checking "Guide". Guide layers are simply layers to guide the positioning of the artwork. Be sure to keep this layer at the lowest position in the layers palette. For help in aligning objects when drawing, you can create guide layers. You can then align objects on other layers to the objects you create on the guide layers. Guide layers are not exported and do not appear in a published SWF file. You can make any layer a guide layer. Guide layers are indicated by a guide icon to the left of the layer name. You can also create a motion guide layer to control the movement of objects in a motion tweened animation. Here is how to find more on guided layers; select Help > Flash Tutorials > Basic Tasks > Work with Layers.

We need to setup a few guiding points to make the walk smooth. Double click on the legs within the man symbol and add an upper guide layer. This makes sure that the top of your walker's legs move from the correct points.

To do this, click the upper layer in the layer palette to make it active, then click on the add layer icon. Select this new layer, then go to the Modify menu and choose "Timeline" (in previous version of Flash it is called layer). From here, you can turn your normal layer into a guide layer. Just make sure that the layer underneath the topmost layer doesn't become guided. If the layer underneath the topmost layer is guided, select it, go to the Modify menu and choose Layer. If the "Guided" option is turned on, switch it off. What we need to make sure here is that, we avoid any dependency from the guide layer to any layers underneath.

On the new guide layer, create a circle and place it at the top of the legs. The circle should be the size of the legs' width, as the two legs should cross each other within the circle. Because the circle is on a guide layer, it won't show up in the final animation.

Lock the "Front leg" layer by clicking on the lock symbol in the layer palette. Click on frame 1 of the "Back leg" layer. This will make sure that you avoid working on the wrong leg.

The walk cycle always has one foot up in the air while the other one is on the ground except for a very brief period of time when both feet are touching the ground. This is called the "contact position" and it is going to take up only one frame of our animation. It is also going to be our first keyframe.

In animation, keyframes are the main drawings of a movement, such as the first and last frames, from which we create the in-between frames. To build a keyframe, click on frame 1 of the "Back leg" layer. Using the rotate tool, arrange the legs as shown below.

Go to the Insert menu and choose "Keyframe". You want to insert a keyframe for each leg layer, one for the front and one for the back. This creates the last contact position of the step. The left leg moves from behind to forward while the front leg moves forward to behind.

The front leg is going to swing backwards and end up in the exact same spot where the back leg touches the ground. The back leg will also swing forward and end up in the same forward position as the front leg. All you need to do here is reverse the leg positions to create the opposite extreme within the walk cycle. Copy the frame "Front leg 1" to "Back leg 2" and "Back leg 1" to "Front leg 2". Figure 1.8 shows the legs after they have been reversed. The clue here is in the leading arm which tell you which leg is in front. However, you might want to color the legs differently.

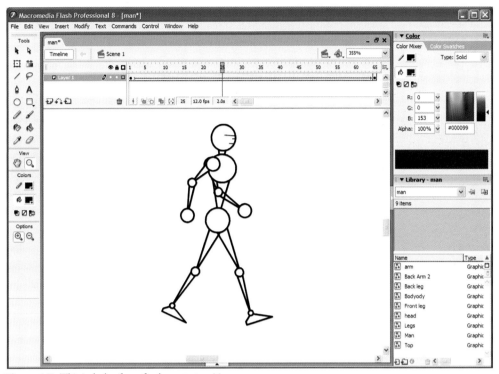

Figure 1.7 *This is the keyframe for the contact position*

Before we forget, let's label those two keyframes we just created. That way, when we add more frames, we know which ones are our keyframes simply by looking at the labels.

Create a new layer, name it "Labels" and add a blank keyframe in frame 1. Select the blank frame, then go to the Window menu and make the Frame panel visible by choosing "Panels" then "Frame". The Frame panel will appear. Type "Contact" for the label name. Also label frame 2 as "Contact2" to identify these two keyframes as main contact positions for our walker's legs.

When our walker reaches the midpoint of his step, his legs will pass each other while travelling on their respective paths. For this reason, we're going to place a new keyframe right in the middle of the step. This is called the Passing position.

Hold down the command key (on a Mac) or right-click (in Windows) and select frame 1 all the way across on each of the three layers and add a frame. To add a frame, go to the Insert menu and select "Frame". Be sure to add one frame for each layer. With your "command" key down, or while right-clicking (in Windows), select the new frame you just created and turn it into a keyframe. Label the keyframe "Passing". Next, select the blank frame on the "Labels" layer, then go to the Window menu and make the Frame panel active. When the

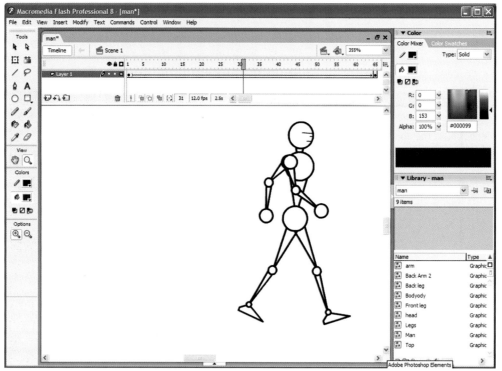

Figure 1.8 *Shows the legs after they have been reversed*

Frame panel appears, the blank frame within the "Labels" layer will be selected. Type "Passing" as the label name.

Arrange the legs so that the front leg is straight at the knee and the back leg is bent. You can toggle the visibility of the legs in order to make it easier to position them if you'd like.

This passing position is our second keyframe out of three total keyframes. The first and third keyframes are our contact positions. Next, we need to define the movement of the legs that appear between our keyframe positions.

To acheive a full step you need to create Flash keyframes by selecting frame 1 from the "Label", "Right leg" and "Left leg" layers and add two frames to each of the two layers. To do this, go to the Insert menu and select "Frame" while the layers are selected. Be sure to add two frames to each layer. Now you have two frames in between keyframe 1 and keyframe 2.

To produce a slower walk, you could add three frames in the in-between positions instead of two, or you could add only one to make the walk faster. Now we need to turn these new frames into keyframes. With your command key down (right-click in Windows), select the

new frames you just created on the two layers. Go to the Insert menu and choose "Keyframe". Position the legs in between the contact and the passing positions. Use the rotate tool and turn on onion skinning to help get the positioning just right.

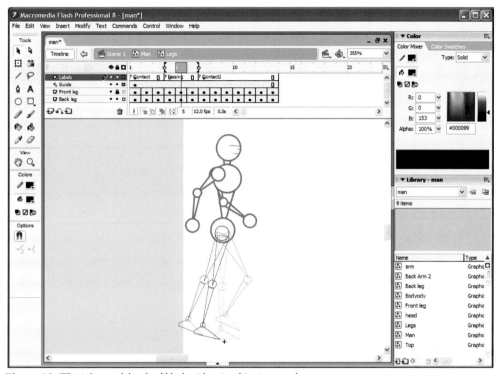

Figure 1.9 *This is how each leg should look with onion skinning turned on*

Now we have five frames:

- Frame 1: contact position
- Frame 2: an in-between
- Frame 3: another in-between
- Frame 4: passing position and
- Frame 5: the second contact position

With your command key down (or right-click in Windows), select frame 4 on both layers. Insert two frames on both the "Front leg" and "Back leg" layers between frames 4 and 5. This pushes the last contact position all the way to frame 7.

With your command key down (right-click in Windows), select the two frames you just created, frames 5 and 6, and make them keyframes.

Next, position the legs to fill both frames, creating two more positions between the Passing position (frame 4) and the Contact position (frame 7). Turn on onion skinning and use the rotate tool to place the legs.

This is half the walk cycle, which is one step of the legs – the full walk cycle will have two steps. To check the animation, be sure to put seven frames in the walk symbol as well as seven frames in scene one. Then, test the scene!

Next, we are going to animate the arms in coordination with the legs. Remember that when you walk, your arms move in opposition to your legs. To reproduce this effect, we need to know where the contact and passing positions for the legs are and use them as a reference. Copy the labels we created in the "Legs" symbol.

Double-click anywhere on your character's leg to go back to the Legs symbol. Select the whole "Label" layer, then go to the Edit menu and choose "Copy Frames". Click on the top half of your walker's body and add a new layer using the Insert menu. Name the layer "Labels", then add a keyframe on frame 1. Within this new keyframe, choose the "Paste Frames" function from the Edit menu so that the contact and passing references are duplicated and ready to be used on the arms.

Go back to the "walk" symbol by clicking on the walk icon in the top left of your window. To begin working on the arms, double-click on the "Top" symbol by clicking on your character's upper body. You can always select the "Top" symbol from the Symbol menu on the top right side of your Flash window, but by doing so, you won't see the onion skinning of your other symbols. So click on your character's head or torso to begin working on the "Top" symbol. You will be able to see the onion skinned movement of the Legs layer.

In the same way we did the legs, let's animate the front arm. The back arm will eventually need to be moved down in the layer hierarchy so that it is below the legs. We will take care of the back arm animation later.

Within the "Top" symbol, add a guide layer at the top. To do this, insert a layer then go to the Modify menu and choose guide. We are looking for a guide layer as in Figure 1.16.

In the guide layer all that we are trying to do is have the advantage of a construction line that becomes invisible in the final animation. Name the guide layer "Connect" and use the circle tool to build a circle in the empty layer. Position the circle on the top of the front arm and the centre of the body as shown in the illustration below. It will be our guide to animate the arm.

Using the rotation tool, set up your two contact positions in frames 1 and 7 at the beginning and end of the walk-cycle, and establish a straight-armed passing position in frame 4.

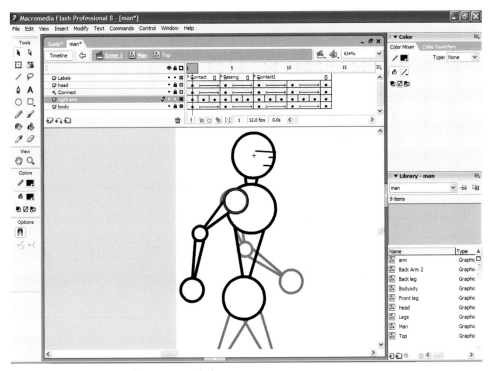

Figure 1.10 *Arms animate in the same way as the legs*

Again, we have 7 frames.

- Frame 1: "Contact"
- Frame 2: in-between
- Frame 3: in-between
- Frame 4: "Passing"
- Frame 5: in-between
- Frame 6: in-between
- Frame 7: "Contact2"

Now we should have the arms moving back and forth within our keyframes. Before we build the in-between phases, we have to create some vertical movement in the torso to imitate the way our bodies naturally move up and down when we walk.

Within the "Top" symbol, setup the first and last contact positions. Go to the last contact position (frame 7, "Contact2") and select the "head", "body" and the "Connect" guide layer. With your command key held down (or right-click in Windows), create a keyframe. Inserting a keyframe with all three layers selected ensures that the keyframe exists on all three layers.

Also create a keyframe in the passing position (frame 4, "Passing") on the "head", "connect" and "body" layers.

Select the "Passing" frame and with the command key down (or while right-clicking in Windows), select the frame all the way down on each of the four top body layers: "head", "Connect", "body" and "Front arm". Insert a keyframe here.

With onion skinning active, move the four layers upward using the up arrow key, as shown in the illustration.

On each layer use a little motion tweening. Make sure you secure the "Front Arm" by locking it – select the layer and click on the padlock icon. To apply the motion tweening, select your first keyframe, which should be our first contact position in frame 1. Be sure to select frame 1 on all the layers except "Front Arm". Next, activate the Frame palette. Within the Frame palette, find "Tweening" and click on the "Motion" option. Flash automatically creates in-between frames for your vertical movement from frames 1 through 4 on all your selected layers. Do the same thing to create the reverse vertical motion between frames 4 and 7, leaving the "Front Arm" layer locked.

Create the in-between frames for the movement of the arms.

Begin with frames 2 and 3. Create keyframes in frames 2 and 3 on the arm layer and position the arms in between frame 1 and 4. Again, use the rotate tool with onion skinning turned on.

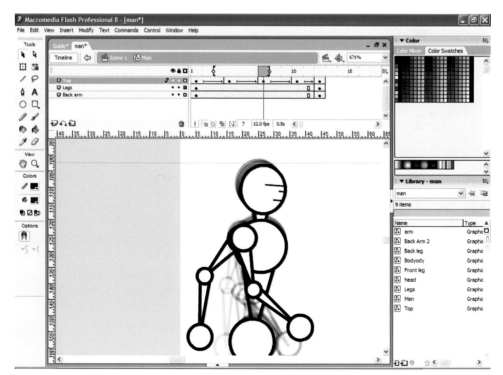

Figure 1.11 *Point of passing*

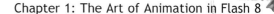

Continue rotating the arm in frames 5 and 6 to create the in-between frames for the second half of the forward swing. This is the same process that we used for the legs. These frames are Flash keyframes, which give us much better control over the figure.

Now we have animated the arm through half of our walking cycle, we still need to swing the arm back towards the start position.

Whilst still on the "Top" symbol, you will see the "Top" icon in the upper left-hand-side of your Flash window. Now select frame 7, and make sure to select it across all four layers: "Connect", "body", "Front Arm" and "head". Go to the Insert menu, choose "Frame" and add six more frames up to frame 13. Be sure that the additional frames are added across all four upper-body layers.

On the "Front Arm" layer, select frames 1 to 6 with your command key down (or right-click in Windows) and copy all six frames. Then, select frames 8 through 13 and "paste-frame" in your selected frames. While the six frames are still selected, go to the Modify menu, select "Frame", then select "Reverse". Now the front arm should appear to go back and forth across 13 frames!

Figure 1.12 *Frames for the second half of the forward swing*

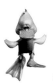

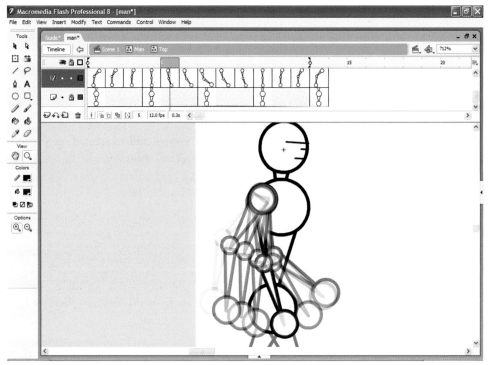

Figure 1.13 *If you switch onion skinning on, you will notice that the arms have a nice arc, this will create a smooth animation*

Lock the front arm layer by clicking on the lock icon in the Layer panel. Select the three remaining layers, "Connect", "head" and "body", and copy the contents of frames 1 through 6. Then paste the contents into frames 8 through 13. There's no need to reverse the body movement within the last six frames because our character will still be moving up and down as he walks no matter which leg is leading.

We need to animate the back arm. Within the "Top" symbol, unlock the "Front Arm" layer, select frames 7 through 13, and copy them.

Go to the Insert menu and choose "Create New Symbol". Call it "Back Arm2". Within the Edit menu, select "Paste Frames". This will drop a copy of frames 7 through 13 from the "Front Arm" symbol into frames 1 through 7 on the "Back Arm2" symbol.

We now need to finish up the other half of the back arm's movement. Select frames 1 through 6 from the front arm, copy the frames, and then paste the sequence into frames 8 through 13 in the "Back Arm2" symbol. Lastly, select the entire sequence of frames from "Back Arm2", then go to the Modify menu and choose "Frame". Click on "Reverse" and reverse the entire arm sequence. Now both of the arms move back and forth in opposition to each other, but they're not lined up perfectly just yet.

Go to the "Walk" symbol and select the original "Back Arm" layer. Go to the properties window and click on the "Swap Symbol" icon. Select the "Back Arm2" symbol and click OK. This should replace "Back Arm" with "Back Arm2".

Turn on the layers in outline so it is easier to position your back arm. Reposition the back arm by placing it in exactly the correct spot. Then reset the visibility for all of your layers.

To see the character walking add frames in the "Walk" symbol and in scene 1. If you don't add those frames within the walk symbol, the animation will not show up.

Select the "Walk" symbol on the upper left-hand-side of your Flash window. With the command key down, (right-click in Windows) highlight all the layers with your mouse and select every frame, all the way to frame 12. Then add a frame by using the Insert menu. Perform the same process in "scene 1" with the layer you have. Select the empty frames up to frame 12, then add a frame using the Insert menu. Be sure to stop at frame 12. The last task we need to perform on the legs is the reversal of movement from the front leg to the back. This is very simple, and is the same process we applied to the arms to make them swing in opposition to each other.

Within the "Legs" object, select the "Back leg" layer. Select frames 2 through 7 and copy the frames. Go to the "Front leg" layer and paste the frames into frames 8 through 13.

Next go to the "Front leg" layer and copy frames 2 through 7. Choose the "Back leg" layer and select frames 8 through 13. Paste in the frames you just copied from the front leg. Now you'll see the front leg swing back to its starting position at the end of the cycle.

We need to add some rotation to the body. When people walk, their bodies move up and down and they tend to lean toward the direction they are walking. This has a lot to do with gravity and forward momentum which is covered in Chapter 3 character animation.

Now that all of the movement for the top of the body is done, let's finish the leg cycle.

To achieve this forward-leaning effect, let's use the rotation tool. Within the "Walk" symbol, select the "Top" layer and add four keyframes at each contact and passing position: frames 4, 7, 10 and 13.

Next, select frame 1, open the Window menu, and make the Info panel active. In the "Align & Info" panel, choose "Transform". Select "Rotate" and type 4. This provides a slight rotation forward (clockwise). You could exaggerate wildly or be more subtle, but that's up to you – which approach best fits your character's personality?

Do the same on frame 7 and frame 13. Then motion tween all the keyframes.

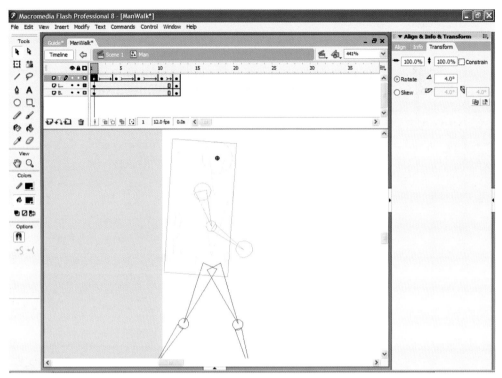

Figure 1.14 *Align & Info panel effecting the MovieClip*

In scene 1 avoid having the same frame play twice. In this case, frame 13 is the same position as frame 1. Since our walk cycle plays in a loop, we don't want to see the same frame twice, otherwise it will appear as a glitch in the animation. Select the four layers within frame 12 and insert a keyframe on each layer. Then delete frame 13. Go to scene 1 and be sure the time frame stops on frame 12.

Make your character walk across the screen!

Scale your character down to fit the screen on the left and then insert a keyframe on frame 70. Move your character to the extreme right side of the screen making sure that you are still in frame 70. Select frame 1 and build a motion tween for the walk across the screen. Adjust the number of frames between the left side of the frame and the right side until you achieve the walking pace. If your character seems to slide while he's walking, check your foot positioning and be sure the steps are evenly distributed so that the spacing stays the same during the walk across screen.

Chapter 3 covers all aspects of the moving character but basically everything stems from this tutorial. From here onwards all depends on the action of the character, it's weight and flexibility and resistance. Playing and manipulating these details is what is going to give life to your character.

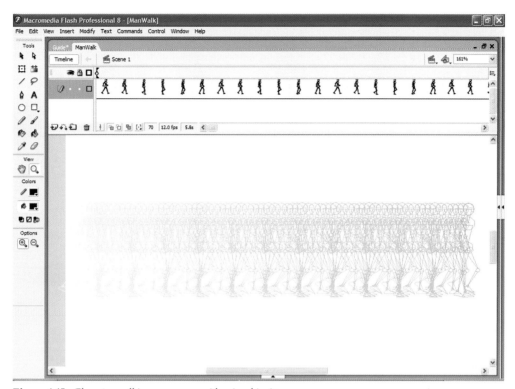

Figure 1.15 *Characters walking across screen with onion skinning on*

Tweening Motion along a Path

Just before we finish this chapter, I think it is useful to be aware that you can move MovieClips along a path. I have found this method of moving sprites along a Motion guide layer very useful. It allows you to draw paths along which tweened instances, groups or text blocks can be animated. You can link multiple layers to a motion guide layer to have multiple objects follow the same path. A normal layer that is linked to a motion guide layer becomes a guided layer.

Flash animations do not have to move along a straight line; they can take any path. Create a new file.

Make a new symbol from a circle and then add it to the main layer and call that layer "ball layer".

With the layer active, choose Insert and then Motion Guide.

You'll notice this created a new guide layer with a loop icon in it.

Click on the guide layer name to make it active. Draw a squiggly line starting at the centre of the ball and move to the right side of the stage area. Is it not smooth enough? Click on the path

(using the Arrow tool), and then click on the Smooth Modifier in the menu bar on your left again and again until you achieve the desired result.

Add another 10 frames to the Timeline and the tenth frame of the ball layer add a keyframe. Whilst still on the tenth frame move the ball to the end of the line on the motion guide and tween

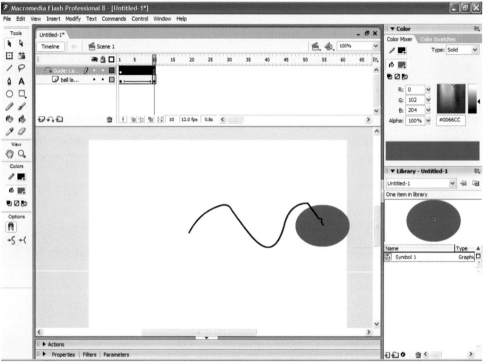

Figure 1.16 *The difference between a motion guide and a guide layer in a demo fla*

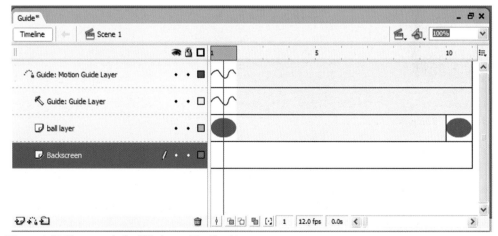

Figure 1.17 *Your example should look something like this*

animation. Now run the movie, if you did not follow this excerise then you can open up the guide.fla and run that.

Also, Flash animations don't have to move along a straight line; they can take any path. With the Triangle layer active, choose Insert and then Motion Guide. You'll notice this created a new guide layer (with a loop icon in it). Click on the guide layer name to make it active if it isn't already. Make frame 5 the current frame so you can see the triangle on the right side of the Stage. Select the Pencil and the Smooth Modifier. Draw a loop starting at the centre of the triangle and bring it around the bottom and back up the left side of the stage area. Is it not smooth enough? Click on the path (using the Arrow tool), and then click on the Smooth Modifier again and again until you achieve the desired result.

Street Fighter Game

There is a lot more to learn about animation but hopefully you can feel confident enough to edit our street fighter fla (streetFighter.fla). What I think is useful for this chapter, is to become

Figure 1.18 *This picture shows an example of just this kind of character animation hierarchy*

familiar with how graphics and movieclips can be embedded into each other to make them more portable. It goes without question that if you were intending to build a running character you would have one overall movieclip for the character. That main movieclip would then house Multiple movieclips for the movement in the different parts of the body in the same way as our walking man was built early in this chapter.

Chapter 2

Planning and Production

The tradition of drawn animation is an art form that has only developed in this century. Film has been the vehicle for this great technology. Traditionally, an animator needed a large team of artists to produce any moving image. Things have changed a great deal with software like Flash allowing you to manage your assets as well as integrate both picture and editorial tools within it. The traditional large teams sole responsibility was to track who is doing what and when. To some extent all this can be done with Flash 8 by one person. Before we go into the depth of animation we need to plan our processes. It is a fundamental part of the project. Especially if you have more than one person working on the animation.

This chapter is structured in three parts.

The first section looks at planning and storyboarding the traditional way but using Flash 8.

The middle section demonstrates *a simple design methodology that plans out all the assets required for a game or animation.*

The final section add productivity tips *to improve your workflow and organize your workspace while using Flash 8.*

Gantt Charts

A Gantt chart is a horizontal bar chart developed as a production control tool in 1917 by Henry L. Gantt, its used by many studios as a way of tracking projects. A Gantt chart provides a graphical illustration of a schedule that helps to plan, coordinate and track specific tasks in a project. Gantt charts may be simple versions created on graph paper or more complex automated versions created using project management applications such as Microsoft Project or Excel. On the CD I have included a excel spreadsheet version.

Planning and Storyboarding

Plan out the scene using a storyboard. I have included one on the CD with support information, Storyboard.fla. I always recommend that you have the action planned out in your mind before you start to create in Flash. Also, keep in mind the character's personality, your unique drawing style and how that fits the overall picture. Time spent here will not only save you time later, but will lead to a consistency that gives the movie a fluid continuity.

Build Snapshots of your Movie

These are sketches that work out the staging of the characters in a scene and its key poses. Each snapshot should tell something about that part of the movie. Your scenes must fit into the visual continuity of the sequence. Your snapshots will guide you through the process of building your movie. They will act as beacons for the animation sequences.

Identify your Camera Angles

Solve your basic problems with camera angles and camera placement to give greater interest to the overall film. You should at this stage be able to update your storyboard, confirming all the camera angles and effects. You should always recheck the size relationship of all your characters.

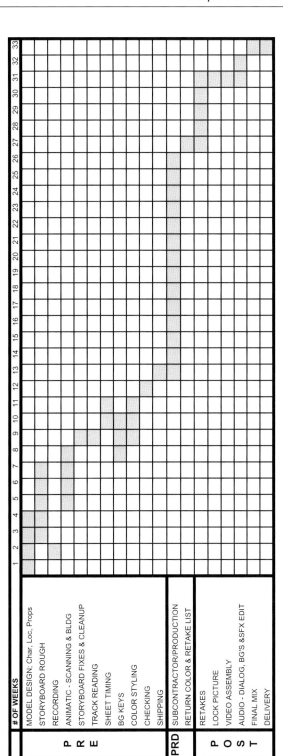

Figure 2.1 *Gantt chart production schedule. This chart is provided on the Production Schedule.xls CD*

Solve All your Camera Angles

I always try to work out each new camera angle in snapshots. It takes 12–24 drawings to create one second of animation. So don't waste time on animation if you have problems with the snapshots.

Take a Moment and Present your Ideas

I always like to take a rain check and present to my client, or somebody who is not directly involved in the project, the ideas and planning arrangements, just in case I may have forgotten something in the planning of my ideas for the scene. At this point I always double-check every thing, including layouts, staging, perspective and key poses.

Timing

Now that all the key poses and staging have been planned you can concentrate on animating the acting, expressions, dialog and timing. Timing charts are put on the key frames so the assistant can put in the additional drawings that are needed to have the character moving at the correct speed and timing that the animator has in mind for the scene.

Tools of the Trade

The most reliable tool to start creating your character is a pencil and a good old piece of paper. It is the process of quick sketching over hundreds of blank white sheets of paper that finally creates those sparks of inspiration. I always build my characters out of a few main basic shapes, if the character is soft and delicate, I will make it out of soft rounded shapes, if my character is the villain then I design him so that he looks angular and jarring, with more points and angles than my soft well-rounded character. Whilst drawing your character you start to learn about it, and in most instances the character is usually full of surprises. If it's not then you have missed a fundamental part of the process and that is the art of spontaneity and surprise. Your characters should fit together in the same environment; they should all have a fairly similar style but at the same time be unique in personality. Once sketched, I then scan the images and convert them to vector line work in Macromedia FreeHand.

Storyboarding

The storyboard is the place to plan out your story in two dimensions. The first dimension is time. The second is interaction. The storyboard is the planning document for everybody involved in production. In it you will outline the action, visual transitions and how the voiceover interacts with the soundtrack. All aspects of the storyline and the impact it makes on the overall story will be planned out in the storyboard.

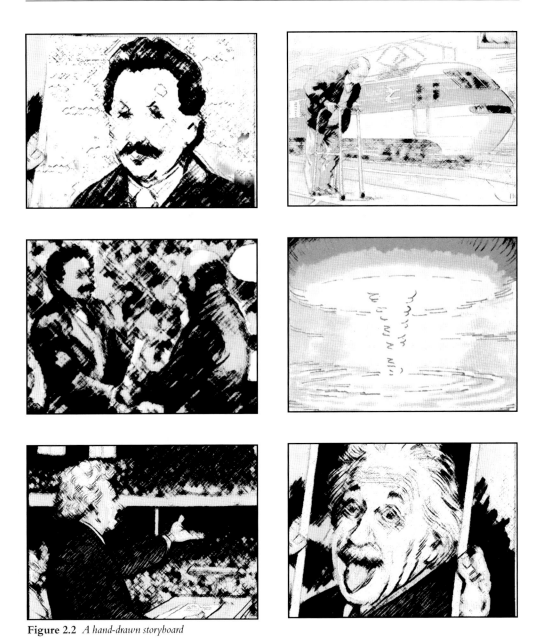

Figure 2.2 *A hand-drawn storyboard*

The Advantages of Storyboarding

Storyboarding will eventually save the team in production, a significant amount of time. In fact you cannot do a full production without some kind of storyboard. It does not have to take a considerable amount of time to render a storyboard. Once the artist has established a personal style it can be as quick as doing a doodle on a piece of paper. The storyboard helps focus everybody's thoughts on the feasibility of the program. If the storyboard

does not work, the program will not work. Sometimes you can highlight serious omissions. I have listed a few additional points:

- The storyboard is a document, which everyone uses as a common point of reference.
- The storyboard illustrates the total content of the program and its overall size.
- Problems will be identified at this stage and corrected rather than at a later stage.
- It speeds up the content-writing process because the writer has an outline of all the content.

Figure 2.3 *A wide storyboard showing a pan across the stage*

If storyboarding has a role to play in the design process then studying how to go about it the right way must influence the design process of an animation or film, hence storyboarding is essential.

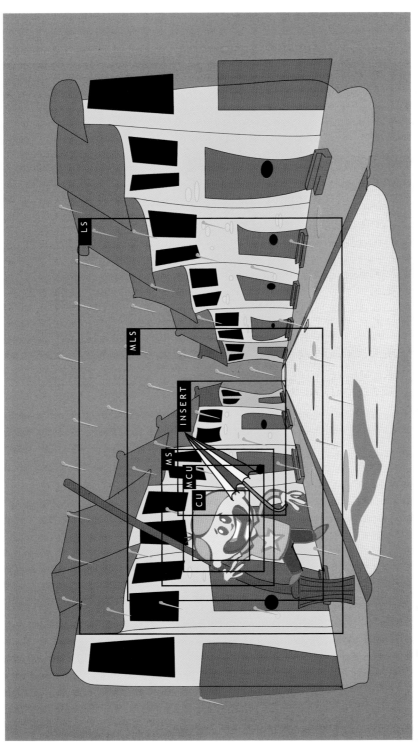

Figure 2.4 *Picture illustrating shooting terms*

Storyboarding: Terms Used in Shooting

Table 2.1 *Abbreviations in Figure 2.4, see Appendix C for more terms*

Abbreviation	Terms
BCU	Big Close up
CU	Close up
MCU	Medium Close Up
MS	Medium Shot
MLS	Medium Long Shot
LS	Long Shot
VLS	Very Long Shot
Insert	Inanimate object

Transitions

Transition is the term used for a number of video or animation techniques that are used to connect, or join separate shots or separate sequences. The more commonly used transition techniques or types are cut, fade, mix/dissolve and wipe. A *cut* is a direct, dynamic splice to another shot and scene. A *fade* involves fading out from the scene to black and then fading in from black to the scene on the next shot. Sometimes these are labelled as a mix or dissolve. Wipes are any number of decorative type transitions and are closely related to *mix/dissolves*. When a particular shot ends one sequence and leads to another it's called a transition scene.

Other terms define the physical movement of a camera during the recording of a scene. *Pan* means to swivel/turn the camera to the right or left (horizontally) from the camera-person's position. *Tilt* means to vertically tilt the camera either up or down. *Dolly* means to move the camera "physically in", closer to the subject or to back out away from the subject. *Truck* is to move parallel along-side the subject within the scene. Closely related to these camera movement terms is the zoom. A movement by zooming into or away from the subject. These techniques can easily be overused. Panning can make viewers dizzy. Zooming isn't a natural movement, so it can be distracting. It's like running towards someone at high speed. Animators can use these techniques to produce particular effects. For example, trucking makes it look like you're "following" someone and zooming is a way of "listening in" on a conversation.

The Three Stages of Storyboarding – Thumbnails

Thumbnails are basic pencil sketches to illustrate the actions. It is at this stage that the immediacy of the process allows the artist the opportunity to test a few different angles on the scene. As you sketch you will find yourself slowly developing a clearer image of the action. My preferred root for this stage is pencil but there is no reason that it could not be a cut paper or even an ink pen or brush.

The Three Stages of Storyboarding – Rough Pass

As you finish scenes or sequences in thumbnail format you can take time to review your sketches and work them up in either Flash or in pencil format. What you are looking at getting out here is a more worked up visual of your story with a more explored character placement, camera angles and even lighting. You can start to add your creative notes and explore what is working well by asking yourself:

• Does the story achieve what I am trying to do?
• How complex are sequences, are they realistic?
• What are the alternatives?

The Three Stages of Storyboarding – Clean Storyboard

This is the last stage, once you have reworked your scenes you can start to write-up the scenes and link some of the images with dialog. The kind of detail that should be included here is:

1. The project title.
2. The dialog information.
3. The scene numbers.
4. Description of visual effects.
5. Backgrounds and other objects.
6. Cameras, moves and dissolves.

Interactive Storyboarding in Flash 8

Flash 8 gives you the capability to produce interactive storyboards. An interactive storyboard is a working version of the movie produced in an easily adjusted form, without requiring any programming skills. It provides a common point of reference to illustrate the structure and look and feel of the project from the end-user experience. The storyboard will define what needs to be written, what graphic assets need to be created, and how best to apply transition and other effects. On the CD in the chapter2 folder you can find the storyboard.fla.

In an interactive environment the production of the interactive storyboard should precede the production of the product specification document. This enables the prototype to be constructed. You can use this storyboard for testing the strategies and techniques of the production process and also as a tool to brief the programmers.

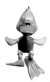

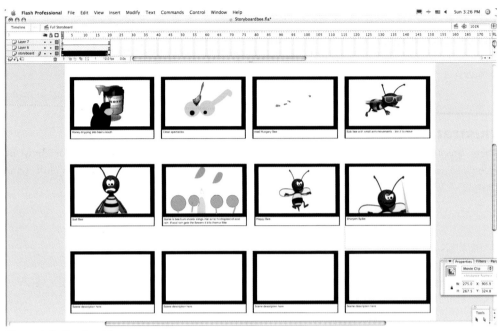

Figure 2.5 *Storyboard.fla*

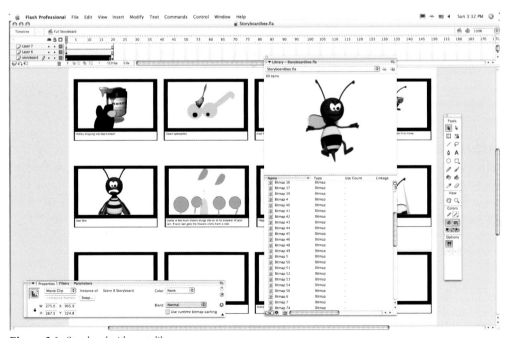

Figure 2.6 *Storyboard with assets library open*

A screen from a storyboard is shown in Figure 2.6. Having created my assets in library format it's then easy and quick to place the character down in every frame and start building the storyline. Pathways can be tested through the material to investigate the look and feel, the consistency and ease of use of the program.

Illustrating your Storyboard

There are many approaches to drawing, but whether you use pen and paper or draw in FreeHand or directly in Flash 8 the most important thing you can do is to establish your personal style.

Always Visualize What you Want to Draw

Unless you have worked out in your mind what you are going to draw it's a false hope that you can just execute the drawing. I like to write a paragraph on each frame before I start drawing. I find it helps me focus on the illustration.

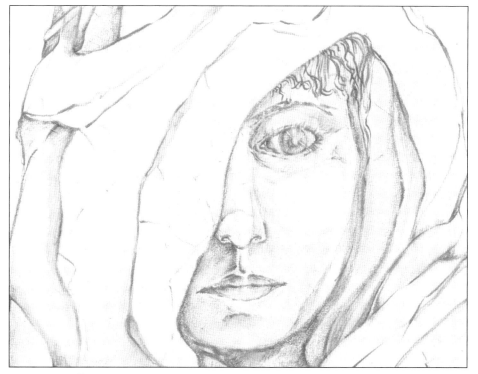

Figure 2.7 *Detail filled in at a later date*

Leave the Detail until Last

Draw the big shapes first. Then work your way down to the detail. Leave 3D detail until later. When you are drawing the 3D start by just drawing the basic shapes like spheres, cylinders or cones. You're trying to establish planes for both depth and perspective. Now, refine and define the various planes, edges and details.

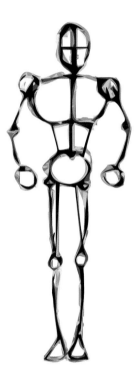

Figure 2.8 *A well-proportioned body*

Proportion

Proportion is the relationship of one size to another. You need to start by working out your proportions. The proportions of the human body are the most important, get them right. The second most important proportions are between objects and the space they occupy. The basic silhouette of an object is often more important than any detail. Work using contrast lighting, so, if your foreground is light, make the background dark, and vice versa.

The following page contains a storyboard from recent work in both digital and pen and paper.

Frame 1 – A wide shot of a woman's face covered with a shawl

Frame 2 – Zoom in on the top of her heal

Frame 3 – lower the camera down towards the bottom of her face

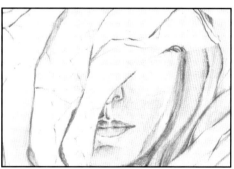

Frame 4 – The shawl begins to part, revealing her face

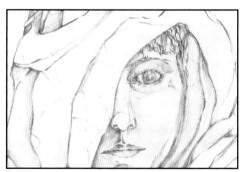

Frame 5 – More of her face is revealed

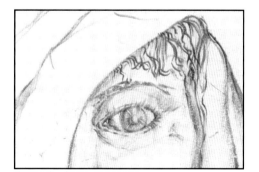

Frame 6 – focus on her eye

Figure 2.9 *Example 2: A 30 second TV commercial*

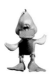

Animation Methods

Two typical computer animation methods are "frame" animation and "sprite" animation. Frame animation is animation inside a frame or on a stage. It is similar to cartoon movies: a sequence of frames that follow each other at a fast rate, fast enough to suggest motion.

Frame animation with transparency information is also referred to as "cel" animation. In traditional animation, a cel is a sheet of transparent acetate on which a single object (or character) is drawn.

Sprite animation, in its simplest form, is a two-dimensional graphic object that moves across the display. Sprites can often have transparent areas. By using a mask or a transparent color, sprites are not restricted to rectangular shapes and lends itself well to be interactive: the position of each sprite is controlled by the user or by an application program (or by both). The Flash 8 library allows you to change the appearance of the sprite, usually by attaching a new image or editing the sprite.

Implementation Tricks

Animation systems, Flash 8, are based on some sort of key framing system applied to a nested transformation scheme. The animator must design the transformation structure and then specify values for the transformations (i.e. translation, scale and rotation values) and the key frame numbers for them to have those values. Here are some tricks on how to generate such animation control files.

Blocking

The conventional technique is to have the narrator record the script first, time it and then generate the animation to the timed sound track. This doesn't always work well in Flash since we are modifying the wording of the narration right up to the last minute. I find it best to first lay out the entire sequence of events with no thought given as to how much time it takes for each event to occur. This is like a detailed storyboard.

Only after the sequence is set do I go back and spread apart the key frame numbers to specify timing. I generally replay an animation many times while reading the narration, repeatedly lengthening the time durations of the motions and pauses to make sure there's time for all the words. More on this scrubbing process in Chapter 4.

Project Management Methodology

Working with a number of people on an animation project can sometimes lead to a communication breakdown. To avoid this, we at Sprite Interactive evolved a design methodology that plans out all the assets required for a game or film. This process not only helps you in the planning but also gives the client a document to sign off on.

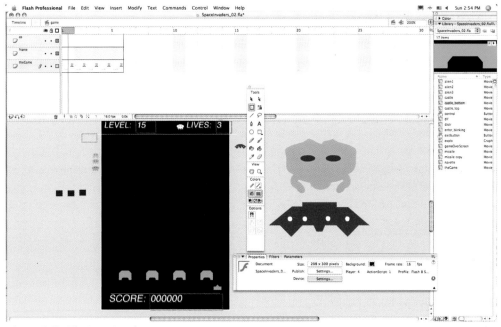

Figure 2.10 *The Sprite Invaders game*

Textual Description

This stage involves producing a description of the game that can be broken down into its basic elements, which could quite easily be a script. When writing the description try to include as much detail as possible about aspects of the animation such as effects and actions associated with things in the animation. The more detail you include the easier it is to break down into a smaller scene and snapshot of the actions.

Identify Assets

Now identify the game assets by extracting all the nouns from your textual description. For example, the following description is taken from a space invaders type game:

> "... you control a spaceship that is being attacked by aliens descending from above in their UFOs. You can fire missiles to destroy the aliens and they can drop bombs on you. If your craft is hit by an alien projectile it is game over".

The nouns identify the top-level assets (or objects) in the design and in Flash these directly translate to Movie Clip assets. The identified assets are:

- SHIP
- ALIEN

- BOMB
- MISSILE
- PROJECTILE
- CRAFT
- UFO

Once the nouns have been identified it is important to remove any duplicate or misleading assets, for example, the PROJECTILE asset is potentially misleading and is simply an instance of either the MISSILE or BOMB assets. Similarly, UFO refers to the ALIEN asset and CRAFT is simply another way of describing the SHIP asset. This check ensures that each asset is unique and removes all redundant information.

Asset Specification

With the assets identified, the next step is to plan the specification for each of these graphical assets. This involves identifying the states associated with each asset and deciding the graphical and audio requirements for each asset state. For example, the SHIP asset can be defined by the following states:

SHIP (ASSETS)
Moving (2 static images, for left and right directions)
Firing (2 frame movie, 1 audio clip)
Exploding (6 frame movie, 1 audio clip)

For each of these states the graphical and audio requirements are specified to give an indication of the amount of resources that should be assigned to developing that asset. The final asset specification may look something like:

SHIP (ASSETS)
Moving (2 static images)
Firing (2 frame movie, 1 audio clip)
Exploding (6 frame movie, 1 audio clip)

ALIEN (ASSETS)
Moving (2 frame movie)
Bombing (2 frame movie, 1 audio clip)
Exploding (4 frame movie, 1 audio clip)

BOMB (ASSETS)
Moving (1 static image)
Exploding (1 static image)

MISSILE (ASSETS)
Moving (2 frame movie, 1 audio clip)
Exploding (1 static image)

One thing to take into account is that many graphical animations can actually be achieved using simple transformations of single images, for example, a car driving away may only require a single image reduced in size over time. This reduces the development time and suitable situations should be identified at this stage.

Identify User Interaction

With the graphical aspect of the game planned out, the next stage is to define the dynamic aspects of the game such as the user interaction and game functions. A textual description of the user control is first required, for example:

"The cursor keys are used to move the ship left and right. The space bar is used to fire a missile".

From this description certain elements of each event can be identified: the input, the action and the asset. These form the basis for the functions associated with each asset:

SHIP (EVENTS)
Move (called when cursor key pressed)

MISSILE (EVENTS)
Fire (called when space bar pressed)

Identify Asset Functions

The game performs actions based on both user input and game functions. A game function could be used to control the aliens, keep score or determine the winning status. To begin identifying the possible functions that an asset can have, the verbs need to be extracted from the textual description. For example:

"The alien craft descend down the screen and drop bombs at random. When a missile is fired it is moved up the screen until it reaches the top or hits an alien. The player wins when all aliens have been destroyed".

From this description, functions for the BOMB, MISSILE and PLAYER assets can be extracted. The functions are called automatically by the game engine and are not associated with any player input. The following are the non-user-based functions associated with each asset.

SHIP (FUNCTIONS)
Explode
Win

ALIEN (FUNCTIONS)
Descend
Drop bomb
Explode

BOMB (FUNCTIONS)
Move
Detonate

MISSILE (FUNCTIONS)
Move
Detonate

You are now in a position to pass the function information to a programmer to code your title.

Productivity and Workflow

Flash 8 has a Preferences dialog box. Flash's Preferences dialog box has seven tabs, and each tab has several sections. The following subsections suggest ways you can improve or enhance the performance and functionality of Flash by adjusting the preferences under each tab. I won't cover all the tabs but I will look at what I believe are the most influential on an animation project.

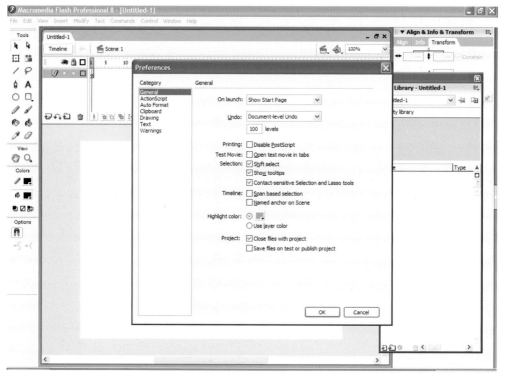

Figure 2.11 *Flash 8 Preference dialog box*

The General Tab

The General tab is miscellaneous preferences that covers all aspects of the program.

On Launch

This enables you to choose what to show upon launching Flash. By default, the Start screen is shown, but you can choose to have Flash open a new document, the last document you had open, or no document at all. You may find it more desirable to open the last document you worked on.

Undo Levels

When you first install Flash 8, the number of undo levels is set to 100. But the undo stack requires memory that your computer may not have to spare. Everything you do must be remembered by Flash so that it can be undone if requested. With this number set so high, your computer is going to work hard. Lowering this number decreases the amount of memory required to run Flash.

Highlight Color

Selecting an object on the Stage, highlights it with a blue bounding box by default. You can change the Highlight color using the nearby color swatch if you set the Highlight color option to Use this color. Alternatively, each layer in the Timeline has its own colored square next to the layer name. To highlight all of the objects on a particular layer using the layer color, change the Highlight color option to Use layer color. This makes it easier to tell the objects on one layer apart from another. This color is also used when viewing content in outline mode (View > Preview Mode > Outlines). You can set the color for the selected layer in the Layer Properties dialog box (Modify > Timeline > Layer Properties).

Project Settings

Project settings enables you to close project files when you close a project in the Project panel (Window > Project) and save project files when you test or publish an opened project. If you don't tell Flash to close all of the project files at once, you'll have to do it yourself. And that's just no fun.

The Drawing Tab

The drawing tab contains preferences for the Pen tool, Drawing settings and Project settings.

Drawing Settings

Change the drop-down list choices in this section to accommodate your particular drawing needs. Choose Smooth from the Smooth Curves menu and choose Tolerant from the Recognize Shapes menu.

Figure 2.12 *Keyboard Shortcuts dialog box*

Figure 2.13 *Timeline is enlarged preview setting*

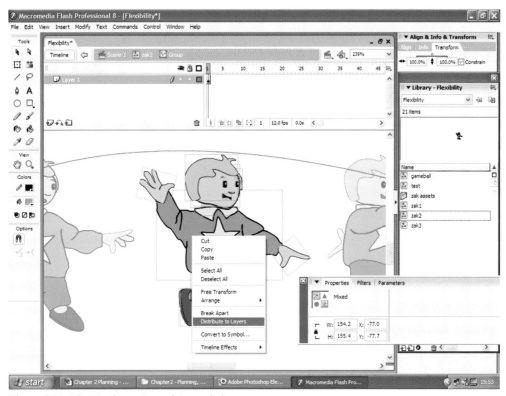

Figure 2.14 *The Distribute to Layers being applied*

The ActionScript Tab

This lets you configure all things related to writing code in Flash, such as the font used in the Actions panel, how reserved keywords are color coded and whether you want to use code hints.

Editing Options

Here, you can set the amount of time delay for code hints when typing in the Actions panel, from 0 to 4 seconds. If you like code hints, 4 seconds can be a long time to wait, so leave it set to 0. If you want to disable code hints entirely, simply uncheck the Code Hints checkbox.

Keyboard Shortcuts

Many commands and features in Flash already have corresponding keyboard shortcuts, such as pressing V to activate the Selection tool. But you may want a faster way to run a command or

Figure 2.15 *Shortcut keyboard*

open a custom panel set (which I'll show you how to create in a minute). Here's how to customize the keyboard shortcuts:

1. Choose Keyboard Shortcuts from the Edit menu on Windows (or the Flash menu on Mac) to open the Keyboard Shortcuts dialog box, shown in Figure 2.15.
2. Click the Duplicate Set button in the dialog box, name the new keyboard shortcut set and give it a name and click OK.
3. In the Commands section of the dialog box, expand the File menu and select Close All (which closes all open documents and libraries).
4. In the Shortcut section, click Add Shortcut, and press the keys you want to use as the new shortcut. For example, you might press Ctrl+Shift+W on Windows or Cmd+Shift+W on Mac. The keys you press appear in the Press key field.
5. Click the Change button. This opens a message warning you that the shortcut is already assigned to the Work Area command.
6. Click Reassign.
7. Click OK to close the dialog box.

Now, when you have more than one document or more than one library open, simply use this keyboard shortcut to close all of your Flash files at once.

When you need to see the Stage a little better and get some of those panels out of the way, press F4 to hide all of the panels at once. Press it again to show the panels.

Panel Layout

Customizing the panel layout in Flash enables you to organize your workspace exactly the way you want, but first you need to know how to dock and undock panels:

1. To undock a panel, locate two panels that are docked together. Click on the titlebar (more specifically, click on the little dots on the left side of the titlebar) of one of them and drag the panel away from the other panel, and then release the mouse button.
2. To redock the panel, drag it over the top of the titlebar of another panel until a heavy black line appears between them. Then release the mouse button.

Here's how to customize your panel layout:

1. From the Window menu, open any panel you believe you'll use often.
2. Next, choose Window > Design Panels, Window > Development Panels and Window > Other Panels to locate any panels that are currently not open. Open the ones you think you'll use often.
3. Arrange the panels in any way you like. Leave a nice view of the Stage, Tools panel, Properties panel and Timeline panel.
4. When everything is arranged how you like it, choose Window > Save Panel Layout to open the Save Panel Layout dialog box.
5. Give your panel set a name and click OK to close the dialog box.

Flash remembers your current layout the next time you launch it, but you might move things around while working. Anytime you want to restore your workspace to your saved panel layout, simply choose Window > Panel Sets > *your panel set*. Choose the Default Layout or Training Layout panel set from this menu if your windows become misarranged or if you can't locate a panel you need.

I always convert my objects to symbols and name them with a simple yet descriptive naming convention. For example, head1, eye1, mouth_wide and so on. However, I do not create names for my layers at this time because there's a much easier and faster way.

After all my symbols are created and named appropriately, I simply select them all (Ctrl+A) and copy (Ctrl+C) them. I now create a new layer and paste them in place (Ctrl+Shift+V). This places them all on one layer, yet as separate symbols. Delete all your other layers so you end up with just the one layer containing all of your character symbols. Select all again and then right-click over your character and select Distribute to Layers as shown in Figure 2.16. Selecting all symbols, then right-clicking the character and selecting Distribute to Layers.

Figure 2.16 *Flash has not only placed each symbol on its own layer but has named each layer based on their symbol names*

Saving Time through Good Document Management

Giving layers a descriptive name based on the kind of object it contains is good practice in terms of Timeline and file management. This is especially important when working with more than one artist – and even more so when working within team environments.

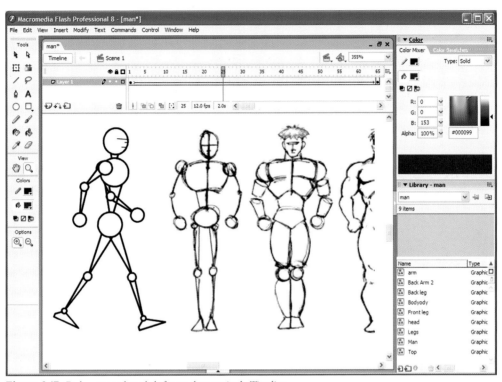

Figure 2.17 *Body parts and symbols for my character in the Timeline*

A layer folder is simply a new layer that acts like a folder to hold other layers. They can be expanded and collapsed. This is extremely functional when dealing with multiple layers for several characters. You can create a layer folder for each character and place all layers inside these folders, giving you the option to collapse them all except for the character you are working on.

Another way to manage your Flash document is building an organized library. When you create or convert something to a symbol, it automatically becomes an object in the library of your movie. To open the library select Window > Library or press Ctrl+L. The library gives you a variety of information and options for each symbol contained in it. You can select each one by clicking a symbol name and view a thumbnail in the library preview window.

If the symbol contains an animation within it, you also see a Stop and Play button in the upper right corner of the preview window. These buttons enable you to preview the animation within this preview window.

The upper right corner of the library contains a pop-up menu with several options. You can create a new symbol, folder, font or video. You can also rename a symbol, move symbols to folders, duplicate or delete a symbol or edit and obtain the properties of a symbol.

Save and Compact

Adding assets to a Flash document, whether they're bitmaps, symbols or scripts, can substantially increase the size of the.fla file. To remedy this, choose File > Save and Compact. This menu option can cut the file size of a large file by half. Generally, it decreases file size by even more than half, especially if you have deleted unused assets from the Library. Using File > Save, which performs an incremental save, doesn't ordinarily lower the file size of the fla, but Save and Compact squashes your file significantly.

Tabbed Documents

If the document windows (PC users only) are maximized within the Flash authoring window, each open document adds one tab to the top of the Flash document window. Click through the tabs to access each open document quickly. Otherwise, you can access open documents from the bottom of the Window menu.

Transfer Software License

To Transfer Your Software License, open the Macromedia Product Activation screen. Click Transfer License and wait. The license is transferred to a Macromedia server, which tracks your registration information with the serial number for your copy of Flash. Next, install Flash on your laptop and register it with the same serial number. You can legally register one copy of Flash on two computers and install Flash on as many computers as you want. You can't, however, use Flash on both computers at the same time (according to the EULA). So before you head for the airport, transfer the license from one computer and then register the copy on your laptop. Instantly, you have a portable copy of Flash. When you get back from your trip, transfer the license from your laptop and register the copy on your main computer. Everything is legal and everyone's happy.

Enable Simple Buttons

Need to see how a button looks but don't want to go through the trouble of running yet another test movie? Choose Control > Enable Simple Buttons. You can now roll over and click those buttons on stage just as you would in a test movie. They do not, however, run any ActionScript associated with them. Enabling simple buttons allows you to see the button in context.

This is just a selection of time saving tips, Chapter 12 has a whole lot more.

Chapter 3
Character Animation

This chapter covers all the major techniques
for drawing and producing realistic character
animations, and includes hands-on
examples and a number of tips and tricks.

The art of character animation can take years to develop; this chapter tries to summarize what an animator has literally taken years of practice and learning to fine tune. Out of all the fields of computer graphics and art, animation is the most difficult. The animator must not only have the ability to draw or pose characters, but also have an acute sense of timing, sense of observation, mannerisms and movement. The following are the principles of character animation. These principles are applicable to traditional forms of character animation, computer animation and more specifically animation created in Flash 8.

We start this chapter by looking at simple techniques of drawing. When you were a child your teacher taught you how to draw the basic shapes like: the triangle, the square, the circle. Things do not really get any more complicated than that. Amazingly everything in the known universe can be drawn using combinations of two or more basic geometric shapes.

First of all, you have to define the basic shapes that make up the object so that you can draw within the boundaries of something. It is like sculpting your subject from a block of wood. This process although easy does not happen the first time, it takes a lot of practice, so do not be afraid in redrawing your blocks and moving them round in order to get the shape the right way. You can start by looking around you and seeing the objects that surround you as a combination of basic shapes. If this is the first time you are doing, stop reading the book and pick up a couple of pencils (2B's or HB's), paper and an eraser and draw everything you see. Do this for about two days (16 hours). Begin with simple things that are inside your house like tables or beds, and then go out and draw cars, trees, buildings, etc. At this stage it is about volume of work than quality. Just get familiar with expressing shapes. Use lots of lines until the shape of the object is defined. Do not be afraid of using the eraser. Start with a basic shape as the greatest fear of most artist is to put the first line on paper.

Drawing the Figure

The basic shapes allow you the bricks to draw anything you want. Learning how to use this technology for drawing characters is simple and all it needs is a pen, paper and your dedication. Of course you need to first have a little of practice.

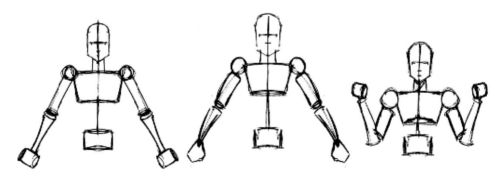

Figure 3.1 *The top half of the body is made up of simple shapes*

I drew them so you can see how they look in several positions using basic shape construction:

1. The arms, forearms, thighs and legs are constructed from cylinders.
2. Shoulders are spheres.
3. A box makes the chest, cones are used to construct the chest and hips.
4. The pelvis is made from box.
5. The hands and feet are made from two triangles.
6. The head is an oval.

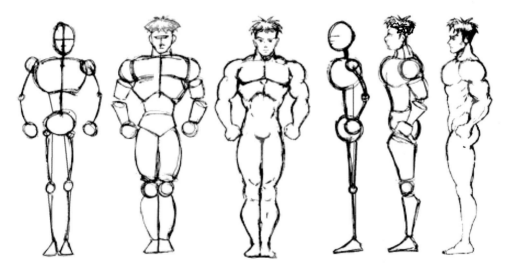

Figure 3.2 *The figures are just an extension of the top half*

Once you have mastered sketching the shapes for the bodies you should look at the head. The basic character head is drawn within an oval like the first image in Figure 3.3.

1. Divide the oval in four using one vertical and one horizontal line. The horizontal line becomes the key line for the eyes to run through.
2. Draw two arcs in the inside extremes of the eye level line, those will later become the eyes.
3. The distance between the eyes is approximately the width of an eye or and eye and a half. Normally the width of a head is five eyes.
4. Divide the lower part of the oval in three equal parts using two horizontal lines. The upper line is where the nose will be located the other is for the mouth.

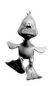

Figure 3.3 *Shows a set of drawings building up through a grid*

Drawing the Head

Looking at it from the side the head can be drawn within a square or using ovals.

Of course it depends on what kind of character are you drawing. In reality very little line work is required to give credibility to an illustration. The audience's eye just works harder to fill in the spaces.

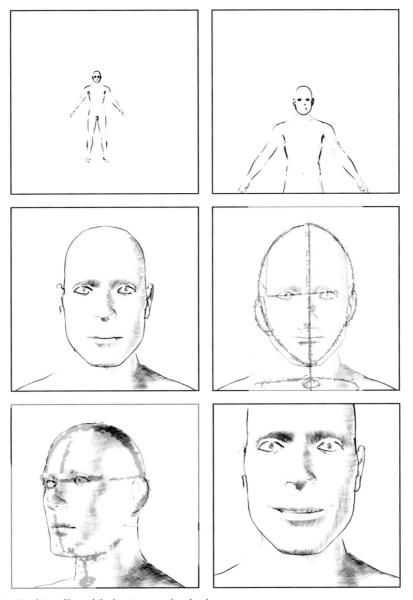

Figure 3.4 *Simplicity of line while showing a storyboard style*

Still using the principles outlined in Figure 3.3, I have drawn a more life like figure but with economy of line. I have maintained a 3D feel to the illustration by just making the lines heavier around the outline.

Action

Before you start drawing a subject in any pose you have to first visualize it in your mind. Then define the position of the character using an axis line to coordinate the position of the character, then add volume to the body using the basic shapes that compound it – cones, cubes, ovals, etc. From then on just build it up. Begin to add details to the figure using all the lines you need until the figure is done. You should always try and visualize the centre line of the subject and the proportions of the volumes in the subject. The best way of learning this technique is by doing fast sketches of characters in different positions.

One technique which I often use is to pause a DVD on an action scene with the characters in a dramatic pose *like* fighting, running and then make a fast sketch of it. The more you practice, the better you will be.

The art of character animation is the art of motion that requires visualizing between two extremes. These extremes are key positions that are then partly filled in by the animator or

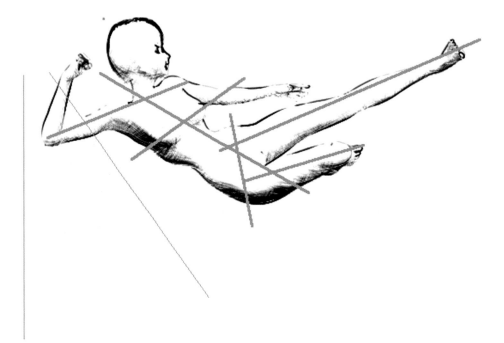

Figure 3.5 *Shows axis line changing as she jumps*

even the viewer's eyes. Character animation is about adding life, and makes the subject a complex life form that does not lend itself easily to simple processes. All aspects of an object's arms, legs, head move independently and when the character does not have arms or legs then it's even more difficult. The animator's job is to add life to non-living objects.

A live performer has personality. An animated character has appeal. Appealing animation does not mean just being comic, cute and cuddly. All characters have to have appeal or presence whether they are cute, villainous, comic or heroic. Appeal can be very difficult to build up in a computerized environment. Using your imagination and being very particular in what you accept takes the process away from the computer and brings it to the realms of the creature. Good personality development will capture and involve the audience and will bring your character to life. The art of storytelling is about appealing to the eyes as well as the mind. A well-drawn character can easily fill in the bits that an animator misses out.

This chapter focuses on the techniques of animation and the way the animator draws the subject using Flash. Although frame rate is an important part of movement, for the moment I wish to solely focus on the technique of drawing. Later on in the book we will look at frame rate and producing for different playback devices.

Character Movement

Character movement can be incredibly complex; couple this with the stylistic approach that you choose for your character, and it can at times seem almost impossible. The animator needs to accept that the process is a learning experience, whereby the observation of everyday life, how things move and just what is going on when an old lady bends down to pick up her cat or a teenager kicks a can as he walks by is their study book or laboratory. It is interesting to watch people exaggerate their feelings or actions and to look at how timing can influence whether an emotion is presented correctly or with the wrong timing totally. The most represented character action is walking. We walk, we see people walking and in the character world even rabbits, dogs and cats walk. It's important to remember that there are many different types of walk and even individual characters are sometimes recognized by their particular walk. Mickey Mouse is recognized by his "double bounce walk" and the way he bounces up and down in midstride. A walk, in essence, is one foot leaving the ground, moving forward, moving to the back and stopping just before its original position. This can then loop to make a perpetual walk seem totally seamless. Another important consideration is the movement the arms and head make. Both of which need to move even if it's only slightly; the rule of thumb here is if the legs move then so do the arms and if the arms move then so does the head.

Exaggeration is a caricature of expressions, poses, attitudes and actions. Action traced from live action film can be accurate, but stiff and mechanical. In feature animation, a character must move more fluidly to look natural. The same is true of facial expressions, but the action should not be as

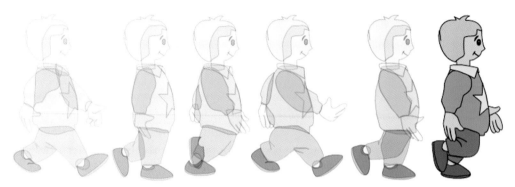

Figure 3.6 *Zak walking*

broad as in a short cartoon style. Exaggeration in a walk or an eye movement or even a head turn will give the character more appeal.

Timing

Expertise in timing comes with experience and personal experimentation. It's impossible to determine all the conditions that your animation will play back in. The rule of thumb for me is to create everything for playback on 15 frames per second unless I am doing it for video and then I do it at 30 frames per second. The basics are:

- More drawings between poses slow and smooth the action, although you can speed up the process by increasing the frame rate of the movie.
- Fewer drawings make the action faster and crisper.

I recommend you stick to 15 frames per second. A variety of slow and fast timing within a scene adds texture and interest to the movement. Most animation is done on twos (one drawing photographed on two frames of film) or on ones (one drawing photographed on each frame of film). In the digital world with playback of 15 frames per second twos are used most of the time, and ones are used during tracks, pans and occasionally for subtle and quick dialog animation.

Arcs, Easing-in and Easing-out

All actions, except for mechanical devices, follow an arc or slightly circular path. This is especially true of the human figure and the action of animals. Arcs give animation a fluidity that allows the animator to flow from one sequence to the other. Think of natural movements in terms of a ball bouncing that just arcs itself into stillness. All arm movements, head turns and even eye movements are arcs. As action starts, there are drawings near the starting pose, one or two in the middle and more drawings near the next pose. The fewer the drawings, the faster the action and more drawings make the action slower. Easing-ins and easing-outs soften the action, making it more lifelike. For exaggerated action, we may omit some easing-ins and easing-outs for a surprise element.

The Walk

The main action in a walk starts at the legs and the lower half of the body. It is basically a continuous sequence of steps.

The midway position of any walk is called the "passing position". Open the Walk.fla file and play it now, make sure that loop playback is on. A feature of the midway position is the body – it is raised higher in the passing position. The reason for this is that in the passing position the leg is straight below the body pushing the body upwards; this can also give the hips a swaying motion as the top of the legs move up to take their position at the midway point. It is important to stress that the midway should always be the middle of the animation sequence, so if for some reason you wish to do the walk in three frames then the middle frame is the high point of the walk.

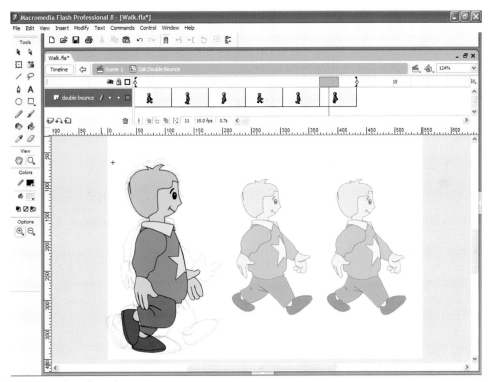

Figure 3.7 *The walk timeline*

The Walk Cycles

The walk cycle is made by repeating the walk on the spot, this is also helped if the background pans through the scene; check out the parallax motion movie in Chapter 10. The walk cycle is primarily a trace back of each of the two extreme positions. All that happens in the passing

position is the body is raised up while the foot slips back along the ground. You will notice that the way I have drawn Zak for these sequences is to make his centre of gravity slightly forward so there is a feeling of moving forward. The passing position applies to the whole body so as the left leg is forward, the right arm is moved forward to counterbalance it. This gives us a natural rhythm to follow that immediately suggests that the body is in balance. If you were looking for a really funky walking style then by making the hands swing out of sequence and applying a double bounce sequence you will be able to get some very interesting results.

The Double Bounce Walk

This walk has been the hallmark of Mickey Mouse. The walk breaks down the rigidity of the animation process and ironically makes it closer to life. One lesson here is that animation should exaggerate movement. The animator needs to observe movement in everyday life and before it is applied to the character you need to "walk the walk" until you get a clear picture in your mind. This mental picture is an important part of helping you set the rhythm for the walk. This walk is created by the bouncing effect that occurs midstride, and is shown in the file DoubleBounce.fla. The stride looks like this:

Unlike the normal walk, where the passing position is the high point, in this walk the passing positions are down with the legs fully stretched out on tiptoes on the up positions.

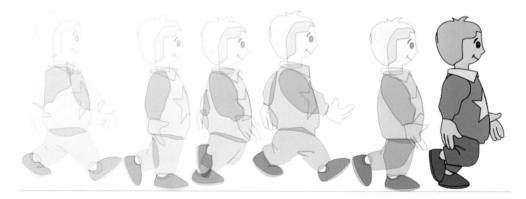

Figure 3.8 *The double bounce walk*

The Slow Lazy Walk

Open the file SlowLazy.fla. The leg movement is very similar to the normal walk, the only difference is that the point of passing is lower but is still apparent. The body has a droopy posture with the head slightly forward and looking down. The head looking down takes the energy out

of the body and is the anticipation of the sluggishness in the walk. I remember describing this walk to a group of students as the gallows walk, your character has been sent to the gallows for committing some heinous animation crime, this is his final walk, head down, shoulders back, arms dangling in resignation of the occurrence to follow.

The Tired/Energyless Walk

If your character should ever find itself lost in the animation desert then you should simulate the slow walk with the only real difference being the length of the body should be slightly longer and lower. To achieve this effect you need to drag the legs behind the centre of gravity of the torso; tilting the torso by 30 degrees. The head should hardly move and be attached to the torso, following the torso movement. When the legs are at their furthest back position they should almost lock allowing the foot to reach out and almost drag the top of the toes on the ground. This move should be supported with a small lurch forward. The arms should dangle for most of the walk except for the short lurch when they should swing slightly. Open Tired.fla and view it.

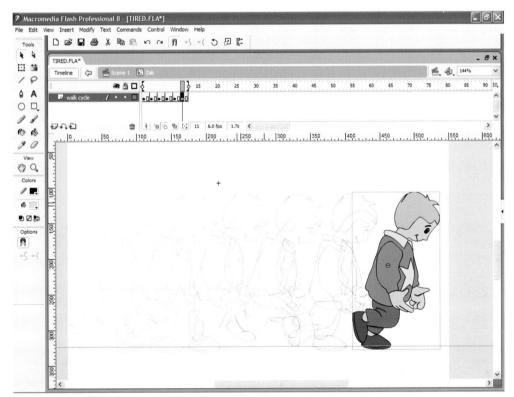

Figure 3.9 *The tired energyless walk*

The Sneaky Walk

The basic action of the sneak falls into two movements: the short sneak and the long sneak. The short sneak is normally quite fast and on tiptoe with the top half hunched up. This is good for illustrating a character as it sneaks up behind another. The movement can be very exaggerated, and is shown in the file Sneak.fla.

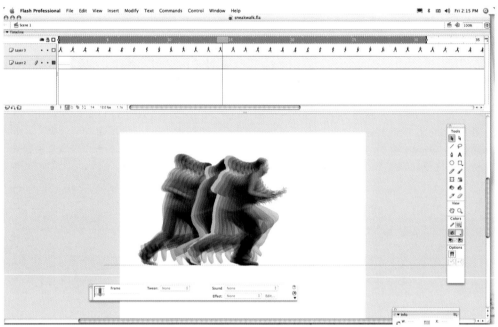

Figure 3.10 (a) *The sneak walk timeline*

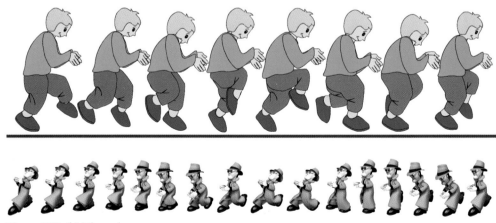

Figure 3.10 (b) *The sneak*

The long sneak is a slower sneak. I always associate this with escaping actions as opposed to the short sneak which I always associate with moving in actions. After the character has committed an animation faux pas he slowly tries to sneak offstage. This is done with long reaches of the legs, elbows bent with most of the body above the gravity point of the character. The head looks down at the legs when they are at their most elongated position, but then looks up when the body catches up with the leg. Look at the file LongSneak.fla.

The Push Walk Backwards

Look at the file PushBackwards.fla. When Zak pushes an E across the stage he is doing most of the work with his legs. His shoulders and arms are hard against the letter. So we use the legs to convey the action and the face to instill the emotion. When the character is pushing a heavy weight most of the body has to be exerting itself. In most instances there is a lean back to try to make the character seem balanced. The heavier the weight the slower the movement. In this situation I always try to change the pace of the movement; at the beginning of the step the push seems slow but before full extension on the legs I double the speed of the movement. This helps convey both the weight and the energy that goes into the movement.

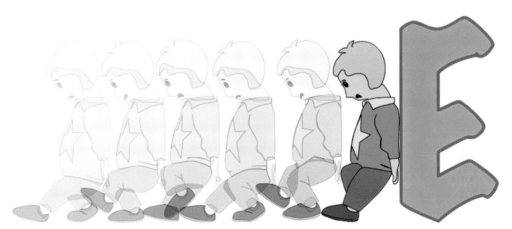

Figure 3.11 *The push walk backwards*

The Push Walk Forwards

I think this walk is much more straightforward. I always thought about it as: the heavier the thing you are pushing the closer you are to it. The steps in this instance are short and slow. If you are pushing a horse then assuming you can get it moving you will be at arm's length with your weight slightly forward in the direction you are going. It is shown in the file PushForwards.fla.

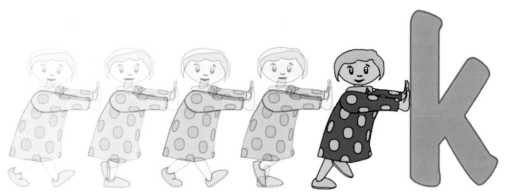

Figure 3.12 *The push walk forwards*

Running

Running is just the walk taken to its most extreme, all the limbs move at a quicker pace. Whatever your timing was for the walk, halve it for the run. You can also reduce the number of frames in your loop, making the loop seem a lot faster. When you are doing the run try lifting the body more at the passing position and enlarge the stride and the push-off at the floor to foot point. The arms are much more energetic because they drive the legs into motion. The run starts at the arms, this creates the anticipation movement that is necessary to kick life into the run. If the character is a sprinter the arms are punching in a bent position acting as a lever for the motion, the shorter the arms, the faster Zak goes. Check out Running.fla to see the example in action.

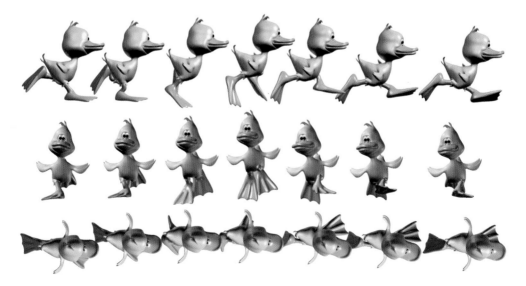

Figure 3.13 *Running cycle from three different views*

We are trying to put more momentum in the run so the centre of gravity is much more forward. It is out of balance with a tipping forward so if the figure was to immediately stop it would fall over. One important definition of the run is that both feet lose contact with the ground; this is the moment of suspension, you see this in horses when they gallop or jump. For a split second the horse seems to freeze. I have, for games, drawn the run as a three frame animation but this is unfortunately too crude for character animation. You can get away with it in the limited area in a game, but not if the character is enlarged; it's not very convincing.

Personality affects the run but also what the runner has to contend with. Running up a hill is far more difficult with the Zak character needing to put all his weight forward to help himself get to the top of the hill. The contact leg is always driving forward. Running down the hill Zak will shift his body weight slightly back. He might even increase his stride, this will increase the moment of suspension; the faster the run the greater the lean backwards.

The three key positions in the run are:

1. The first contact position: This is when the energy is summoned up and the strength and direction of the character show.
2. The moment of suspension: This is the point where there is no contact with the ground but the figure is still moving forward; the lean is very apparent with the arms swinging.
3. The down contact position: This is when the body sinks into the bent contact leg.

As a rule the run should be drawn in single frames; this is known as "ones". When put into cycle these positions look like the picture below, also shown in RunCycle.fla on the CD.

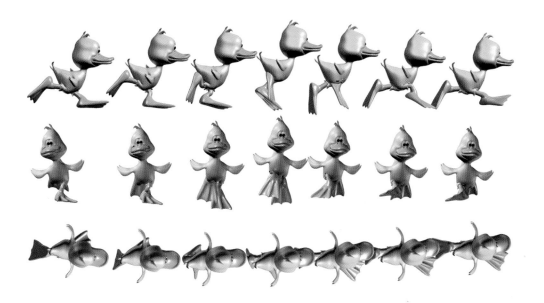

Angry Walk

This action adds to and enriches the main action and adds more dimensions to the character animation, supplementing and/or re-enforcing the main action. Example: A character is angrily walking toward another character. The walk is forceful, aggressive, and forward leaning. The leg action is just short of a stomping walk. The secondary action is a few strong gestures of the arms working with the walk. Also, there is the possibility of dialog being delivered at the same time with tilts and turns of the head to accentuate the walk and dialog, but not so much as to distract from the walk action. All of these actions should work together in support of one another. Think of the walk as the primary action, and arm swings, head bounce and all other actions of the body as secondary or supporting action.

Anticipation

Lifelike movement is a primary goal of animation. Early animators observed nature (including themselves) and experimented with techniques for making animated actions more closely resemble their natural counterparts. Newton's third law of motion states that "for every action there is an equal and opposite reaction". In many instances, a movement in one direction is preceded by a smaller preparatory movement in the opposite direction. By imitating and exaggerating these small movements, animated drawings are given a more naturalistic appearance. As Zak prepares to run off the screen from right to left, he initiates a left movement to shift his gravity to anticipate the move. This is done in three stages: a static pose, anticipation in the opposite direction and finally the run.

Figure 3.14 *Anticipation*

The more carefully you observe living things, the more you will notice them. In order to move a mass efficiently, a force must be directed against its centre of gravity. Aligning the mover behind the centre of gravity of the mass (for pushing) or in front of the mass (for pulling) produces part of the anticipation motion. Understanding and recognizing anticipation will enhance your powers of observation. You'll begin to see the evidence of it all around you, and recognize it in the animation you watch. Here's an example of anticipation in action, Anticipate.fla on the CD:

Zak is at the starting blocks of a race. He gets himself into position and then waits for the signal to go. Bang! When it goes he slips back slightly and then shoots forward. Everything that moves

benefits from an anticipatory movement. If the anticipation is correctly applied you can make a character disappear offscreen in only a few positions. The audience will just fill in the rest. When moving a weight or throwing a ball remember to use the backward motion. This may be one or two swings with the ball. When Zak moves off his seat he prepares the action with a small backward lean.

Squash and Stretch

For me squash and stretch have always been a subsection of anticipation. When a ball bounces it is at the point of impact that it squashes but this anticipates the change in direction as it changes direction at the first frame the ball stretches out. This action gives the illusion of weight and volume to a character as it moves. How extreme the use of squash and stretch is depends on what is required in animation. Usually it's broader in a short style of picture and subtler in a feature. It is used in all forms of character animation from a bouncing ball to the body weight of a person walking. This is an important element to master. Flash can do a lot of the hard

Figure 3.15 *Bouncing ball*

work in scaling distortions but you still need to have a clear picture in your mind as to what you are doing.

Stretching serves to emphasize the speed and direction of motion. Squashing highlights the effect of an abrupt change of direction or a sudden stop. Like many characteristics of animated drawing, the drawing made in the application of squash and stretch defines the animator's style. You can see the bouncing ball in the bounce.fla movie on the CD.

Squash and stretch are not limited to high-speed violent actions, they can be applied in moderation to any action. The more energetic the action, the more exaggerated the squashing and/or stretching. Often the most intense activities result in several cycles of squashing and stretching before the character returns to its initial pose.

Flexibility in Motion

An animation should be like a liquid moving along an inclined surface, totally flexible in its movement. Like a liquid not all the parts of a character move at the same time. Parts of the body, whether an arm or leg or even head, lead the action with other parts following through.

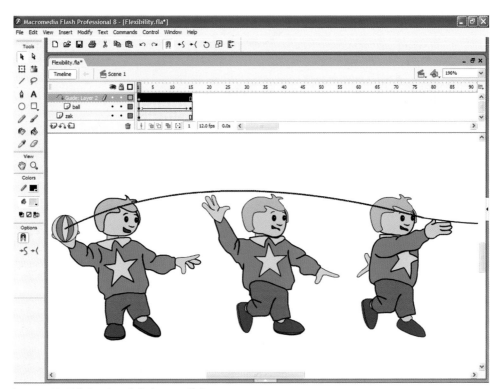

Figure 3.16 *Zak throwing a ball along a guide line*

Occasionally limbs will seem to break away from the action to release a ball or to swing a bat, but they will always do that as part of the follow of the whole and in line with the initial limb that leads the action. The liquid that seems to pour down the incline occasionally creates another arm that splits off and then later joins the main body.

Every action has a breaking point as it goes through a series of changes of direction in the joints; Zak throwing a ball demonstrates this. As he moves through his action the movement starts with the arms and ripples out to the wrists where they seem to crack like a whip just before the moment of release. You will notice in this animation the ripple moves out not only to the wrists but at the same time down the body lifting the feet onto tiptoes – the body leans forward at the point of release. To see this in action look at Flexibility.fla.

Overlapping Action

When the main body of the character stops all other parts continue to catch up to the main mass of the character, such as arms, long hair, clothing, coat tails or a dress, floppy ears or a long tail. An acrobat waving a banner will change direction but the banner will follow on its path of

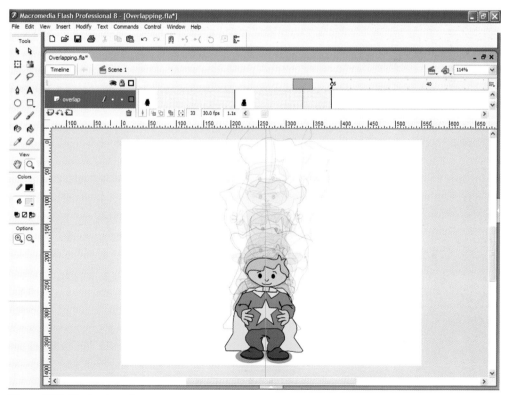

Figure 3.17 *Overlapping action*

movement until it reaches its full length, then it changes direction and follows the acrobat. Nothing stops at once.

Overlapping is a godsend to help set a scene or to set continuity. Have a look at Overlapping.fla. Clothing is a great example of overlapping action. A cape will continue to move towards Zak well after he has stopped. There might even be a little flurry or a crack at the extreme edges of the cape, as you can see in the Overlapping.fla animation. Hair, banners and scarves all move as a result of overlapping action. Timing becomes critical to the effectiveness of drag and the overlapping action.

Head Turns and Eye Movement

A pose or action should clearly communicate to the audience the attitude, mood, reaction or idea of the character as it relates to the storyline. The effective use of long, medium or close-up shots, as well as camera angles, also helps in telling the story. We started this chapter by looking at the walk and then covering the various details associated with the walk including the arm swings. Visually most people are drawn to the eyes and mouth. There is a limited amount of time in a film, so each sequence, scene and frame of film must relate to the overall story. Anticipation and exaggeration can be a few artful strokes away from making a difference between showing the personality of a character and it being just a poor illustration. The viewer can be easily confused with too many actions at once. Use one action, clearly state it and this will get the idea across. Staging the character in this way directs the audience's attention to the story, check out HeadMovement.fla on the CD.

The head suddenly turning with an exaggerated movement can really present a feeling of shock and surprise. The double take is a great example of this. It starts with the head swinging in an arc from left to right, the full frontal being the lowest position. The more exaggerated the movement the more shocked and surprised is the viewer.

If you turn your head from side to side you will notice that your eyes blink as your head turns. If the pupil is moving from side to side of the eye this again moves in an arc position. The eyes tend to lead the direction of the head.

Animal Animation

The same rules apply for animals as apply for character animations:

- A movement is always in an arc whether it's a bird flying or a horse galloping.
- Anticipation is an important part of any movement.
- Exaggeration turns on the character of the animal and makes it more cute and likeable.

One thing I learnt a long time ago and I found very useful is: you can lose size, volume and proportions whilst drawing animals, especially when you combine a number of animals of

different sizes. The method of pose-to-pose animation is a planned-out process charted with key drawings and done at intervals throughout the scene. This matches perfectly with Flash's in-betweening process. By drawing these key frames separately it is much easier to maintain all aspects of scale and balance in the picture. Size and proportions are controlled better this way, as is the action.

Birds

Birds have four wing positions: two up and two down. The two positions of extreme are the main keyframes. The first position is the uppermost position: as the wings drag against the air of the downward thrust the wing becomes concave. This is noticed only at the full frontal position. When the wing reverses its direction upwards there is a reverse curve. At the end of each curve there is a snap to the wings. This method mimics that natural flight pattern of birds; however, in real life wings do not simply curve back the other way when they are on the way up, as they do in cartoon action, they follow the more complex structure; the wing bends in the middle and the body drops slightly resulting in a body movement in the opposite direction of the snap. Over a cycle this effect results in an up and down movement of the body. The file to look at on the CD is Bird.fla.

Birds tend to fly in different ways depending on their activity and size. A bird of prey will glide round in circles as it targets its prey. An eagle will occasionally beat its powerful wings. As a rule the larger the bird the slower the movement, the smaller the bird the faster the movement. The up and down movement of the body will also differ depending on the size of the wing; a big wing will make a more exaggerated body movement. A small wingspan will have less impact on the body movement.

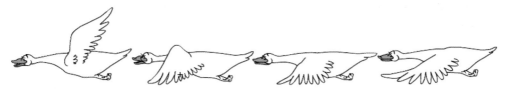

Figure 3.18 *The goose flying*

Four-legged Animals

I have always approached the four-legged animal as two independent human characters. For the walk just animate the front legs – they should then map on to the back legs. The only thing to take into account is that the back legs are a stride out of sync with the front. So when the front right leg is forward, the back right leg is back. The only thing to watch out for is the potential stretch that may happen from poor distancing of the legs. All the rules of the walk in two legged animals apply here – we have created an example of a horse walking, Horse.fla on the CD.

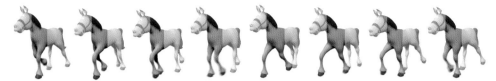

Figure 3.19 *A horse walking*

It's possible to have a great deal of fun with the four-legged walk. The variations of this are endless. The great variation of movements, actions, double pace and bounce can make almost whatever you produce seem original. Head and tail move in the opposite direction to their nearest legs, for example when a head moves up the shoulders are moving down.

Rotoscoping

I have always believed that this art of tracing live action can result in a dull and mechanical animation. It is by exaggerating action that an animation takes on a life of its own. I have always

Figure 3.20 *Rotoscoping QuickTime movie in Flash*

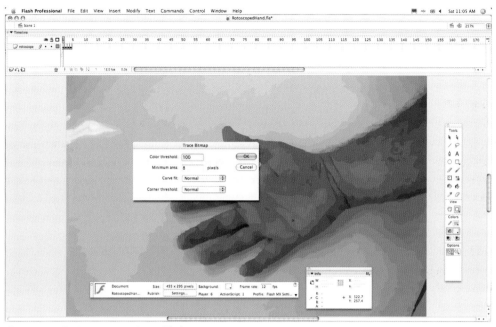

Figure 3.21 *Setting up rotoscoping in Flash*

found it very difficult to exaggerate a Rotoscoped movie. In the pre-computer era, a section of film would be printed out as a series of photographs. The animator would trace over the photographs and transfer the drawings to film one frame at a time. Computers have eliminated the need to photograph the drawings and speed up the process of moving from the original live action to the rotoscoped movie. For example see Rotoscope.mov on the CD.

I have always found Apple's QuickTime video clips as the best format for Rotoscoping. All Apple Macintosh computers come with QuickTime, and if you do not have it for your PC then you can download it from www.quicktime.com. You do not need the Pro version to Rotoscope. On occasions I have shot material in DV format and reduced the frame rate to 15 fps and saved the file in component video without sound.

You should set up your file to match the pixel size of your QuickTime clip. When you have set up your movie you should import the clip into Flash as a linked file. This is important because you do not want the clip embedded into the Flash movie. If you should move your fla file to another machine take note that you will probably lose the link to the movie and it will not show up in your file. If you're exporting from Flash to SWF, the imported video will not export with the animation. However, if you export it as a MOV file via file/export the video will export without sound.

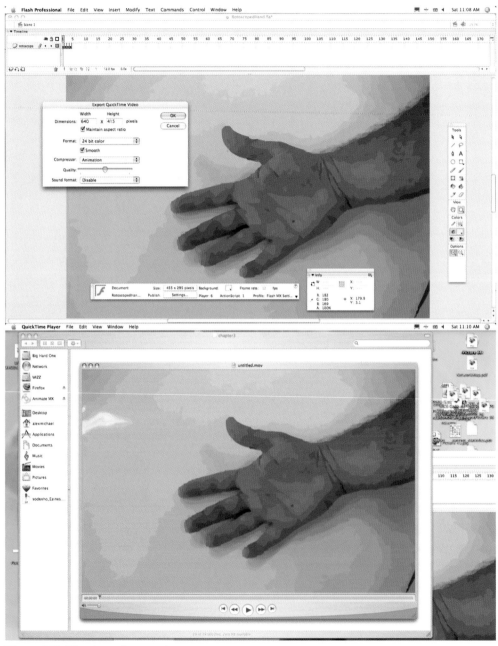

Figure 3.22 *Three images for rotoscoping*

Once you have imported your QuickTime movie you should lock the layer it is sitting on. You should create a new layer and add the number of frames that exist in your QuickTime movie. You can now trace the movie frame by frame. When you have finished adding the level of detail you need you can hide the layer that the QuickTime movie is on and play back your masterpiece.

Chapter 4

Facial Animation and Lip Syncing

Once you start on the initial
steps to animation your biggest
obstacle is combining both
sound and movement.

Nowhere is this more apparent than in the art of facial animation and lip syncing. Initially you need to master techniques that map phonemes to mouth positions. Visemes are the shapes mouths make when sounding the consonants and vowels that form the word. These sounds are phonemes, and are the smallest utterance of sound that string together to make words. Sadly for the animator it does not just stop there. We also need to allow for facial expression. In reality facial expression and head movement are a great tool for conveying atmosphere.

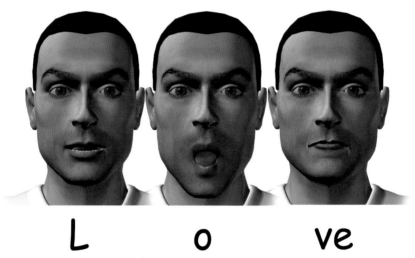

L o ve

Figure 4.1 *Close up of four lip sequences spelling out the word love*

Although all animators have to make a desicision on how many phonemes their style requires, in reality we cannot count the number of phonemes in English speech. However, we can identify 36 clear instances of phonemes in speech (14 pure vowels, 22 pure consonants). There will never be much agreement on the exact number of combined vowels. Most animators will want unique phonograms for [**ch**-tsh], [**j**-dzh] and [**ai**] – bringing the total to 39. Many will want to grant phonogram status to [oi], [au] and a few r-combinations bringing the total to about 46. An alphabet with 46 phonemes would be more than enough to represent the significant sounds in both British and American dialects of English. But this would be too many for the animator to manage.

Be warned that many words are not pronounced the same in different dialects of English. This means that there is one phonemic representation of one dialect. One phonographic representation cannot cover all the dialects of English. This is a different issue than the one just discussed. It is not a question of not being able to recognize clear instances of a phoneme. Rather it is a case of which phonemes should be used with particular words.

How do broadcasters determine what pronunciation to use on the air? It is the same problem. If a broadcaster can pronounce it, then it can be spelled in a phonemic notation. The dialect used by broadcasters is designed to be the easiest one for a widespread audience to understand. A good base dialect would be the broadcaster's dialect.

There are two broadcast dialects that can be described as BBC-English and NBC-English. Since these two dialects are not the same, their pronunciation guide spelling would also differ. Assuming that both broadcast dialects pronounce/ei/and/ai/as/ei/and/ai/. Many of their listeners do not. Words containing/ei/can be pronounced e: in northern English and/ai/in Cockney./ai/is pronounced/a:/in parts of the Southern U.S. and also in parts of England.

For my work over the last 10 years, I have focused on the use of eight distinct phonemes. This is a highly personal position and if you decide to go for ten or twelve, then that's fine. I would however say the more you have the more you complicate the job of lip syncing.

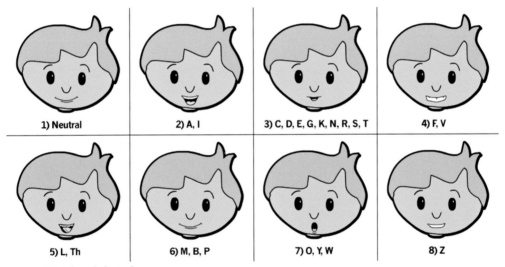

Figure 4.2 *The eight basic phonemes*

The voice track is usually recorded first with all the animation, and expression work drawn afterwards. This is great for the voice actor and the animation. It creates a lot of work for the animator.

Probably the most rigorous part of any animation drawing process is to keep the character free flowing. As animators we do not always accomplish this but the more elastic and free flowing your movement the more credible your character is. This elasticity is hard to execute in Flash or any vector-based drawing tools. Sometime the only way to achieve this is by going back to paper and pen.

What is Lip Syncing?

If you've ever animated a character and you have wanted to make it talk or sing, then you would have touched on the art of lip syncing. This is the art of taking a pre-recorded dialog, and making a character move its lips as if to speak this dialog. This involves figuring out the timings of the speech (breakdown) as well as the actual animating of the lips/mouth. In addition, making the actual setup or mouth positions needed can also be considered a part of the entire lip sync process.

Creating speech may appear to be difficult. We use the eight basic mouth expressions to represent English speech, as shown below.

Starting with a neutral expression:

- The mouth is held wide open in a big smile to form the A, I expression.
- The teeth are held together with an open mouth to form the C, D, E, G, K, N, R, S, T expression.
- The lower lip is held against the upper teeth and the centre of the upper lip curves up to form the F, V expression.
- The mouth is held partly open, with the tongue placed between the teeth, to form the L, Th expression.
- The lips are held together when forming the M, B, P expression.
- The lips are in a puckered position when forming the O, U, Y, W expression.
- The mouth is in a smiling position while the teeth are held against each other to form the Z expression.

Once you start breaking it down into small components it becomes easier to understand how speech is put together. In the early studies of animation students assume that each letter has a mouth shape but it soon becomes apparent that the mouth shapes can be grouped into the eight positions above. It is good to look for overlapping shapes that might represent a number of phonemes, as this will save hours of work. For example, you may need to use the F phoneme for Th, so this should be looked at as a basis that you can work from in all situations. In certain situations when I am trying to achieve a high level of realism, I tend to divide these phonemes even more, getting as specific as I can.

I find that working on long sequences of lip syncing can be a very tiring process. I have included file LipSyncModeller.fla on the CD: look and use the lip positions in Flash for other Flash animations. Try it out.

M B P The lips touch together and are pressed firmly closed. They can intersect a little to show the difference between this phoneme and the neutral pose. It is worth breaking away from the symmetry by rotating the lower lip up, and the bottom lip down and in.
Sample words: Man, Bang, caP

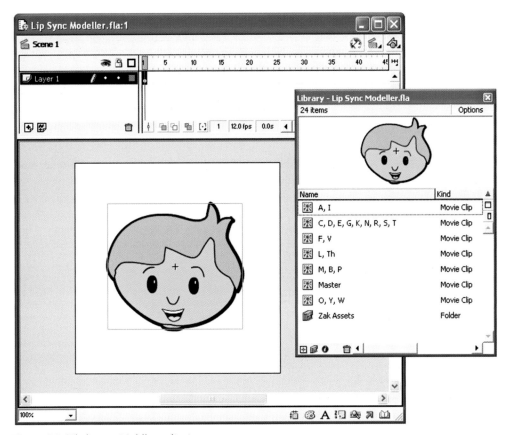

Figure 4.3 *The lip sync Modeller application*

C K G　　This is not opened as far as the vowel phonemes. The jaw rotates down, and the teeth are separated about the height of a tooth. A good illustration of this pose should allow for the teeth to show around 30% of the mouth area with the tongue and inside mouth representing the other 70%.
Sample words: Carry, looK

CH SH J　　The lips are puckered outwards and narrow the mouth a bit. The teeth are together.
Sample words: CHerry, SHout, Jump

F V　　The lower lip is curled/rotated up and underneath the upper teeth, so that it is pressed between the upper and lower teeth. The upper lip should be brought up a bit so the upper teeth are exposed.
Sample words: Fish, ProVe

A　　Place the corner of the lips above the vertical centre point of the open mouth.
Sample words: Apple, blAde, Ape

I U Open the jaw slightly more than in the A pose, but less than the O pose. The corner of the lips are placed at or below the vertical midpoint of the open mouth.
Sample words: If, Under, wOnder, pIck

O This is the most extreme open mouth position. The corners of the lips are placed at the midpoint of the vertically opened mouth, and the mouth is narrowed/puckered naturally since it needs to narrow as it opens.
Sample words: Open, OAt, Over

E This is the smallest opened mouth position, the mouth opens about the same as a C K G, but is widened out left and right.
Sample words: swEEt, EAt, fEEt

TH The tongue protrudes out and is pressed between the upper and lower teeth. These phonemes are the most used poses that benefit from drawing the tongue movement.
Sample words: teeTH, forTH, THat

N D T L For poses where the tongue touches the teeth, rotate the tongue up and behind the front teeth.
Sample words: Name, Dog, ouT, baLL

S Z With the teeth together the lips expand up and down and widen so the teeth are visible.
Sample words: Snow, Zoo, Sneer

R You can probably get away with a regular C K G pose, but I tend to open the upper lip into kind of a sneer.
Sample words: Roll, dooR, wondER

W OO Q The mouth contracts/narrows into a small opening with the lips puckered outwards.
Sample words: WOOd, drEW, QUIet, fOOd

Drawing a tongue can really convince the viewer that your character is talking. Adding teeth to the drawing helps reinforce the idea that your character is really talking. Since the mouth of your character will be open it is generally a good idea to have some amount of detail in there. Teeth, gums, tongue and some inside mouth cavity. You may not think you need gums but for poses like the sneer, you'll see them, so they should be illustrated.

Having a more detailed breakdown like this can help when doing more realistic facial animation. There is one other item you need to be aware of for setup. That is emotion or expression. Unless you want your character to remain perfectly flat, you'll need to make it look happy, sad or a wide variety of other expressions. Typically there are six base emotions, shown in Figure 4.4.

You need to create phonemes not only in a flat style but also in each of these expressions. So you might have the phoneme for "oh" as "oh my"! seven different ways. Think about how someone's mouth may change between saying "oh my" really loud and scared, versus a sorrowful slow expression.

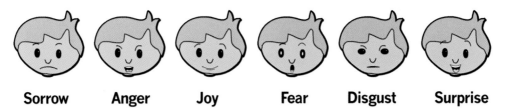

Sorrow Anger Joy Fear Disgust Surprise

Figure 4.4 *Expression*

Eye Expressions

It is almost inevitable that the eyes have a lot to do with expression and should not be illustrated staring blankly into space. Any variations in the eye position will be picked up by the viewer with some very dramatic consequences. No matter which language you speak, the eyes have a universal way of communicating with you.

The method you plan to use for animating will directly influence how you want to approach the setup. My choice is to use different poses of phonemes and expressions. Then if I need to, I sometimes tween between the start and end of each word, the tween can interpolate smoothly between each head. By illustrating the effect expressions have on the face, any phoneme or expression can be made from only a few illustrations. I have listed below a quick description of each of these illustrations and how they are used; you can also see this working in Head.swf.

Grin L and Grin R – A basic half smile. The mouth remains closed. This allows it to blend with an open vowel phoneme, such as an A to get an opened mouth smile. In some cases this blend won't be perfect and for long-lasting smile shots, you may want to make an open mouth smile as well. Flatten the bottom of the eyes.

Sneer L and Sneer R – This is pretty much a one muscle target, usually it's good to try to get a crease line from the nose to the side of the mouth. I tend to expose a bit of the upper gums as well. These two targets can be used to expose the upper teeth more when needed during talking, as well as for anger, disgust and other expressions.

Frown – A basic frown pose. Technically there are two separate muscles pulling the corners of the lips down. I also make the lower lip pout outwards.

Figure 4.5 *Expression with eye movements*

Eyebrow Up L and Eyebrow Up R – For cartoon characters all you need is the simple up and down. To be realistic, the outer edge of the eyebrow tends not to move very much, while the centre area moves more.

Eyebrow Down L and Eyebrow Down R – The eyebrow moves down and in and the centre of the eyebrow area starts to wrinkle.

Squint – In this target I have the eyelids close to meet at the exact middle, and also tend to bulge up the area beneath the eye.

Blink L and Blink R – Here each eye closes individually so you can offset blinks. By having this separate from the squint, you can use the squint to get the eye shape and then go back and animate in blinks later. I tend to have the eyelids meet at an area 3/4 of the way down from the top.

You should try to have the left and right side as separate components. This not only gives you control of the expressions but makes the character more lifelike by breaking away from the mechanical symmetry that is so common in computer-based characters. You can make your character grin to one side, or blink one eye and so on. If you are trying to or need to save space and create some of these as one expression, you should make the illustration offset left and right a bit – such as the smile on one side slightly higher than the other. This will help make the face asymmetrical and look more natural. Once your character is set up, you are ready for the next step in lip sync, Track Analysis.

Track Analysis

Track analysis, or breakdown, is the art of listening to pre-recorded dialog and sound, and planning the timing. Traditionally the audio would be played on a device with a counter. The animator would play it over and over and write down the estimate of when each phoneme occurred.

For cartoons this information was (and is) recorded on what is called an exposure sheet, or X-sheet for short. An X-sheet is really nothing more than a glorified table. I find opening another Flash movie and using that for my X-sheet is just as good as going down the conventional root. Quite simply, an X-sheet comprises numbers representing frames down one column, and then other areas where you can pencil in dialog notes, camera instructions and so on.

The Flash animator should always embrace all-fashioned techniques. I believe we should take the old techniques and develop them within the digital environment.

My favoured method for track analyses is to load the audio file into a Flash file so you can see the waveform and timecode. Then repeatedly play the whole or parts of the audio, figuring out the timing and commenting on aspects of speech. This is exactly what you would do on an X-sheet.

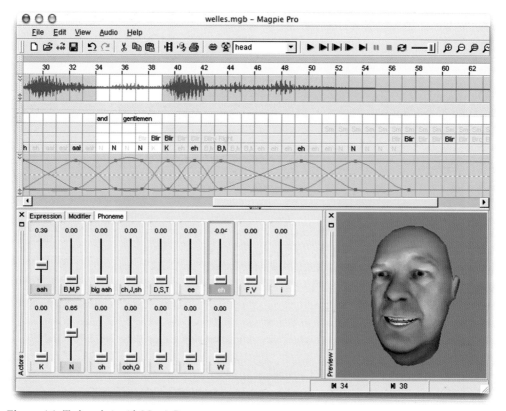

Figure 4.6 *Track analysis with Magpie Pro*

Track analysis can get even easier than this. There is a software available that not only shows the waveform and timecode, but actually has a digital exposure sheet and allows bitmaps of phonemes to be played in real time. So you can see and check how your breakdown is working as you create it. Another variation of this is to simply work in a 3D animation program like Poser with Ventriloquist. You can then scrub the time slider back and forth to hear the audio and then key the pose at the right place. A suitable alternative for manually breaking down audio is Magpie.

At the top of the line is the automatic voice recognition. These packages automatically look at a WAV file and figure out the timing and phonemes for lip sync. All you need to do is go back and tweak to correct any errors. My personal favourite is Ventriloquist by Lips Inc. This utility can take an audio file, a text line of what is in the file, and automatically generate nicely weighted morph f-curves for phoneme-based weighted morphing. It can also create a digital X-sheet for you if you still want to enter the data by hand, or want to write your own importer. It still requires tweaking, but is pretty good for a first step, or as a final step in cases where time doesn't permit. Magpie is available at http://www.thirdwishsoftware.com/magpie.html and runs on Windows XP and NT machines. It allows you to drag and drop custom phonemes into a digital exposure sheet as well as view 2D images for each phoneme in real time for playback.

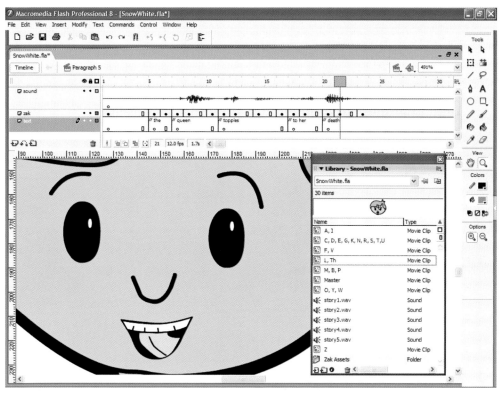

Figure 4.7 *Sound broken down into actions*

Analysing voice is simply a matter of listening to small chunks of the audio and marking the proper phoneme for the proper frames. As an example, I have used SnowWhite.fla, this is Zak telling the abridged version of the Snow White story (in my scary voice!).

1. First prepare your sound. You should break the sound clip down into separate sections as this helps to manage the animation efficiently and means that the movie can be broken down into separate scenes. A good guide is to use separate sentences, for example the story used in this example was broken down as:

 i. story1.wav
 "There lived a beautiful Princess named Snow White, whose beauty upset her jealous stepmother, the Queen. The Queen consulted her Magic Mirror as to who was the fairest in the land".

 ii. story2.wav
 "One day, the mirror said that Snow White is the fairest. The Queen plots to have Snow White killed by her Huntsman. He does not kill her".

 iii. story3.wav
 "She finds a cottage, and cleans it and then falls asleep. The Dwarfs return from work and find her".

 iv. story4.wav

 "The Queen finds out that she is still alive poisons her with an apple. She collapses".

 v. story5.wav

 "The Queen topples to her death. The Prince, kisses Snow White. Her eyes open. Snow White and the Prince ride off".

2. It is best to keep the original sound in the highest quality sound format possible as you can use Flash to export the audio at different compression levels for different uses, i.e. a CD-ROM would use a lower compression while a web site would need a much higher compression to save space.

3. Next create the movie. In Flash, create a new movie with three layers. Name the top layer "sound", this layer will hold the sound clip. Name the middle layer "zak", this contains the frames of the animation. Name the bottom frame "text", this contains the original lip sync text as frame comments.

4. To make the process easier, select the "sound" layer, select "Properties" from its context menu, and set the "Layer height" to 300%. This will make the waveform much easier to see. Do the same for the "text" layer, and set its height to 200%. To make the frames wider select the button in the top right of the timeline and select "Large".

Figure 4.8 *The time setup in Flash 8*

5. This will be the standard layout for developing the movie. Next, open the scene panel and duplicate the scene for each section of the story, in this case it would be four times. Name each scene "Paragraph 1", "Paragraph 2" etc. Now we are ready to add the story and the sound. To add the sound clips, select File>Import, and import the five story.wav files. Once imported they will be available to use in the movie.

Figure 4.9 *Setting up the size of the preview frames in Flash 8*

6. Create a keyframe on the first frame of each "sound" layer, and from the Properties panel, select the appropriate sound for the scene. Make sure also to set the "Sync" setting to "Stream", this is important since any other setting will result in sound sync problems with the exported movie. You will now see the sound waveform along the top of the Timeline.

7. Create keyframes on the "text" layer for each word of the dialog being spoken. Using the Properties panel, set the frame label for each keyframe to be the word being spoken, add // at the start to make the word appear as a comment. Arrange the keyframes to correspond to the correct part of the audio waveform.

8. Finally, you need to create the faces and lip positions for the animation. These are based on the eight basic lip positions and are used to build the whole animation.

Figure 4.10 *The sound Properties panel*

9. Open the file named SnowWhiteTemplate.fla, this provides you with the complete empty template as described above.
10. To begin each scene add the asset "Master" from the library to the stage, this displays Zak in a neutral pose. Create a new keyframe to correspond to the start of the next word of the dialog. For example, the first paragraph "There lived a beautiful princess ..." starts with an "L, Th" position for the "There", followed by another for "lived".
11. Continue this process for the other words in the scene. Once complete, you need to insert the lip positions for the word transitions. The new "scrubbing" feature of Flash MX allows you to preview the sound when moving the playhead along the Timeline. You need to set your voice over audio file to Stream. Not only will this preserve the lip sync, but it will also allow you to "Scrub" back and forth across the timeline to hear your sound frame by frame.

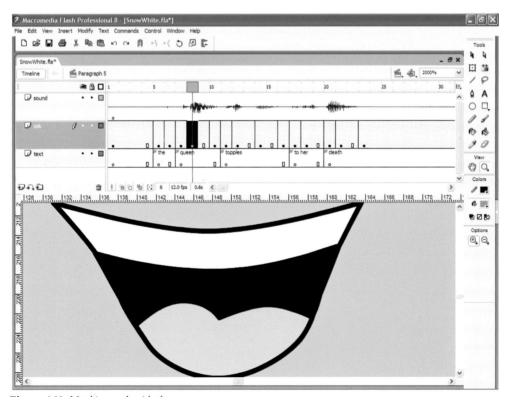

Figure 4.11 *Matching words with phonemes*

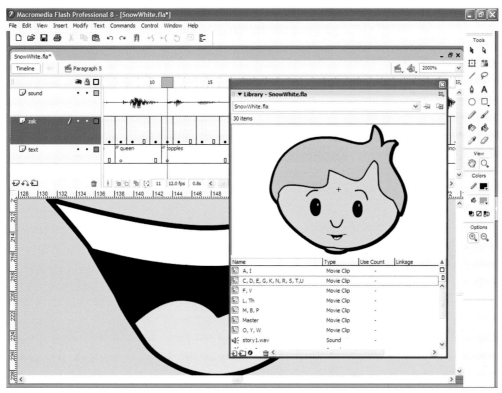

Figure 4.12 *Creating the expressions in the library*

The other thing to keep in mind when analysing the voice is the sound of each phoneme. Remember that a phoneme or sound of the voice doesn't need to actually match the spelling of the word. One famous example is that "ghoti" spells the word "fish". Granted, that looks like it would sound like "goat-tea" but phonetically it can just as easily sound like the aquatic animal. Here's how: Take the "gh" from the word "enough". The "o" from the word "women". Finally "ti" from the word "nation". As you can see, all of these words have sections that are spelt one way but sound another. Keep this in mind and really listen to the sound of each phrase as you do the breakdown.

Finally, it's OK to drop phonemes. For example, look at the word "Pilot". The "ihhh" sound of "lot" isn't there. It simply is dropped. One of the key tricks in getting lip sync to work right, especially fast paced speech, is to learn what to drop and what to keep. Think of the mouth as flowing and figure out what the best shape is at that point. Do this by listening and looking at what phonemes are around the current frame. In general, if you hit the M B P phoneme and the large vowels that follow, your animation will usually look correct. Everything else is really just an in-between of the extreme mouth closed, mouth open and mouth tighten poses. Think about puppets. Typically they have a mouth open, and a mouth closed pose. Yet in many

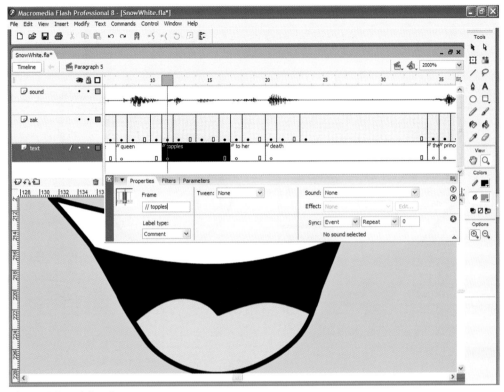

Figure 4.13 *Labelling frames*

cases, people accept a puppet as actually talking. If your lip sync looks off, check the timing of these poses first. Chances are correcting them will correct your animation.

When I first start to do breakdowns, I tend to put a keyframe on every frame. For example, take a look at the breakdown I have for this WAV file on the opposite page. Frame 4 has a W OO sound. However, as shown in the text version of the breakdown, I start by placing a keyframe on all frames. This does not mean I have a different phoneme on each individual frame. Rather, there are no in-betweens. What this does is make the animation very snappy. Each phoneme literally pops in, which makes it easier to see mistakes in the timing. If this animation looks a bit harsh or wrong, you're quite right.

Essentially this version suffers from a lack of tweening, making it look too rough. Also the fact that I'm using only 14 basic phonemes – none of which really looks like a yelling type expression – makes it seem out of place. Plus the phonemes don't really smoothly correlate to each other.

Once you have finished the track analysis you should have your finished X-sheet. With that information you are ready for the final phase of actually animating your character.

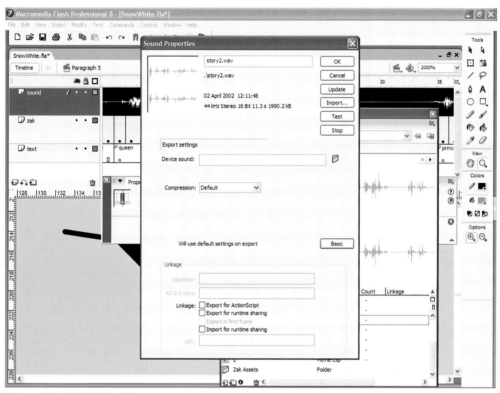

Figure 4.14 *WAV file breakdown*

Animation

We have finally arrived at the animation stage! This is where some of the real fun happens. As you saw, doing breakdowns is really pretty simple and in some ways tedious work. At this point, you can start to actually make your character have emotion and come alive.

Probably the simplest way to get from a breakdown to an actual animated character is to simply replicate the breakdown in your Flash file. All you really need is to get a keyframe of the pose on the right frame as listed on your X-sheet. The best way to animate the face is to start with the object, your X-sheet and then manually pose each keyframe yourself. If there is one thing I'd highly recommend when doing facial animation it's buying a mirror. All you do is look at your X-sheet and copy the pose and then say the word and look at yourself in the mirror, match what you see to your character in your Flash file, go to the next keyframe and repeat this process. The benefits of this method are that you are not limited to any preset phonemes. The mouth will look very natural since you will be posing every frame as it would look. You can go extreme when needed, smaller when not. Pay attention to how letters change especially consonants when they're around vowels.

Hand animating allows you to pay close attention to snap, offsetting the left and right sides of the face to make things look more natural, and is generally a better looking result. One thing to keep an eye on in any method though is the interpolation.

Back to our lip sync animation. At this point, you should have a pretty well-adjusted version of the character speaking. Up until now, chances are you haven't animated the upper face. Simply adding in some eyebrow and eye movement can really add a lot to the character and expression. In fact, the eyes are what most people focus on when talking, so in that sense it's even more critical than the mouth. What I tend to do is write down ideas on the X-sheet as I animate. I just make notes at different frames with things like, expand eyes, raise eyebrows, etc. Most importantly again, look at the mirror! I repeatedly act out the dialog looking in a mirror experimenting with different versions. Then, I just match that to the animation.

This is actually quite easy, since you already have the breakdown and know when each word occurs. You might notice that when you say a certain word, or part of a word, your eyebrows go up. All you need to do is look at your X-sheet, then find what frame the word starts on and set your eyebrow keys. Actually, it's a good idea to offset the upper face and even parts of the lower face so things don't always hit keys on the same frame. When the whole face works together the results are even better.

At this point, all that is left is to animate the actual body and head motion. Once again, I use a mirror, act it out and animate. I'd recommend studying how people move when they speak. There can be some very subtle head motion – and I think there is a propensity for new animators to either overdo or underdo this. Think about what words you want to accent and which parts you want to play down. It also helps to get inside your character's head to figure out what it's thinking. That helps a lot especially with animating the eyes. As in all cases, study from life, and one more time, use that mirror!

Tricks of the Trade

Do not start animating before you have bought a mirror! Having got this far you should feel confident in trying out your own facial animation. Doing lip sync breakdown is a great way to work on building your timing skills. It really forces you to pay attention to every frame. There's nothing like moving a phoneme one frame back and having everything suddenly work.

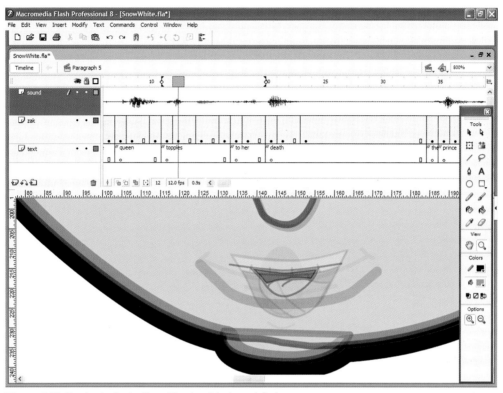

Figure 4.15 *Preview in the timeline with onion skinning switched on*

Make phonemes for consonants paired with vowels. Compare how your mouth is shaped for the "L" in "Lease" versus "Loop". In the first case it's wider, in the second much more puckered and closed. So for each consonant, you might want to make extra phonemes where it's paired with a vowel, such as "la", "li", "lo", "lu", "le" and "loo".

If you are animating someone with an accent, pay close attention to how they pronounce certain words. Actually breaking down an accented speech is a great way to force yourself to really listen to the track, instead of just dropping in what you think are correct phonemes.

Remember, one of the key points, especially for fast speech, is knowing when not to put phonemes in. If it looks like your character's mouth is opening and closing too fast, it means you need to drop frames. Think about how the mouth would blend between the phonemes, and then stick that pose in place of several others.

I will never have two different mouth positions keyed on consecutive frames. If the speech is fast, I will drop one. The general exception to this rule is the M B P and F V poses, followed by a vowel. In some cases, you may want to go from a closed mouth straight to a large open mouth. This gives more snap and may look better.

Make sure you hit the M B P phonemes and large vowels at the right point. As long as you get those extremes at the right point, your animation should look correct. In addition I usually hold the M B P and F V poses for at least two frames so that the mouth is closed at least fairly tight for two frames, then has one in-between, and finally is followed by a vowel. Note this is a general rule and sometimes has to be disregarded.

Consonants tend to take on the shapes of the vowels around them. The word "kind" and the word "look" would have different shaped "K" phonemes. The W OO vowels tend to have a very big effect on consonants they are close to.

Why is Event Sound Quality Better than Streaming Sound Quality?

Issue

A sound whose Sync property has been set to Stream has a lower sound quality than the same sound whose Sync property is set to Event.

Reason

Streaming sound will usually have a lower quality than an Event sound. With Event sounds, the entire sound is loaded so every sample in the sound is preserved. With Streaming sound, Flash must share available bandwidth with other streaming content through the Macromedia Flash Player. As Flash is event-based rather than time-based this can present a problem, as sound by its very nature is *always* time-based. Although priority is given to the Streaming sound, Flash may still discard sound samples in order to make sure the sound arrives on time. Fewer samples will result in a less well-defined sound.

Sound while Authoring with Flash 8

While there is no way to force more data through a connection than it can handle, designing your Flash movie to deliver content more efficiently may be helpful. Consider the following tips when authoring with sound:

Make sure that "Override sound settings" in the export panel is not selected. If it is, the default MP3 quality will be used for event sounds. If the default MP3 quality is lower than the sound quality settings in the library, for that particular MP3 the sound may not sound as expected.

Use sounds set to Stream for only that content which absolutely must synchronize with the Timeline, such as spoken words which are lip-synched. Spoken word requires less bandwidth, and you can adjust the bit rate in the Sound Properties panel to obtain results that are acceptable to you. You can then place less time-critical sound, which requires more bits to represent (such as background music) in its own Timeline and with its Sync property set to Event.

Optimize your movie so that content does not create bottlenecks. Use a *preloader* where necessary, and use *optimization techniques* to ensure that streaming content is not critically affected by bandwidth limitations.

Chapter 5

Sound and Dialog

This chapter outlines how you can use sound to make your animations more fun and exciting. You will learn how to edit sound effects and how to integrate these sounds into Flash 8. The chapter also covers compressing sounds for optimal playback and descriptions of the different digital sound formats. The sound object is demystified with tutorials that explore the construction of the sound object and its implementation into a movie. At the end of the chapter you can have a go changing the sound in the streetFighter game on the CD (streetFighter.fla).

Using Sounds

Adding sound to your movie adds a whole new dimension to it. Sound can make a simple animation captivating. Flash does not create sound files, you need to create sound with a sound program or acquire them from a sound collection.

You need only one copy of a sound file to call that sound into your file to use in any number of ways. Sound files are imported into Flash via the library where they are stored along with bitmaps and symbols. Sound file should be placed on the Timeline in a separate layer. Flash supports the following:

WAV (Windows only)
AIFF (Macintosh only)
MP3 (Windows or Macintosh)

With QuickTime 4 or later installed on your system, you can import these additional sound file formats:

AIFF (Windows or Macintosh)
Sound Designer II (Macintosh only)
Sound Only QuickTime Movies (Windows or Macintosh)
Sun AU (Windows or Macintosh)
System 7 Sounds (Macintosh only)
WAV (Windows or Macintosh)

Sound uses large amounts of disk space and RAM. MP3 sound data is compressed and is smaller than WAV or AIFF sound data. Generally, when using WAV or AIFF files, it's best to use 16-bit 22 kHz mono sounds (stereo uses twice as much data as mono), but Flash can import either 8- or 16-bit sounds at sample rates of 11 kHz, 22 kHz, or 44 kHz. Flash can convert sounds to lower sample rates on export. Remember that Sounds recorded in formats that are not multiples of 11 kHz (such as 8, 32, or 96 kHz) are resampled when imported into Flash.

If you want to add effects to sounds in Flash, it's best to import 16-bit sounds. If you have limited RAM, keep your sound clips short or work with 8-bit sounds instead of 16-bit sounds.

The Sound Object

The sound object lets you control sound in a movie. You can add sounds to a movie clip from the Library while the movie is playing and control those sounds. The sound object has four elements

A sound file imported into the library.
A sound instance created with the new Sound() constructor.
A MovieClip object that stores the loaded sound file.
A link to the identifier for the linkage ID.

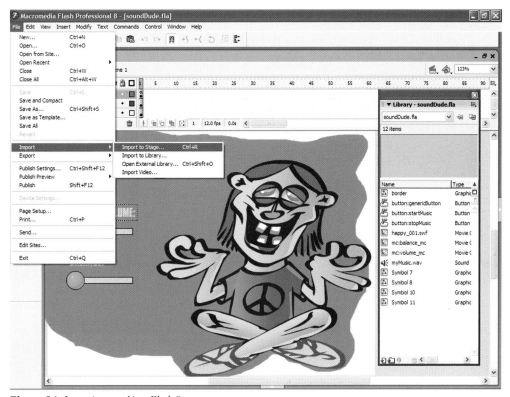

Figure 5.1 *Importing sound into Flash 8*

The file on the CD is soundDude.fla. This is a complete file with both switches, balance and volume control. The purpose of this file is to illustrate a full working version of a sound application. I have left a few little things to be done on this if you want to reuse it but in principle, it is all there and fully working. Every function and object in this application will be dealt with individually later in this chapter.

The SoundDude file focuses on using the sound object as a way of handling code. Later in this chapter we will look at aspects of this code-driven method. First we need to start with the basics, just using the timeline.

To import a sound file, select File>Import from the main menu, then navigate to the folder where you've stored your sound file and select the file you wish to import.

There are two different types of audio that can be included in your presentations: these are streaming sounds and event sounds. Sound in Flash is primarily controlled from the Property Inspector with a sound selected.

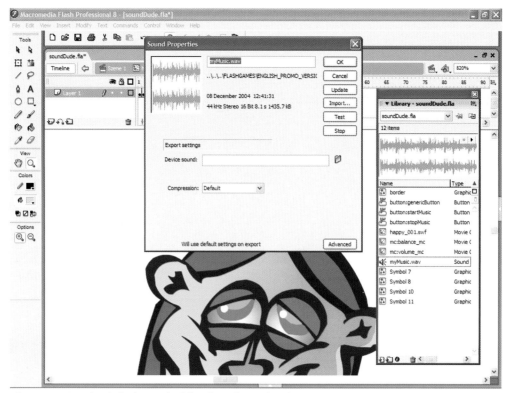

Figure 5.2 *SoundDude.fla showing the full working of a sound application*

Streaming Sounds

These are sounds that you set to play with a keyframe, and they play as long as the length of the frames that they occupy. Flash sets the movie to stream along with the sound, and if the movie cannot keep up with the sound it skips frames.

Event Sounds

Event sounds are sounds that occur when an event happens in a movie, most typically when a user presses a button. You will learn how to apply sounds to buttons later in this chapter. Event sounds are not synched to the animation, and the whole sound clip must be downloaded before the sound will play.

Importing Sounds

Flash brings the sound file into the library and to use the sound you drag it from the library onto the stage or you call it from an ActionScript. You can also hear a sound directly from the library, in the same way as you would view a movie clip, by pressing the small play button at the top right of the thumbnail (which, for sounds, is a waveform representation of the sound).

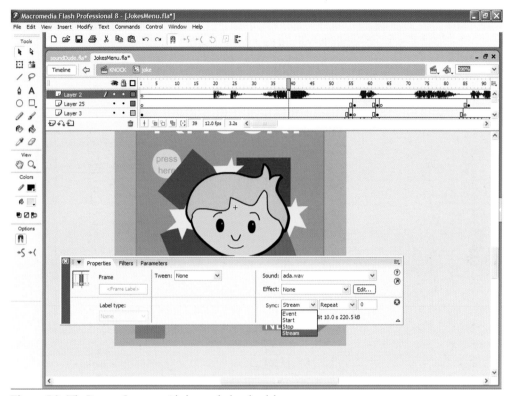

Figure 5.3 *The Property Inspector with the sound selected and the status menu open*

Adding a Sound to the Timeline

Adding a sound to your movie is easy, but there are two important factors to bear in mind when you are dealing with streaming sounds: firstly you must make sure that you place the sound clip on the frame where you want the sound to begin, and secondly you must create a new layer for each sound you want to play in your movie. In the next exercise you will open a library of sounds, import one of them and then set it to play when your movie begins.

1. Open the Sounds.fla file as a library (File>Open as Library). (It's a bit different in Flash 8: Select "Import" from the file menu and click on "Import external library". So you need to open the EllenZak.fla first and then import the external library. Then you can drag and drop the library items from one library to another.)
2. Now open the EllenZak.fla file from the chapter6 folder.
3. Open File>Import>Open External Library, open Sounds.fla
4. From the Sounds.fla library drag the Laugh.aif sound into the EllenZak.fla library.
5. Now create a new layer in the EllenZak.fla movie called Intro Sound, and with this layer selected drag a copy of the Laugh.aif sound onto the stage. A graphic representation of the sound will now appear in the timeline. Now test your movie (Control>Test Movie) to hear the sound as the movie plays.

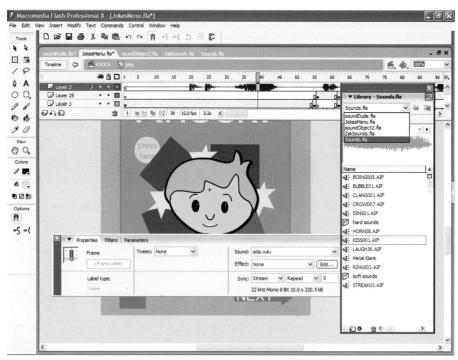

Figure 5.4 *Open External Library open Sounds.fla in Flash 8*

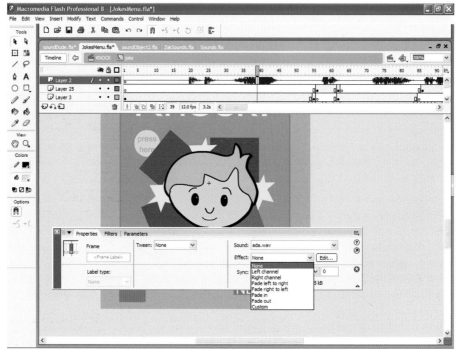

Figure 5.5 *It should be like the above pic*

The Sound Properties Panel

Once you have a sound in your movie you can add a preset sound effect to it using the sounds panel or you can customize it using Flash's editing capabilities. The sound effects in the drop-down menu are:

None – Applies no effects to the sound file. Choose this option to remove previously applied effects.

Left Channel/Right Channel – Plays sound in the left or right channel only.

Fade Left to Right/Fade Right to Left – Shifts the sound from one channel to the other.

Fade In – Gradually increases the amplitude of a sound over its duration.

Fade Out – Gradually decreases the amplitude of a sound over its duration.

Custom – Lets you create your own In and Out points of sound using the Edit Envelope.

The Sound Panel also lets you choose how to synchronize a sound, and you can select from the following options:

Event – This synchronizes the sound to an event, such as a button press, or when the playhead reaches a particular keyframe. An event sound plays independently of the timeline. Event sounds stop in the middle of play and start from the beginning each time they are triggered.

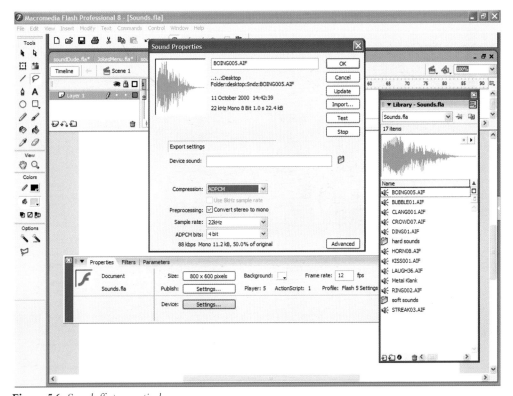

Figure 5.6 *Sound effect properties box*

Start – Start sounds are similar to event sounds, but they play to the end before restarting.

End – This stops every occurrence of a specific sound at the frame where the stop is located. To use this function simply create a new layer, insert a keyframe where you want the sound to stop, insert the sound you wish to stop into that keyframe and set the Sync to Stop. This is the only way to make an event sound stop as they run independently of the timeline.

Stream – This synchronizes the sound to the timeline, and these sounds end when there are no more frames in the timeline, they are useful for when you are trying to sync a sound to an animation.

Loop – Specifies the number of times you would like the sound to repeat.

In Flash 8 you can now select endless loop as well.

The alternative to dragging the file on the timeline manual is a link from the sound file to a target or the timeline using the attachSound method. This method takes as a parameter the ID of the sound symbol, as specified in the Symbol Linkage Properties dialog. Flash only looks for sounds with ID names that are in the local library. More about ActionScript-driven approach later.

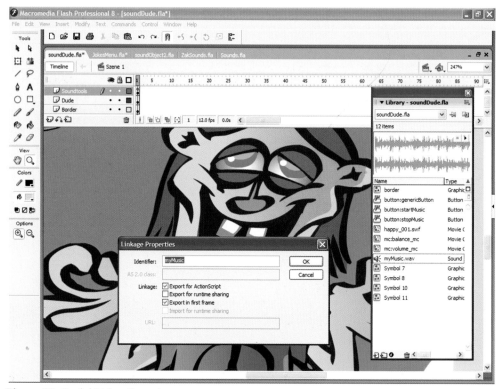

Figure 5.7 *Symbol Linkage Properties*

If you do not specify a target when you create a new Sound object, you can use the methods to control sound for the whole movie. You cannot have more than eight sound objects playing simultaneously. To create a new Sound object you need the following constructor.

```
SoundObjectName = new Sound (MovieClipObjectName)
```

SoundObjectName is the name for the instance of the sound object you are creating, MovieClipObjectName is the name of the movieclip target/timeline where you want the sound instance to be created. This new sound instance is not the actual sound but is merely a reference to the sound you will be using. This approach dictates that sound is never dragged from the library onto stage or placed in a frame. The sound is defined in a frame or movie clip and an identifying name is attached to the sound while it resides in the library, except in the case of loading an external MP3, which we will treat separately.

Organizing Sound Objects

First you have to decide on a naming convention. I allow the instance name of the sound object to determine all other associated names with that sound object. This will help later as the ActionScript is written, both in making the names easier to recall and in providing the ability to reuse your code. For example:

Instance name of sound object: myName
Name of its attached audio file's identifer: myNameSnd
Instance name of empty movie clip used as a container for sound object: myNameMc
Variable name for position: myNamePosition
Variable name for setVolume: myNameVolume

You should, where possible, define all of your sound objects on the _root level (see Figure 5.8). Define all sound objects in the first frame of this layer (see Table 5.1). With this approach you will always be able to see the path to your object. It will be easy to determine the paths to the sound objects, since they will be like;

```
_root.sound1, _root.sound2, etc.
```

Customizing Sound Effects

Clicking the Edit button from the Sound Panel opens the Edit Envelope box, where you can modify and create sound effects. Edit Envelope basically lets you change the In and Out point of your sound, and lets you change the volume of each sound channel. The Edit Envelope has three windows, and a set of controls you can use to control your movie. The upper window contains the sounds in the left channel, and the lower window contains the sounds in the right channel; the central bar is the time of the sound.

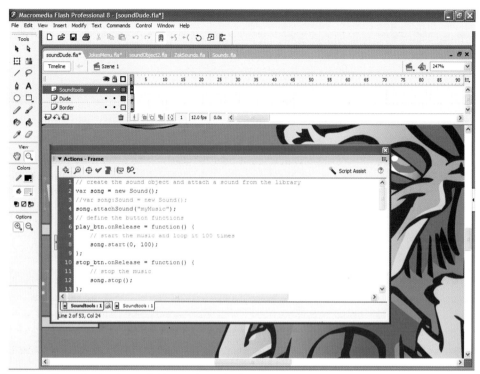

Figure 5.8 *Screen showing the sound objects on the root level*

Table 5.1 *This is a table of all the handlers for the sound object*

Method	Description
Sound.attachSound	Attaches the sound specified in the parameter.
Sound.getBytesLoaded	Returns the number of bytes loaded for specified sound.
Sound.getBytesTotal	Returns the size of the sound in bytes.
Sound.getPan	Returns the value of the previous setPan call.
Sound.getTransform	Returns the value of the previous setTransform call.
Sound.getVolume	Returns the value of the previous setVolume call.
Sound.loadSound	Loads an MP3 file into the Flash Player.
Sound.setPan	Sets the left/right balance of the sound.

(Continued)

Table 5.1 *Continued*

Method	Description
Sound.setTransform	Sets the amount of each channel, left and right, to be played in each speaker.
Sound.setVolume	Sets the volume level for a sound.
Sound.start	Starts playing a sound from the beginning or an offset point set in the parameter.
Sound.stop	Stops the specified sound or all sounds currently playing.
Sound.duration	Length of a sound in milliseconds.
Sound.position	Number of milliseconds the sound has been playing.
Sound.onLoad	Invoked when a sound loads.
Sound.onSoundComplete	Invoked when a sound stops playing.

The envelope line contains the volume control for each sound, each channel has its own envelope line which appears at the top of the channel displays. You move this using the small square on the line, which is called the envelope handle. You can add up to eight envelope handles to your envelope line by clicking on the line, and you can remove them by dragging it out of the window. The buttons at the bottom left of the Edit Envelope box are the stop and play buttons to test the sound as you edit it, and in the lower right there are buttons to allow you to Zoom in, Zoom out, and the Seconds and Frames buttons to view the sound in either seconds or frames.

Sound Compression

Before you use sound in Flash, you should set the compression settings. Compression is always a trade-off between sound quality and file size, and Flash lets you export sound using three different formats, ADPCM, MP3 or Raw (and WAV if you are in Windows), you can also set export settings for each individual sound in Flash.

To set sound compression:

Open the Sounds.fla file and open the library.

Select one of the sounds from the library and click the Properties button to open the Properties dialog box.

In the dialog box that appears you can choose from the following settings:

ADPCM – This is best for short event sounds such as button sounds. The web publishing standard is 22 kHz (compared to 44 kHz for CD quality).

MP3 – This is best used for longer, streaming sounds, such as soundtracks. You see the Bit Rate and Quality and the file size reduced or increased. Choose a Bit Rate higher than 16 Kbps for better sound quality.

Raw – This exports sounds with no sound compression. The standard for web publishing is 22 kHz.

Speech – The Speech compression option exports sounds using a compression that is adapted to speech. In the Sound Properties dialog box, select Speech from the Compression menu.

For Sample Rate, select an option to control sound fidelity and file size. A lower rate decreases file size but can also degrade sound quality. Select from the following options:

5 kHz is acceptable for speech.

11 kHz is recommended for speech.

22 kHz is acceptable for most types of music on the web.

44 kHz is the standard CD audio rate. However, because compression is applied, the sound is not CD quality in the SWF file.

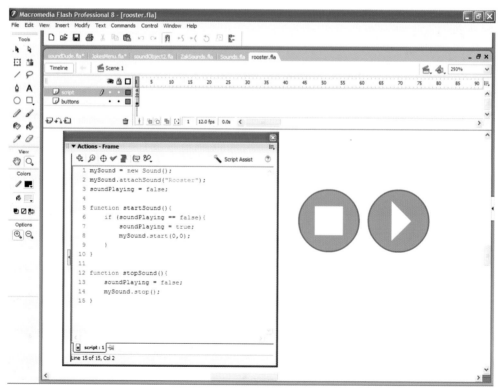

Figure 5.9 *Testing the Properties dialog box*

Now test the different settings by choosing a setting and then clicking the Test button.

When you are finished click OK to return to the main movie.

As yet Flash 8 will not allow you to record sound within the program, but it does offer tools to manipulate imported sound files. With these tools you can further minimize the size of animation files by reusing files with alterations that make them seem new. Importing a sound places it in the library of the current project. When you play your animation, the sound will begin when the playhead reaches that keyframe. If the timing is off, just click and release the keyframe to select it, then click and drag it to another frame to change the beginning point. Sometimes, a single frame forward or backward will make a big difference, especially when you are using a low frame rate for the web.

Directional Sound

ZakSounds.fla on the cover CD has one sound embedded in it, ZakOk.wav, which appears to come from the front right of the screen first, then the back centre, and then the middle left. Shifting of the sound is done within the Properties menu. It can be done even if your sounds were recorded in mono, which, for reasons of file size, usually should be the case. Select the Pan sound scene, right-click the sound's keyframe, choose Properties and then the Sound tab.

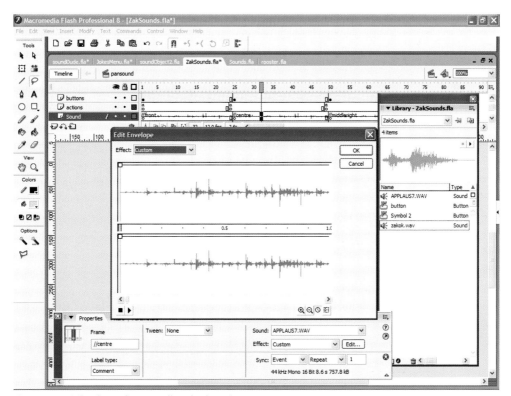

Figure 5.10 *The edit envelope controlling the channels*

Flash has assumed correctly that you want stereo output, so it has put a copy of the sound file in the left channel (upper) and another in the right channel. By choosing left channel in the effects drop-down box, the volume line in the right channel has been set to zero. You can choose fade in or fade out, as well as fade right to left or vice versa. You can also choose custom, and move the sound back and forth at will. With a long dialog, you can set each character's voice in a different speaker by alternately raising and lowering the volume line in each channel.

For a sound that travels from the centre to the right, the left and right channels are equal at the beginning, but the volume line goes to zero in the left channel as the sound plays.

This gives the illusion of the sound being centred, then moving to the right. A stronger illusion might be achieved by having the sound start at 50% in both channels, then rise to 100% on the right while falling to 0% on the left. In fact since the little character starts far away, a lower volume might have been chosen for the starting point of each channel. A longer sound and corresponding action would display this stereo effect better.

The beauty of manipulating the sound after recording is that it needs to be downloaded once across the web. Then the Flash plug-in moves it around by changing the volume of the two stereo channels. Each time you reuse a sound, as I did in this movie, you can call up the Properties dialog box and alter the character of the sound. This same box allows you to make the sound loop over and over. This is an interesting effect with music loops or short percussive sounds. You can also use controls here to select a single portion of the sound instance to be played. This allows you to reuse different snippets of a longer sound in various places in your movie.

Sound Surround

While Flash cannot exactly create true multi-channel surround sound with just one sound clip, it comes pretty close by utilizing the left and right channels to make an "enhanced" stereo effect. Open the file named ZakSounds.fla and go to the surround scene.

Once the Flash file has been opened, the steps below will show exactly how to make the sound pan from speaker to speaker. Follow these steps:

1. Use the properties panel to set up a sound for a frame.
2. Once that has been done, choose the tab marked Sound.
3. Here's the tricky part – making the sound file pan from area to area. In the Sound area where all the wavy lines are, click anywhere on the area with your mouse. You should see a small box with lines coming from the beginning.
4. You can also move where the boxes are located to increase or decrease the volume for just that part. Add as many as you want up to a limit and you can scroll till you find a good place to add more marks.

5. The top box is for the left speaker and the bottom box is for the right speaker. Varying the volume level individually for each box will cause one speaker to be enunciated more than the other causing a simulated 3D sound effect. See the complete image below for the boxes used on the animation on the first page.

Use the Zoom Out command (see the magnifying glass with the + sign in Figure 5.12) and add these lines and then preview it. The difference is amazing, and this is how many web sites have this 3D sound effect for many of their animations.

Controlling Sounds through Scripts

The following script creates an object called mySound that will create a folder for a sound file from the library, named Rooster inside a MovieClip named music within a larger MovieClip named musicBox.

```
MySound = new Sound(music.musicBox);
```

You will notice that the above code still does not specify the sound to be used from the library, all this specifies is that a folder is located in the musicBox timeline. The MovieClip object references an optional argument for the new sound() constructor. If you do not put the target, the new sound instance's methods control the sound properties of the movie's main timeline. The following creates a sound resource on the same timeline as the 'new Sound()' function call.

Whether you include or omit the target argument, the instance will be created on the timeline that contains the 'new Sound()' function call. However, the timeline which this instance's methods will control is determined by the target. There are two concepts here: (1) the familiar concept that object instances (like variables) live in the timeline in which they are created, and (2) the new concept that Sound objects control the main timeline unless a target is explicitly provided.

```
mySound_1 = new Sound();

mySound_2 = new Sound();

mySound_3 = new Sound();
```

The above code is declared on frame 1 of the main timeline and so sound resources loaded into the Sound object will be stored in the same timeline. If you try to control the Sound object then all the sound files in that MovieClip will respond as the structure does not allow each sound resource to be stored in its own container. To solve this problem you need to create a unique MovieClip object to hold each sound resource.

In the following tutorial we will create two buttons on stage that control the sound object. A complete version of this tutorial is available on the CD rooster.fla the sound file ROOSTER.WAV can also be found on the CD.

Create a new document and Import a sound file.

1. Choose "Import to Library" from the "File" menu.
2. Import your ROOSTER.WAV.
3. Now right click on the ROOSTER.WAV library sound object and click on "Linkage ...". The identifier, which, in this example, is ROOSTER, must be unique.
4. In the dialog box "Linkage Properties" give your sound a unique link name ("Rooster" in our case), enable "Export for ActionScript" and "Export in first frame" and click "OK".
5. Create the graphics for the 2 Buttons, one for start and one for stop.
6. Now select the graphics for the start button and choose "Convert to Symbol" from the "Insert" menu. (or press F8)
7. In the dialog box give the buttons library names. Make sure you have selected "Button" as Behaviour for both buttons and click "OK".
8. Make one button a stop button and the other a start button.

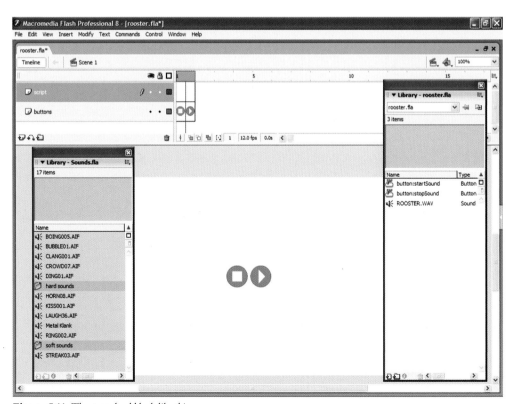

Figure 5.11 *The stage should look like this*

Now that you have the buttons, you have to create a sound object that will be controlled by the buttons.

9. Create a new layer in the main timeline (_root) and call it script. Select the first frame of it.

```
mySound = new Sound();
```

This tells the Flash Player that it should create a new sound object. You then have to attach a sound file to it so there is something to play.

10. Decide where to define the sound objects.

If the sound objects are defined all on the same level, it simplifies affecting the sound object later. For example, if the sound is defined at the _root level and then is to be started by pressing a button within a movie clip, the code would appear as follows:

```
on (press) {

_root.mySound.start()

}
```

If each sound object is defined in different movie clips, the path to the sound object will need to be tracked. When a call is made to the sound object, the complete path to the location where the sound object is defined will need to be spelled out in the ActionScript. For example, if the sound object is defined in a movie clip named "mc1" which is in another movie clip called "mc2" the ActionScript would appear as follows:

```
on (press) {

_root.mc1.mc2.mySound.start();

}

mySound.attachSound(''Rooster'');
```

The function attachSound uses the unique names of the library objects.

Because the Flash Player can't hear if there is sound playing or not you need to declare a control variable "soundPlaying" with the value false.

```
soundPlaying = false;
```

11. Now to use the buttons to control the sound object you need to create two functions:

```
startSound() and stopSound():

function startSound(){

if (soundPlaying == false){
```

```
        soundPlaying = true;

        mySound.start(0,0);

    }

}

function stopSound() {

soundPlaying = false;

mySound.stop();

}
```

Add this code to your play button:

```
on (release) {

startSound();

}
```

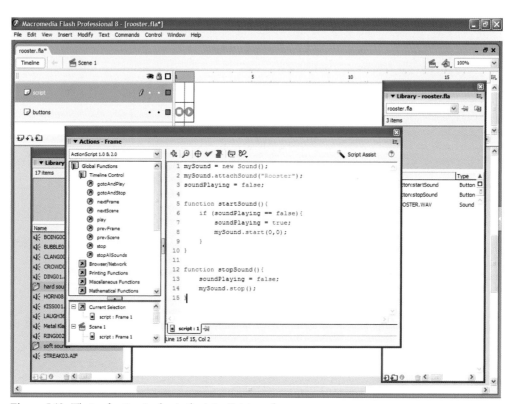

Figure 5.12 *The two functions in place in the ActionScript panel*

So What is Happening in this Tutorial?

First we will start with the code for the buttons that dictates when a user has clicked on the button

```
on(release) -
```

the code within the function "startSound()" will be executed.

This function first checks if the sound is not playing:

```
if (soundPlaying == false)
```

If so it sets the variable soundPlaying to true and starts the sound.

```
soundPlaying = true;

mySound.start(0,0);
```

The first value in the brackets is the offset. 0 means the sound is playing from the start. The second value is the number of loops. 0 means no loop.

The below code stops the button:

```
on(release){

stopSound();

}
```

The stop button calls the function stopSound() when you click on it. The stopSound() function sets the variable soundPlaying to false and stops the sound:

```
soundPlaying = false;

mySound.stop();
```

You should link only one sound object to any given MovieClip object. Changes to one Sound object on a MovieClip object will be passed to other Sound objects on the same timeline. In addition you should never use the name sound for a new Sound object like this:

```
Sound = new Sound();
```

How to Start, Stop and Loop a Sound Object

The syntax for starting a sound object is as follows:

```
mySound.start([offset,loop])
```

It has two arguments:

```
_root.mySound.start(0,99);
```

In this example, "mySound" is the instance name of the sound object. The "offset" is the amount of time (in seconds) that is missed before starting to play the sound. The "loop" is the number of times you want the sound to loop. In the above example, this would start mySound at its beginning position of zero and loop it 99 times.

The syntax for stopping a sound object is:

```
mySound.stop(['' ROOSTER''])
```

It has one argument:

```
_root.mySound.stop(''ROOSTER'')
```

It could also appear as:

```
_root.mySound.stop();
```

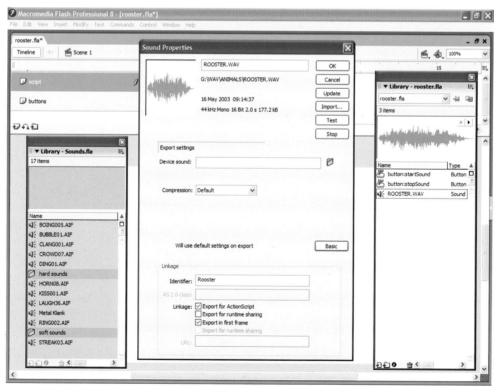

Figure 5.13 *The linkage identifier*

In the first example, the linkage identifier "Rooster" is used. If the linkage identifier is not used, all sounds will stop – unless the sound object is defined with a specific movie clip. For example, if you want to stop one of the four sounds that are playing, and the sound has not been assigned to a specific movie clip, then you must specify the linkage identifier name as part of the stop command.

If you associate the starting of a sound with an event like a button press, unless you want multiple copies of the sound object playing at the same time, You need to keep the sound from playing if it is already playing.

```
on (press) {

if (playing!=true) {

    _root.mySound.start(0,999);

    playing=true;

}
```

And when the sound is stopped by a button:

```
on (press) {

    _root.mySound.stop(''ROOSTER'');

    playing=false;

}
```

Controlling Independent Sound Objects

Wherever you attach the sound object, it becomes a child of that movie clip. To affect multiple sound objects independently, each sound object must be associated with its own unique movie clip. Any call to a method of a sound object, such as setVolume, will affect all sound objects that are the child of that timeline. This can be an empty movie clip or one that is being used for something else. The result will be to group your sound objects by movie clip.

If you have figured out how to fade the volume for a sound object, but you find that it is also fading the volume for all other sound objects too, you will find the solution in how you built the sound Movie Clips.

The following assigns a sound object as the child of a particular movie clip when the sound object is initially defined:

Define the sound object

```
mySound = new Sound(mySoundMc);

mySound.attachSound(''ROOSTER'');
```

In the above example, "mySoundMc" is the instance name of a movie. You will also notice that there are no quotes around the movie clip instance name.

Create an empty movie clip and drag it out onto the _root stage. Give the movie clip the instance name of "mySoundMc". It is not necessary for the "mySoundMc" movie clip to contain the ActionScript that starts the sound object. The "mySoundMc" movie clip can remain empty. The sound object "mySound" then becomes a child of "mySoundMc". The only purpose of mySoundMc is to serve as a container or association for the sound object.

It is not necessary to create an associated movie clip for sound objects that only need to be started. It is needed when advanced methods such as setVolume and setPan are required for multiple independent sound objects, or when you need to stop one sound object while others continue.

Once this is done, the methods of "mySound" can be manipulated independent of the other sound objects. The way by which the sound object's methods are called do not change. In other words, once you define the sound object as being attached to a particular movie clip, you never again need to reference that movie clip to control the sound object. Since, in our example, the sound object was defined on the _root level, calls to methods of the sound object would still only need to reference the _root path.

So, if you wanted to pan mySound completely into the left speaker channel, the following would be used:

```
_root.mySound.setPan(-100);
```

Note the differences in the ways the following sound objects are defined:

```
mySound = new Sound(mySoundMc);

mySound.attachSound(''ROOSTER'');

otherSound = new Sound();

otherSound.attachSound(''ROOSTER2'');

on (press) {_root.mySound.setPan(-100)}

on (press) {_root.otherSound.setPan(100)}
```

If you panned mySound, only the sounds associated with the movie clip "mySoundMc" would pan to the left. If you panned otherSound with the above configuration, all sounds, regardless of where they were defined or to which movie clip they were assigned, would pan to the left.

You can also associate sounds with specific movie clip instances. Define the sound object as before, except instead of indicating the name of a movie clip instance, use the keyword word "this" as follows:

```
mySound = new Sound(this);

mySound.attachSound(''ROOSTER'');
```

If the sound object is defined using the keyword "this", calls to the sound objects, such as setVolume() and stop(), will only affect the movie clip timeline where the sound object is defined. The sound object, mySound, which is defined with the keyword "this", reacts in the same way to the sound object in the previous tutorial when it was associated to a specific movie clip when it was defined on the _root timeline.

Using the keyword "this" has both advantages and disadvantages. One advantage is that, if the SWF file containing the sound object will be loaded into another movie using loadMovie, there is no risk of losing its association with the movie clip it was associated with when it was originally defined. The disadvantage is that the path to the sound object must be used when calling it into action. If there are a lot of sound objects scattered about in numerous movie clips, it can be quite confusing.

Controlling All Sounds Globally

```
mySound = new Sound(mySoundMc);

mySound.attachSound(''ROOSTER'');

otherSound = new Sound();

otherSound.attachSound(''ROOSTER'');
```

As in the above example, one sound object was defined on the _root timeline as being assigned as a child of the movie clip "mySoundMc". The other, otherSound, was not assigned to any movie clip. Note how these two sounds are stopped in the following example:

```
For mySound:

on(press) {

    mySound.stop()

}
```

```
For otherSound:

on(press) {

    otherSound.stop()

}
```

They are stopped exactly in the same manner. However, because "mySound" was assigned to be the child of the movie clip "mySoundMc", the stop call to the "mySound" sound object only stops sounds associated with the movie clip "mySoundMc".

By pressing the stop button for "otherSound", which was not assigned to a movie clip, it will stop all sounds, including sounds assigned to a specific movie clip. This can be convenient if you want to stop all sounds or control the volume or panning for all sounds. Here is an example from the Flash documentation:

```
globalsound = new Sound();

globalsound.setVolume(50);
```

The above example creates a new instance of the Sound object called globalsound. The second line calls the setVolume method and adjusts the volume on ALL sounds in the movie to 50%.

Volume Control for a Sound Object

For this example, changing the volume for a looping background sound will be described. Unless you have only one sound object, or you want to keep all sound objects at the same volume, the looping sound object will need to be associated with a unique movie clip as outlined in the previous section. Here are the steps:

Create an empty movie clip, drag it out onto the _root stage, and give it an instance name such as "myLoopMc".

Import the sound file ROOSTER from the sndObject.fla into the new movie's library and set its linkage properties identifier to an appropriate name such as "ROOSTER" assuming it has not maintained all this information from the transfer.

Define the sound object on frame one of a layer, for example, called "Sound Objects" using an instance name such as "myLoop", and use the setVolume method to establish the volume level. A variable, "myLoopVolume" will be used to set the volume, so that it can be manipulated later.

The resulting sound object should appear as follows:

```
myLoop = new Sound(myLoopMc);

myLoop.attachSound(''myLoop01'');

myLoopVolume=50;

myLoop.setVolume(myLoopVolume);
```

Volume for a sound object can be set between 0 and 100. In the example, the volume is set to 50%. The setVolume can be placed in a variety of locations – on a button, in a function, on a frame within another movie clip on stage. Just remember that if it is placed in any place besides the _root level, the path to where it was defined needs to be included as follows:

```
_root.myLoop.setVolume(myLoopVolume)
```

If you wanted to include a volume slider, create a movie clip that can be dragged as in the following tutorial. Create a formula to have either its x or y axis values control the setVolume variable. As the axis increases or decreases, the volume percentage increases or decreases an equal amount.

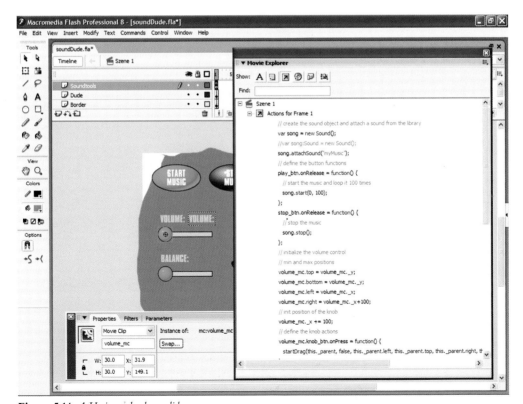

Figure 5.14 *A Horizontal volume slider*

Building a Horizontal Volume Slider

Create two images: the slider track and the image that will slide. Make the base of your slider 100 pixels wide, as the width would then correspond exactly to the volume range.

Place both on stage as movie clips.

From the pull-down top menu, select "View" and then "Rulers".

Place your slider image, exactly in the middle of the base. This point will represent volume at 50%.

Give your slider movie clip the instance name of "hslider".

Select your slider movie clip, press F9 to access actions for the movie clip and add the following

```
//the slider moves 50 pixels to the left

onClipEvent(load) {

left=(_root.hslider._x) - 50;

//Replace or remove the 1.1 with whatever pixel number

top=_root.base._y + 1.1;

//The slider moves 50 pixels to the right.

right=(_root.hslider._x) + 50;

//''bottom'' equals the ''top'' value to remove any vertical movement
from the slider.

bottom=_root.base._y + 1.1;

//Loads the slider in base

_root.hslider._x=_root.base._width/2;

//establishes pixel range for calculating volume

volCalc=_root.hslider._x - 50

onClipEvent(enterFrame) {
```

This constantly sets the current x-axis position of the slider to "sliderx" and then sets the volume to the x-axis value - volCalc.

```
sliderx=_root.hslider._x;

myMusicVolume=(sliderx-volCalc);
```

```
    _root.myMusic.setVolume(myMusicVolume);

    _root.currentVolume=_root.myMusic.getVolume();

//Displays volume in dynamic text box with the Var name of currentVolume..

}

onClipEvent(mouseDown) {

    startDrag(this, false, left, top, right, bottom)

}

//

onClipEvent(mouseUp) {

this.stopDrag();

}
```

The slider movie clip can now be dragged from its centre starting point to both ends of the base image. The goal is to position your slider movie clip graphic so that its x-axis starts directly in the middle of the base. The variable "sliderx" is defined as equal to the current x-axis point of your slider movie clip each time a frame is processed; so you can calculate 50 pixels when the slider slides to the right and 50 pixels when it slides to the left.

The ActionScript for the above could also be placed in an event handler on a frame of any movie clip that loops such as:

```
this.onEnterFrame = function () {code here}
```

Building a vertical slider is the same, but a change has to be made in the way the slider works as it changes from vertical to horizontal sliding. When you drag the slider up, the y-axis pixel number decreases, so the formula used to convert the y-axis to a variable for the setVolume method needs to take this into account. The following is the formula used for a vertical slider:

```
//The variable ''vslidery'' represents the current y-axis location of
the slider (which has the movie clip instance name of ''vslider'').

myMusic.setVolume(100-(vslidery − volCalc))
```

Pausing a Sound Object

The sound object is stopped rather than paused, and at the point it is stopped, its position in milliseconds is recorded as a variable. To continue the sound object from its "paused" location, the position variable is used in the next start command for the sound object. The following code

works for a pause and continue button:

For the pause button:

```
on (press) {

    myMusicPosition=_root.myMusic.position/1000;

    _root.myMusic.stop(``myMusicBoom'');

}
```

For the continue or play button:

```
on (press) {

    _root.myMusic.start(myMusicPosition,0);

}
```

For the stop button:

```
on (press) {

    _root.myMusic.stop(``myMusicBoom'');

    myMusicPosition=0;

}
```

In the above example, "myMusicPosition" is defined as the current position of the sound object "myMusic" when the pause button is pressed. When the play button is pressed, the starting point for "myMusic" is set to myMusicPosition. When the stop button is pressed, the variable "myMusicPosition" is reset to zero.

Starting Actions When a Sound Object Ends

The method "onSoundComplete" allows you to have actions occur upon completion of a sound object. The syntax for this for a sound object with the instance name of "myMusic" is as follows:

```
myMusic.onSoundComplete = callbackFunction
```

Commonly, "onSoundComplete" is used as follows:

```
myMusic.onSoundComplete = function() {

trace(``My Music has finished'');

}
```

If you wanted the next dynamically loaded MP3 to load when myMusic completes, the following code could be used:

```
myMusic.onSoundComplete = function() {

_root.myNextTrack.loadSound(''myMusic.mp3'');

_root.myNextTrack.start();

}
```

In the above example, a sound object with the instance name of "myNextTrack", which was defined on the _root timeline, would load the music file defined at that point and start playing it as soon as the file "myMusic.mp3" completed.

The onSoundComplete method does not need to be called in a movie clip that loops. Once the frame containing the onSoundComplete code has been processed, the function will process its commands every time the sound completes. In fact, if the onSoundComplete method is placed in a one frame loop, it may not work, as the loop is constantly redefining the function.

If the sound starts and ends a second time, the onSoundComplete call will continue activating whatever ActionScript was contained within its function definition. If you don't want the function to call the initial onSoundComplete actions, redefine the onSoundComplete with a new function.

If a sound object is started while the same sound object is playing, the sound object will play on top of itself. This is not a way to keep the play button from restarting the sound while it is playing. Most of the examples set a variable of "playing=true" when the play button is pressed. The play button also looks to see if "playing!=true" before allowing the play code to process. However, when the sound object completes, the "playing" still equals "true", which keeps the play button inactive even when the sound has completed.

One way to resolve this is to use the onSoundComplete method. The following code used for the play and stop button to build the example used in this section:

```
on (press) {

//Play Button

if (playing!=true) {

    _root.firstSound.start();

    playing=true;
```

```
_root.myTextBox=''Playing''

}

_root.firstSound.onSoundComplete = function() {

_root.myTextBox=''Complete''

playing=false;

}

}

The stop button:

on (press) {

if (playing==true) {

    _root.firstSound.stop(''firstSound01'');

    playing=false;

    _root.myTextBox=''Stopped'';

}

}
```

In previous versions of Flash, timing an animation to end at the same time a sound ended was very difficult to achieve. With this method, there is a way to make sure that animation and sound synchronize. Combine onSoundComplete with the new "position" method of the sound object, and the animation to sound synchronization possibilities are so much easier and more controlled.

Loading an External MP3 Dynamically as a Sound Object

The "loadSound" method of the sound object allows MP3 files to be loaded dynamically. Most of what has already been described about sound objects is true for dynamically loaded sound objects. The notable exceptions involve loading the sound object as streaming versus as an event. If the sound object is loaded as streaming, it begins to play before it has completely downloaded onto the user's computer. If the sound object is loaded as an event, the file must completely load before it can be played.

The syntax for dynamically loading a sound object with an instance name of "myMusic" is as follows:

```
myMusic.loadSound(''url'', isStreaming)
```

The sound object method, "loadSound", is used as follows:

```
myMusic.loadSound(''sample.mp3'', true)
```

In the above example, the MP3 file, sample.mp3, is loaded from the same folder that contains the SWF file. It loads into the sound object "myMusic", and it is loading as a streaming sound object. Loading as an event is the default. If neither true or false is specified for streaming, the sound object will load as an event.

To use the loadSound method, the sound object must still be defined. The main difference being that it is not attached to a sound in the library. The following is a common way to define the sound object with the loadSound method:

```
myMusic = new Sound(myMusicMc);
```

```
myMusic.loadSound(''music.mp3'');
```

In the above example, a new sound object is defined with the instance name of "myMusic", and will load as a child of the movie clip with an instance name of "myMusicMc". This will give you the ability to control its properties independent of movie clip sounds on other timelines.

In the second line, the external file "sample.mp3" is instructed to load into the sound object "myMusic". It will load as an event, versus streaming, as the Boolean value of true or false is not specified. Therefore, the default status (event) will be used.

All of the controls for sound objects described so far work for dynamically-loaded streaming MP3's, with the exception of starting the MP3 with the mySoundObject.start() method. Streaming MP3's start as soon as there is enough data to play the sound; therefore, the loadSound call to the sound object is the start command. However, you should be able to stop the streaming sound and restart it with the mySoundObject.start() call. My experience with this is that it is only partially available due to a bug in the Flash Player.

Common Error Message with MP3's

"One or more files were not imported because there were problems reading them". A common reason to get this error message is that the file being loaded was encoded at over 160 kbps. Flash cannot import MP3's with a bit-rate over 160 kbps.

Getting Creative with Sound Effects

Animators can mix and arrange tailored soundtracks within Flash by using it as a music sequencer. The benefit is to produce more interactive and custom-like soundtracks with greater impact and control.

Traditional production music is "flat" and pre-mixed, and doesn't give you access to the raw audio components necessary for customization or to reduce file size. Moreover, the over-abundance of loops that are available on the Internet cannot provide the breadth or flexibility to create truly compelling audio.

If you are a musician, you can create component-based audio in a variety of music software packages, including Sonic Foundry's Acid, which does much of the compositional work for you and is already component- or loop-based. If you're not a musician, or don't have the time to create your own original score, you can use component-based audio. These packages are usually composed by professional musicians, and have solved the tedious problems of needing to properly edit and master your component audio files so that they transition seamlessly into the frame-based timing environment of Flash and other multimedia production tools. The advantages of buying in sound clips from a professional sound library are:

• Sample accurate timing of components in multiples of length and modular phrasing.
• Specific BPM (beats-per-minute) rates which are optimized for frame-based tools.
• Tools for determining compatible frame rates, and synchronization and arranging tools to help Flash work as a music sequencer.
• Mastered specifically for ease of mixing using layers.

Event Sounds: Mouse-overs and Transitions

Generally speaking, there are two types of event sounds:

1. Mouse-over events, which occur, you guessed it, when the user mouses over a hot spot.
2. Transitions, which occur most commonly on mouse clicks, but can also happen programmatically.

Mouse-overs usually need to be soft, arrhythmic and high-blend sounds, whereas transition sounds are usually more effective with hard sounds, and have more flexibility with regard to rhythm and blend. Of course, there are no hard and fast rules. This model assumes that you are working

with a background music track and thus want mouse-overs to occur smoothly, on top of the music. Transition sounds, on the other hand, are often used to change scenes, and benefit by having a hard sound, which acts as a distraction to cover up the abruptness of a sudden stop or change in the background music. The next exercise is an example of creating buttons that have a mouse-over sound and a transition sound that fit into the background music of a movie. You can open the movie SoundMix.fla for a view of the final movie, or follow the following instructions to create your own sound effects:

1. Create a new movie clip, and set it up so that it resembles the screenshot as shown in Figure 5.15. You need to build five layers, called, from top to bottom, actions, loop2, loop1, button and background.

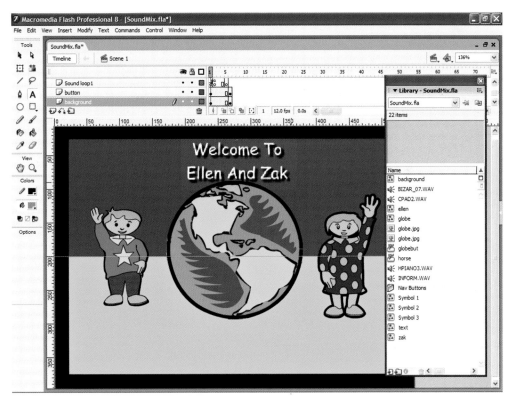

Figure 5.15 *SoundMix.fla*

2. Now create a new button to go into the button layer. Go into editing mode for this button and attach a soft sound to the "over" state of the button and a hard sound to the "down" state of the button; you do this simply by dragging the sound you want to add from

the library onto the stage with the particular state of the button selected. We have provided folders with a couple of examples of hard and soft sounds in the Sounds.fla file.

3. Now go back to scene 1 of your movie and import two sound clips into your library, these will be triggered as you navigate between the two areas of this movie clip. Put one in keyframe 1 of the loop1 layer, and the other in keyframe 5 of the loop2 layer and set the number of loops for each sound to a high number so it will loop continuously.

4. Now add a Stop action in the keyframe that is after each sound. This will stop the playhead in order to wait for user interaction, but the sound will have already been triggered and continue to play.

5. Make sure there are separate instances of your button in keyframes 1 and 5 of the buttons layer, and add a gotoAndPlay action to each button, telling the button in keyframe 1 to goto frame 5 and the button in keyframe 5 to goto frame 1.

6. The last important thing to do is to tell the current playing loop to stop playing when the button is clicked so that the sounds do not overlay each other. We could use a "stop all sounds" action for our button, but that would negate the mouse hit sound we just created.

Instead, place the sound you wish to stop on the timeline, and set its sync method to "stop", place the sound in the loop2 layer in the first keyframe of the same layer and set its sync to stop, and place the sound in the loop1 layer into the fifth keyframe of the same layer and set its sync to stop. Your timeline should look like the picture on the following page.

Event sounds make for ideal usages of Flash's sound object. When creating background music soundtracks, I prefer using the timeline, because it gives me a visual interface for aligning and synchronizing sounds with graphics. With event sounds, on the other hand, this is not as crucial, and ActionScript gives us much greater control.

Controlled Chaos – Colliding Mouse-over Sounds

If you have many buttons with mouse-over sounds on your page, a user can cause multiple instances of event sounds to play at the same time by rolling quickly over the buttons. This can be a desired effect if the sounds blend, such as with harmonized vocal riffs. Usually, however, this creates an undesirable commotion, which can even cause clipping (digital distortion) to occur. This can be avoided by setting the mouse-over sound to the "start" method (rather than "event" method) when you are using the same sound for all buttons. The start method makes sure that not more than one instance of a sound is playing at a given time. If you are using different sounds for each button, you will need to use the stop sync method or the sound object as explained above.

Soundtrack Looping

One thing Flash is not so good at, is seamlessly looping back to the beginning of a movie clip. If you have ever inserted an audio clip and tried to make it loop by using a goto and play action, you know what I mean. Even in forced frame mode, Flash glitches just a bit as it repeats. The best solution to this problem is fading your sound track in and out.

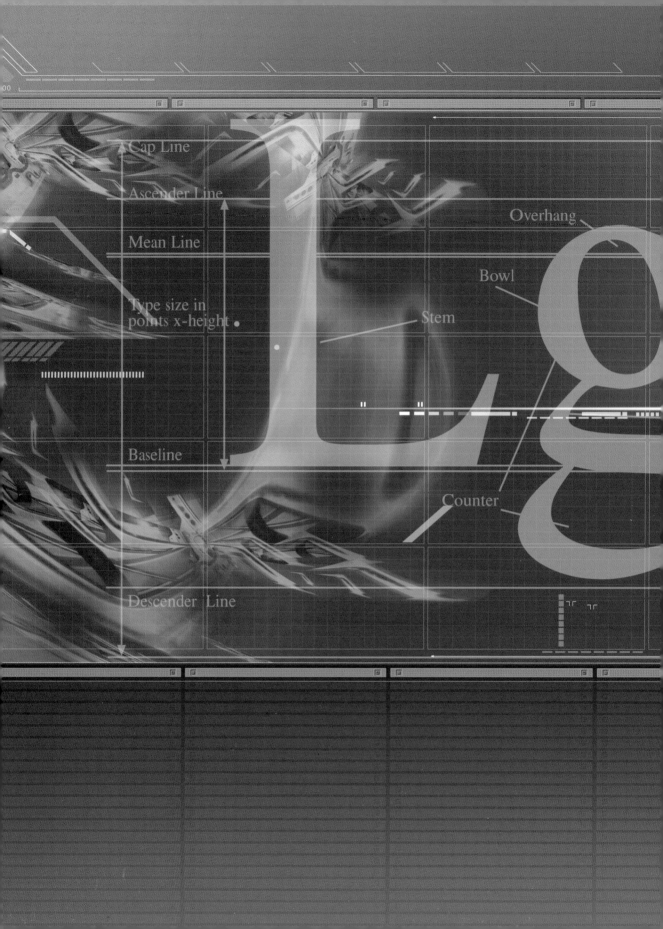

Cap Line

Ascender Line

Mean Line

Type size in
points x-height

Baseline

Descender Line

Overhang

Bowl

Stem

Counter

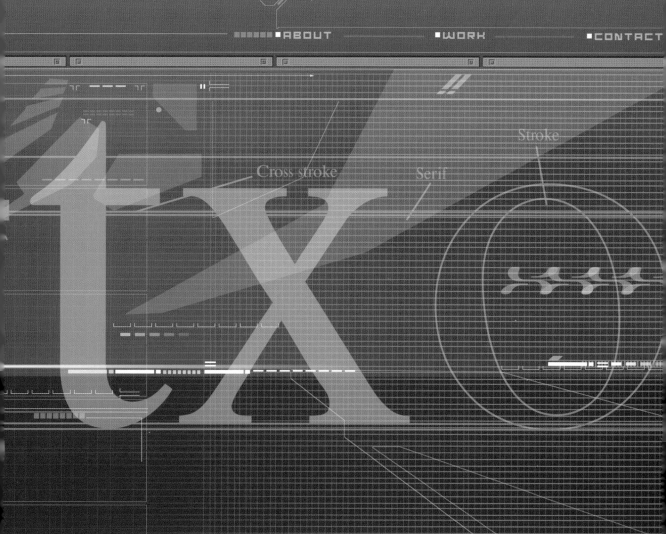

Stroke

Cross stroke　　　　Serif

Chapter 6

Titling, Pixel Fonts and Typography

This chapter takes a look at using typography effectively in a number of common situations in your animation. It first covers the art of animated text and then moves on to look at pixel fonts. In Appendix A, we have a potted history of typography for the budding typographer. The closing tutorial looks at the different fonts used in our game and looks at the different tools and decisions that affect the final style.

Although this book is about animation it seems unlikely that the animator or designer will not encounter a situation where type is needed in the project. The Internet has changed the nature of type. What at one time was solid and made of lead and had its rules is now reduced to dots on a screen completely in the designer's control.

Many early printers were not just printers, but typographers as well. The first independent type foundry was owned by the French type master Claude Garamond. Although not the inventor of movable type, Garamond was the first to make type available to printers at an affordable price. Garamond based his type on the roman font. Before Garamond's independent practice, men such as Jenson, Griffo and Caxton played specific roles in the development of type. Jenson perfected the roman type, Caxton conceived a bastard gothic font, and Griffo developed italic. Several of the fonts we see on our computers have evolved from the work of type founders of the fifteenth and early sixteenth centuries.

FlashType – High-quality Font Rendering Engine

Flash 8 has a number of revolutionary new features but for this chapter, we will look at the font rendering engine and the filter effects. FlashType makes small fonts look clear and improves readability. It provides clear, high-quality text rendering both in the Flash authoring environment

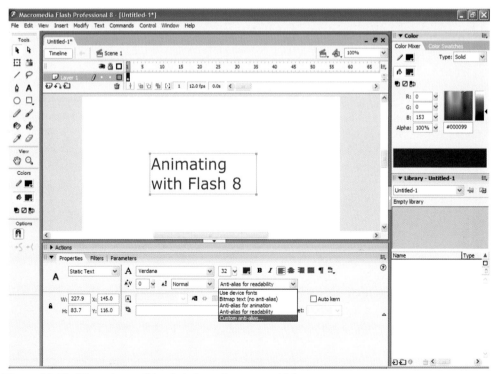

Figure 6.1 *FlashType makes small fonts look clear and improves readability*

and in the published SWF files. FlashType greatly improves the readability of text, particularly when it is rendered at smaller font sizes. While FlashType is available in both Flash Basic and Flash Professional, the new custom anti-aliasing option is available only in Flash Professional. Custom anti-aliasing lets you specify the thickness and sharpness of fonts used in individual text fields. FlashType is automatically enabled whenever Flash Player 8 is the selected version of the player, and anti-aliasing for readability or custom anti-aliasing are the selected anti-aliasing modes. Using FlashType may cause a slight delay when loading Flash SWF files. You will notice this delay especially if you are using several different character sets within the first frame of a Flash document, so be aware of the number of fonts you use. FlashType font rendering may also cause an increase in the Flash Player's memory usage. Using four or five fonts, for example, can increase memory usage by approximately 4 MB.

When Flash Player 8 is the selected version of Flash Player, and anti-alias for readability or custom is your chosen anti-aliasing option, FlashType anti-aliasing applies to the following:

- For untransformed text that is scaled and rotated.
- While the text can be scaled or rotated, it must remain flat, if you skew the fonts or otherwise manipulate the font shapes, FlashType automatically is disabled.
- For all font families (including bold, italic and so on).
- For display sizes up to a size of 255 points. Because magnification affects the display size of the text, when you zoom-in, the text redraws at larger point sizes, thereby disabling the anti-aliasing for readability font rendering, once a size of 255 points is reached.
- For exporting to most non-Flash file formats (GIF, PNG or JPEG).
- FlashType is disabled if the Flash Player 7 or earlier is the selected version of Flash Player.

About Filters (Only Available in Flash 8 Professional)

The built-in filter effects like drop shadow, blur, glow, bevel, gradient bevel and color adjust. Filters are visual effects applied to MovieClips and text fields and are natively supported and rendered in real-time by Flash Player. This includes moving shadow effects. Unfortunately the filter function is only available in the Flash Professional version.

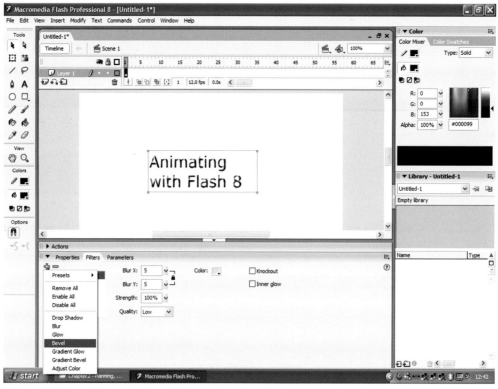

Figure 6.2 *View of the properties box with filter setting activated*

Typography for the Animator

The majority of design and animation projects pose problems because of the variety required between the key parts of the title and the character aspects. When you introduce type to your project you open up the title to a vast library of type styles. To solve this you have to find two or more different typefaces, each matching not only its corresponding text but also all other fonts in the composition. Creating solid contrast links between different fonts is a real challenge. Each font being nearly as complex as a character in an animation; it can be difficult to find two fonts whose features can be used for the variety of different stresses in a movie. The safest option in any project is using the same font, or its variants (e.g. bold or italic), for all of your needs. This single font solution may not be perfect, but in many cases it may be better to ensure consistency instead of taking risky aesthetic decisions. Using one font family is by far preferable in small compositions such as logos, information graphics or an interface.

If you decide to go for two fonts, which pair do you choose? The basic answer is: serif fonts work fine with sans serifs, and vice versa. These two types of fonts are different enough for their contrast to be immediately obvious, resulting in a harmonious and well-balanced screen. As serif and sans serif were not developed in parallel, we cannot base our decisions on historical

acceptance; most, if not all, of today's serif faces are rooted in past ages, while the majority of sans serifs were created in the current century. More useful is matching the level of looseness versus rigidness and artificiality of each font style.

Harmony in Pairs

Garamond and Frutiger work perfectly together because once set, the composition style and the fonts are left to interact only with each other, and also because the contrast between them is so deep and multiaspect. Perpetua and Gill Sans is another beautiful combination of fonts. Both fonts designed by Eric Gill for Stanley Morison of the Monotype Corporation in 1925. Gill was asked to create a new typeface "for the expression of a contemporary artist". He began work on what would be known as Perpetua, and not long after that a sans serif, to be called Gill Sans. They became an immediate success with the public. Gill Sans has become the leading British sans serif, sometimes being described as the "national typeface of England".

Figure 6.3 *http://www.meantangerine.com has an array of typographic styles, from industrial, techno and sci-fi, to traditional sans and serif text*

It is a good idea to accompany the contrast of fonts by the contrast of other typesetting aspects, particularly font variations (bold, italic, etc.). You may have noticed that many sans serif fonts do not have italics in the proper sense, but only slanted (sometimes called oblique) variations. This is not by accident; the very nature of sans serif design doesn't allow for an easy transformation into an italic face. Most serif fonts have really small italics that, despite having very different letter shapes, are well dovetailed with the roman variety.

Professional designers rarely use something besides the simple, traditional typefaces. The budding typographer should focus on a careful study of a small set of classical typefaces rather than indulge in complex designs. The better the type style, the more focus is drawn to the content rather than the distraction of complex combinations. However, if you are looking for a modern font style then we recommend a number of non-mainstream web sites to visit throughout this chapter. The end of Appendix A has a wider selection of font sites.

Five Important Steps to Type Design and Layout

The modern animator designer who is working in a software environment like Flash MX has a very difficult role to play in producing a movie. That role takes you through many of the traditional disciplines like typography and yet the final quality of animation and character needs to shine through. Below I have outlined five steps to help you through this process.

1. **Font Selection**

 • Pair a serif font for body text and a sans serif font for headlines. Avoid mixing two very similar typefaces, such as two scripts or two sans serifs. They can cause a visual clash.
 • Limit the number of fonts.
 • Limit the number of different typefaces used in a single document to no more than three. Avoid monospaced typefaces for body copy. They draw too much attention to the individual letters distracting the reader from the message.

2. **Column Width**
 Avoid setting type in lines of more than sixty-five characters. Longer lines cause the reader to "double", or read the same line twice. Avoid setting type in lines of less than thirty-five characters. Shorter lines cause sentences to be broken and are hard to understand.

3. **Line Length**
 Apply the alphabet-and-a-half rule to your text. This would place ideal line length at 39 characters regardless of type size. Apply the points-times-two rule to your text. Take the type size and multiply it by two. The result is your ideal line length in picas. That is, 12 point type would have an ideal line length of 12 C 2 or 24 picas (approximately 4 inches).

4. **Heading and Uppercase**
 Keep headlines between 14 and 30 points, keeping in mind that the closer in size to the body text, the harder it is to distinguish headlines from other text. Avoid setting type in all

capital letters. Capital letters slow the reading speed and take 30% more space than lowercase letters. Make sure headings are close to the paragraphs they belong with. That makes it easy for readers to tell what paragraph the heading relates to.

5. **Kerning**

Kerning is pushing together or pulling apart of individual letters. Normally, lack of kerning is noticeable in larger type sizes. Letters that often need kerning:

T and o
T and r
T and a
Y and o
Y and a
W and o
W and a
T and A
P and A
y and o
w and e

Round characters can be kerned more than straight characters.

Figure 6.4 *http://usabletype.com is an interesting site for picking up tips on fonts for web*

Text Animation

Text animation can be very time-consuming, since every letter in a block of text must be manually animated, added to ActionScript for effects which is a long production process. The idea of pre-programming text effects using code is very handy and totally reusable. At Sprite Interactive we use a number of tools for text animation. They are handy and inexpensive with an automated process and a series of text-animation templates. The two most popular tools are Swish 2.0 and the web site Flashtyper (on www.flashkit.com). Both pieces of software are easy to use: you simply enter your text and select an animation effect from a pull-down menu. You can then move the effect along the Timeline to coordinate it with other elements or effects you need to add. Animations can also be animated and enhanced with Flash. These programs include basic drawing tools so you can add custom shapes to your animation. Both include hundreds of animation effects with unlimited customization options with which you create your own.

Animations created in Swish 2.0 or Flash Typer can be exported to Macromedia Flash's SWF format, as well as to Flash; you can use them as movie clips within larger animations. You can use both of these tools even if you do not have a copy of Flash. Swish provides several features that let you create full-featured web animations. Using the version of Swish on the web site www.swishzone.com you can follow the steps below to a simple way of animating your text.

Creating Text Animation Using SWiSH

This is a step-by-step tutorial on how to create your first text animation using SWiSH Movie. This tutorial illustrates some of the text effects and gives you an outline how the application works.

1. Start the SWiSH application
2. From the File Menu select>New
3. Define your Movie's properties by selecting the Movie Panel and changing the Width to 700, Height to 450 and Frame Rate to 15. Set the Background Color to white. The "Movie" Panel should look like this:
4. Centre the stage area within the layout panel. In the Zoom Controls of the Layout Panel click on the Zoom 100% button.
5. Make sure that you have Scene 1 selected in the Outline Panel, and press the Insert Text button on the Insert Toolbar. You should see the word "Text" appear in the centre of the stage in the Layout Panel.
6. Change the word "Text" to the words "Animating Text" in the text window by selecting the "Text" Panel. Change the font size to 48 point from the drop-down font size Menu, or by or entering 48 in the font size box of the "Text" Panel. The "Layout" Panel should look like this:
7. In the Timeline Panel click on Frame 1 in the row for "Animating Text". Press the "Add Effect" button, which is on the left of the "Timeline" Panel. Select Fade > Fade In from the drop-down Menu. Double click on any Frame of the Fade In Effect in the

Figure 6.5 *Tutorial so far in SWiSH*

Figure 6.6 *Tutorial so far in SWiSH*

Timeline, the "Fade In Settings" dialog box will appear. From the "Fade In Settings" dialog box, press the button labelled "More Options >>" then uncheck the "Continue from previous Effect" checkbox to access the Start at tab. From the Start at tab, select X scale>Scale Factor, and enter the value 30 in the% edit box and press enter. Select the Motion tab, and select X Scale>Resize to 100%. Press the "Close" button, at the bottom right of the dialog, to close the dialog box.

8. Press the Play Movie button on the Control Toolbar. You should see the words "Animating Text" increase in scale as it fades in. This will continue to loop until you press the Stop button.

9. Click on Frame 10 in the row for "Animating Text". Press the "Add Effect" button, and select Fade>Fade Out from the Menu.

10. Press the "Play Movie" button. You should see the words "Animating Text" fade in, and then fade out. You can press the "Stop" button to stop the movie.

11. Right-click on the Fade Out Effect in the Timeline, and select Properties from the context Menu to display the "Fade Out Settings" dialog box. Change the Duration from 10 to 4. By Pressing the "Play Movie" button again. You will see the words "Animating Text" fade out faster, because you have shortened its duration. Press the "Stop" button.

12. Press the "Insert Text" button. The word "Text" will appear directly over your first word on the stage, it will also appear in the Timeline and the Outline Panel. In the Text Panel change the word "Text" to the word "animating", the font size should be set to 48 point.

13. Press the "Insert Text" button to create a third word. Change this word to "By" and leave the font size at 48 point.

14. Press the "Insert Text" button again to create a fourth word, change this word to "Alex" and leave the font size at 48 point.

15. From the Timeline click on the Fade In Effect you created for the word "Animating Text" and while holding the CTRL key down, click on the Fade Out Effect next to it. Both the Fade In and the Fade Out Effects should be highlighted. Right-click and select Copy Effect from the context Menu. You may need to resize or scroll the Timeline so you can see the rows you want to work on.

16. On the Timeline, right-click at Frame 17 next to the word "By" and select Paste Effect. Paste these Effects at Frame 35 next to the word "MY" and at Frame 52 next to the word "Alex".

17. Click on the Fade Out Effect for the word "Alex" to select the Effect, then right-click on it and select Properties from the context Menu. The "Fade Out Settings" dialog box should appear. Select the Motion Tab, and select X Scale. Resize to Scale and enter the value 400 in the% edit box, press enter and the click on the "Close" button.

18. Press the "Play Movie" button on the Toolbar. You should now see the sequence of words "Animating Text", "by", "Alex", fade in while increasing in scale and then fade out. The Word "Alex" will fade in while increasing in scale and then fade out while decreasing in scale. Press the "Stop" button.

19. Now press the Save Movie button on the Toolbar. You should now see the "Save As" dialog box. Type "myTxtAnimation" into the File name edit box and press Save. Your Movie has now been saved as a .swi file and can be opened at a later time.

Pixel Fonts

Screen fonts have enjoyed a tremendous increase in popularity in the last decade. Legibility on screen, even in small point sizes, is the essence. Flash 8 now compensates for some of the issues of anti-aliasing text through the FlashType rendering engine. The Anti-Alias for Animation setting produces anti-alias text that animates smoothly. The text also animates faster in some situations, because alignment and anti-alias are not applied while the text animates. This option produces a larger SWF file size, because font outlines are included in the SWF file.

If you've ever tried setting text in Flash at small sizes, you would probably have been very disappointed. Flash's anti-aliasing makes small type look out of focus. So why does this happen? This is because the fonts were designed for printing and not specifically optimized for screen display. Printer fonts are intended to work with high resolution output devices not on low resolution computer screens.

The converse of this are fonts that are designed for optimal screen display are going to look chunky and pixelated if they are printed. They are called pixel fonts because they are literally painted pixel by pixel. Everything you see on a computer screen is made up of pixels and so all computer fonts have a pixel font representation.

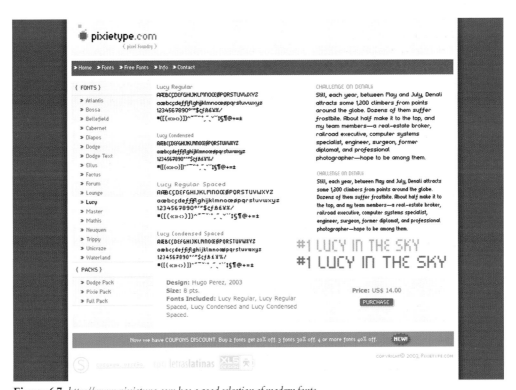

Figure 6.7 *http://www.pixietype.com has a good selection of modern fonts*

In 1984, Apple introduced the Macintosh computer and gave us the concept of "What You See Is What You Get". The Apple ImageWriter dot matrix printer still echoed the pixels on the screen but could do so at 144 dpi – giving smoother results than a straight screen copy. In the mid -1980s, along with Adobe PostScript and Aldus PageMaker, any PostScript font was supplied in two parts; a resolution independent, outline printer font and a low resolution bitmap counterpart. The bitmap (pixel) font gave an approximation of the high resolution printer font, allowing designers to see a rough preview of how the page would look when printed. Usually, only supplied in two or three sizes, the pixel fonts were often simple in letterform and in spacing, especially when set at sizes other than 9, 10 or 12 points.

Apple developed the TrueType font format and launched it in 1991. With TrueType, there was no need for separate printer and screen versions, there was only an outline font and the computer generated the screen font on the fly by rendering the screen font from the outline description. TrueType was introduced in Microsoft Windows 3.1 in 1992 but was not very good as Windows, at that time, ran in 16-bits with fairly slow processors and couldn't render fonts smoothly. It wasn't until Windows 95 arrived that the full potential of TrueType started to appear on screen.

What is Anti-aliasing?

Aliasing is an effect on computer screens, it appears on all pixel devices, where diagonal and curved lines are displayed as a series of little zigzag horizontal and vertical lines. Anti-aliasing, is the name for techniques designed to reduce or eliminate this effect, by shading the pixels along the borders of graphical elements. A simple model for anti-aliasing pretends that rendering takes place by *averaging* the image that would be produced on an infinite-resolution device. Anti-aliasing depends on screens that can display many colors; screens managing only 256 colors generally can only do good anti-aliasing at the expense of their range of colors. If color were not involved, the problem would be much simpler, and screens capable of only 16 shades of gray would show notable improvements over pure black and white screens. Color schemes must deal with a range of shades between any two arbitrary text and background colors.

Font smoothing, or anti-aliasing, gives the impression that the viewer was seeing a printed page on the screen. It works by rendering the outline printer font in multiple shades of the font color against the background "page" color. Where the type's edges met the paper, they were blended into the background color with a range of intermediate tones. At larger type sizes, this works well but at smaller typefaces the stroke (thickness) is only one or two pixels wide. The whole character is "blended" giving a fuzzy, uneven appearance. Anti-aliasing is damaging to the look and readability of type at small font sizes.

With screen-based multimedia and the World Wide Web, the screen is the output device, type needs to be designed specifically for that medium. Type carved into wood or stone, or engraved into metal, is visibly different in character from that destined for print and likewise so should type destined for screen be different than text destined for print.

TrueType Fonts

All through the early eighties, I struggled with the various fonts in the market working in Hypercard and VideoWorks. So I created my own font which I used as a screen font. Being a Mac screen font, it was of no use to Windows users – and anyway, it only had a very basic character set of caps and numbers. To correctly form a capital letter, you need atleast five pixels vertically. Lesser than five pixels and horizontal strokes running together in a letter "E" and "A" are just impossible. To stop the bottom of one line of type running into the next, I added an extra pixel at the top and bottom as leading. Later, I added several more variants – condensed, expanded and all the corresponding bold weights. TrueType fonts are essentially a scaleable outline font that can work at any size, but when you want a deliberate "bitmap" look with every pixel being an identical square, there are certain rules you have to follow. Every square pixel in the font characters has to align exactly with the pixels on the screen. This means that pixel font can't be scaled like printer fonts or some font pixels will distort to fit the screen pixels grid. Pixel fonts can only be set at one "designed" size – or exact multiples.

With bitmap editing programs like Photoshop and Fireworks unlike Flash, pixel fonts can be set easily. As long as anti-aliasing is switched off, you can work in pixels and not points, you always get crisp, sharp type that looks great at small sizes. You can always use a font or two for regular work. I would recommend www.miniml.com for a wide selection of pixel fonts at very affordable prices. See Figure 6.8 for a screen from the web site.

Figure 6.8 *Miniml.com a great site for pixel fonts*

Pixel Fonts in Flash

Small type in Flash with anti-aliasing on blur badly. Without it, they look jagged and crude. Flash, being an animation program, requires each frame to be rendered as quickly as possible and that means that font smoothing is not as good as it could be. Anti-aliasing in Flash is optimized for speed, not quality. Small type sizes that are smoothed in a bitmap editor will usually look much fuzzier in Flash.

If you publish your Flash movie in "Low Quality", anti-aliasing is switched off. With less processing to do, the animation runs faster and smoother. But, if you have any slanted lines or curved shapes, they will look jagged. Publish it at "High Quality" or any of the intermediate settings, you will get some degree of anti-aliasing. Whilst this is ideal for curved shapes it is not for small type. So, the trick is to have small type that doesn't anti-alias, even at high-quality settings.

All your X and Y points need to be set to non-fraction values to prevent anti-aliasing. If you can arrange for each and every pixel in a type character to fit the pixel grid of the screen exactly, see Figure 6.9, there will be no anti-aliasing and the type will look sharp regardless of the published quality. It's when font pixels cross screen pixels that anti-aliasing occurs, see Figure 6.10.

Figure 6.9

Figure 6.10

A GIF image, like all bitmap images will not scale well. If it is originally 90 × 60 pixels and you resize it to 180 × 120 pixels, the extra pixels are guessed through a process called interpolation. Like TrueType and PostScript fonts, Macromedia Flash is a vector format and is resolution independent. With vector shapes and regular fonts, Flash will render any frame at any size. However once you introduce specific pixel measurement, rows of pixels are either invented or discarded. The same goes for pixel fonts, but where some softer GIF images are just about acceptable when scaled, type, with definite hard edges, will suffer badly.

Pixel fonts in Flash, should have every pixel in the type synchronize precisely with the pixels of the screen.

The first thing you must do is to make sure that your document measurement units are pixels and not points, inches or millimetres. This is done in the "Modify" menu under "Document". Use the "View" menu or magnification pop-up at the top right of the work area to set to 100%.

Then you must make sure that you are working at a magnification scale of exactly 100%. Your workspace will be at an arbitrary size determined by the size of your monitor. When you place any object in Flash, it can fall at fractional x, y coordinates. Flash MX has a "Snap to Pixels" item in the "View" menu which snaps new objects, and static text, to the screen's pixel grid. You must make sure it is switched on otherwise you might have to adjust type box coordinates manually in the "Info" palette. Pixel fonts have to be set at the correct "designed" size. You can't specify just any size. If the font is designed correctly, every character should be sharp with no anti-aliasing. If the font size is ten pixels, you can set the type at 10 or, if you want a deliberate pixelated look, at 20, 30, 40 or any multiple of 10.

In the paragraph tab, always set pixel fonts ranged left or right. Setting them centred introduces approximations that can take the setting off-grid. Apart from making sure that the type size is set correctly, you have to avoid any transformations that will take the pixels off-grid. This rules-out any form of letter-spacing, kerning, adjustments to character width or baseline shift. All these introduce sub-pixel measurements that are okay for print type, but pixel fonts can only work with whole pixels.

When you publish a Flash movie, it converts type into vector shapes, just as it does with any other rectangle or curved shape. Unlike print or Web publishing, you don't have to worry about the user not having the font installed. They will see exactly what you want them to see. The downside is that you have to publish the movie at a fixed size that can't be scaled. In the "File" menu, "Publish Settings" dialog "HTML" tab, select "Dimensions: Pixels" and input pixel size of the movie. This means that the user can't scale your Flash movie within a Web page.

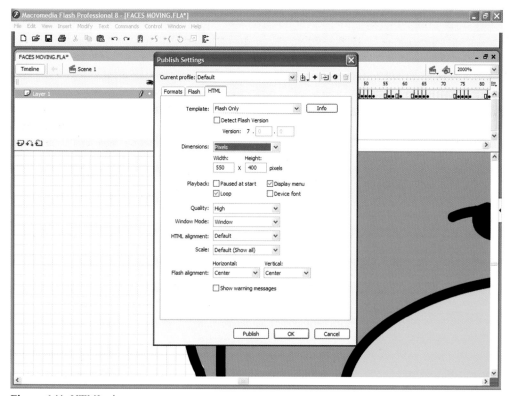

Figure 6.11 *HTML tab*

There are five different font rendering options available in Flash 8. To choose an option, select the text field and open the Property inspector. Select an option from the Font rendering method pop-up menu:

- **Device Fonts:** This option produces a smaller SWF file size. The option renders using fonts that are currently installed on the end user's computer.
- **Bitmap Text** (no anti-alias): This option produces sharp text edges without anti-aliasing. It produces a larger SWF file size because font outlines are included in the SWF file.
- **Anti-Alias for Animation:** This option produces anti-aliased text that animates smoothly. The text also animates faster in some situations because alignment and anti-aliasing are not applied while the text animates.
- **Anti-Alias for Readability:** The advanced anti-aliasing engine is used for this option. This option offers the highest-quality text with the most legible text. It produces the largest SWF file size because it includes font outlines and special anti-aliasing information.
- **Custom Anti-Alias:** This is the same as Anti-Alias for Readability, except that you can visually manipulate the anti-aliasing parameters to produce a specific appearance. This is useful for the best possible appearance for new or uncommon fonts.

Animating Pixel Fonts

For small static text in a Flash movie, pixel fonts provide crisp type that stands. If you are animating the text, however, this same sharpness can be a drawback. Instead of gliding smoothly across the screen, it will seem to move in a series of staccato jumps. The solution is to add some blurring by deliberately shifting the text off the pixel grid – until it comes to rest. This means that you have to make some delicate adjustments when tweening to work best when the blurring is in the same direction as the movement – just like Photoshop's "Motion blur" filter. Ideally, the amount of blurring should increase with the animation speed. In Flash 8 you can define your text as bitmap font. Animation works fine then, without any jumps. If you define your text as anti-aliased for reading/readability the animation jumps appear.

Larger Blocks of Text

Although there are few difficulties in setting short lines of text with pixel fonts, some Flash designers want to set larger blocks of text and find they have problems. As the lines of text become longer, it becomes increasingly difficult to make sure that every pixel in the type lands exactly where it should. When you string a long line of characters together, the cumulative effect of very small errors in the character widths means that they move progressively further off the pixel grid, maybe coming back onto it again further along.

The errors could be in the font design or in the computer's translation from its idea of points into pixels. Points and pixels are the same on Macs – 72 to the inch, so there's less chance of problems there. On Windows, there are 96 pixels per inch, so point-to-pixel conversion calculations are required and rounding errors can creep in.

Flash's line spacing is specified in points even when everything else is working in pixels. Points and pixels don't mix on Windows! If you find that multi-line text is becoming blurred, you can try breaking it up into individual lines. If some text is sharp and some blurred on the same line, the only workaround is to publish the .SWF file at "Low Quality". Text can look fine on one PC and be out of focus on another – probably down to the fact that there were different video cards.

Dynamic and Input Text

As Flash converts static text into outlines, large amounts of text can lead to large file sizes and slow downloading times. Embedding a font (or just the characters used) into the movie can help keep the files to manageable sizes.

When you embed a font into a Flash movie, it's converted into Flash's own internal format. In doing so, the font size can be changed. It doesn't matter if you change the size of a regular printer font, which is going to anti-alias anyway, but changing the size of a pixel font usually means that it will blur. Some freebie fonts get round this problem by making the font the same size as Flash's internal format. If you want to use dynamic or input text in Flash, consider using a "Device Font" like Verdana or Georgia to minimize file sizes.

Figure 6.12 *Pixel grid*

Flash's magnification pop-up only goes to 800% but the field beside it allows you to type whatever you like up to 2000%. At 1600%, and with "Snap to Pixels" switched on, you can actually see the page's pixel grid and how the font pixels relate to it.

An objects X, Y position can relate to its top left corner or to its centre. A tiny icon on the "Info" palette consists of three rows of three squares. The black square represents the point from which measurements are made to any selected object. The black square should be in the top left corner for pixel fonts because measurements made to the centre won't lock to the grid. The top left of the text's bounding box should be on the pixel grid lines, as should every pixel of each character.

You can adjust individual character positions using "Break Apart", in the "Modify" menu. By typing values into the X, Y coordinates in the "Properties" or "Info" palettes; you can move characters by a tenth of a pixel in any direction. Using "Break Apart" a second time turns the characters into shapes and they can no longer be edited as type, but can be edited as shapes. Flash does this anyway when the movie is published.

To keep the correct relationship between the pixels on a screen and the pixels that make up the characters in your font, you must specify your font sizes in pixels, not points. A ten pixel font is not necessarily the same as a ten point one. Set up your image editor to work in pixels and set your document resolution to 72 ppi (pixels per inch). Fonts are like small mosaic tiles that have to fit into a larger mosaic grid – the stage. Mosaic tiles are a fixed size, you can't stretch them or squeeze them to fit off-grid. If you zoom-in on any character, you will see that it is also made up of square tiles and these tiles have to fit on the pixel grid of the screen.

You must never distort these fonts or alter their letter-spacing by anything other than a complete "tile". Make sure that the text settings in your graphics program are set to "neutral". No condensing or expanding, no kerning, no letter-spacing and definitely no anti-aliasing. If your font is designed at 10 pixels, it will only fit the pixel grid if you set it at 10 pixels, although you can also set it at exact multiples too. At 20 pixels, for instance, there would be four tiles in the grid instead of one.

A problem can arise if you use a centred paragraph style. The math required to centre text can result in fractional spacing and vertical rows of pixels can mysteriously disappear. Always set your pixel fonts ranged left and centre it by moving the whole layer.

If you place a character off the pixel grid, it will be "averaged" across multiple pixels and you will get blurred, anti-aliased text. Make sure that all your text is at exact X, Y positions on the screen and that your Flash movie can only be viewed at 100%. Flash MX has a new "snap to pixel" facility that ensures that pixel fonts are always on-grid. Make sure it is switched on before you try to place text.

As these fonts are in TrueType® format, they can be used in Flash and other vector graphics programs. When the Flash file is published, it converts the fonts into vector shapes so there is no problem with the fonts not being available on the user's system. They will still have to conform to the mosaic tile principle. The "tiles" have to fit precisely to the screen's pixel grid. These fonts work fine as static text, their use in Flash's dynamic text boxes requires them to be installed on the viewing computer or to be embedded.

Embedded fonts behave differently from those used in static text boxes and are unlikely to give the required results. When Flash embeds fonts, their sizes are changed. Although this doesn't matter much with anti-aliased fonts, which are blurred anyway, pixel fonts get shifted off the pixel grid of the screen. This is due to the errors caused by the small difference in the size of each character. The effect is that the text goes in and out of phase with the screen grid and goes from sharp to blurred and back again. Embedding pixel fonts in Flash movies is not recommended for this reason.

You can check if the font pixels are in register with the screen's pixels by switching-on Edit>Grid>Show Grid and zooming-in to 800% or more. Any off-grid font pixels will blur. Switch to "Outline" mode to hide the fills if you have solid background areas. You can see this in Figure 6.10.

The other thing that affects anti-aliasing in Flash is the Publish Settings. In the "HTML" tab there is a pop-up labelled "quality". Setting this to "Low" switches off the anti-aliaing completely and has the added benefit of giving faster and smoother animation – as there is less processing to do. Unless you are combining pixel fonts with regular printer fonts or have other shapes on the screen that require anti-alias, use this setting to avoid unwanted font smoothing. It is not possible to have different "quality" settings in the same movie or on different layers but you can chain movies of different quality settings together to switch anti-aliasing on or off as required.

PaintShop Pro™

PaintShop Pro sets all text at 96 ppi regardless of the page resolution setting. It also does not allow you to set the fractional point sizes required to get pixels. At 96 ppi, a pixel is 1.333 points. To set a 10 pixel font, you would have to set it at 7.5 points and you currently cannot do that. If you use PaintShop Pro, the workaround for the minute is to set 10 pixel type at 15 points and resize the whole image to 50% or you can change Windows to run at 72 ppi.

Changing Windows to Work at 72 ppi

The difference between points and pixels on Windows causes problems in some programs such as PaintShop Pro and Macromedia Flash. PaintShop Pro only allows type to be specified in points and doesn't accept the fractional point sizes necessary to do the conversion – 10 pixels = 7.5 points.

Flash only allows line spacing to be set in points, not pixels, so multi-line text can go out of sync with the screens natural pixel grid.

Temporarily setting Windows to run at 72 ppi instead of its default 96 ppi solves these problems completely. Once you have made your files, you can switch back.

Here's how you do it.

1. Right-click on the desktop and choose "Properties" to bring up the "Display Properties" dialog.
2. Click on the "Settings" tab.
3. Click the "Advanced" button.
4. You will see the DPI Setting pop-up menu, which will be set to "Normal Size [96 dpi]".
5. At the bottom of the pop-up menu, you will find the "Custom Settings" item – choose it.
6. Set the scale to 75% and you should see a sample of Arial 10 point at 72 ppi, which is what we want.
7. Click on "OK" and you will be prompted to restart Windows.

When Windows restarts, everything on the screen will be 75% smaller than it was before. You can compensate by changing the screen resolution if things look too small. If you work at 1024×768, change to 800×600. Note: you should only do this on a conventional cathode ray tube monitor. LCD monitors don't run satisfactorily at anything other than their natural resolution – just like pixel fonts – and will anti-alias everything. On an LCD monitor, change the window zoom to 200% to see what you are doing.

Now, you are working at 72 ppi and pixel and points are identical so PSP and Flash will render pixel fonts as they should.

To revert to 96 ppi, just do the same procedure again but choose "Normal Size [96 dpi]".

Embedded and Device Fonts

For playback of Flash movies, there are two options for dealing with fonts. Font outlines can be embedded in the published SWF, or you can choose to let the Flash Player use fonts installed on the playback system. The playback system fonts are called "device fonts".

The different types of text fields in Flash – Static, Dynamic and Input – behave differently in terms of how fonts are included, or not included.

The main benefit to embedding font outlines is that text fields will always display in the chosen font, regardless of whether that font is installed on the playback system. Also, text fields whose fonts are embedded will always be anti-aliased (smoothed) by the Flash Player. However, Bitmap fonts are treated as bitmaps becsoue they do not contain outline information, will never anti-alias.

The biggest drawback of embedding fonts is an increase in SWF file size. If several different movies use the same font or fonts, you can reduce file size by using shared font symbols. Using device fonts results in a smaller movie size, since font data is not included in the file. Device fonts are often a good choice for displaying text at small point sizes, as anti-aliased text can be blurry at small sizes. Device fonts are a good choice for large blocks of text, such as scrolling text.

Text fields that use device fonts may not display the same across different systems and platforms, however, since Flash Player uses fonts installed on the system. For the same reason, device fonts will not anti-alias and may appear jagged at large point sizes. Flash device font types offer a compromise between the display consistency offered by embedded fonts and the small file size of using device fonts.

Static Text Fields

By default, font outlines for characters used in a Static text field are included in a published SWF. As a result, Static text fields will anti-alias. Because outlines for just those characters used in a Static

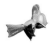

Figure 6.13 *Text Options panel*

text field are included in the published SWF, and not every character in the font, Static text fields are a good choice for animating small amounts of anti-aliased text.

If you want a Static text field to use device fonts, select the Use Device Fonts option in the Text Options panel.

Text contained in the field will not be anti-aliased (smoothed) by Flash Player during playback. This can improve legibility for text at small point sizes, while making text at larger sizes appear jagged. Anti-aliasing can affect performance, so select this option if optimal frame rate is more important than smooth fonts edges. However, if the font used to create the text field is installed on the playback system, Flash Player will use that font to display the text. Otherwise, Flash Player will substitute a font installed on the playback system. Typically, a standard font such as Times will be used.

Device Fonts "Types"

A concession between the display consistency of embedded fonts and the smaller file size of using device fonts is to use one of Flash's device font "types". The Fonts pop-up menu in the Character panel contains three of these fonts: _sans, _serif and _typewriter. These fonts define a general font type for a text field that, during playback, will be substituted with an installed font that matches that type. For example, on Windows systems, Flash Player (typically) substitutes Times New Roman – a common Windows font – for _serif. The following table shows how the font types typically map to commonly installed fonts on Windows and Macintosh platforms. For Static text fields, even if Use Device Fonts is not selected in the Text Options panel, choosing one of these fonts will cause Flash Player to use device fonts.

Device font type	Windows	Macintosh
_sans	Arial	Helvetica
_serif	Times New Roman	Times
_typewriter	Courier New	Courier

Limitations of Device Fonts

Because Flash Player relies on the system to display device fonts, there are some limitations on animating and tweening text that use device fonts. Although masks may display correctly inside the Flash authoring environment, device fonts cannot be masked. The final SWF will not display the text block. A device font used in a symbol can be motion tweened, but any alpha changes applied to the symbol will not display for the device font's text block. Scaling or rotating may display fine during authoring, but will cause text to disappear in the published SWF. A text field that has been scaled or rotated, or a text field inside a symbol that has been scaled or rotated, will not display text. However, you can mask device fonts only by using a movie clip as a mask. You cannot mask device fonts by using a mask layer on the Stage.

The Game

We can now go back to our game and look at the different text and how to find it. For me one of the most useful tools in Flash 8 is the Movie Explorer to view the document structure.

Figure 6.14 *Movie Explorer filtering all the text in the project*

It helps you arrange, locate and edit media. With its hierarchical tree structure, the Movie Explorer provides information about the organization and flow of a document.

1. Select Window > Movie Explorer.
 If necessary, enlarge the Movie Explorer to view the tree structure within the pane.
 The Movie Explorer filtering buttons display or hide information.
2. Click the pop-up menu in the title bar of the Movie Explorer, and select Show Movie Elements and Show Symbol Definitions, if they're not already selected.

3. Configure the filtering buttons, along the top of the Movie Explorer, so the only ones selected are Show Buttons, Movie Clips and Graphics; Show Action Scripts; and Show Video, Sounds and Bitmaps.

 If you move your mouse pointer over a button, a tool tip displays the name of the button. Examine the list to view some of the assets included in the document, and to see their relationship to other assets.

4. In the Movie Explorer pane, expand Actions for Play to view ActionScript that Flash created when you added the Play video control behaviour.

5. To close the Movie Explorer, click its close box.

Chapter 7

Flash Mobile and Flash Lite 2

This chapter is an overview of developing content for Mobile Phones and the Pocket PC. In this chapter I want to spend some time explaining the Macromedia Flash Lite features as well as describing some best practices for creating content for these mobile devices.

I will take you through essential issues such as interface design, movie size and format and optimum movie size for playback on handheld devices. This chapter discusses in-depth the importance of mobile communications as we look into the future, and how they will change the multimedia industry. On a practical point I feature two products with all the source code and a template for all mobile development and finally I round off the chapter by looking at two implementations of Flash within mobile and with Flash as the interface element on the web to the mobile device. In addition there are eight games available on the CD for mobile Flash Lite 2. Kick-start your Flash-Lite development by downloading the Flash Player, it costs $10, click on the "Buy Flash Lite 2" button under "Flash Lite Player for developers" on the Macromedia site. Once you download the player you can play all our Flash Lite applications on your phone. The source files for all the games are on the CD.

With the release of Flash 8, Adobe has significantly improved and enhanced the mobile development environment, making it easy for developers to create Flash content for a wide range of platforms, including mobile phones and PDAs. Some of the new features which are really exciting are the built-in templates for mobile devices, the ability to embed MIDI,

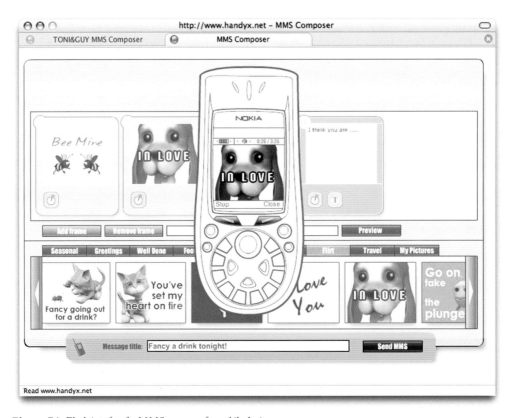

Figure 7.1 *Flash interface for MMS composer for mobile devices*

WAV and MP3 sounds into content, and the ability to publish content for the Flash Lite profile directly from the authoring environment. Flash 8 has limited feature set while Flash 8 Professional is for those of you who create rich applications, including those for mobile devices. A new and really exciting feature is the ability to load and stream 3gp-videos.

The embedded software and the user interface presents the biggest challenges for any kind of development in the Mobile market. No matter how small and efficient a device, consumers will not accept it if it is dull or difficult to use. An essential part of the user experience is the operating system (OS) of the device. Unless the manufacturer develops a custom OS for its integrated product there are three main options: Palm OS, Windows CE (Pocket PC) and Symbian. The choice of OS can have a significant impact on power consumption, which is a vital issue for wireless devices.

You may want to test your Flash Lite content in the emulator provided by the target device's manufacturer. Unfortunately, this is not possible with the Flash Lite Player. You can check out the difference between the UIQ of Zacandellen and the Symbain 60's series version of the game by playing the goose game.

The Flash Lite Player is tied to the handset by its IMEI, or serial number. The IMEI number is required to generate the player installer and to install the player. Because emulators don't have an IMEI number, there is no way to install the Flash Lite Player into the emulator.

How to Test Flash Lite Content

Flash 8 Professional includes a testing player for Flash Lite that will run Flash Lite content in Test Movie mode. This is the only way to test Flash Lite content locally on the development machine, however some device capabilities cannot be tested (i.e. battery level, signal strength, etc.). The only way to be certain of the quality of your product is to test your applications on the actual target handset regularly during development.

The Goose game is an example of this multi-delivery approach. Originally drawn in FreeHand, the flying goose became a demonstration in animation and how birds fly. It was then developed into a game running in Flash Lite 1.1 on the SonyEriccson P900. The brief for the game was to use one asset to create a flock of geese. The geese, although one asset, would vary by size and with the use of tints we are able to give them the illusion of distance. This game finally became part of an updateable magazine running on all Flash Lite enabled phones. An interesting interface difference between the two is the crosshair on the computer version which is draggable and moved round by input from the mouse. On the P900 version, the user uses the stylus for shooting the geese and so the crosshair does not exist on this version.

Figure 7.2 *Flash Lite dynamic magazine*

The Flash Developer Base for Creating Content

The mobile environment has relied heavily on Java (J2ME) for the multimedia experience. The process of developing content on this platform was always the domain of programmers. The Flash Lite platform brings with it the existing one million Flash developers who are seasoned at building rich user interfaces, games, animation, enterprise applications and e-learning applications to Flash Lite. Ironically, Flash allows the easy development of wallpapers, business and e-learning applications, cartoons, dynamic user interfaces and sports, news and weather applications, all of which can benefit from the one key feature of Flash; its ability to render vector content.

With a mobile device, users can be using your content anywhere: on a train, walking down the street, lying down in bed or even while driving their cars. When people are using your mobile content, they aren't constrained to use it with a fixed location as they are on a laptop or desktop. One thing will never change in the mobile market, that is devices will always be very different because of displays, processors, inputs and connection speeds. The only sure way of testing is on the targeted device.

Flash 8 has had numerous builds on the Flash Lite profile for mobile phones. The latest releases have added several key features related to connectivity, device-specific capabilities and standards support.

Flash Lite offers the following features for mobile phones:

- actionscript (supports Flash 7 syntax – object orientation)
- event sound triggering
- load and stream 3gp videos
- mobile shared object to store data on device
- HTTP-based data connectivity
- SVG support (playback only)
- Expanded access to phone capabilities
- A new content development kit (CDK)
- Vector graphics rendering
- Bitmap and jpgs images
- Gradients
- Audio – event sound
- Static text with fonts embedded in the SWF file
- Input and dynamic text with fonts embedded in the SWF file
- Input and dynamic device text
- Frame-based animation
- Tweened animation – motion and shape tweening
- ActionScript 2 supported
- event sound triggering
- Keyboard navigation

Features of the Flash Lite Player
Network Connectivity

Flash Lite content can now exchange data with a server through an HTTP connection, also the data streams to the phone, which greatly improves the user experience. Developers now have a new raft of possibilities for creating applications that can pull data now for dynamic content updates. Previously, mobile phone users could only view static content (screensavers, wallpapers), and could only update once it was replaced/reloaded. Developers can now build applications like news headlines, sports scores and menus, and update them dynamically.

Mobile SVG Support

Macromedia is committed to supporting standards in the market place, and the mobile world is no different. With the release of Flash Lite 1.1, we are meeting the requirement of playback of the W3C open standard Scaleable Vector Graphics (SVG-T) directly within our player, as it is mandated by the Third Generation Partnership Project (3GPP) for use within Multimedia Messaging Service (MMS) messages. This way, handset manufacturers, OEMs and operators can deploy a single technology (Flash Lite) and be better integrated in the phone operating system (as opposed to using multiple technologies based on multiple standards), which makes for a much simpler deployment with one player instead of many.

Phone Capabilities

Developers now have access to specific mobile phone capabilities, such as network connectivity status, date and time, vibrate functionality, language support, audio support and others. They can create content specific to a consumer's mobile phone environment, and can graphically represent these elements to consumers, thus providing a more integrated experience.

User Input

Many devices let users perform tasks or interact with their interfaces in more than one way. The Flash Lite supports various methods of input. The user may have to simultaneously address an incoming call while interacting with some Flash-based content. Offer users a choice of using the numbers on their touch pad or using their stylus so that they can easily use your program. The main methods include the stylus (operated like a pen or pencil), the joy stick and the mobile phone key pad used to enter text into any form and to control movies and games, hardware keys that can be remapped to perform specific functions, and external keyboards. Function keys are not supported, devices usually offer some type of small keyboard with arrows and most ASCII characters, but not the function keys. Certain keys are not supported, and it's a good idea not to use them but to provide alternatives for desktop and Mobile applications. For example, small touchable icons that can be used with the stylus or a finger are often a good substitute. You can also create a special icon that brings up a small touchable keyboard or keypad if the Mobile keyboard is not desired.

On the P900, jog dial and stylus are the main method of interaction between the user and the device. The animator should always try to create navigational controls and buttons that encourage dragging and clicking. The zakellenP900.fla from the CD demonstrates the simplest use of the stylus and jog dial. We have also built functionality around the jog dials for both navigation and selection for the p900 and p910i.

Separating Interface from Functionality

People will interact with your movies in different ways on different devices. They may be using a PDA, like a Pocket PC or a CLIÉ, or they may be using a mobile phone. Your users may interface with your movie by using either a stylus or their fingers to press buttons.

Do not make your functionality device-dependent. While you may be deploying to only one device today, you should leave your options open to publish your project on additional devices in the future. By separating your functionality from the events that trigger it, you leave your options open to offer a version for a different device in the future, like a mobile phone. If you are triggering functions in your movie, try to create triggers that work on many devices, rather than on just one. The ellenzak.sis file demonstrates this by running the magazine on a Nokia 60 series using only the softkeys. Install this on your phone and check it out.

Buttons

Buttons should be treated differently for the Mobile content. The main difference is that devices like the P900i do not use mice for input and as a result they have no cursor. When the user is interacting with a Pocket PC movie, a pen tap generally translates as a mouse click. A rollover state is not needed, and should be avoided as pen taps can "stick", meaning the rollover state will be displayed after the click. Make sure to make the hit states on the buttons large enough for a hasty pen tap or the occasional finger if the application is a "quick reference" piece.

Right-click Menu

Holding down the pen does not bring up a contextual menu (right-click menu). If the hold-down menu was enabled, it would interfere with file dragging operations because some devices are stylus-driven. This has been disabled to allow drag and drop functionality to be implemented more easily into the Mobile environment. In projects that require a zoom feature, which had previously been in the right-click menu, you can use on-screen controls to allow the user to zoom.

Screen Economy

Not all devices have the same screen size. While most development environments don't have an easy method for dealing with this issue, Flash vector technology can easily be set to scale to fit the display size of the device. A Mobile application should be expandable and not require specific screen parameters to function. If an application relies solely on the characteristics of the display area, then the user interface has not been clearly separated from the application.

Fonts and Text

Although embedded fonts give you more control over the design of your content, they also add to the size of your movie. Using device fonts helps keep your file size small. Serif fonts tend to lose their details on screens while most sans fonts display better than serif fonts.

Alias Text Support

Because of the limited screen size of mobile devices, Macromedia has added a new option for rendering text: the Alias Text button.

The Alias Text button in the Property inspector lets you render text so that it looks good at small sizes (12 point and below). Macromedia Flash supports this option for static, dynamic and input text. The Alias Text option makes small text legible by aligning text outlines along pixel boundaries. This makes the text appear aliased, even when you've enabled anti-aliasing.

Another solution for fonts on small screens is to use pixel fonts as featured in Chapter 6. These are fonts that are built on pixels – they don't anti-alias, so they remain crisp and clear. There are few sites that sell these fonts. They show up well on small device screens.

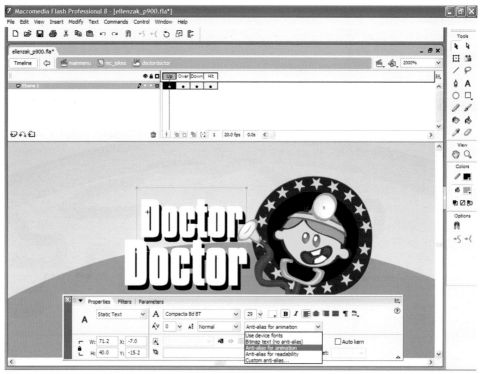

Figure 7.3 *The Alias Text button in the Property inspector*

Figure 7.4 *Twelve-point Arial text rendered in Macromedia Flash 8 Professional*

Colors, Vectors and Images

Devices vary in how well they display content and how many colors are available. Depending on the model, the color depth of a device display can be anywhere from 4096 to 65,535 colors, or from four to 16 levels of grayscale. Choose highly contrasting colors when possible because

the displays often have low contrast. Use graphics that have a high contrast ratio between colors and that have sharp edges in the details of the picture.

Animation

When creating animated content for a mobile phone, it is important to keep in mind the phone's CPU limitations. The following guidelines can help prevent your Flash Lite content from running slowly: if you need to provide intense or complex animation, experiment with changing the quality setting of the content. The default quality setting is Medium. To change the quality setting in Flash 8, select File > Publish Settings, and select the HTML tab. Select a quality setting from the Quality pop-up menu. Because changing the quality setting might noticeably affect the visual quality of the Flash Lite content, make sure to thoroughly test the SWF file. You can also use ActionScript to control the rendering quality of a SWF file, by using either the _quality property or the new FSCommand2 setQuality() function. For the _quality property, valid values are LOW, MEDIUM and HIGH. The following code sets the rendering quality to LOW: _quality = "LOW".

To set the quality in Flash Lite you need to use FScommand2("SetQuality", "low"). You can also set the level of anti-aliasing using _highquality = 0 . . . 2.

Figure 7.5 *SetQuality and full screen setting on zakandEllen*

Although animating with ActionScript may produce more desirable results, in general, you should avoid unnecessary use of ActionScript because it can become processor intensive. The best advice is to limit the number of simultaneous tweens and use Alpha effects on symbols sparingly, as they are very CPU intensive. In particular, it is generally not a good idea to tween symbols that have alpha levels that are not fully opaque (less than 100%). Avoid large masks, extensive motion, alpha blending, extensive gradients and complex vectors.

Stacking Content

Scrolling large amounts of text and graphics, particularly with Flash, will slow down any device because of slow processor speeds. When displaying multiple pages of text or graphics on a Mobile Phone, it is often better to avoid scrolling completely by adopting a "Stacking" model – displaying the one piece of information needed at one particular time, with navigation for the user to flip between pages, or "cards" in the stack. This stacking system can contain a number of frames, or scenes. Cards/frames contain buttons of several kinds, text fields and graphics; any of these objects can be shared between several cards to make a background with common elements. To create a stack, you need to lay out your objects (either card-specific or shared by all the cards of a background), then writes scripts that respond to user actions such as opening a stack, going to a card, clicking or double-clicking or typing.

This allows you to create more space for more content. Adding a new chunk of information pushes it on top of the current project phase. When finished with the current phase, go back to the previous "card". For a scheme like this, create a panel that knows how to push itself onto the card stack and pop itself back off. The ease and flexibility of using Macromedia Flash comes into play at this point. Using simple frame actions to go forward and backward in the Timeline is a quick way to create a "stacked experience".

Using Templates

The templates that come with Flash 8 are extremely helpful tools for mobile developers. These templates preset the correct preferences for your target platform, and each template allows you to apply a cutout bitmap graphic of the target device as a guide layer. As you create your Flash content, this visual guideline layer lets you lay out the content as it will appear on the device.

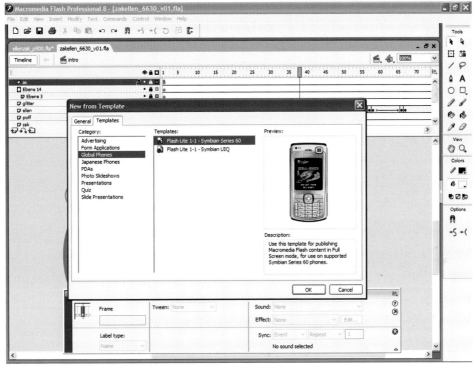

Figure 7.6 *Template dialog box showing multiple mobile templates*

Creating Device Cutouts

Now that you've been playing around with the templates, you're probably wondering, you can make all the different variations in work with your project. How can you keep the form factors of all the different devices in mind? One trick that works pretty well is to print out the bitmaps of the devices and place on the guide layers in the mobile templates. Glue the printout to a thin piece of cardboard and cut a hole where the device screen is. You now have a device cutout, which is very handy during the conceptual stage. Place your cutouts against different sketches or roughs to see how your content will display within the device. The cutouts are also useful for figuring out how to fit content in a small space or as a quick check of content.

Providing Multiple Levels of Reinforcement

Sound is often considered the illegitimate child of the multimedia industry. You'll often hear people telling you not to use sound at all. The general gripe is that sound is annoying, and no one cares about what it is communicating. The importance of audio content is increasingly being recognized as a key building block in delivering multimedia services, from interactive game audio and messaging through to entertainment, polyphonic ringtones and device personalization. The audio capabilities of mobile devices have traditionally been restricted on mass-market devices to blips and beeps, or on higher end devices to playback of simple MIDI or

audio recordings. Many people predominantly interact with the world in an auditory manner. Sound can alert a user to open an application; much like a ringing phone prompts you to answer it. It is easy to imagine that in the near future, mobile devices will host critical applications, possibly even the ones that people's lives may depend upon. Even in the ordinary day-to-day use of a mobile device, you get more out of applications that use sound. If you provide audio to reinforce the displayed data, the user can get a good idea of what's going on.

When a user needs to make a critical decision in seconds, make that easy for them. Use as much visual and audio reinforcement as you can.

First of all, a mobile device is not a tiny desktop. There is a new medium at play that merits a new development approach, with a higher focus on usability. If you build it they may come. If it's confusing, they will leave. Spend more time at the start of your project testing for usability. It's much easier and cheaper to make changes when your project only exists on paper. You can probably repurpose a lot of code you've already written for previous projects, as well as set up a lot of code for reuse in future projects. Structure your animations so that once you write your first few mobile projects you'll be able to reuse your routines.

Video Playback

Flash Lite 2.0 now supports video playback using the video rendering application on the device. This means that any video file that the device supports can also be rendered in Flash Lite 2.0. (Typically this includes 3GPP and MPEG-4 files.)

You can embed these video files directly into the SWF or load them externally, either from the device itself or a network address. Flash Lite then uses the device's video helper application to render the video inside the Flash content.

The 3gp_example.fla file on the CD is a working demo that runs on a Nokia 60 series phone. I have included two video files for you to play with.

The first part of the action script that kicks on frame one, sets up the interface quality and key input listening scripts. On frame sixteen, we initiate the play video and also include the URL where the video resides which could be local.

The final bits of scripts inniate the quit events.

When testing mobile interfaces it is interesting to see what users do when they get stuck. Let them struggle with your application after all in most instances they are not used to the phone. Ask them to speak their thoughts aloud. When they get stuck, ask them what they expect they should be able to do. Ask them how they'd do it. Then take this valuable information and reengineer the aspects of your application as needed.

```
Movie Explorer

Show:  A

Find:

Szene 1
    Actions for Frame 1
        status = fscommand2('SetSoftKeys', '', '');
        status = fscommand2('FullScreen', true);
        var myListener = new Object();
        myListener.onKeyDown = function() {
            var keyCode = Key.getCode();
            if(keyCode == 'soft1'){
                pauseVideo();
            }else if(keyCode=='soft2'){
                fscommand2('quit');
            }
        };
        Key.addListener(myListener);
    Actions for Frame 16
        leftCommand = 'Pause';
        rightCommand = 'Exit';
        function pauseVideo(){
            if(videoPlaying){
                v2.pause();
                videoPlaying = false;
                leftCommand = 'Resume';
            }else{
                v2.resume();
                videoPlaying = true;
                leftCommand = 'Pause';
            }
        }
        v2.play('http://www.cartoons-online.com/preview/3gp/HamsterVideo.3gp');
        videoPlaying = true;
        stop();
    Actions for Frame 20
        gotoAndStop(_currentframe-2);
    Actions for button
        on(keyPress '<Enter>'){
            fscommand2('quit');
        }

Szene 1 -> -as- -> Frame 1
```

Figure 7.7 *The movie explorer window showing all the action script to run a video player on your mobile*

Anticipating Other Platforms

Multimedia and the devices that play it, will continue to grow and evolve. Mobile developers are already dealing with a number of different device factors, and many more coming in the future. The Pocket PC has a screen resolution of 240 × 320 pixels. Some CLIÉ models offer a 320 × 480 screen size. We already have mobile phones with 640 × 480 screen resolution. We already have domestic devices with wireless built into them i.e. TVs on fridges and really tiny phones. In the next few years we should see Flash playing on retail packaging like cereal packs and toys maybe.

One big advantage that Flash had on the web was its vector capability. You should try and maintain that advanatage on mobile. Set up your files so that they can scale up or down to meet the different display needs now and in the future. Think about structuring your entire

project so that you can resize it. And it's not just a matter of rescaling the project itself. If you're using bitmapped fonts, you can't rescale them since they work at particular point sizes. If scaled incorrectly, all the text becomes illegible.

Authoring Content for Devices
Exporting Content for Various Versions of Macromedia Flash Player

When authoring for mobile devices, you need to use the correct Macromedia Flash publish settings based on the Macromedia Flash Player requirements of your target device. For more information on some of the devices that play Macromedia Flash content, refer to the Mobile and Devices Developer Center for a list of devices and content development kits for each. To customize your Macromedia Flash publish settings, you can select an option from the Flash tab of the Publish Settings window. You can access this window in three different ways:

Select File > Publish Settings.
Press the Settings button on the Property inspector with the Stage selected.
Use a keyboard shortcut: Control+Shift+F12.

If you're using the built-in templates for devices, then Flash presets the Flash Player publish settings for each device. However, if you're not using the templates, then you'll need to ensure that you customize the settings for your device.

Figure 7.8 *Macromedia Flash publish settings*

The only setting you need to change is the Version setting. Select the proper version of Macromedia Flash Player in the pop-up menu. The rest of the settings are optional and you can refer to the Flash 8 Help panel for additional information on them.

Internal/External Player for Flash Lite

Macromedia Flash Lite is a Flash profile developed specifically for mobile phones. This profile requires fewer device resources so it can operate in most mass-market phones currently shipping. The Macromedia Flash Lite profile uses Macromedia Flash 7 objects and ActionScript 2. Beginning with the NTT DoCoMo 505i series and the Nokia 60's series mobile phones, every handset has the Macromedia Flash profile embedded or available so that it can play screen savers and Macromedia Flash movies.

Internal Testing

In Macromedia Flash 8 you can test Flash Lite content in the authoring environment. Select Flash Lite 2.0 in the Version pop-up menu in the Publish Settings dialog box and test your movie.

Disable Keyboard Shortcuts option.
To emulate the functionality of the phone keypad on a numeric keypad, select Control > Disable Keyboard Shortcuts.

Figure 7.9 *Emulator at work running a video file on a Nokia 60's phone*

External Testing

To test Flash Lite content outside the authoring environment, use the external Standalone Flash Player (SAFlashLite.exe). It installs with Macromedia Flash; you can find it at the following locations:

Windows: C:\Program Files\Macromedia\Flash MX 2004\Players\Release\FlashLite1.0. Macintosh:\Applications\Macromedia Flash 2004\Players\Release\FlashLite1.0.

To use the player, you need to specify a SWF file to view. Double-click the SAFlashLite.exe to open it and select File > Open.

In the Open dialog box, click the Browse button to locate a file and hit OK. Your Flash Lite content plays in the window. It's important to note that while you're testing, you're trying to emulate the phone's input methods, so use the Tab, Enter and 0–9 keys on your keyboard.

Refer to the Macromedia Flash Content Development Kit for the NTT DoCoMo 505i Series and the Flash 8 Help panel for additional information. You can include device event sounds in Macromedia Flash documents that you author for playback on mobile devices. However, Flash doesn't directly import some of the common sound file formats used for mobile phones, such as MIDI. Flash Lite 2.0 now also supports device specific sound formats like SMAF, AAC, AACPlus.

Here's a workaround that you can use to import these sounds. To summarize, when you author sound files in Flash documents for playback on mobile phones, use a placeholder. Set up the placeholder to use any supported import file format, such as MP3, WAV or AIFF.

Figure 7.10 *Standalone Flash Player file open dialog box*

Link the sound placeholder in the document to an external mobile phone sound, such as a MIDI file. During the publishing process, Flash replaces the sound in the document with the linked external sound. The published SWF contains the external sound and will use it for playback on a mobile phone.

To add an event sound to a Macromedia Flash document for playback on a mobile device:

Open a mobile devices template in Macromedia Flash.
To do this, select File > New.
In the New from Template dialog box, click the Template tab and select Mobile Devices in the Category panel.
Select the Nokia 60 series template.
Select File > Publish Settings.
In the Publish Settings dialog box, click the Flash tab.
In the Version pop-up menu, verify that Flash Lite 2.0 is selected. Click OK to close the Publish Settings dialog box.
Select Window > Other Panels > Common Libraries > Buttons. Select a button and drag it to the Stage. Close the buttons library.
Double-click the new button. The Timeline changes so that you can edit the button, displaying frames named Up, Over, Down and Hit.
Select Insert > Timeline > Layer to create a new layer.
Select Modify > Timeline > Layer Properties and change the name of the layer to "Sound".
Select the Down frame in the Sound layer and insert a keyframe.
Select Window > Other Panels > Common Libraries > Sounds.
Select a sound in the sounds library and drag it to the main document Library panel. Close the sounds library.
Associate the sound with the keyframe. In the Library panel, right-click the sound and select Properties to open the Sound Properties dialog box. (see Figure 7.11.)
In the Device sound text box, type a path or click the folder icon and browse to the location where the mobile device sound file (MID) is located. Click OK.
Be sure the down keyframe in the Sound layer is selected and drag the sound from the Library panel onto the Stage to add the sound to the current layer.
Test your movie by pressing Control+Enter. Make sure that you have enabled the Disable Keyboard Shortcuts option.
Press Tab on your keyboard. A yellow rectangle appears over the button. Press Enter and hear your MIDI sound play
You can publish your movie (Shift+F12) to generate a SWF so you can test it.
Test Flash documents that contain MIDI sound data by playing them with Standalone Flash Lite Player (SAFlashLite.exe). If you select the Flash Lite 2.0 option in the Version pop-up menu on the Publish Settings dialog box, the Test Movie command plays the SWF using the internal player.

This feature works with event sounds only, as mobile devices do not support the Effect, Sync, Edit and Loop options. You must specify an external device sound file for each sound in a document if you want the sound to play on a mobile device.

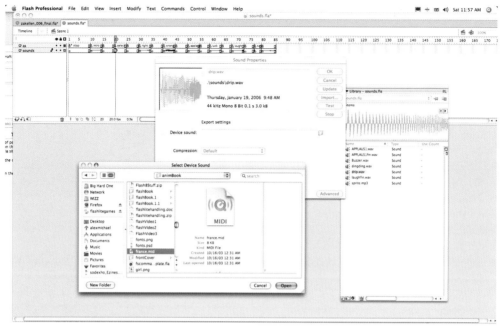

Figure 7.11 *Sound Properties panel*

As with all external files, the device sound file must be available during the Publish process, but the SWF does not need the file for playback.

Testing Mobile and Devices Content

Most animators do not have access to all supported devices for testing; that's why it's important to know your options when you need to test your mobile and devices content.

Generally speaking, one easy way to test your content is to ask other developers who have the devices to test your content for you. You can do this by posting a request in a discussion group such as the Macromedia Flash Handhelds Online Forum. Usually other developers are happy to test content and provide valuable feedback regarding what works and what areas can use improvement.

Mobile phones require you to sign up for service with a provider if you don't already have the specific phone model. For PDAs, it's a bit easier because they don't require any type of service activation and they're readily available. Being able to test your content and see how it works on hardware, is always the best-case scenario. This will let you make necessary changes quickly to ensure the content works properly.

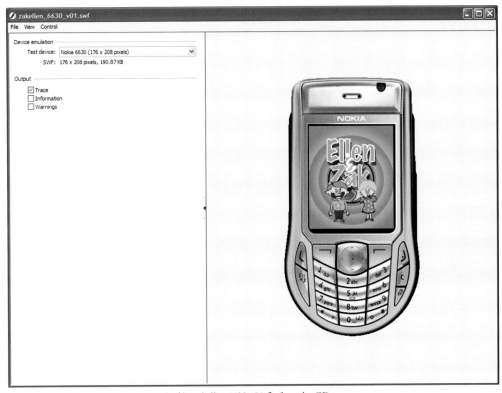

Figure 7.12 *Testing on the series 60 the file zakellen.6630.v01.fla from the CD*

Ellen and Zak is the first European implementation of an offline children's and infotainment service that is regularly updated without user interaction and incorporates a unique user experience. The main objective of Ellen and Zak is to provide customers with a unique, offline mobile multimedia fun and entertainment service, available on both 2.5G and 3G devices.

Ellen and Zak delivers twice monthly games and magazine style content to users' phones. These pre-configured reports cover general educational games, jokes, world games and facts and include pictures, headlines and more detailed stories that can be browsed instantly both on and offline. Customers can access Ellen and Zak content by clicking an icon on the main menu of their mobile phones. Clicking this icon launches the client and presents the user with the most recent edition. The pages of each edition are stored temporarily on the device for offline use whenever and wherever you are. Ellen and Zak offers a simple pricing model based on monthly subscriptions, like a real newspaper. The most interesting aspect of this product is the animation which is done using vector forms which scale up and distort appropriately. You can see this in the two following examples showing the main index on two different devices.

Macromedia Flash Lite supports two new ActionScript functions: FSCommand() and FSCommand2(). Many new FSCommand and FSCommand2 commands were introduced in

Flash Lite 1.1. For a complete list of ActionScript expressions supported on mobile phones, see Appendix C, "Supported ActionScript".

Almost all of these new ActionScript functions are available only for creating Flash Lite 2 content; however, not all of them are applicable to all mobile phones. Be sure to check the functions and commands you plan on using before integrating them with Flash Lite content for specific mobile phones.

FSCommand()

Flash Lite 2 supports the FSCommand() function, which enables Flash Lite content to communicate with Macromedia Flash Player, the host application, and the device hosting the player

FSCommand2()

The FSCommand2() function is a new ActionScript function that is supported in Flash Lite 2 but is not yet supported in the standard desktop version of Flash Player. The FSCommand2() and FSCommand() provide similar functionality, with the following main differences:

- FSCommand2() can take an arbitrary number of arguments.
- During the playback of a Flash application, the FSCommand2() function is executed immediately, whereas FSCommand() is executed at the end of the frame being processed.
- The FSCommand2() function returns a value that can be used to report success, failure or the result of the command.

Quit()

The Quit() function causes Flash Player to stop playback and exit. It is executed immediately upon invocation. You can see an example of this in figure FScommands where the FSCommand2("quit"); is invoked. If this function is not supported, a value of −1 is returned.

The Quit() function is supported only when Flash Lite is running in standalone mode. It is not supported when the player is running in the context of another application (for example, as a plug-in to a browser).

Syntax

Status = FSCommand2("Quit")

Return value

A value of −1, if the function not supported.

Supported applications

This feature is not supported in all mobile phones.

Platform integration commands

A standard set of commands has been created to get and set platform-specific information. These include information such as current time and date, network status, signal strength, battery level and so on. The implementations of these commands all rely on either FSCommand or FSCommand2 commands.

You can also use ActionScript to control the rendering quality of a SWF file as outlined earlier in this chapter, by using either the _quality property or the new FSCommand2

setQuality() function. For the _quality property, valid values are LOW, MEDIUM and HIGH. The following code sets the rendering quality to LOW: _quality = "LOW"; For more information about the setQuality function, see Chapter 5, "New FSCommand and FSCommand2 commands".

SetQuality()

The SetQuality() function sets the quality of the rendering of animation. The value of the quality argument must be high, medium or low. The SetQuality() function is executed immediately upon invocation. If this function is not supported, a value of −1 is returned.

Syntax

status = FSCommand2("SetQuality", quality)

Here, quality is either a defined variable or a constant string value (for example, "medium").

Return value

A value of −1 if the function is not supported; 0 if it's supported.

toggleHighQuality() Action

It turns anti-aliasing on and off in Flash Lite. Anti-aliasing smooths the edges of objects but results in slower movie playback. The toggleHighQuality() action affects all movies in Flash Lite.

FullScreen()

The FullScreen() function sets the size of the display area to be used for rendering. The size can be either full screen or less than full screen. Set the size argument to true, to indicate full screen and to false otherwise. The FullScreen() function is executed immediately upon invocation. If this function is not supported, a value of −1 is returned. This command is supported only when Flash Lite is running in standalone mode. It is not supported when the player is running in the context of another application (for example, as a plug-in to a browser).

Syntax

status = FSCommand2("FullScreen", size)

In this example, size is either a defined variable or a constant string value (for example, "true").

Return value

A value of −1 if the function is not supported; 0 if it's supported.

This feature is not supported in all mobile phones.

The following list describes the key features of the development of these titles in the Flash Lite:

Fullscreen: The player can either run in standard mode (176 × 144 pixels) or in full-screen mode (176 × 208 pixels). To enable the maximum user experience and the best brand awareness, Ellen and Zak runs in fullscreen mode.

SetSoftkeys: To make it as easy as possible for the user to run Ellen and Zak on a mobile phone that supports standard 5-way navigation, Ellen and Zak uses the phone's soft keys. In order to configure these soft keys for use with the application, Macromedia defined a new FSCommand2 to set and reset the use of the two soft keys.

SetQuality: Even though mobile phones are more powerful than ever before, the performance is still poor if you want to run applications like Ellen and Zak within Flash Lite. For that reason the quality of the rendering of the vector graphics within Flash Lite can be adjusted using ActionScript within the content at runtime from high to medium to low. For example, all news channels are rendered in low quality to make the scrolling of the text as smooth as possible. The weather channel, however, uses high-quality anti-aliasing because of the scaling of the map. There is no general rule that applies to all situations. It is a case-by-case decision that requires a lot of performance test on all target devices.

Loading external data on runtime: The Ellen and Zak application consists of some 53 single files. The core files, which include all the graphical user interface elements like the icons and news ticker, will be pre-installed on the device. The actual content (text, images and weather data) is updated twice a day. Each edition is only about 30 KB for the entire mobile newspaper. This saves expensive network capacity and makes the delivery possible in a much smaller timescale to all the users of News Express. The Flash templates already provide all the necessary functionality, including scrollbars, animations, scripts and weather map. The specific content can be displayed using the loadMovie and loadVariables events. Old content is overwritten by new editions as story lines or games are created.

Network Access

It's possible for Flash content that resides on a mobile phone to download new data from a web server by using various functions, which are described below. The Flash Lite specification supports the getURL()action which is processed once per frame or per event handler.

The getURL() action can be associated with the following keys: 0–9, ★, # or the Select key. Only the first getURL() call in a keypress statement block is executed; all subsequent getURL() calls in the same block are ignored. The getURL() function can be used to load another SWF or HTML page (http), a secured (SSL-Secure Sockets Layer) HTTP page (https), send e-mail (mailto) or dial a phone number (tel). With Flash Lite, it is possible to load data and SWF files from a web server using the loadMovie(), loadMovieNum(), loadVariables() and loadVariablesNum() functions. By using these functions you can update Flash content that resides on a mobile phone. These actions will be processed once per frame or per event handler.

SWF file size and memory Supported mobile phones impose limitations on the size of Flash Lite SWF files and on the amount of runtime memory they use. The SWF file size is a larger issue for mobile phones than for desktop computers because mobile phones don't have as much RAM as desktop computers. There is a prescribed limit on how large a web page can be, whether or not it includes Flash Lite content. For most mobile phones, this limit is 100 KB. The runtime memory available to Flash Lite applications running on mobile phones is limited and might vary among models. Generally, for mobile phones, this limit is not less than 1 MB. Because Flash MX Professional 2004 does not provide a mechanism for checking a phone's runtime memory consumption, Macromedia strongly recommends that you test all content

on actual mobile phones. Performance optimization CPU speed in mobile phones varies among models and is typically much slower than the CPU speed in current desktop computers. Therefore, it is extremely important to consider application performance and optimization from the beginning of each project for creating Flash Lite content created for mobile phones. Make sure to unload unused image files or remove the embedding movieclip, because bitmap image eat up memory very quickly.

The following are case studies from Sprite Interactive who have built and utilized Flash in commercial mobile project.

Figure 7.13 *TONI&GUY Mobile Logo selector*

Company – TONI&GUY

The Challenge
Drive more customers to salons on quiet days during the week using mobile technology.

The Solution
Sprite was the first company in the UK to use digital vouchers for TONI&GUY. The digital vouchers took the form of TONI&GUY logos delivered from the TONI&GUY web site via a flash interface to a user's handset. To redeem the voucher, the customer had to take their handset to a participating TONI&GUY salon, each voucher entitled the customer to a discount on a haircut. The aim of the campaign was to get customers into salons on quiet days, and it was a success across all the participating salons, although the conversion rate was not as high as expected, out of 250 logos downloaded in one area only 25 people turned up for a haircut; this was a considerable amount, however, for a previously quiet day.

Figure 7.14 *TONI&GUY MMS composer*

We also plugged in an SMS composer to the TONI&GUY back office system, allowing salons and staff at TONI&GUY to send out mass SMS messages. This system became a powerful communication tool both internally in the management of the TONI&GUY owned salons, and externally as salons used the technology to reach customers on quiet days offering them discounts if they turned up in the salon with the text message on screen. These initiatives were one of the first of their kind in the UK and still remain ground-breaking examples of cross-media promotion, receiving coverage in a number of marketing journals, including Revolution.

Company – TONI&GUY
The Challenge

Use mobile technology to distribute the latest TONI&GUY haircuts. TONI&GUY was one of the first fashion brands to embrace mobile technology, and they have always been at the forefront of mobile development. TONI&GUY wanted to further its online strategy by launching an MMS service for its customers.

The Solution

Sprite developed the first web-based MMS message composer for TONI&GUY, which allowed users to download haircuts and style collections from the site to their phones. This was done through a simple, graphic-rich web-based interface, the user simply had to select the collections they wanted delivered to their phone, enter their number and network information and the MMS was dispatched. Sprite worked with Netsize to develop the billing and delivery infrastructure, and downloads could be tracked in real-time, with a web-based back-office system. This enabled users of the TONI&GUY site to share potential new styles with their friends and show then to a stylist when visiting a salon.

Company – T-Mobile
The Challenge

T-Mobile approached Sprite to build the official UEFA 2004 European Championships Mobile Quiz application in both J2ME and Flash Lite 1 and WAP service after seeing the success of our Football Mobile Quiz on their network.

The Solution

We worked closely with T-Mobile to define the functionality of the products, there were three elements to the project:

SMS

An SMS quiz. To register for the quiz the user sent a message to a shortcode. Each day users were sent out 3 multiple choice questions, they then had to respond with what they think is the correct answer. 50 randomly chosen winners (people who have answered the most

Figure 7.15 *The T-Mobile UEFA 2004 Quiz*

questions correctly) would be announced at the end of each week to win a prize. The correct
answers to the questions were published on the WAP site.

Flash

There was a downloadable UEFA European Championships Quiz Java and Flash Lite games. This
featured 500 multiple choice questions on the history of the European Championships. When
the quiz was complete the user was given a shortcode; the first 10 people from each country to
test the shortcode, won a prize.

WAP

There was also a WAP site with an up-to-the-minute Euro Championships quiz on it. To use
this site a user first needed to register on the site with a unique username. This username

allowed the user to rank on the quiz leaderboard. At the end of each week during the Championships 50 questions were added to the site on the previous week's football. The aim was for the user to log on each week, and answer the 50 questions. Old questions were archived for users who registered late to catch up on. Throughout the Championships the leaderboard showed which user has answered the most questions correctly. At the end of the Championships the user who had answered the most questions correctly won a prize.

It was decided to develop the project in four main languages, English, German, Dutch and Czech. The questions were written in-house and the translations contracted out to our network of external translators. The questions were translated and proof-read in each language and then compiled in-house. All QA and testing was carried out in-house, with particular attention paid to the replication of language-specific characters (accents etc.). The service was launched on T-Mobile to coincide with the UEFA 2004 Championship and went on to become a huge success on the network.

Chapter 8

Introduction to Video

When people talk about broadcast quality they are usually referring to NTSC/PAL/SECAM standards. This chapter looks at the production of video and the issues around it. The focus is around development for television and video, and how to optimize your Flash movies for publishing on video, film and DVD. We start by demystifying this world and then move on to explaining the basic principles of exporting your movie to other formats preparing the way for the more advanced chapter on Flash Video.

At the core of Flash video is the Flash for Video (FLV) file format. FLV files include encoded audio and video data that is optimized for delivery through the Flash Player. This keeps the Flash Player footprint as small as possible by using a single video rendering format.

Edited video content is encoded into the FLV format as it is imported into the Flash authoring environment. Once imported into the Flash authoring environment, FLV files can be converted to movie clips or exported back out as standalone FLV files that can be invoked and streamed by the Flash Player.

You can choose from a variety of options for embedding video into Flash movies or options for streaming external video files at runtime, or options for exporting Flash video to other formats. This chapter and the following chapter introduces you to video, the FLV format and advanced video technique using the FLV format.

Figure 8.1 *Wide screen displaying content created in Flash converted to Quicktime and burnt on a DVD-ROM*

The Video Format

Probably the single greatest human invention is television. Although we may have some concerns about the content of what we see on TV, the technology of TV has completely and irrevocably changed the human race.

As web animators move away from the animation on the Internet to the more established medium of television and video they have been astounded by its total lack of standardization and despite advances in communication and technology that bring the World together, video standards keep us apart. It's hard to believe that a person from the UK travelling in the US and shooting video cannot view their recordings on a US TV or VCR. Even DVDs suffer from this problem. DVD standards also include a factor called region coding, which adds a whole layer of complication. Radio transmission enjoys standards that are in use everywhere in the world, yet television does not. The world is divided into three standards that are basically incompatible: NTSC, PAL and SECAM.

Table 8.1 *Broadcast systems around the world*

Broadcast Format	Countries	Horizontal Lines	Frame Rate
NTSC	USA, Canada, Japan, Korea, Mexico	525 lines	29.97 fps
PAL	Australia, China, Most of Europe, South America	625 lines	25 fps
SECAM	France, Middle East, Africa	625 lines	25 fps

So why are there these three standards or systems? Television was "invented" at different times in various parts of the world (US, UK and France) and politics played a large part regarding which system would be employed as the national standard. The rise of globalization and the standardization of the digital economy was an almost impossible leap to predict, and no consideration was given to global TV broadcast systems. The thought that information could be exchanged electronically, and as easily as having a conversation with someone over the phone, was almost unbelievable.

NTSC (720 × 480 and 29.97 fps)

NTSC stands for National Television Standards Committee and was approved by the FCC (Federal Communications Commission) as the standard for television broadcasting in the US. It is the US standard that was adopted in the early 1930s and debuted at the World's Fair in New York in 1939 as the first consumer video format. NTSC is based on a 525-line, 60 fields/30 frames per second at 60 Hz system for transmission and display of video images. It is an interlaced system in which each frame is scanned in two fields of 262 lines, which are then combined to display a frame of video with 525 scan lines. This system works fine, but one drawback is that color TV broadcasting and display were not part of the equation when the system was approved. The implementation of color into the NTSC format has been a weakness of the system, leading it to be nicknamed "Never Twice The Same Color". You may have noticed that color quality

and consistency varies quite a bit between Broadcaster. Nevertheless with all its failings, NTSC is the official analogue video standard in the US, Canada, Mexico, some parts of Central and South America, Japan, Taiwan and Korea.

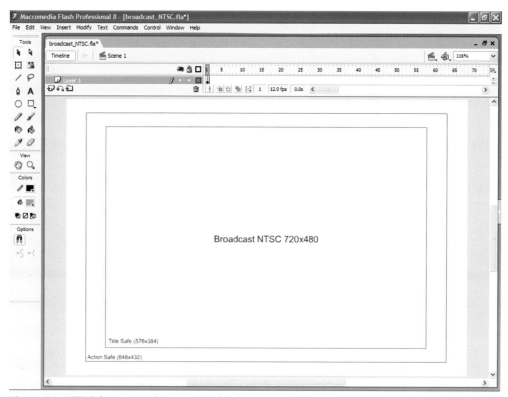

Figure 8.2 *NTSC dimensions and restrictions, see broadcast.NTSC.fla on CD*

PAL (768 × 576 and 25 fps)

PAL is the dominant format in the world for analogue television broadcasting and video display and is based on a 625-line, 50 fields/25 frames per second, 50 Hz system. Like NTSC, the signal is interlaced into two fields, composed of 312 lines each. Several distinguishing features are:

- A better overall picture than NTSC because of the increased amount of scan line.
- Since color was part of the standard from the beginning, color consistency between stations and TVs is much better.
- The biggest problem with PAL is the fewer frames (25) displayed per second, this creates a flicker in the image, very much like the flicker seen on projected film.

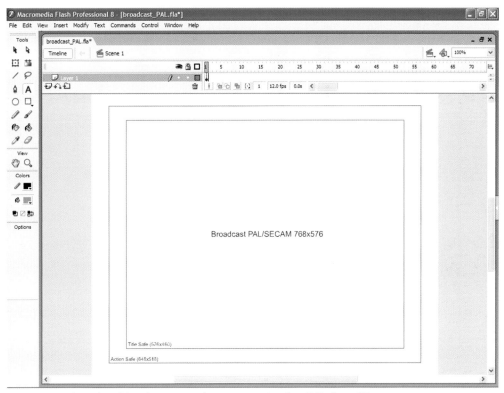

Figure 8.3 *PAL and SECAM dimensions and restrictions, see broadcast_PAL.fla on CD*

Since PAL and it variations have such world domination, it has been nicknamed "Peace At Last" by those in the video professions. Countries on the PAL system include the UK, Germany, Spain, Portugal, Italy, China, India, most of Africa and the Middle East.

SECAM (768 × 576 and 25 fps)

Developed in France, SECAM is superior to NTSC, but not necessarily superior to PAL (in fact many countries that have adopted SECAM are either converting to PAL or have dual-system broadcasting in both PAL and SECAM). SECAM is the "outlaw" of analogue video standards.

Like PAL, it is a 625-line, 50 fields/25 frames per second interlaced system, but the color component is implemented differently than either PAL or NTSC. In fact, SECAM stands for (in English) Sequential Color With Memory. In the video profession, it has been dubbed "Something Contrary To American Methods", due to its different color management system. Countries on the SECAM system include France, Russia, Eastern Europe and some parts of the Middle East.

Figure 8.4 *Safe area averaged out overall systems*

HDTV

HDTV has an aspect ratio of 5.33:3 or 16:9 and it uses 1,125 scan lines operating at 60 Hz with a framerate of 30 fps. It has square pixels which are much smaller than NTSC pixels. Just to complicate things other formats exist within the specification with varying resolutions and framerates.

The main reason that each system is incompatible is that they are based on different framerates and bandwidth, which prevents such things as video tapes and DVDs recorded in one system from being played in the other systems. However, there are solutions to these conflicting technologies, already in place in the consumer market. In Europe, for instance, many TVs and VCRs sold are multi-system capable, and in the US this problem is addressed by retailers that specialize in international electronics products. You can also get video tape converted from one system to another and you can even purchase camcorders (Hi8 and Digital8) in the US market that, even though they record in the NTSC system, can play your tape back on either an NTSC or PAL TV.

Television Display

Every video signal is composed of horizontal and vertical lines that build each frame. A frame of video may be either interlaced or progressive. When a frame is interlaced, the odd-number horizontal scan lines are drawn first and then the even-number lines. Every frame is divided in half, or into fields. Every interlaced frame is composed of two fields, with odd or even

number of lines. So a framerate of 30 fps contains 60 fields per second. If frames are drawn in one pass they are called progressive (as displayed on a computer monitor). Progressive frames look better as stills because all the information is there and not spread over two fields.

The scan rate for an analogue video signal refers to the amount of time it takes to draw lines of information on the screen. The horizontal scan rate is measured in Hertz, which directly relates to the number of lines painted on to the screen in one second. The faster the rate, the less the flicker. The scan rate for NTSC is 15,750 Hz which is in effect 17,750 lines per second.

Other terms that you will find useful understanding are:

Brightness
Refers to the maximum light output, measured in candelas/metre or ANSI Lumens. The higher the number, the better.

Black Level
Black is black in a good video display, but details in night scenes should still be clear. Look at the darkest parts of the picture and see if they are really black, or merely charcoal gray.

Contrast Ratio
The difference between the brightest part of a picture (peak white) and the darkest. A contrast ratio of 350:1 is acceptable, but most new displays are capable of much more – 500:1, 700:1 and higher. The bigger the spread, the better the display. The effective contrast ratio of a projector is determined by the "gain" of the screen – how much light it throws back into the room.

Color Accuracy and Saturation
Color accuracy is one of the primary factors for creating realistic images. Most televisions are setup with the color balance wrong and the level too high. Compare your own skin tone and the color of the real sky to what you see onscreen. Reds tend to overflow the outlines of an object when the color level is too high.

Resolution
CRT displays are sometimes rated in "lines of resolution", a confusing concept because they produce images via horizontal scanning lines. "Lines of resolution" refers to how many distinct vertical lines can be counted onscreen – the higher, the better. *LCD* and *plasma* screens are rated like computer monitors and digital cameras, by *pixel* (picture element) count. A display with a resolution of 1920 × 1080 is far superior to one rated 780 × 420. A low pixel count yields grainy pictures, with a stair-step effect at sharp transitions.

Aspect Ratio

Televisions have a 4:3 (horizontal: vertical) aspect ratio. 4:3 was chosen for TV because it matched the cinematic standard at the time. The film industry responded by offering widescreen pictures; fifty years later, the electronics industry is starting to catch up. New 16:9 screens can accommodate commercial films and high-definition programming in their full glory. 16:9 is very close to the 1.85:1 widescreen standard used for most commercial releases. Similarly, a TV program produced in 4:3 will have black bars on the sides when shown on a widescreen display.

The Human Eye

The human eye retains an image for a fraction of a second after it views it, this is called persistence of vision and is essential to all visual display technologies. Still frames are presented at a fast enough rate so that persistence of vision integrates these still frames into motion. Originally, motion pictures set the frame rate at 16 frames per second, this was found to be unacceptable and the frame rate was increased to 24 frames per second. In Europe, this was changed to 25 frames per second, as the European power line frequency is 50 Hz.

Figure 8.5 *Persistence of vision*

When NTSC television standards were introduced, the frame rate was set at 30 Hz (half the 60 Hz line frequency). Then, the rate was moved to 29.97 Hz to maintain 4.5 MHz between the visual and audio carriers. Movies filmed at 24 frames per second are simply converted to 29.97 frames per second on television broadcasting.

The brighter the still image presented to the viewer, the shorter the persistence of vision, so bright pictures require more frequent repetition. If the space between pictures is longer than the period of persistence of vision, then the image flickers, therefore, to arrange for two "flashes" per frame, interlacing is used. The basic idea here is that a single frame is scanned twice, the first scan includes only the odd lines and the next scan includes only the even lines. With this method, the number of "flashes" per frame is two, and the field rate is double the frame rate, thus, NTSC systems have a field rate of 59.94 Hz and PAL/SECAM systems a field rate of 50 Hz.

Interlacing creates a problem due to the fact that you really do not have a frame rate of 50/60 Hz. For example, vertically adjacent picture elements do not appear at the same time; if the scene is moving then this creates a series of serrations on the edge of moving objects. Other aberrations include such things as misalignment (where the horizontal edges of one scan do not match with the next), and interline flicker, where slight mismatches between subsequent lines cause a shimmering effect. If the still frame images are presented at too low a rate, rapid motion becomes jerky and odd looking. This is especially a problem in action movies where high-speed chase scenes are common.

Most movies destined for film theatre audience are shot on a material similar to what we use for traditional photography. 24 pictures are made for every second of a scene. You can shoot a movie with your photo camera, except that you have to switch films every 1 or 1.5 seconds. When we watch film in a theatre you see 24 pictures (also known as frames) per second. But when we buy these movies on VHS tapes or DVDs to watch them on your TV screens you have a problem. PAL screens require 25 pictures per second and each picture has to be split into 2 fields. But as 25 isn't so much higher than 24 what we commonly do in PAL countries is that we take the original 24 fps (frames per second) movie and speed it up to 25 fps. This means that voices and music has a higher pitch and that the movie, is shorter. This effect although apparent on long movies, it makes very little difference to peoples enjoyment of the film.

In NTSC, we need 29.97 fps. Speeding up the movie is no option as the speed difference would be noticed. So what happens is that after splitting up frames into fields certain fields are repeated to obtain the higher framerate. Basically 4 frames are turned into 10 fields. So a higher framerate doesn't mean more fluent motion – quite to the contrary NTSC is a bit more jerky as some fields are being displayed twice. On the TV this isn't so much of a problem.

Digital Versatile Disc (DVD) Video Technology

There are four main areas that digital video can be divided into:

- Physical CD distribution
- Collection of original footage (similar to Hi8/VHS/S-VHS camcorders)
- Over-the-air broadcast television
- Cable/satellite broadcast television

DVD-Video is the physical, disc-based distribution channel. All of the DVD variations are based on the same CD. However, compatibility issues exist. DV is the most common collection of original digital footage. DTV is used fairly often to describe the overall digital over-the-air broadcast method. With specific formats noted as:

- HDTV – High Definition TV, a 16:9 ratio image at greater than a 1000 lines of horizontal resolution. There are two resolutions defined by the United States Federal Communications Commission (FCC). Both can be presented in progressive (typical of computer monitors) or interlaced (typical of NTSC televisions).
- SDTV – Standard Definition TV, a 4 × 3 ratio image at approximately 720 lines of horizontal resolution. Also available in interlaced and progressive. Takes only a small part of the HDTV bandwidth allowing as much as four separate programs to be sent down the same HDTV channel.
- DSS is the generic term for the small dish satellite systems used to deliver multitudes of channels to the home. Cable TV operators deliver a similar digital signal via cable to their subscribers.

The one thing to remember about all of these different digital video formats is that hardly any of them are directly compatible with any other format. To get from one format to another will require some form of transcoding.

DVD-Video Compared

DVD-Video uses an MPEG-2-based compression technique for the video image. MPEG-2 is also used with DSS, digital cable, HDTV and SDTV.

DVD-Video employs a variable bit-rate compression scheme. Variable bit-rate compression allows the compressionist (the person making the decisions about how much compression to use) to apply a higher compression ratio to a low detail, low action scene; while allowing a high detail, high action scene to be compressed at a lower ratio. This is because the higher detail/action scene would show artifacts more as the compression ratio is increased. A lower detail/action scene doesn't change as often and thus can be compressed at a higher ratio without artifacts appearing. A disadvantage of variable bit-rate compression is that it is not a real-time operation.

Another element of the MPEG-2 stream used with DVD-Video is the additional information encoded in the video stream. Navigation information, language information, subtitle information, parental control information, Dolby Digital audio are all contained in the DVD-Video

MPEG-2 Video Stream

DSS and digital cable use a constant bit-rate compression. Since these distribution channels are dealing with real-time events, there is no time for variable bit-rate compression, therefore, the

image is always compressed the same amount whether it is a low detail/action scene or a high detail/action scene. DSS and digital cable do not provide navigation, subtitle, parental control and alternate language abilities found in DVD-Video, these delivery channels would not be able to interpret these data elements.

The MPEG-2 stream coming from over-the-air broadcast channels contains a different structure than either of the other MPEG-2-based data streams. Resolution is one of the first things that differs from the other two. DV tapes do not use an actual MPEG-2 compression. While the basic theory used for compression is the same for DV and MPEG-2, the DV compression is not MPEG-2.

DVD-Video Quality

DVD-Video uses MPEG-2 compression. Any time an image is compressed there is the opportunity for image degradation. A good compressionist can create such a good image that most viewers will not be able to see any compression artifacts in the movie.

Figure 8.6 *'quarter page image' Badly compressed material. You can see this image as it should be in Figure 8.10*

A computer screen is capable of providing a much higher quality image than a NTSC/PAL/ SECAM television screen. There are text titles, which may be perfectly acceptable on a television

but will look very poor on a computer screen; this difference will most likely be traced back to a less than ideal job of compressing the original material.

General Video Information

There is DVD-ROM, MPEG-2 and DVD-Video:

- DVD-ROM is the big picture.
- DVD-Video is one way to use DVD-ROM.
- DVD-Video is one way to use MPEG-2.
- DVD-Video is a specific use of MPEG-2 video on DVD-ROM in a specific manner.

A DVD-Video disc contains a stream (a track) of MPEG-2 (Main Profile@Main Level, also known as MP@ML) video compressed and encoded in either a Constant Bit Rate (CBR) or in a Variable Bit Rate (VBR). The DVD-Video specification also allows the lower resolution MPEG-1 CBR and VBR video.

An interesting aspect of DVD-Video is the ability to have the 24 frames per second (fps) film encoded at 24 frames a second. With other forms of home video, the 24 fps film standard has to be converted to the NTSC specification of 29.97 fps via a process called 3:2 pulldown. (NTSC consists of 30 frames with two fields each.) What 3:2 pulldown does is double one field creating three fields for one of 24 film frames – and does this often enough to turn the 24 film frames into 30 video frames (actually 29.97 video frames). In order to display these 24 frames on an average television, the DVD-Video playback device does an "on-the-fly" 3:2 pulldown.

So, why have 24 frames encoded and do on–the–fly conversion? With current computer displays and with future digital TVs it will be possible to display the actual 24 fps in which the film was shot. As a result, a more correct feel will be imparted to the playback of movies shot on film and transferred to video.

Figure 8.7 *Scan tests Synthetic Aperture's Test Pattern Maker software*

Video Image Information

The number of pixels in a DVD-Video frame is typically 720:480 of NTSC source material. The traditional method of measuring NTSC devices has been "lines of horizontal resolution". Using this method:

- VHS source material is rated at approximately 230 lines for standard 4:3 screens (approximately 172 for 16:9 screens).
- Laserdisc is approximately 425 for 4:3 (approximately 318 for 16:9).
- DVD-Video is approximately 540 for 4:3 (approximately 405 for 16:9).

In practical terms, DVD-Video will most likely be rated at approximately 500 lines of horizontal resolution.

A 720:480 pixel count should not be confused with a "lines of horizontal resolution" measurement. The numbers may be different. Here's why: "lines of horizontal resolution" (LoHR) comes from the ability of a device to resolve an industry-standard reference image. Part of the image has groups of lines printed at various distances from one another. LoHR is determined at the point where these printed lines are resolvable into individual lines. So while it is possible to have 720 horizontal pixels, if you cannot visually distinguish each line, you don't have 720 LoHR.

MPEG uses temporal compression. Temporal compression uses a key frame to record everything in the frame, this complete frame is an I-frame. During temporal compression, subsequent frames consist of only the differences from the I-frame, so a still image can be an I-frame. The still frame can be displayed for a specified amount of time; or it can be displayed indefinitely – generally with a "continue" button on the screen. Still frames can play sound. Menus are generally still frames.

Subpictures are not still frames, they are much more restrictive and do not have the color range or detail of MPEG-2 video. Subpictures are used as overlays on the MPEG-2 video stream for subtitles, closed-captioning, karaoke, menus and very simple animation. A portion of the DVD-Video interactive command set allows a title developer to perform effects such as scroll, move, color, highlight and fade subpictures. There are 32 subpicture streams available within the DVD-Video spec and they can contain four colors from a palette of 16 colors and four contrast values out of 16 levels from transparent to opaque.

Audio Options

A DVD-Video disc can have up to eight audio tracks (tracks are sometimes referenced as streams). Each of these tracks can be one of three formats:

- Linear PCM – from 1 to 8 channels.
- Dolby Digital (also known as AC-3) – from 1 to 5.1 channels.
- MPEG-2 audio – from 1 to 5.1 or 7.1 channels.

Note: tracks (or streams) are composed of channels.

Additionally, the Digital Theatre Sound (DTS) format is an optional format. DTS is another 5.1 channel format developed to improve the audio experience in movie theatres. There is reserved within the DVD standard an audio stream format for DTS. DTS format DVD-Video discs first appeared in the late spring of 1998.

Figure 8.8 *Flash 8 from DVD on wide screen with Dolby Digital sound*

Linear PCM

Linear PCM is generally the default audio track. It is sampled at a rate of 48 kHz or 96 kHz; audio CDs are sampled at 44.1 kHz. A sample size of 16, 20 or 24 bits is allowed, audio CDs use a sample size of 16 bits.

According to the DVD-Video specification it may contain up to eight channels, and there is a maximum bit rate of 6.144 Mbps. Linear PCM is uncompressed audio which means the choice for the number of channels may limit the sample rate or sample size used. Typically up to five channels should be able to use the highest data rates and sizes.

While DVD-Video playback devices are required to support any of the above variations, the device could subsample from 96 kHz down to 48 kHz while not using the full 20 or 24 bits.

Still the lowest output from the PCM track would be 48 kHz @ 16 bits – better than audio CDs using 44.1 kHz @ 16 bits.

Dolby Digital

The Dolby Digital format is compressed data using the AC-3 technique. The source material is normally taken from PCM recordings at 48 kHz at up to 24 bits. Typically you will find Dolby Digital to be a 5.1 channel format. The "5" breaks down to left, centre, right, surround left and surround right. The ".1" channel is the low frequency effects (LFE) channel – the channel that would be directed to a subwoofer. However, there are a number of valid channel formats in DVD-Video Dolby Digital:

- single mono
- dual mono channels
- standard stereo
- left/centre/right
- stereo w/single surround
- left/centre/right/single surround
- stereo w/dual surrounds
- left/centre/right/dual surrounds

With each of the previous settings the ".1" (LFE) channel is optional. Again, the most common channel format you will find for Dolby Digital is the 5.1 arrangement. You will also find that most regional 1 DVD-Video discs contain a Dolby Digital track. Although as of late spring 1998 a number of DTS DVD-Video discs started to appear.

MPEG-2 Audio

The definition of MPEG-2 audio allows it to be a multi-channel format, although some playback devices provide only basic stereo left/right delivery. Somewhat like Dolby Digital there are a number of channel configurations available with MPEG-2 audio, including:

- single mono
- stereo
- stereo w/single surround
- stereo w/dual surround
- left/centre/right
- left/centre/right/single surround
- left/centre/right/dual surround
- left/left-centre/centre/right-centre/right/dual surrounds

As with Dolby Digital, the LFE channel is optional on all of the above channel configurations. When the LFE is added to the last one in the above list, it is often notated as "7.1".

Both MPEG-2 and MPEG-1 formats are supported, although MPEG-1 Level III (also known as MP3) is not supported.

DTS (Digital Theatre Sound)

DTS is an optional DVD-Video multi-channel audio format (typically 5.1). The DTS format can provide a data rate nearly four times as much as Dolby Digital – meaning less possibility for audio artifacts from compression. It also means that other options in the overall data stream may have to be dropped (like fewer language tracks or no alternate angle tracks, and so forth). DTS has several possible channel configurations, including:

- single mono
- stereo
- left/centre/right
- stereo w/single surround
- stereo w/dual surrounds
- left/centre/right/dual surrounds

All have the option to include the LFE channel. The devices which support DTS are normally marked with an official "DTS Digital Out" logo.

SDDS (Sony Dynamic Digital Sound)

Another option for multi-channel audio is SDDS in 5.1 or 7.1 configurations. However, Sony has not announced any plans to provide support for SDDS in the DVD-Video arena.

Interactive Video

DVD-Video allows a limited amount of interaction with the disc contents. This interaction is far less than CD-ROM on computers, but it is more than people would expect from a video tape or laser disc.

The primary method of interaction is through the use of menus. Most DVD-Video discs provide a menu for selecting a variety of elements from the disc, such as playing the movie, playing the background video, hidden surprises and even simple games. Some discs provide alternate story lines that can be selected via the menu system.

The menus consist of a backdrop image with up to 36 buttons which are selected by using a remote control with left-right-up-down arrows or a mouse/trackpad on a computer with DVD-Video. Once a button is selected, a select button on the remote control will activate the selected activity.

Supporting the menus is a very basic command instruction set (not available to the person playing the movie, but available to the disc developer). There are 24 system registers that contain

information such as language code, audio and subpicture settings, parental level and so forth. There are also 16 general-purpose registers for command instructions. Using the commands provide a method to branch to other commands. Commands are used to control the player's settings, move to different sections of the disc and control such elements as the selection of audio streams, video streams, camera angles, subpicture and so forth.

The content of a DVD-Video disc is organized by "title" (movie) and "sections of titles" (chapters). The chapters can be organized through the use of a program chain or "PGC". For example, a PGC can be created to play back only the chapters that would cause an "R" rated movie to become a "G" rated movie if the parental control level was set in such a way, or the PGC could create an alternate storyline. PGCs can be used to construct other sequences of chapters as well.

Following a PGC is seamless; there are no breaks in the flow of the movie – like there is when two sided laser discs are flipped. Different PGCs are different paths through the same material.

Subtitles

Subtitles are not generated by the computer, they are placed on the disc by the DVD pressing operation. The subtitles are therefore a part of the MPEG2 data stream that can either be "turned on" or "turned off". If they are "turned on" they are composited over the top of the video image. If "off" they are ignored by the process and simply are not displayed. On most DVD-Video discs there will be more than one language available for subtitles. Each of these different language subtitles are a part of the MPEG-2 data stream. If a specific language is selected to be displayed, that part of the data stream is composited over the video image. The font is selected and recorded in a subpicture stream prior to the pressing of the DVD-Video disc.

Flash to Video

The process of outputting movies to video in Flash has been available for as long as you have been able to export QuickTime movies, and this has been the case since the advent of Future Splash Animator. QuickTime video is incredibly versatile: I have used it for everything from broadcast-quality video for television to web streaming. Flash 8 strengthens this link between the two applications to make them work together. I have produced interactive buttons for movies running on a layer in QuickTime.

Flash can save images directly as a QuickTime movie, either as a movie with a video (bitmapped) track or as movie with a Flash track. The Flash movie retains its native format, and Flash vectors are not converted into bitmaps or QuickTime vectors. Bitmapped graphics embedded in a Flash.swf remain bitmaps after import into QuickTime.

Figure 8.9 *TONI&GUY Interactive DVD with Flash interface*

Figure 8.10 *TONI&GUY Flash Interactive layer in Quicktime*

To convert the Flash movie to bitmaps, export the movie in a QuickTime video format and the Flash vector images will be converted into cel animations. These movies are typically much larger than they would be if they retained the Flash graphics in their compact vector format.

One reason for creating a Flash movie in a QuickTime movie is to include graphics in formats that are not directly supported by QuickTime. For example, the Flash application can directly import vector graphics from Adobe Illustrator or Macromedia FreeHand. An easy way to incorporate these graphics into QuickTime is to import them into Flash and then import the Flash.swf as a QuickTime track.

Producing interactive movies using the Apple QuickTime Player opens a whole new dimension in interactive kiosk work. The process of using an application like Director or Flash to produce kiosk software can be compelling but its biggest downfall is in its inability to deal with video in real time. To overcome this problem you can use content in QuickTime with an interactive Flash layer. The buttons on this layer seem to move at almost lightning speed to different areas within the movie unlike the clunky Director or Flash movie. We have had this working with an intro animation, navigation linking to bookmarks in a movie, a semi-transparent control interface and titles layered over a movie.

MiniDV

QuickTime creates lots of different playback opportunities. The particular one I will focus on is to use QuickTime as a carriage device to record your animation to tape. All professional systems can record QuickTime to tape, and BetaSP and DigiBeta are the most popular video formats that TV broadcasters use.

MiniDV can parallel the quality of the high-end systems. You can take a MiniDV recorded Flash animation and dupe it to BetaSP through the S-Video output onto an editing deck. The quality is of a professional standard. The sound on MiniDV is 16 bit, 48 kHz stereo (this is slightly above CD quality) so any output from Flash should be without any compression to give it the maximum fidelity.

Preparing Flash Movies for Video

First you need to establish the playback device's frame rate. NTSC is 30 fps (frames per second) and PAL/SECAM is 25 fps. If you are animating for NTSC your frame rate would be exactly 29.97 fps which over a short sequence is of no consequence, but over five to ten minutes will cause your animation to lose sync with your audio. You can overcome this problem by splitting your animation into small chunks and then stitching them back together in an application like Adobe Premier.

Most of the time you will animate for 30 fps, and you can even animate at 15 fps. If you create your animation at the rate of 15 fps the video will show one animation frame for every two video frames with the total effect of your character walking slightly slower.

Color

Computer monitors show millions of colors, but the TV screen does not have the same color range, in particular certain colors like bright reds, yellows and light blues suffer from bleeding. The standard color palette in Flash is really not the best color palette for video production. If you have created an animation sequence already, you can force the video color palette using Adobe Premiere or After Effects. Both applications have filters for enforcing color on video clips. The problem with forcing a color palette onto a video clip is that you will almost certainly get colors that do not translate well, and if this is the dominant color of your character then almost certainly it becomes a problem. It is better to understand the limitations of the color palette and select a color that will work in all playback environments.

Computer Screen to Video Anomalies

Frame dimension for video can vary from format to format but a standard for images on computer (based on square pixels) is 640 x 480 which should be used for all computer-based images for video. Computer monitors use a square-pixel format which will scale in proportion into the format required. Anything you draw that needs to be circular will appear squashed and distorted on TV. If you take your image and scale it to fit 720 x 480 pixels you will notice on the computer screen that the image is distorted but when converted to TV the images look fine.

Another anomaly you need to watch out for is the problem that occurs because of interlacing. A TV screen is interlaced, which means that the cathode ray scans every other horizontal line of phosphors at every cycle of a complete image on screen. On a computer this only happens once, and the problem occurs because a TV screen drops out 1/60 of a second. So if any of the horizontal line work in your art is one pixel thick expect the artwork to flicker. This is a very distracting condition and is best avoided at all costs. Because of Flash's vector capabilities it is easy to get caught out by this problem, the solution is to avoid all small details, including thin line work.

An application that I have found useful for maintaining color and scale integrity is Echo Fire (http://www.synthetic-ap.com). It displays the composition on your NTSC or PAL video monitor, letting you see how your artwork really looks. After all, if you're not seeing what your project really looks like, you're not seeing differences in color, the interlace and color coding artifacts, and the image overscan. Working with non-square pixels on a square-pixel computer monitor means your image is always stretched or squashed, and being able to see

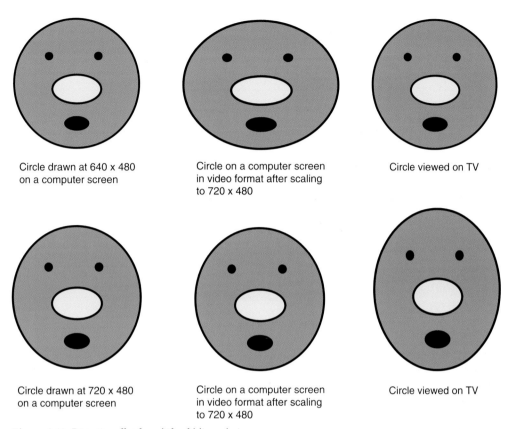

Circle drawn at 640 x 480 on a computer screen

Circle on a computer screen in video format after scaling to 720 x 480

Circle viewed on TV

Circle drawn at 720 x 480 on a computer screen

Circle on a computer screen in video format after scaling to 720 x 480

Circle viewed on TV

Figure 8.11 *Distortion effect from shifts of delivery devices*

your project previewed on a real NTSC or PAL video monitor lets you work accurately and more quickly.

Working to film resolution is quite interesting; ultimately you will need to convert your file out of the vector format to a high-resolution.bmp. This conversion process is disastrous if the original Flash file contained any bmp file and the bmp picture will become jaggy and unattractive unless you use high-resolution originals. Depending on the film recorder you are printing to you may need to go up to 4k pixels across, for Super Panavision 70 film.

Film is an analogue medium, so it doesn't have "pixels" as such, but the film scanners that you will ultimately have to pass through have pixels and a specific resolution. Once you have established the resolution for your film you can export a numbered sequence by "Exporting Movie" and using the pict or bmp format. This will export individual frames on the chosen resolution. You will almost certainly need a high capacity tape drive, as each frame may be as much as 2 megabytes.

Figure 8.12 *Synthetic Aperture web site*

Outputting Video from Flash

In this tutorial we will output a QuickTime video file. You cannot do this on the PC but you can do an equivalent conversion of AVI files with the exception of the codec choice. Open up the file named HamsterVideo.fla.

1. Choose File > Export Movie. In the save as type list, select QuickTime.
2. The QuickTime Video format converts the Flash movie into a sequence of bitmaps embedded in the file's video track. The Flash content is exported as a bitmap image without

Figure 8.13 *Quicktime export settings on a Mac*

Figure 8.14 *AVI export settings on a PC*

any interactivity. This format is useful for editing Flash movies in a video-editing application and is not to be mixed up with the QuickTime Publish option. This creates movies in the QuickTime 4 format, copying the Flash movie onto a separate QuickTime track. The Flash movie plays in the QuickTime movie exactly as it does in the Flash Player, retaining all of its interactive features. If the Flash movie also contains a QuickTime movie, Flash copies it to its own track in the new QuickTime file.

3. In the dialog box, enter 720 × 480, uncheck Maintain Aspect Ratio. This stretches the 640 × 480 pixel image.

4. Set the format to 24-bit color and check the smooth check box. This applies anti-aliasing to the exported QuickTime movie. Anti-aliasing produces a higher-quality bitmap image, but it may cause a halo of gray pixels to appear around images when placed over a colored background. Deselect the option if a halo appears. On windows PCs there is no smooth check box or the selection.

5. On the Mac set the Compressor to DV-NTSC or DV-PAL and move the Quality slider all the way to the right for a full uncompressed file. On windows PCs select AVI

Figure 8.15 *The Movie in QuickTime*

as export format. You can then select the codec you want to use. More on codec in the next chapter.

6. Select sound to the highest possible using 44 kHz, 16-bit Stereo. Click OK. This conversion of vector to a pixel-based video can create enormous files in DV format. On windows PCs, as soon as you export the movie including the soundtrack, Flash exports it as a movie with bitmap graphics otherwise it just embeds a swf file within the mov file.

Windows users will need to convert the AVI file to DV using Media Cleaner or a similar conversion application. If you export from Flash using the animation codec at its highest setting and in the Format pop-up window select 32-bit color the result will be a movie with an alpha channel you can composite over other elements in a video-editing application.

With the introduction of the Flash 8, support for video has improved with the addition of many new capabilities to the authoring and runtime environment, giving animators more options for delivering embedded video and progressive and streaming files. The next chapter takes you through the many options for video and all the compression formats.

Chapter 9

Flash Professional and Video for Broadcast

Macromedia Flash Video easily puts video on a web page in a format that almost anyone can view. This chapter provides an introduction to Flash Video, including information on how to create and publish Flash Video.

Flash Video is based on the technology behind the Flash Player – so it's ready to play in almost all of PCs worldwide. This means:

No more massive player installations.
No lengthy registration forms.
No ads attempting to upsell you to other players.

With Flash Video, when the page loads, the video plays. It's that simple.

This chapter will take you through the process of creating on-demand Flash Video.

You can either use your own video clip or use ours alex.mov.

Encode the video in the Flash Video (FLV) format.

Decide on a delivery mechanism.

Add the video to your web pages, and publish the pages to the web.

To complete the tutorials in this you must have Flash Professional 8 installed.

Flash Professional 8 Advantage

Flash Player 8 adds a new, advanced video codec, On2 VP6. This codec provides superior video quality that is competitive with today's best video codecs at a much smaller file size. In addition the support for a real alpha channel at run-time makes this version of Flash 8 a revolutionary new product. This capability provides the unique ability to overlay video composted with a transparent and semi-transparent alpha channel over other Flash content. More on this overlay feature in the next chapter.

Stand-alone Video Encoder

The advanced video encoder, available within the Flash authoring tool, as a plug-in to professional video editing tools, as well as a stand-alone tool, provides advanced encoding options that allows developers to optimize quality and file size of video content. Flash Video files can be compressed using either the new, high-quality On2 VP6 codec or the Sorenson Spark codec. This encoder also includes a batch-processing capability to encode multiple video files at once. As you get more used to using video you can export video directly to Flash from leading professional video-editing and encoding tools such as Avid Xpress/Media Composer and Apple Final Cut Pro.

About Video and the Web

Video is the medium that most directly echoes our day-to-day experiences of life through sound and motion. Early video content on the web has often been simply a rectangle playing back on your computer monitor, usually in a separate pop-up window covering the web site page that created it. The video images are often small and difficult to make out, and the overall experience is poor.

Bandwidth: The Data-intensive Format

Video is a data-intensive format, requiring megabytes of data to display even short video clips. The growth of broadband has greatly reduced this technical obstacle, and increasingly large numbers of site visitors have the bandwidth required to receive video content via the web, but file size is still a problem for many visitors. The conventional video is both large and requires many frames to make motion.

The complexity of authoring video and the lack of a standard tools creating interactivity, navigation control, had meant that video playback on the web has been uninspiring. In addition most video playback clients are not pre-installed on most visitors' systems, so many visitors must pause to download a plug-in or application before they can view video.

What Flash Video brings to this environment is video content that is seamless and in context, in a form that site visitors can view using Flash Player. The Flash Player is installed on over 92% of the personal computers worldwide.

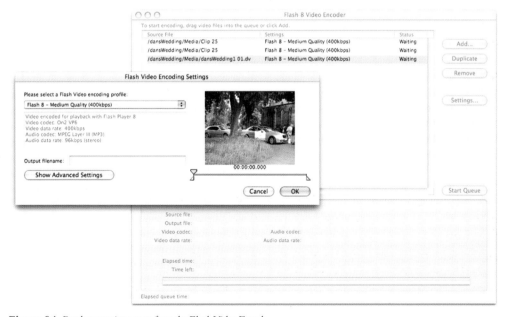

Figure 9.1 *Batch processing screen from the Flash Video Encode*

Table 9.1 *A quick revision on the most popular TV formats*

	Image size	*Frame rate*	*Aspect ratio*	*Display*
NTSC	720 × 480	29.97	D1	Interlaced
PAL	720 × 576	25	D1	Interlaced
Computer	Varies	Varies	Square	Progressive

Animation and Flash Video

Flash Video starts playing quickly, and provides immersive and interactive experiences. Flash treats Flash Video as just another media type, which means that it can layer, script, and control video just like any other object in a SWF file.

Figure 9.2 shows an example from the CD VideoFlash.swf of a web page containing Flash Video synchronized to text and graphics. A SWF file can contain graphics, text for creating video controls. It can refer to an external FLV file, and it plays in Flash Player. An FLV file contains primarily audio and video, and it plays inside a SWF file.

Flash Professional 8 includes the following tools and features:

Flash Video Import wizard:

The Import Video dialog guides you through converting video files to FLV format and configuring the FLVPlayback component.

Choose File > Import > Import Video to import video into Flash.

FLVPlayback component:

This is best for playing external FLV files and to connect to Flash Media Server video streams in your Flash movie. This new video component, which includes video playback controls, makes customizing or "skinning" the video player much easier than before.

New encoding options:

You can now encode Flash Video in three ways:

Through the Flash Video Import wizard.

Figure 9.2 *A Flash Video file playing inside a SWF file*

With the stand-alone Flash 8 Video Encoder.

Through the Flash Video QuickTime Export plug-in, which lets you encode audio and video into the FLV file format when exporting from third-party video editing applications that support QuickTime exporter plug-ins.

Figure 9.3 *An example from the CD VideoSWF.html*

Flash Media Server formerly Flash Communication Server is Macromedia's streaming media server that streams audio and video to Flash Player 6 or later.

Flash Video Streaming Service is a cost-effective monthly subscription service from third parties that use Flash Media Server to provide hosted streaming video with high performance requirements and worldwide scalability. For more information on hosted services read on.

Dreamweaver includes a Flash Video import mechanism to put Flash Video onto a web page easily, with a more limited number of customization or "skinning" options for the video player. But you must have an encoded FLV file before you can use it in Dreamweaver.

Options for Authoring

Before you can use Flash Video on your site, you need to decide how to deliver the video; the two primary options are to deliver it as a progressive download or as a streaming video. Embedding video in the Flash Timeline is not recommended and should only be used for short video clips with no audio track.

For help deciding which delivery option to use, see the following table. Find your situation in the left column, and then see which delivery options are recommended. If two options are marked, then either one is recommended.

Table 9.2 *Delivery options*

	Embedded	Progressive	Streaming
Video is under 5 seconds long	•	•	
Video is 5 to 30 seconds long		•	•
Video is over 30 seconds long		•	•
Low viewership expected		•	
Medium to high viewership expected			•
Instant start			•
Intellectual property protection			•
Live video streams			•
Variable streaming rates based on visitor's bandwidth			•

After choosing a delivery option, you need to decide which authoring tool to use Flash or Dreamweaver.

Importing video directly into Dreamweaver is ideal for situations where you want to put a small video onto your site quickly and easily, with no interactive elements beyond simple video controls.

If you need to build a more interactive experience or need to heavily customize the look and feel of the video, you must use the video features in Flash 8. You also need Flash Professional 8 to encode Flash Video (FLV) files. But before you can add video to your web page, you must acquire the video and encode it, which involves converting it to the Macromedia Flash Video (FLV) format.

Video Shooting Tips

Before we see how Flash Video is encoded and about how to get best results when capturing video. We need to step back and look at the content on your video. In some cases, the material

might be animation that you have already compiled from other Flash projects. Your content might effect material that you have created in Adobe After Effect or Adobe Photoshop. You might have purchased stock material from a library or you might have decided to shoot the video yourself. If you are venturing out with your DV camera for the first time, below are a few tips. Even if you follow just some of the advice, you'll be well on your way to making better Movies.

Get a Tripod, and Use It

The first step in improving your video is stabilizing it. Even if you have built-in image stabilization, you will notice the difference. One of the best ways to improve the appearance of your videos is to get a quality tripod and learn to use it.

Planning your Shoot Beforehand

Make sure you're clear on what shots you need to tell the story. If you're on your own, write up a list of shots you need. Write the story beforehand in your head, and list the elements you want to get video of to do that story. Forgotten how to write up a story board then refer back to Chapter 2 of this book. Think about what's going to look good visually, and how your shots are going to come together sequentially.

Roll Blank Tape before you Start Shooting

Before you start shooting every sequence roll around 15 seconds of tape. With your first shoot for the session you should roll your tape for 30 seconds at the beginning of your tape with the lens cap on or preferably with camera to display color bars. (see your camera manual for this setting).

Avoid Excessive Panning and Zooming

When panning and zooming, use slow, smooth and deliberate motions. One of the most common video mistakes is making constant movements and adjustments. Be deliberate when making adjustments. Take a shot of something and leave it there for 10–20 seconds, stop the recording and take another shot. Don't quickly pan the camera from one subject to another. You need to remember that any full frame pixel movement loses compression. You can end up with some very large file if you have too many of these.

Learn to Use your Camcorder

Having good knowledge of your camcorder's features and functions is a necessary element of making better videos. You should learn how the image settings like white balance, exposure and backlight affect the image. You need this because when you are shooting you need to have your eye in the viewfinder or on the LCD screen, not looking away at the controls to zoom, focus or make other corrections.

Shoot in Sequences

Shoot your video in sequences, where you take a general scene or an action and break it into various parts or segments and shoot each one, rather than doing it as one long shot. Think of

different scenes, as in a movie. Each of those scenes is made up of sequences. In each sequence, you need to follow the action, and shoot wide, medium and close-up.

Buy a Microphone and Shut Up When Shooting

The best audio purchase that you can make if you're mostly doing home videos is a lavaliere (lav) microphone. It's designed to clip onto the clothing of the subject, near their mouth, and plug into the camcorder to pick up the best possible speech audio. Lavs are also small enough that you can hide one somewhere in a scene to pick up better sound than a camera mounted mic. But remember when shooting, keep quite and let the subject do its thing.

Get the Composition Right

Be aware of composition in your shots and how you frame your shots, particularly with interviews. Avoid a shot of a person with a plant or pole behind them. It will look like the plant or pole is growing out of the back of the person's head. Always pay attention to your surroundings and don't be reticent or shy about rearranging furniture, moving things on a desk, pushing plants out of the frame of your shot. If you need to improve the setting, ask the subject of your shoot to change positions so you properly frame the shot. Good shot composition uses the "Rule of Thirds". This is where you treat the screen as being divided into a tic-tac-toe pattern. When framing a person for a close up, you want their eyes on the top line and the centre of their head on the left or the right line (i.e. facing inward). Although this may cut off the top of the subject's head, it will provide the proper balance and really make your shot look professional.

Video Capture

Capturing video is much more demanding than still frame as the amount of data generated can be high. There are three popular formats used when capturing video; AVI, MPEG and Motion-JPEG. Which format is used will depend upon several factors, such as required quality; image size; length of sequence; available storage capacity; distribution media and cost. The detail on how you do this process is also dependant on what you have as a computer and what capture capabilities it has. If you are taking the clips into Flash then you should work with uncompressed files if your computer can handle it.

Linear Editing Compared to Non-linear Editing

Linear editing is the video editing process used for many years in which a video production is put together by transferring shots from a source tape to a program, or master, tape in sequence one after another in strict order, beginning to end. If changes are required in the first part of the resulting master tape, then the following shots on the tape must be re-edited and reassembled. Editing is greatly stalled using this process. With the advent of fast computers and peripherals that can handle gigabyte digital video data, the editing process is simplified with non-linear editing (NLE) software applications. Since all the source footage required to assemble a video production now can be stored on a computer hard disk in digital format, access to all shots at any point in the editing process is possible with NLE, and changes to any part of a video

production can be done at any point without the need to recreate the sections following each change or edit.

You have Shot your Video, What Next?

This section assumes that you already have some video in a format other than FLV. Many video editing tools allow you to capture video directly from your digital video camera. For users who work extensively with video-based content, Flash Professional 8 includes the Flash 8 Video Encoder and the QuickTime Exporter. Flash Basic 8 only provides video encoding for use with embedded video.

Flash Video Import Wizard

The Flash Video Import wizard lets you encode video clips into the Flash Video (FLV) format. The Video Import wizard has limitations in that you can only encode one video clip at a time, and the process of encoding can be both time- and computer-intensive.

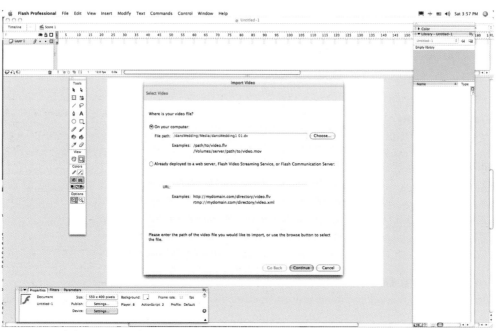

Figure 9.4 *Flash Import Wizard*

Flash 8 Video Encoder and Embedded Cue Points

Flash 8 Video Encoder lets you batch-process video clips, allowing you to encode several clips at a time without having to interrupt your workflow. In addition to selecting encoding options

for video and audio content, the Flash 8 Video Encoder also lets you embed cue points into video clips you encode, and edit the video using crop-and-trim controls.

Embed cue points directly into Flash Video (FLV) file so events can be triggered dynamically during playback. Used in conjunction with the new Flash Video component, you can easily coordinate the playback of accompanying graphics and animations when individual cue points are reached. For more on cue points see Chapter 10.

FLV QuickTime Export Plug-in

If you have Macromedia Flash Professional 8 and QuickTime 6.1.1 installed on your computer, you can use the FLV QuickTime Export plug-in to export FLV files from supported video-editing applications. You can then import these FLV files directly into Flash to use in your Flash documents.

The following video-editing applications are supported by the FLV Export plug-in:

- Adobe After Effects (Windows and Macintosh)
- Apple Final Cut Pro (Macintosh)
- Apple QuickTime Pro (Windows and Macintosh)
- Avid Xpress DV (Windows and Macintosh)

Using the FLV QuickTime Export plug-in to export FLV files from either Flash 8 Video Encoder or video-editing applications significantly streamlines the process of working with FLV files in your Flash documents. With the FLV Export plug-in, you can select encoding options for video and audio content as you export, including frame rate, bit rate, quality, and other options. You can import FLV files directly into Flash without needing to re-encode the video after import.

The On2 VP6 and Sorenson Spark Video Codecs

A codec is a compression/decompression algorithm that controls how video files are compressed during encoding, and decompressed during playback. The VP6 video codec is the preferred video codec to use when creating Flash content that uses video. VP6 provides the best combination of video quality while maintaining a small file size. By default, Flash Video Encoder exports encoded video using the On2 VP6 video codec for use with Flash Player 8, and the Sorenson Spark codec for use with Flash Player 7.

If your Flash content dynamically loads Flash video (using either progressive download or Flash Media Server), you can use VP6 video without having to republish your SWF for Flash Player 8, as long as users use Flash Player 8 to view your content. By streaming or downloading VP6 video into Flash SWF versions 6 or 7, and playing the content using Flash Player 8, you avoid having to recreate your SWF files for use with Flash Player 8.

Capturing Good Video

In addition to the physical properties of your video there are a variety of factors that affect the efficiency of the encoder and, ultimately, the user experience of the video playback. Two factors play a significant role in the encoding process: source quality and frame motion.

Whenever possible, always encode a file from its uncompressed form. If you convert a precompressed digital video format into the FLV format, the previous encoder can introduce video noise. The first compressor has already performed its encoding algorithm on the video and has already reduced its quality, frame size and rate. It may have also introduced some of its own digital artifacts or noise. This additional noise affects the FLV encoding process and may require a higher data rate to playback a good quality file.

Frame Motion

Frame motion is the percentage of the pixels that change from one frame to another. This change can result from a person or object moving, camera effects or post-production effects. Camera effects such as camera panning, zooming or hand-holding result in almost 100% pixel change from frame to frame.

The video compressor uses a method of dropping frames and then encoding a series of fully uncompressed frames. These uncompressed frames, called keyframes, are used to calculate and "rebuild" the missing frames during playback.

Best Practices for Encoding On-demand Video

The term "On-Demand Video" refers to video that loads as a frame is reached in the SWF. When you encode on-demand video, you must balance a variety of factors, including amount of motion depicted, file size, target bandwidth, frame rate, keyframe interval and the pixel dimensions of the video. You can specify values for some of those factors when you encode Flash Video.

For detailed information about specific values to use for various settings, see the article Best Practices for Encoding Flash Video at the Macromedia Developer Center. This article provides a table of recommended settings.

Flash 8 lets you deliver on-demand video in any of the following ways:

- Using embedded video within SWF files.
- Using progressive download FLV files.
- Streaming video from your own Flash Media Server or from a hosted server using Flash Video Streaming Services.

The following are the guidelines to follow when compressing video to Flash Video for delivery over the Internet.

- A higher bandwidth allows for more motion in the video, larger files, better frame rates and larger pixel dimensions.
- The less motion there is in your video, the smaller the file size.
- Reduce frame size when bandwidth is limited and frame rate and quality are important.
- As the target bandwidth decreases, reduce the keyframe rate. A lower keyframe rate reduces the bandwidth demand.
- High-motion clips require more information to flow to the player. So as motion increases, you must increase the keyframe rate, the frame rate and the data rate.
- If the video source you are encoding comes directly from a video camera, always enable de-interlacing and set the Flash Video encoder to the upper field. If your video is interlaced, selecting this option increases the performance of the video encoding and playback.

About Bit Rate

Bit rate is the amount of data transferred per second. When you encode Flash Video, you specify a bit rate for the encoding. Bit rate is important, so you need to know whether your audience is on a 56 kbps or a 2 Mbps connection.

About Keyframes

Flash Video is encoded as a sequence of keyframes with full-frame uncompressed images taken from the video at regular intervals. Each frame is followed by information about how to change the pixels of the keyframe to produce the delta frames between that keyframe and the next. During playback, the decoder recreates the delta frames based on the keyframes.

The keyframe interval is the number of delta frames between keyframes. The greater the interval between keyframes, the harder it is for the decoder to recreate the missing frames. Also, if your keyframe interval is too great, you may not have a large enough data rate to compress and transmit the data bits. Therefore, a high-motion video clip with a large keyframe interval results in the perception of poorer quality.

All MPEG movies are built out of 16×16 squares. To save space the squares that are "almost identical" to the same squares in the next frame of the movie are discarded. This makes a very high compression ratio, because in a scene where two people are talking and not moving very much the only squares that need to be copied across one frame to the next are those around the mouth. But because only squares are carried across from one frame to the next you do not have a complete picture, just squares! For example, to view frame five you must load frame 1, 2, 3 and 4 and stick all the squares together to make frame 5! A keyframe is added every second to keep track of the position of the movie. It also provides a perfect picture on

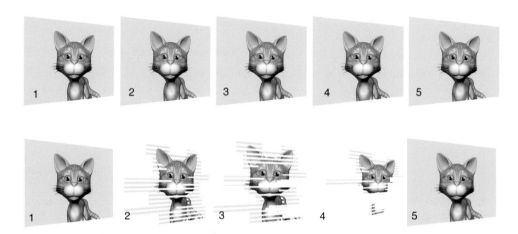

Figure 9.5 *The top row represents frames 1-5 in an uncompressed AVI file. The frames below form an MPEG file. Frames 1 and 5 are Keyframes showing a complete picture, but frames 2, 3 and 4 contain only the bits of information (delta frames) that are different from the previous.*

which the half frames (delta frames) can be based. Most compression software uses 1 keyframe every 5 to 10 seconds. Because keyframes, as full pictures, hold much more information than partial frames they will increase the file size quite a bit. So obviously the fewer you have the better the compression. If you chop a compressed file "in–between" keyframes the player will not be able to reconstruct the movie frames until it reaches the next keyframe in the list!

With Flash Video, keyframes are particularly important if your presentation approach provides a seek or scrub feature, which allows a user to advance the stream during playback.

Embedding Video within SWF Files

Multimedia developers have been able to embed video within SWF files by importing video and placing it on the Timeline in the Flash authoring tool, since the introduction of Flash MX and Flash Player 6. When the SWF file is published, the video is fully contained in that file. This approach requires only a normal web server to deliver the video.

There are some benefits in using embedded video, such as the ability to see the individual video frames on the Flash Timeline and create overlays and interactions with the aid of the Flash design tools. However, embedded video is recommended only when you want visitors who have Flash Player 5 or lower to be able to view your video, or when your video clip is under five seconds long. In all other cases, embedded video is not recommended.

Embedded video has some limitations:

- If your video content changes, you have to republish the SWF file to make the change.
- The full video file must fit into the local memory of the playback system.
- During authoring, each time you want to preview or test part or all of your Flash content, you must publish the entire video file. This can add significant time to the authoring process.
- For web delivery, the entire video file must be downloaded from the web server in order for playback to begin.
- The video frame rate and Flash Timeline frame rate must be the same, because they share the same time base.
- After 120 seconds of continuous video playback, users may experience audio synchronization problems.
- File length is limited to a maximum length of not greater than 16,000 frames.

Therefore, the embedded-video approach is recommended only in specific cases as described above; and even in those cases, you should use it only when you want to deploy very short clips of video, when the quality of that video is not very important, and when the video content is unlikely to change very often.

External Progressive Download

Progressive download enables developers to use ActionScript commands to feed external FLV files into a SWF file and play them back at runtime. You can use the netConnection and netStream commands to set the FLV file to playback, and to control the Play, Pause, Seek and Close behaviours and the buffertime and size for a given video file. This is available in the Flash Player 7 onwards. The video content (FLV file) is kept external to the other Flash content and the video playback controls. Because of this, it's relatively easy to add or change content without republishing the SWF file.

Flash Professional (starting with Flash MX Professional 2004) also includes video components that you can use to quickly add a full-featured FLV or MP3 playback control to your Flash project. In Flash Professional 8, the FLVPlayback component provides support for both progressive download and streaming FLV files. This component, new to Flash Professional 8, is easy to "skin" or customize, so that you can make your video player match your site design. Flash Professional also includes a set of behaviours that can be used in conjunction with media components to create automated interactions between video sequences and slides in a project.

Using external progressive FLV files has a number of advantages, the biggest being at runtime, video files are loaded from the local disk into the SWF file, have no limitation on file size or duration. There are no audio synchronization issues or memory restrictions.

Streaming Video

The best and most robust delivery option is to stream video and audio files from a server running Flash Media Server. In streaming, each client opens a persistent connection back to the video server, and there is a tight association between the video being delivered and the client interaction. This lets you deliver features such as bandwidth detection to serve up the right size video, quality of service metrics, detailed tracking and reporting statistics, and a number of interactive features along with the video experience.

As with progressive download, with this method the video content (FLV file) is kept external to the other Flash content and the video playback controls. As there is a persistent connection between client and server when streaming, the FLV content can be changed based on feedback from the user or the application. In particular, the most useful feature is the switching to a lower bit rate video if you notice a quality-of-service degradation.

The following are a few other advantages:

- The video starts playing sooner.
- Streaming uses less of the client's memory and disk space, because there is no downloadable file.
- It provides more secure delivery of media, because media does not get saved to the client's cache when streamed.
- Only the parts of the video that are viewed are sent to the client. So it makes more efficient use of network resources.
- It provides better tracking, reporting and logging ability and reporting on traffic and throughput.
- It enables multiway and multiuser streaming for creating video chat, video messaging and video conferencing applications.
- It delivers live video and audio and can capture video from a client's webcam or digital video camera.

If you do not want the expense of buying and maintaining server hardware and Flash Media Server software you can get all the benefits of streaming Flash video and MP3 files with the Flash Video Streaming Service. This is a Macromedia-authorized Content Delivery Network partner approved service. It is a load-balanced, redundant deployment of Flash Media Server. You can find out more information if you go to the Flash Video Streaming Service homepage on macromedia.com.

Flash Video and your Web Site

Putting your video on the web can be done in three different ways:

Put the video clip in a directory on a web server.
Put your video in an HTML editor like Dreamweaver.
Put your video in an SWF file using Flash 8.

Before you can add video to your pages, you must decide which delivery mechanism to use. Is it going to be progressive download or streaming.

Figure 9.6 *HTML template with video playing inside it*

You can use Dreamweaver 8 to quickly add video to your web page without having to use Flash. If you need advanced capabilities for adding interactivity, layering video with other Flash animation, and synchronizing the video with text and graphics – then you have no choice but to use Flash.

When you add Flash Video to a page, you should also add a behaviour to the page to detect for Flash Player. In particular, you should check that any visitor trying to view the page has a version of Flash Player that lets them view the content you're providing. You can learn more about Flash Player Detection from the macromedia web site or you can use the detection.html template provided on this CD.

Importing Flash Video into Dreamweaver

You first need to have encoded Flash Video (FLV) file before you begin.

To add Flash Video to a web page using Dreamweaver:

1. Launch Dreamweaver 8. Choose File > Open from the main menu and select the *zacandellen.html* file.
2. In either Design view or Split view, position your cursor within the editable content region and delete any existing text, such as "[insert video here]".
3. Select Insert > Media > Flash Video from the main menu to launch the Flash Video Component.
4. Select Progressive Download Video from the Select video type pop-up menu, and the appearance of the Flash Video dialog box changes to show the following options for this format:

 - **URL:** Specifies the URL of the FLV file to embed in your HTML document.
 - **Skin:** Specifies the URL of the skin to load.
 - **Width:** Specifies the width of FLV display.
 - **Height:** Specifies the height of FLV display.
 - **Constrain:** Maintains the aspect ratio of the video if the width or height text boxes change the corresponding value.
 - **Detect Size:** Detects the dimensions of the FLV file and automatically populates the Width and Height text boxes.
 - **Auto play:** Specifies whether you play the video when the web page opens.
 - **Auto rewind:** Specifies whether the playback control returns to the starting position after the video finishes playing.
 - **Prompt users to download Flash Player if necessary:** When selected, this option embeds the required JavaScript code to detect users' Flash Player version and prompts them to download a newer version, if necessary. If this option is not selected, the Message text box is disabled.
 - **Message:** A message displays if a user's current Flash Player version isn't high enough to view the Flash content.

5. Click the Browse button next to the URL text box. Navigate to the Amazon directory on your hard drive, select *fashion.flv* from the *videos* folder, and click OK.
6. Select a skin from the Skin pop-up menu. For this exercise, select *Clear Skin 3*. The area below the Skin pop-up menu shows you a small preview of the specified skin's controller. Click the Detect Size button so Dreamweaver calculates the width and height of the current FLV file automatically, and then populates the text boxes with the correct dimensions of the video.
7. Select the Auto play check box if you want the video to play automatically after the page loads. Make sure that the Auto rewind check box is enabled if you want the video to return to the first frame after it completes.

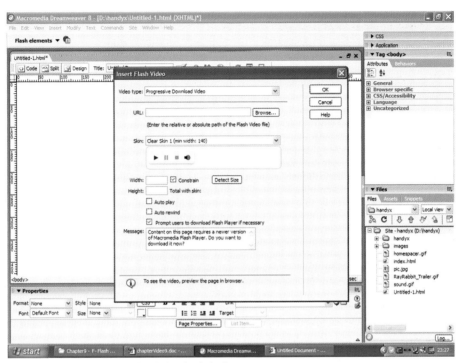

Figure 9.7 *Specify your options in the Flash Video dialog box*

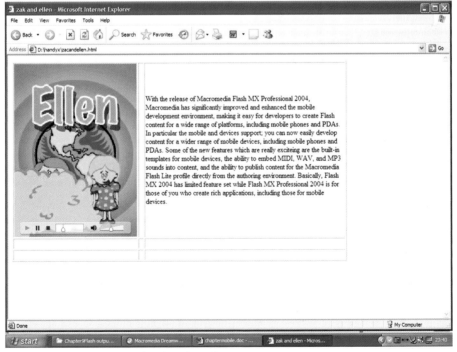

Figure 9.8 *This video controller uses the Clear Skin 3 skin*

8. Click OK to apply your settings, and Dreamweaver generates and inserts code that you need to embed the selected video into this web page. Embedding an FLV file and a player adds 8 lines of HTML code which configures the Flash Video component based on your selections.

Based on the settings that you chose for this exercise, Dreamweaver inserts the following code into your document:

```
<object classid="clsid:D27CDB6E-AE6D-11cf-96B8-444553540000"
codebase="http://download.macromedia.com/pub/shockwave/cabs/
flash/swflash.cab#version=8,0,0,0" width="320" height="240"
id="FLVPlayer">

  <param name="movie" value="FLVPlayer_Progressive.swf"/>

  <param name="salign" value="lt"/>

  <param name="quality" value="high"/>

  <param name="scale" value="noscale"/>

  <param name="FlashVars" value="&MM_ComponentVersion=1&skinName=-
Clear_Skin_3&streamName=../videos/fashion&autoPlay=false&autoRe-
wind=false"/>

  <embed src="FLVPlayer_Progressive.swf" flashvars="&MM_Component-
Version=1&skinName=Clear_Skin_3&streamName=../videos/fashion&auto-
Play=false&autoRewind=false" quality="high" scale="noscale"
width="320" height="240" name="FLVPlayer" salign="LT" type="applica-
tion/x-shockwave-flash" pluginspage="http://www.macromedia.com/go/
getflashplayer"/>

</object>
```

The parameters you specify in the wizard are inserted into the HTML, and pass information to Flash using FlashVars. The skin Clear_Skin_3 is copied to the same folder as the HTML file, but without the file extension (.swf) in the HTML code. The second parameter, streamName, points to the FLV file you defined in the URL text box. It is a relative path and again omits the FLV file extension (.flv).

The next two parameters are Boolean (true/false) values. They are based on your selections in the wizard. If you want to modify the skin or path to the FLV file, then you can modify these values directly using Code view in Dreamweaver. You might need to edit the width and height parameters manually in both the param and embed tags. These values correspond to the

width and height of the FLV document; however, if you use certain default or custom skins, then you might need to alter these values if your skin contains a border and is larger than the dimensions of the FLV file.

You will need to repeat twice the FlashVars values in both a param tag as well as the embed tag so that the code works with Internet Explorer– and Netscape-based browsers.

Components for Flash Video

You can import a video file that is already deployed to a web server, or you can select a video file that is stored locally on your computer, and upload the video file to the server after importing it into your FLA file. To learn more about coding your video controls using ActionScript, go to the Flash LiveDocs section, "About Playing Back External FLV Files Dynamically". Select Using Flash>Working with Video>About Playing Back External FLV Files Dynamically.

1. To import the video clip into the current Flash document, select File>Import>Import Video.
2. Select the video clip you want to import. This is either a local video clip stored on your computer, or you can enter the URL of a video that you have uploaded to a web server.
3. Select Progressive Download from a standard web server.
4. (Optional) If the video you are deploying is not in FLV format, the Import Video wizard displays the Encoding panel.
5. Select a skin for your video clip. You can choose to:

 - Not use a skin with the video.
 - Select one of the predefined skins.
 - Select a custom skin of your own design by entering the URL of the skin on the server.

 The Video Import wizard will encode your source video clip into the FLV format and create a video component on the Stage that you can use to test video playback locally.
6. Upload the FLV encoded video clip. which you should find in the same folder as the source video clip you selected with a.flv extension. Flash uses a relative path to point to the FLV file (relative to the SWF), letting you use the same directory structure locally that you use on the server. If you choose to use a predefined skin, Flash copies the skin into the same folder as the FLA file and uploads the video skin.

The Video Component

You must edit the component's URL field to that of the web server to which you are uploading the video using the Component Inspector panel.

Flash Video Streaming Service

You can import a video file that is already deployed to a Flash Media Server or you can select a video file that is stored locally on your computer, and upload the video file to the server after importing it into your FLA file.

1. Video clips that are already deployed to a server must have previously been encoded in the FLV format.Select Stream from Flash Video Streaming Service (FVSS) or Stream from Flash Media Server (formerly Flash Communication Server).
2. (Optional) If the video you are deploying is not in FLV format, you can use the Encoding panel to select an encoding profile, and crop, trim and split the video clip.

When the video you are deploying is not in FLV format, the Import Video wizard displays the Encoding panel.

3. Select a skin for your video clip. Select a custom skin of your own design by entering the URL of the skin on the server.

The Video Import wizard will encode your source video clip into the FLV format and create a video component on the Stage for video playback locally.

4. Upload the following:

 The FLV encoded video clip (which is located in the same folder as the source video clip you selected with a.flv extension)
 The video skin (if you choose to use a skin)
 If you choose to use a predefined skin, Flash copies the skin into the same folder as the FLA file
 The video component

 You must change the FLVPlayback component URL field to specify the web server to which you are uploading the video.

Streaming Service

Macromedia has partnered with leading content delivery network (CDN) providers to offer hosted services. Built with Macromedia Flash Communication Server and integrated directly into the delivery, tracking and reporting infrastructure of the CDN network, Flash Video Streaming Service provides the most effective way to deliver Flash Video to the largest possible audience without the hassle of setting up and maintaining your own streaming server hardware and network. These providers are:

http://www.akamai.com/en/html/services/streaming.html

http://www.vitalstream.com/macromedia/

http://www.mirror-image.com/flash/

All Flash Video Streaming Service providers offer the following capabilities:

- Built-in load balancing and failover to scale video despite of heavy traffic.
- Video streaming that starts the instant viewers click Play.
- High-performance network.
- Automatic tracking and report generation.
- Flexible bandwidth and storage.

Flash Video Streaming Service – Live

Flash Video Streaming Service does have a secure option which enables you to monetize and protect streaming Flash video content. In addition to the standard features listed at the top, Flash Video Streaming Service Live provides the following:

- Delivery of live Flash Video streams.
- Special set of tools designed to support live video streaming.
- Real-time encoder for encoding live video on the fly.

Chapter 10
Advanced Video Techniques

In addition to explaining the process of Live Video, I will, in this chapter, look at chroming effects using the Final Cut Pro keying process and a walk through using Adobe After Effects. Once we have created our video content, we will produce a cue movie. We will also look at Broadcasting Live Video.

The way that Broadcasting Live Video works is, a SWF file is created as the broadcast application, it sends the live video to your Flash Media Server or to a Flash Video Streaming Service server, which republishes the live video to be viewed by anyone who logs onto your web page and connects to the stream using Macromedia Flash Player. In addition to live video streaming, Flash Media Server lets you produce video chat, video messaging, webcasting, video conferencing, stop-motion capture and so on. The live video capabilities in Flash Media Server include audio push, record and record-append.

Video support in Flash 8 has been improved dramatically. A combination of the (FLV)Playback component and support for an 8-bit alpha channel open up new possibilities for Flash animators. Flash 8 allows you to simply link to a Flash Video (FLV) file that has an alpha channel, and any objects or animations will show through in the background.

Introducing Alpha Video in Flash 8
What is the Alpha Channel?
The 8-bit alpha channel is more commonly known as Keying, which can be Chroma or Luma. Keying is the process of matting out specified colors in a frame of video. Applications like FINAL CUT PRO and AFTER EFFECTS can look at each frame, find every pixel containing the color you have chosen for a background key color and make that pixel transparent. This allows the underneath layer to show through. If you use Luma Keying instead of Chroma, your application

Figure 10.1 *Integration of 8-bit alpha*

will instead select all the pixels in the frame that have a higher brightness value than the specified Luma Key value.

The possibilities of using alpha video are endless. You can dynamically change the background of a video, either integrate video into traditional animation and games, or overlay an interactive guide over your content with no loss of quality.

Why use Chroma instead of Luma? Luma primarily has only grayscale values with a scale of black to white or dark to bright. Whilst chroma is color, or RGB values that have a lot more variation in color than there is in luminance. So its easier to set a very specific color value to key out without touching anything you don't want to key out. Luma is good if you are trying to build gradient keys, from semi-transparent to opaque smoothly across the frame. Keying means choosing a color for a background that an effects application will get rid of, leaving the video layer underneath.

Chroma Keying

You can use any color for chroma keying but there are two colors that are commonly used, blue and green. If you have been presented with a choice of blue and green for our key color, you will need to make sure that your SUBJECT doesn't contain that color. If you decide to use another color then remember that secondary colors or primary colors from the color wheel will include some portion of the primary color.

Although I prefer to work in blue, green is generally a more popular choice. Green items are rare in most people's wardrobes. You can't help it, people like to wear Blue stuff. Outdoor filming will also mean that you will be covered in Blue light as daylight has significant amounts of blue light.

Alpha video or keying in Flash 8 is now available because of the incorporation of On2 VP6 videocodec in Flash Player 8. It is a huge increase in quality over the old Sorensen codec. On2 VP6 enables you to encode an 8-bit alpha channel directly into FLV files. Popular video editing application such as Adobe After Effects, Apple Final Cut Pro and the Avid suite can do this.

When preparing a video for keying, it is important to shoot the video against a solid green- or blue-screen background. Consistent use of that color is critical. To get good even lighting without shadows, you need diffused lighting. You will see from our Alex.mov file that we used a fabric which is not ideal as you can see every fold or crease on it. But as an indicator of the cleaning process in After Effects its worth having a play with this movie clip. Pointing a light directly at the subject will give uncontrollable specular lighting. Find poster board, matte board, plywood painted white, anything white and bring it to your shooting space. Instead of directing your lights at the screen or subjects, bounce the light off the bounce card onto the subject and you will find that it spreads evenly and mixes with other light sources easily. As distance from the light

Figure 10.2 *Video shot outside with blue fabric in Apples Imovie*

source doubles, the amount of light making it to the subject is quartered. A combination of light is lost through bounce card and the distance gives you a pretty good set of controls for lighting values. If bouncing the light kills too much light, you must use direct lighting, but you still need to diffuse the light. I find that bubble wrap works surprisingly well. Keep it in the light path but well away from the bulb.

When you setup the stage, make sure that you have a distance of 8–10 feet or more between the screen and the subject. The more distance you put between the blue screen and the subject, the more you limit the amount of spill light and shadow between your keying screen and the subject. It is best to setup lighting in two parts, one for the foreground and the other for the background.

Get the best camera you can. Video captured with a webcam can be very difficult to key because of the high level of background visual noise. MiniDV is a vast improvement but it is still more difficult to key than higher quality, lower compression formats.

Every camera is different, find out what settings it has before you start filming. You will need to know how to do white-balancing. It is best to get a camera that allows you auto focus with color-enhancement settings.

Lock your white balance and camera's focus before shooting. It is best to use a lower depth of field. Refer to your owner's manual to achieve the best results you can. To find the perfect

focus level place a test object on the screen, find a focus level that you are happy with and then lock it if you can. Otherwise just turn off the autofocus feature altogether and focus manually. Make sure that the camera is at least as far away from the subject, as the subject is from the screen and farther away if possible, using zoom for composition wherever possible. A camera zoomed-in has a far lower depth of field and will pick up every little detail from your screen. You need the smoothest most even blue background you can get. An out-of-focus background that has the right Luma and Chroma value is better than a sharp focus background where the camera records every detail.

The demonstration material we created for this chapter is shot in outdoor light. You have more control over your lighting in a studio setting but outdoor lighting or floodlighting can produce reasonable results.

When you set up your lighting, start with the background and remove as many shadows as you can. Once you have established a reasonable balance, setup the subject lighting. Make sure the subject looks is not casting unwanted shadows, check to see if foreground lighting has caused any obvious spills onto the screen.

At this point you need to consider the direction of your lighting. You need to make sure that the subject light is stronger on the sun side and fade to silhouette on the other for landscape backgrounds. Adjust your lights for that reason. It's essential to think of your foreground and background lighting as different effects to be kept separate.

It is best just to avoid moving the camera during shooting at all costs. Motion, blur keys badly in DV, combine that with the shadows cast when you change angles, you then have a significant amount of work cleaning your clip. Organize your shoot to key into different takes where you will still be able to get the best camera angle and best lighting without motion shots. The most useful thing you can do if you have more than one movie clip is to storyboard your shots and your lighting diagrams.

Video shoots are usually costly and time-consuming to setup, so always film more than you think you'll need. Keep notes and shoot lots of video. Reshooting scenes later may be tricky and you might not have the budget to do it all again. Because you will want to shoot lots of video, take notes of the time indexes of shots. Notes don't have to be full of details; just record the minutes and seconds where the clip starts.

Testing your shots will vastly improve the finished product. Take time for test shots – the more time you can spend testing, the better. Bring ten-second shots into your video editing program and see how the colors turn out, and how easy it is to remove the background from your video. Use the simple principle, if it doesn't look right, change some settings and try again. Make absolutely sure that your subjects aren't wearing anything with any color even remotely close to green and that they are not wearing stripes or patterns. Stripes and patterns cause a form of artifacting that generates color in the video signal which isn't really there. Your subject may be

wearing a black and white stripe shirt, but when you look at the shot on your screen you'll see flickering rainbows stream through the pattern. Unless you have got lots of time to play with stick with monotone earth tones or blues.

When you shoot faces keep the camera lens level with the subjects nose and get tight focus on the eyes. It will always be obvious if the eyes are out of focus. Try to come up with interesting techniques for getting around the 2D look of flat lighting in the subject that is a sign of keyed effects. Always take a good look at the footage you are going to key the subject.

DV Chroma Key requires sharp well-defined edges. Tie back hair if possible. The finer the detail, the more difficult to separate from the background keying color. TV studios are using higher res cameras and so the stuff looks great. Your DV camera will have lots of problems with a couple of strands of hair, even at really close quarters. At the same time keying imperfections that are obvious up close, disappear with a little distance.

If your project requires high-quality video, you will probably need to hire professional studio and video personnel to film your video for you. You can rent professional video equipment and setup your shoot in your basement or garden, where you can control the environment the best. For experimental work, you should be able to get away with a consumer camcorder and some bright reading lights or outdoor filming.

Keying in After Effects

The following tutorial will help you to get started with creating and importing alpha videos into Flash. You will key a simple file Alex.mov from the CD in After Effects and see a simple application that demonstrates the keying technology.

After Effects can look at each frame of video, find every pixel containing the color you have chosen for a background key color and make that pixel transparent. Then whatever you have on the video layer underneath will show through. Keep in mind when creating your own alpha video that keying is not the only option available to you. You can also set custom masks, manually erase the background which is good for cleaning up open areas that keying cannot remove.

Having shot your footage using a key color, we will use the keying filters in After Effects to remove the color and reveal the layer underneath. This sounds easy and would be if your lighting was perfect. Unfortunately, if your lighting isn't perfect, you will find that your initial key does not remove all you want to remove. In addition, it will take away some of what you want to keep. The sample files that accompany this chapter include a video file (Alex.mov), with which you can play. Note that the process of keying a video varies from video to video and application to application but basic process follows these steps:

1. Create a new project in After Effects (File>New Project).

Figure 10.3 *Alex.mov in After Effects*

2. Create a composition (Composition>New Composition). In the Composition dialog box, select your video options and set the size, length and other settings that may apply to your project. In the case of this sample, use a size of PAL DV 720 × 576 and leave everything else on default.

3. Import your source video file (File>Import>File). Find the Alex.mov file, click Open, and drag it to your work area. The work area will probably be labelled "Comp 1".

4. Open the After Effects Filters panel (Windows>Effects & Presets). You will see a category called Keying (see Figure 10.4). Effects & Presets panel showing the open Keying section.

The Keying category shows the default keying effects you can use with After Effects.

5. Select the Color Key effect, this removes the color that closely matches the source color you choose. Drag this effect from the Effects Panel onto your video. After Effects uses layers to control effects so you do not need to be too precious, everything is easily returned to its original format.

6. Select the eyedropper to the left of Key Color and select the background color of your video.

7. The option below Key Color is Color Tolerance. This tells After Effects how much color in the range of the selected background color to remove as you move the slider left to right. For this example, choose a setting of about 100, which removes an adequate amount of color. The next selection is Edge Thin, this "pulls" in the color bounds around your subject, removing color that the Tolerance setting couldn't remove. You don't need to adjust this setting for the First Color Key effect.

8. The third setting, Edge Feather, softens the edges from where the color was removed. Setting this to 1.1 gives your video a cleaner look.

Figure 10.4 *Effects & Presets panel showing the open Keying section*

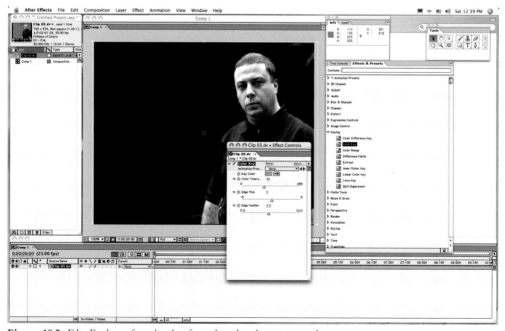

Figure 10.5 *Edge Feather, softens the edges from where the color was removed*

9. When working with the Alex.mov file, I found it necessary to use the Eraser tool to remove color remnants to finalize the video.

10. Export this video as an FLV file. If you installed Flash 8, you'll see an Export to FLV option in After Effects. Select File>Export>Macromedia Flash Video (FLV), name the file Alex.flv, and click Save. This opens the Flash Video Encoder settings dialog box.

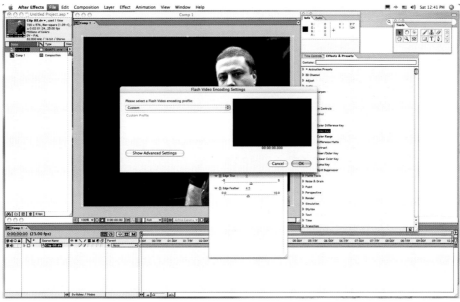

Figure 10.6 *After Effects Color Keying controls, showing the settings for the demo*

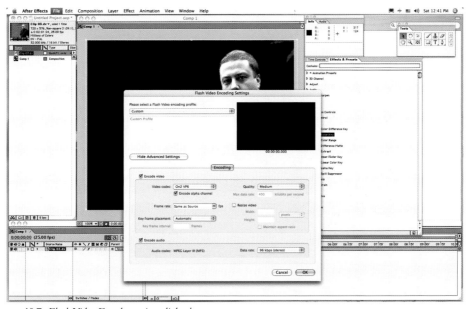

Figure 10.7 *Flash Video Encoder settings dialog box*

If you don't have After Effects, or you have another video editing application that doesn't support the FLV format, then export to another video format that supports alpha channels and use the Flash 8 Video Encoder to convert your file to the FLV format. Using the Flash Video Encoder has a number of advantages over the After Effects FLV Encoder option. For example, you can add cue points to your video before encoding. More on cue points is explained later in this chapter. Using this feature can save you lots of time and effort later on. Flash 8 Video Encoder also supports the crop and trim options.

11. To encode the alpha channel, click the Show Advanced Settings button and click the Encode Alpha Channel option (see Figure 10.7). Leave the rest to the default settings. After you select your settings, click OK. The FLV file will be saved to the location you chose earlier.

There should be little or no blue in the subject, at the same time the background should be very saturated with your color key. That is the theory. In practice you start to like what you see by the third time you try it out. You can assess your success in lighting by how far up you can slide the Tolerance setting without losing parts of the subject. One important thing that is easy to forget is that the frame you are working on is only one of many and that the lighting and color values will change over time. Check out a few frames across the whole footage and just make sure lighting has remained consistent.

Experiment a lot with your choice of color and your Tolerance setting within Adobe After Effects. Adobe After Effects is a great tool for this kind of work. And it's mainly due to the superb flexibility of the tools which are used to accomplish the keying process.

A good After Effects or Final Cut Pro artist can use these applications as an artistic tool drawing away from the canned effects which have their place. Many of the effects that ship with After Effects will look quite familiar to the Final Cut Pro user. This is the case even down, to how the control work. The control palettes of After Effects standard plugins often have the same parameters and keyframe with the same interpolation conventions.

Figure 10.8 *Final Cut Pro interface*

After Effects and Final Cut Pro are two different types of software – FCP is primarily editing, and AE is primarily motion graphics and compositing. A lot of features overlap allowing you to create a 30 second commercial in AE – and you can do a lot of motion graphics in FCP.

As we go to print with this book here are five things that After Effects has that FCP doesn't:

1. Bezier curve masks – you can create masks in any shape instead of 4 or 8 point shapes
2. 3D – you can move your "camera" through and around layers of video and graphics.
3. Time remapping – you can continuously slow down or speed up a clip.
4. Text on a path – you can create text that moves along a circle or any shape.
5. Motion Math – you can set up certain layer properties to affect other layers mathematically – like the volume of an audio layer affecting the size of a video layer.

Here are 5 things FCP has that After Effects doesn't:

1. You can put multiple clips on one layer.
2. FCP has much superior editing tools.
3. You can watch video and simple layering, transitions and titles in real-time.
4. You can capture and output video.
5. FCP is a single software environment – you don't have to use multiple programs with the trouble of importing and exporting media.

Figure 10.9 *The video import wizard*

Importing and Using Alpha Video

This process is a repeat of the import in chapter 9 but it takes our video clip to completion. Now that you have your new alpha video file, import it into Flash. The video import wizard in Flash 8 uses a four-step process to import your videos:

1. Create a new project in Flash 8 (File>Import Video).
2. The first screen enables you to browse for your FLV file. Locate the Alex.flv file in your assets folder and click Next.
3. The next screen allows you to specify up to four settings for deploying your video. For this demo, use the default option Progressive Download from a Web Server and then select Next to continue.
4. The third screen is where you apply your skin to the video player. Select the skin you would like from the pop-up menu and click Next.
5. You will see a confirmation screen of your import. Click Finish. The FLVPlayback component will be placed on the Stage for your use. To see your results you need to publish your file.

What Flash 8 allows you to do is to play with your movie clips by scaling or rotating them. You can even put them on a motion path. If ever you find yourself in need of a very large background, such as a skyscraper or a landscape, and your blue backdrop is only about 12 feet by 10 feet, you can easily rescale yourself.

Embedding Cue Points (Flash Professional Only)

Each cue point consists of a name and the time at which it occurs. You specify cue point times in hour:minute:second:millisecond format; the default frame rate is 30 frames per second (fps). Cue points cannot be specified using frame numbers. They must be specified using milliseconds rather than frame numbers. Check out CuePointVideo.swf.

Cue points cause the video playback to trigger other actions within the presentation. You can create a Flash presentations that have video playing in one area of the screen while text and graphics appear in another area. A cue point placed in the video triggers can update text and graphic, keeping the content up-to-date with the other information on screen.

To define and embed cue points, you must either use Flash Video Encoder or import a video clip using the Video Import wizard.

The tutorial for this is CuePointVideo.fla:

1. Start a new file and go to the Import>Video import.
2. From the Encoding panel of the Video Import wizard, click Show Advanced Settings.
3. Select a predefined encoding profile from the Flash Video encoding profile pop-up menu. You can at this point crop-and-trim and do basic editing to your movie.
4. Click the Cue Points tab.

Figure 10.10 *Defining an embed cue point in a video clip*

5. Use the playback head to locate a specific frame (point in the video) where you want to embed a cue point. Select the playback head, and use the left and right arrow keys to locate specific points within the video. This works on increments of one millisecond. A cue point marker is displayed on the slider control at the point where the cue point was embedded. You can use the cue point marker to adjust the placement of the cue point.

6. When the playback head is positioned on a frame where you want to embed a cue point, click the Add Cue Point button. Flash Video Encoder embeds a cue point on that frame of the video, and populates the cue point list with a placeholder for the name of the new cue point, and the elapsed time and video frame at which the cue point is located (this is the time during playback when the event will be triggered). Flash Video Encoder also displays a pop-up menu that lets you select the type of cue point to embed.

7. Specify the type of cue point you want to embed, an event cue point or a navigation cue point:

 - Event cue points are used to trigger ActionScript methods when the cue point is reached, and lets you synchronize the video playback to other events within the Flash presentation.
 - Navigation cue points are used for navigation and seeking, and to trigger ActionScript methods when the cue point is reached. Embedding a navigation cue point inserts a keyframe at that point in the video clip.

255

8. Enter parameters for the selected cue point. Parameters are a set of key-value pairs that you can add to the cue point. The parameters are passed to the cue point event handler as members of the single parameter object.

Broadcasting Live Video

The way you provide the video stream for live video is by using a source of live video, which must be encoded in real-time as it is captured. Unlike the procedure for on-demand video, with live video the capturing, encoding and publishing steps all happen at the same time. Because of the need to setup a streaming service, I am not going to do a tutorial on live streaming video. But I am going to get you started and in addition I will point you to services on the web that offer the Flash Media Server for the streaming video.

The Encoding Best Practices for Live Video at the Macromedia Developer Centre details how to create a broadcast application. I started with this example and I would strongly recommend anybody interested in doing this to start there. In addition the Flash Media Server includes several sample applications and components that let you capture and broadcast live video. So if you are interested and you are going to purchase the media server then there is lots of very useful material there.

I have outlined the steps below for capturing live video.

1. The first step is to create an SWF file that captures and transmits live video, also known as a broadcast application. You can also download a demonstration file from macromedia at http://www.macromedia.com/devnet/flashcom/articles/broadcast.html
2. Create a live streaming swf application on your Flash Media Server or use the video_tutorial.fla supplied on this CD.
3. Create an SWF file that plays streaming video, and publish it to your web site.
4. Flash Player 6 and later contains an audio and video encoder that lets you capture audio and video directly from any camera or microphone connected to your computer. You run a broadcast application, on the computer that the camera is connected to. The broadcast application contains all of the settings that are required to encode the video in real-time. Many of these settings are the same as those discussed in the previous chapter on bit rate and keyframes. Connect a digital video camera or web camera to your computer, and then open the broadcast application that you created.
5. Publish the live stream from the camera to your Flash Video Streaming Service.
6. You must create a web page that allows visitors to view the broadcast through the Flash Player.

Encoding Live Video

Live video can only be streaming video. The other options available for on-demand video are not available for live video. The live video source can come from any camera connected to a computer. It could be a webcam connected to your laptop's USB port or a digital video camera.

I would recommend a capture card as it will make a significant difference to the quality of live video by sending a better video signal to the broadcast application and moving much of the encoding processing from Flash Player to the hardware.

The more frames that have to be displayed in a second, the higher the file size. If you need to reduce the final file size, you must lower either the frame rate or the data rate. Something has to be done if you need to reduce the file size. So it is either through lowering the data rate and leaving the frame rate unchanged, the image quality is reduced to yield a smaller file size. Or you lower the frame rate and leave the data rate unchanged, the file size is reduced but the video may appear to stutter and motion may look less fluid.

A simple tip that will help a great deal is if you ever need to reduce the frame rate it is always a good idea to use an evenly divisible ratio of the original frame rate. So if your movie is running on a frame rate of 24 fps, then you can reduce the frame rate to 12 fps, 8 fps, 6 fps, 4 fps, 3 fps, or 2 fps. If the source frame rate is 30 fps, in most cases you can adjust the frame rate to 30 fps, 15 fps, 10 fps, 6 fps and so on. If your video is more than 15 minutes long and working in NTSC then audio will drift noticeably out of sync if you do not adhere to the 29.97 fps rate or an accurate even division for lower frame rates to 2 decimal points.

Pixel Distoration

In Chapter 9 we looked at the distoration from video to computer screen. It is worth looking at that again through a video editing application which compensate for the pixel aspect ratio discrepancy by scaling the video image in real-time while rendering it on the computer monitor. This is done because the images are intended to return to television monitors for final display. For web display, real-time compensation is not a good approach, given that the video sequence is destined to be displayed on a square pixel monitor, and should be hard-rendered to compensate for the discrepancy.

Chapter 11

3D Animation in a 2D Environment

Animation is basically one trick after another. Whatever it takes to get your vision on screen is the right way. Regardless of the software, whatever you produce will finally be judged on its appeal and quality. So the first thing you should know about 3D and Flash is that there is no 3D in Flash. So, to attempt to make things look 3D in Flash you need to fake it.

You have three options: creating a real 3D scene in a program outside of Flash and bringing in a pre-rendered 3D animation which is to be displayed frame-by-frame as though a movie.

Dynamic creation of mathematically calculated 3D through Actionscript. This requires an understanding of programming and we touch on this and offer a number of examples for the animator to play with. Don't worry if you do not understand the programming as it requires both good maths skills and a deep knowledge of Actionscript.

Combining of effect and movement that give the impression of 3D depth.

If I want to quickly explore an animation sequence before I start to draw it, I use Poser. You can create images, movies and posed 3D figures from a reasonable selection of fully articulated 3D human and animal models in Poser. The Libraries of pose settings and facial expressions are also quite interesting. Poser's interface was very easy to learn, and within a short time I found that I had simulated the walk I needed and I had the individual frames in FreeHand to trace over. Objects, identical in size and shape, can appear to have two vastly different weights by the animator manipulating timing alone. This sensitivity to timing and movement made me find an extraordinary feature of Poser. The ability to explore objects and manipulate their mass and the force required to change their motion made me really appreciate the importance of Poser as an animation tool.

Walkthrough of Mannequin

On 2D drawn animation you work on the basic poses of each scene by drawing poses of the entire character so the timing and acting can be worked out. Once the poses are finalized, then the in-between drawings are created to complete the action. With Poser animation, keyframes are values at certain frames for the articulation controls of a model, these are set up in a hierarchy. The computer calculates the in-between values based on a spline curve connecting the keyframe values.

One of the biggest differences between 2D drawn animation and computer animation is the fact that computer animation is truly three dimensional. An animation sequence can look great from one angle but when you look at it from another, the arms may appear to be going through the body and the knees bending the wrong way. You have to get into the mindset of animating from at least two different views. The benefit of the 3D environment is you can reuse the animation of a scene or parts of the animation in lots of different ways with lots of different camera angles. This is great for storyboarding. If you simply look at a scene of animation from a different camera angle, it will look completely different. By just varying the timing of the motion or changing the motion of an arm or head it will cease to resemble the original.

The computer gives the animator the ability to create images that look real but are based on years of experience of rendered 3D images. You can now give characters different textures and

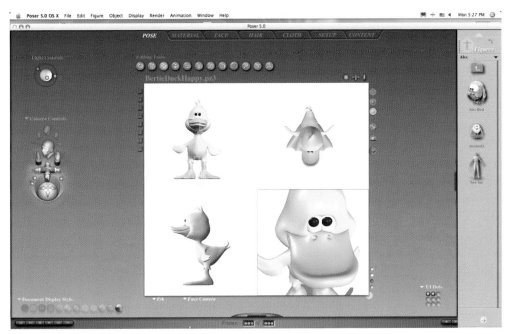

Figure 11.1 *Poser still from different angle of the same figure*

render them with texture mapping, ray tracing and radiosity, which takes the animator down a thought process that I find quite staggering. You can make an object look just like it's made of marble or rubber and really explore the texture by using predetermined sequences. The real challenge for the animator is first to build your model, then you can explore the marble or rubber effects when it is in motion. Although rendering is very much a mechanical process, exploring the process is just an additional tool for the animator's tool box. Breathing life into your character has nothing to do with the rendering and everything to do with the way the object is animated. As you build and create things in the 3D environment you also need to be aware that you still have one more process to go through before the end user can see the product. That process is the conversion of the sequences in .swf format.

If you want to go down the 3D rendered route I would recommend Swift3D, Plasma or my personal favourite for character work Poser. What these products do is render out 3D scenes you build within their programs which are then exported into swf files, movie files such as .avi and .mov, which can then be imported and manipulated within Flash. As with most 3D applications you may not even need to use Flash at all if the final results. Most of the updated 3D applications offer a well developed authoring environment where you fully function Flash movies in SWF format. These products do all the hard and dirty work of 3D animation and rendering reducing the need of Flash to doing nothing more than simply playing frames of an animation. They are a great solution for 3D animated loops or movies, but given their linearity, it can greatly limit the level of interactivity you may want. Poser is a great tool for the animator as not only

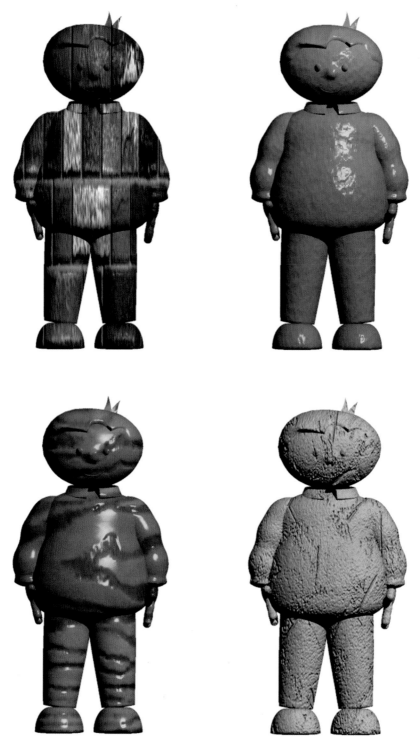

Figure 11.2 *Zak rendered out in lots of different textures*

Figure 11.3 *Swift 3D material and animation library*

does it teach you about movement, but it can also be a quick way of finding out what is possible in your animation and is great for storyboarding. It is the animator's imagination that gives a character its qualities.

3D Modelling for Rendering and Animation

The 3D creation process can be quite complicated, with most applications offering a basic number of tools, usually made up of lathe tools for creating shapes out of a profile and extrusion of shapes. Every rendering or animation begins with a model. Characters, tables, chairs, windows and walls all pull together to form a virtual environment. There are many different approaches to building a computer model; however, there are techniques that can make the process easier, and the rendering smoother and faster. When animating characters, every movement and every action must exist for a reason, but the most important rule in modelling your character is to keep it simple. This rule is so important that you will probably discover that all of the other rules are actually just practical applications of the "keep it simple" principle. Rendering is extremely demanding on a computer, therefore, if you want to do bigger, better and faster rendering projects you only have two choices – buy a bigger, better, faster computer or take maximum advantage of what you've got. Translated, that means keep it simple, and you can do more.

Paint Detail into a Model

Most 3D applications have a paint tool for doing detailed work. Details can often be painted into a model instead of being physically modelled. In fact it is sometimes almost impossible to model some detail. Many things can be painted far more easily than they can be modelled. Transparency and bump mapping can add depth and dissolve sections of simple geometries allowing them to simulate things of much greater complexity. If you look at Zak's star you will see that instead of modelling that detail you can apply it as a texture map. You can of course add this level of detail within the Flash environment.

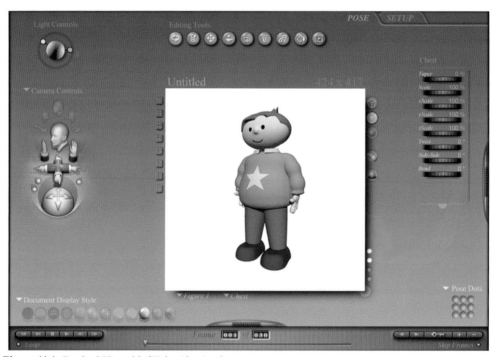

Figure 11.4 *Rendered 3D model of Zak with painted star*

Use Symbols

Using symbols for repetitive items (doors, windows, furniture, etc.) will lower the overall size and complexity of your data file. It will also allow you to edit these items globally, and allows you to hide them to temporarily improve a rendering performance. Once you have built your basic building blocks you can then take them into your Flash environment and use them as library items.

Build a Library of Standard Objects

When building objects for rendering it's worth taking the time to do them well and importing them into Flash for testing. By building a standard library of those objects that you use again and

again, you can spread the cost of building them over several projects. Organizing your library into a growing database of assets will not only be a great time-saver but it will be an important commercial asset.

Planning

Last but not least, you should always spend some time planning out a project up-front before building the actual model. This will help you to decide where it is appropriate to place detail, which areas might be ignored, what resources will be required, etc. Planning will also help you to maintain the project scope, and keep the job on budget.

Readability of Actions

Proper timing is critical to making your model understandable. It is important to prepare the audience for the anticipation of an action and then action itself, and then the follow through or reaction to the action. The balance has to be the main focus on moving your model from A to B with the right look and feel, spending 15% of the time for the anticipation and 15% for the reaction. There are always exceptions to the rules, but you will find unless your object needs to move at lightning speed across the screen, the above rule applies in most instances. In fact the faster the movement, the more critical it is to make sure the audience can follow what is happening. This is done through getting the opening sequence right, the moment of anticipation. You explore this moment of anticipation by setting multiple cameras onto the actions and exploring the different renderings.

The audience's eye must be led to exactly where it needs to be at the right moment to see the action; they must not miss the moment of total anticipation. It is important that the audience sees only one scheme at a time; if a lot of action is happening at once, the main focus will be overlooked. The point of interest should stand out in contrast to the rest of the scene. In a still scene, the eye will be attracted to lots of chaotic movement. In a very busy scene, the eye is attracted to stillness. Actions should always overlap; this slight overlapping is the only way an animator can maintain the flow and continuity between whole schemes of actions.

Poser Walk Cycle Exported to Flash

Curious Labs, the creators of the Poser 6, have added the ability to export to .swf format. This tutorial will explain the process of creating a simple walk, and illustrate the different rendering formats. The final movie plays back a number of the mannequins moving at different speeds across one movie. I have tried to simplify the process of creating a cycle with Poser 6 and then taking it into Flash. The different rendering options should demonstrate how to keep the resulting file size low. Poser has the potential to export large files but our objective is to render small files. My favoured approach is to use the character as a template for redrawing figures

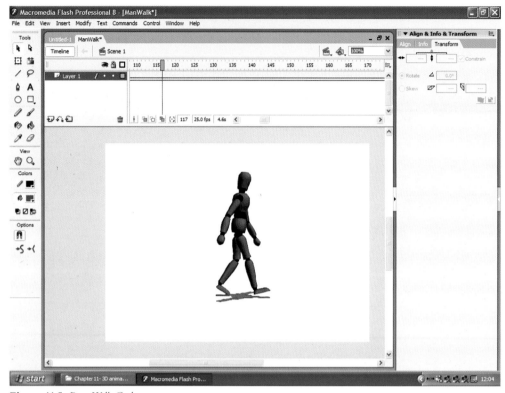

Figure 11.5 *Poser Walk Cycles*

in either FreeHand 10 or in Flash MX, as I always find the characters a little too mechanical directly out of Poser. If you are thinking of using the characters directly, there are many rendering styles that you can set within Poser. This is not an exhaustive selection, there are many more built into Poser but you can create your own styles.

Creating the Walk Cycle

Download a demo of a 3D character animation or use the frame rendering in the mannequin folder on the CD. Timing of a motion can also contribute greatly to the feeling of size and scale of an object or character so whatever figure you choose to use, take into account that it may not look exactly as I have rendered it. If you think about it a large figure has much more weight, more mass, more inertia than a normal figure, therefore it moves more slowly. A quick tip: any changes of movement in a large figure should be slightly slower than a smaller figure whose movements tend to be quicker. This tip is useful if you have many figures on screen. Let's start a tutorial that assumes you are using either your own rendered frames or the pre-rendered frames of the mannequin on the CD.

What you are going to do is to place the animation into a new Flash file as a movie clip. Then we are going to apply a tween to the walk cycle, making the figure move across screen

whilst walking from one point to another. You can see a completed SWF version of this on the CD ManWalk.swf or you can check out the fla, ManWalk.fla.

1. In a new Flash file, create a new movie clip by going to Insert>New Symbol, making sure that you select graphic for the symbol type. If you select Movie instead you will not be able to see the animation on stage unless you test the movie. Inside this symbol, import the .swf file you've just created by going to File>Import. This will create 120 keyframes on your movie clip's timeline. It is also important to note at this stage that a cycle created in most cases will probably repeat frame 1 with the last frame in this instance frame 120. You should remove frame 120 or it will make the animation a little jerky.
2. Return to the main timeline and drag the movieclip you've just created out onto the stage. Motion tween the movie clip so that it moves from the left side of the screen to the right.
3. After testing your movie, adjust the tween and frame rate so you can get the right pace within the movement.

Now that you've got the basics, in every step of the production of your animation, ask yourself why is it there? Does it further the story? To create successful animation, you must understand why an object moves before you can figure out how it should move. So try it out in different camera angles to change the pace. Character animation isn't about making an object look like a character, character animation is about making an object move as though it were alive, and making it look like all of its movements are generated by its own thought process. It is the thought that gives the illusion of life:

"It's not the eyes, but the glance – not the lips, but the smile . . ."

This tutorial should give you an idea of the building frame for 3D in Flash. When it comes down to it you might ask yourself whether it is worth doing this as the file size is prohibitively large because of the single frame animation.

Building 3D Characters

Building characters can be quite a daunting experience for the novice 3D animator. Swift 3D has to be the product of choice as it is easy to learn and is geared towards web animations and the SWF format. It is no surprise that Swift 3D is very popular among Flash developers; it uses a familiar concept of timeline-based animation with keyframes and tweening, plus a few function-curve-style options for customizing the characteristics of keyframes. Swift offers output for geometric solids and very good flat-color output for organically shaped models. The tools are designed and laid out in a clear and intuitive way. If you want to move models around, do some simple animation in a package which is easy to learn and use – Swift is a good choice. You can get a demo version of it from www.erain.com.

Launch Swift 3D. The first thing I do is to split the active viewport by selecting View>Secondary Camera. If you have multiple monitors, you can undock the property tools palette and put it on another monitor to stop your view from becoming totally claustrophobic. Your viewports

should be nice and big. When you mouse over any tool button in Swift 3D, you get a pretty good tooltip. Most of them say exactly what they do.

The basic nature of the viewports in Swift 3D is a little different from most 3D packages. In 3D applications, when you build an animation, you drop an actual camera into your scene, complete with all the controls that a real-world camera has. You can follow what the camera is seeing by opening a separate window for it and then toggling back to the regular viewports to move your objects around your scene in a familiar environment. In Swift 3D, the viewports are the cameras, and vice versa. There are two main areas of impact where this is concerned. First, it is easier to keep track of simple animations, because you know exactly what you are getting. The second way this affects you is that you have to be very careful when you animate cameras, this is because you only get one camera to capture your animation. If you get creative, you can animate a standard view (top, bottom, etc.) and use it as a secondary camera, but then you lose your ability to view and select in that view.

The first time you click in a viewport, you activate that viewport. The next time you click, you select the object you click on, or pan the viewport, depending on where you click. Rotation is handled with Swift 3D's transformation Crystal Trackball tool. You can constrain the rotation of objects to a number of increments, which is especially handy if you are a beginner with 3D concepts.

Swift 3D does not contain the sophistication of Poser, but unlike Poser the Swift environment does allow you to build models.

2D Trying to be 3D

Before Flash, code-driven animations had to be written in lower-level languages such as C and Java, which needed a lot more programming expertise, were less robust (particularly Java) and took a lot longer to write. With the development of ActionScript, a high level language, a lot of the hard work is already done for you, for example, you do not have to tell it how to move an asset, you just have to tell it where to put it. ActionScript also has a robust structure to code around (the Flash Interface) which makes it much easier to get to grips with.

Code-driven animation consists of a number of static elements that use a function to move over a mathematically generated path. The beauty of code-driven animation lies in its flexibility, and the parameters of the animation can easily be changed to manipulate your animation without having to re-draw it. Code-driven animation is also very memory-friendly, and only needs the space needed to store the lines of code. You can also reuse lines of code in other code-driven animations, making them very efficient. The fact that you can reapply your code also means that you can easily use a favourite technique over and over without having to re-draw all the frames. Our examples are a source of extra functionality for your animations, and give sophisticated results with minimum fuss and effort. The following examples are a demonstration of these techniques

that use complex programming. It is not intended that the animator turns into a programmer to understand the engine behind these effect. They are here to demonstrate a whole different approach to 3D animation in a fun way that can be applied to people's projects.

Parallax Scrolling

Parallax scrolling is the effect one sees when looking at a scrolling series of "layers" scrolling at different speeds. Each layer represents a distance from the viewer (the foreground, the background, far in the distance, etc.). As the entire view "scrolls" or moves in a 2-dimensional direction (no depth movement), the layers scroll at a different speed. The farther away from the viewer a layer is supposed to be, the slower it will scroll. This creates the illusion of depth. Parallax scrolling is used extensively in computer games and animations.

The beauty of parallax is that you can place a static character in the foreground, and then change how fast it moves simply by speeding up or slowing down the speed of the scrolling. The example in this chapter uses a desert scene that can easily be modified, all you need to do is change the graphics in each movie clip that makes up the scene. There are four movie clips, Background, Far, Middle and Near, and you do not have to change the code to change the background, just the graphics. You will notice that the three levels of the scene all move at different speeds, this variable is set in the first frame of the Parallax Background movie clip. The movie clips are tiled across the screen, and the second frame of the movie clip sets each level of the scene to start its movement again if it has moved half way across the main scene.

Starfield

A starfield is a nice effect that can add a great sense of depth to your movies if you are building space animations. The "Star Field" movie clip can be dropped straight onto your movies, and only requires a small amount of tweaking to work in any size of movie. To see the ActionScript that drives the movie open the "Star Field" movie clip in editing mode and then select keyframe, one of the actions layer. Here you need to set the width and height of the movie you will be dropping the starfield into, and the rest of the calculations are done for you. Check out the starfield.fla.

The star graphic is a tweened animation that is called "Moving Star", which can be found in the "Star Field Assets" folder in the library. You can change the graphical assets in this animation to make the stars in the starfield appear however you would like.

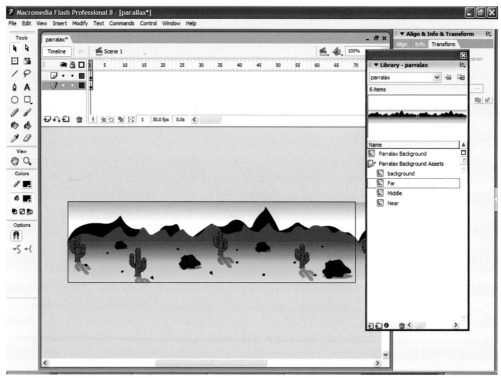

Figure 11.6 *Parallax scrolling from the parallax.fla*

3D Effects

There are many different degrees of 3D you can apply into your Flash movie. This can range anywhere from a simple zoom in and out of a movieclip to a dynamically drawn spinning 3D object. All 3D revolves entirely around one concept, perspective scaling. This is the thought of having a position and scale of a shape on the screen based on its theoretical position away from the screen itself. This then becomes its 3D positioning. With 2D positioning on

Figure 11.7 *A 2D and 3D chart*

the screen you are always the same distance away from the screen. So the only directional movement is either left and right along the horizontal or x axis or up and down along the vertical or y axis. Movement towards and away from the screen is totally interpreted as scaling and not depth.

The z axis doesn't exist. Flash only reads the x and y axes. The z axis is where perspective scaling comes to play and is created by the programmers.

The view of the z axis is looking down on or into the z axis given your default view in x and y, you are unable to detect the movement along the z axis. To see any movement, you need to create a set of visual clues. The two main techniques for showing that change is scale and overlapping.

Interpretation of Scale through Z – The Depth Scale

As a shape moves away from you it gets smaller. When moving closer, shapes get bigger. The same applies in *distances* travelled. If a man in the distance begins walking to the left, the journey to your eyes seems very small. On the other hand, if a man very close to you walks left, that distance would seem much greater in comparison. So the further away an object is in 3D space, or the greater its value back along that z axis, the smaller that object is in both size and in its rate of movement along the x and y axes.

So what you need to do in Flash is to develop a percent of scale from which to alter a shape's scaling for size and position or movement. That percent will be based on a set z values – the value kept to determine how far back in 3D space, or how far along the z axis, a shape in that 3D space is positioned.

Overlapping

If there is more than one 3D object moving around along that z axis, you will need to define how they overlap each other to show correctly who's closest and "on top". This is called overlapping and is based on the z value. In Flash, the swapDepths method allows you to control the transposition or arrangement of movieclips on the screen. This method can be used with other movieclips to target numerical value. It's the numerical value that puts a movieclip above other movieclips with a lower depth value. This makes it easy to say swapDepths to the z value. If swapDepths was used directly with the z value, shapes further back in space would have a higher z values, they would actually be put on top of those shapes closer with smaller z values. This is opposite of the desired outcome. To fix this, all you'd need to do is reverse the z value by turning it into a negative z. So, when using the swapDepths with a −z, the distant shapes have a smaller value and get placed below those in front. Any screen object such as movieclips, buttons and textfields, cannot share the same depth in any given timeline. Setting that depth, will knock out any other object in that depth by default, Flash will just put the new object in the depth that the old object was in. It just literally swaps the depths of those two movieclips as if the other movieclip was passed in swapDepths and not a number.

The Origin

Representations of 3D on your computer screen are all based on the three axis–coordinate system (x,y and z) around its origin or centre point. This is the point (0,0,0) – a 0 value for each x, y and z. The way Flash is set up in 2D, the (0,0) point for x and y, or 2D origin, is located in the upper left-hand corner of the screen. For 3D, the (0,0,0) point would then too be in the upper left-hand corner of the screen as well. Being there, though, would mean that the viewer would be looking at the 3D scene you've made for yourself at an odd angle. What you need to do is centre that scene for a straight-on view. In 2D space, for example, you always work not all around (0,0) but somewhere off to the right and down towards the centre of the screen. Similarly, the same will have to be done with any 3D scene you make, otherwise you will be looking at things from an odd angle. Straightening things up require having to manually shift that origin position to the centre of the screen so that the 3D scene can be seen head on and not at an angle. Just as in 2D, though, this is simply a matter of throwing in an offset value for both x and y. When you want a movieclip in 2D to be in the centre of the view, you set its _x and _y values to a position in the centre of the screen. To get a 3D scene in the centre of the screen, you'd do the same.

Zooming Figures

Here there are three movieclips, all human figures, being moved back and forth in 3D space being scaled and transposed according to their positions in that space. This scaling and movement is based on their respective z values assigned to each figure's movieclip in Actionscript.

Steps to Create this Animation

1. Draw out or import whatever shapes you wish to move within the 3D space. Or you can use the files on the zoom.fla. Create three items give each a name (Tom, Dick and Harry). The grid simply gives the appearance that there is a ground for the figures to move on. It has nothing to do with any 3D calculations.
2. You then need to setup some variables. The first two variables that are going to be defined are the origin or offset and the focal length of the perspective view. The offset is to make sure everything being placed in 3D is set in the centre of the screen. If our 3D calculations are based around the point (0,0), the imagery would be thrown up in the upper left-hand corner of the screen. The origin is an object with x and y values to allow that shift of the imagery to the centre of the screen.
 The focal length is a variable that sets, as it implies, the focal length of view which determines how much perspective is seen for any given position in space. The larger the focal length, the less things seem to distort in any span within a distance along z. The value 300 is pretty average, so that will be used here.
3. Define variables for each figure to represent their position in 3D space. This will require x, y and z properties – one for each axis of movement/positioning. These values will determine its "real" position. With the focal length you can determine how to represent each figure on the screen visually as it should appear on a 2D screen though it's technically in 3D. Give each a slightly different x and z position so that they are staggered in the space.

Figure 11.8

Figure 11.9 *Zooming and swapDepth animation zoom.fla*

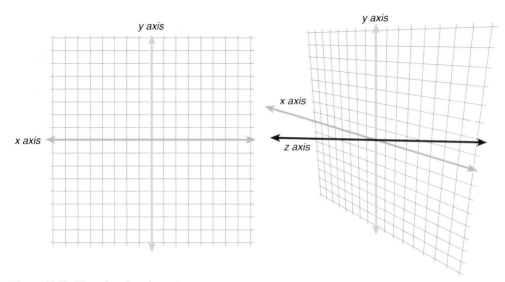

Figure 11.10 *The scaling along the z axis*

Along with the x, y and z, another variable, dir, will be defined for each figure. This represents the direction of each figure as it moves in the screen. Each figure is either moving forward or backward based on the value of this variable dir. One more variable, speed, will be added to determine how fast the movement of each figure is in the scene.

4. A function must now be created to handle the onEnterFrame event of the figures as they are moved within the 3D space. This will move each figure back and forth along the z axis using speed and the dir variable of each figure. It will also calculate the needed scaling, positioning and overlap for each figure so that it appears to be in 3D on the 2D screen. This function operates on one figure at a time, so each figure would need to have this function defined for it to be moved and scaled. First it is written as a function and then set for each figure's onEnterFrame event. All three figures will use that same function for their enterFrame. And that function is as follows:

```
backAndForth = function(){

this.z += speed*this.dir;

if (this.z > 500){

this.z = 500;

this.dir = -1;

}else if (this.z < 0){

this.z = 0;

this.dir = 1;

}
```

The first piece of the function just moves a figure's z value using speed and the dir variables.

3D starts to come into play on scaleRatio. The scaleRatio variable is derived from the figure's current z value and the focal length using the perspective formula. This is then used to correctly move and scale the figure for its appearance on the 2D screen. Position (_x and _y) is based around the origin's position along with scaled x and y values for that figure and size (_xscale and _yscale) is based on 100% times the value of scaleRatio. With that, you have a correctly positioned and scaled clip on your 2D screen that appears to be in 3D.

```
var scaleRatio = FocalLength/(FocalLength + this.z);

   this._x = Origin.x + this.x * scaleRatio;

   this._y = Origin.y + this.y * scaleRatio;

   this._xscale = this._yscale = 100 * scaleRatio;

   this.swapDepths(-this.z);
```

The only remaining code is the swapDepths which is based on z. Setting the depth of the figure to a negative z value assures that if it's closer to view its on top of other figures in the scene.

5. The last step is setting that backAndForth function to be the onEnterFrame event functions for each of the figures so that each figure is positioned and scaled to every frame accordingly.

```
Tom.onEnterFrame = backAndForth;

Dick.onEnterFrame = backAndForth;

Harry.onEnterFrame = backAndForth;
```

This exercise has been about setting your own values for 3D positioning in x, y and z and use the scaleRatio (based on the focalLength variable) to determine the actual _x and _y positions on the screen so that on the screen, in 2D, they appear to be in 3D. The zoom.fla has a full working example of this tutorial.

Shape Movement Versus Camera Offset
The previous examples showed shapes moving in an apparent 3D space. Though the shapes are able to move about and reposition themselves, the view itself, or *camera*, cannot. A camera represents a theoretical location in a 3D space that acts as the point of view of that space. As with the previous examples, the camera there didn't move, or really did anything at all, so there was really no need to even acknowledge its existence. Sometimes you will want to move the camera to allow the view to change in respect to everything else in your 3D world. For the most

Figure 11.11 *The moving.fla demonstrates the movement of both object and camera*

part, all a camera really is, is a set of 3D offset values for your 3D shapes. With a camera moving towards an object, you get the same effect as if the object was moving towards you.

We can demonstrate this concept by contrasting shape and camera. Here, we'll have a single object, back in space along the z axis and then using figure movement and camera movement, contrast between the two.

There are two parts to this example. The first is with normal movement of the figure back and forth and the other is with the figure still and the camera moving back and forth. The figure movement is nothing new – the only difference there is the inclusion of a centred "theScene" movieclip to prevent the need for an offsetting origin object. As you can see cameras don't move, they move everything else to adjust for what would happen if they did.

Panning the Camera

Programming can be applied in Flash 3D to do some camera panning. This involves some basic trignometry to rotate the camera view or to decide in what direction the camera is pointing. The camera is looking straight into z, in panning the camera you need to spine the z axis around until you'd be looking at x, and from there, back to z again. The y axis remains up the whole time, so this rotation is based in the x and z axis space.

Figure 11.12 *Spin showing the spinning panning cameras*

It is not the camera that is rotating rather everything else in the 3D scene *around* the camera, just as with before when moving the camera, it wasn't so much moving the camera as it was moving everything in location to it. The same thing applies in rotation as with movement. You can see an example of this on the spin.fla.

Simple Camera Panning

The panning motion alone doesn't do much in terms of depth, so the 3D-ness of this example may be limited but is great for building interactive buttons. The file on the CD Buttons.fla is a flash lite file for mobile 60 series phones.

Figure 11.13 *Panning the camera around viewing figures (LEFT and RIGHT keys) panning.fla*

Rotation Outside the Camera

The whole concept of panning is rotating shapes in the 3D space around the camera. This puts those shapes in front of the camera which are viewable, as well as rotates shapes behind the camera which are not. Anything below a relative 0 z is technically behind the view and hidden. However, we can take advantage of the flexibility we have with the focal length and rotate images around the (0,0) location of the camera without hiding any of the shapes. This will give the impression of shapes rotating around a centre point but, since we can see the shapes on the inside of that centre point, that centre point won't be seen as the camera centre but, rather, a point in front of the camera. This allows us to easily rotate shapes in a fully viewable circle right in full view on the screen.

Panning Camera Forward and Backward

The next step is to move forward and backward as well as panning for left to right. It gets boring if your camera movement is always facing the same direction. Now, however, the camera is

facing other directions so no longer would forward movement be associated with *just* the z value. It will include z and x. How much, depends on the rotation of the camera. If you think back to the triangle and rotating an object based on sine and cosine, what you are basically doing is moving an object from the origin and placing it cosine of angle times radius spaces along the x and sine of angle times radius spaces along the y, ultimately moving it all in that instance in a diagonal.

What if you repeat that process without rotating the line any further and just kept moving the shape by that x movement and that y movement? What you would get is motion in the direction of that angle! As the angle changes, so would the movement, but based on that shape's current position as long as those values kept getting *added* on to its current.

Basic Shading

Shading is another technique that can add a lot of depth to a shape in a 3D space. Basically, you're just colorizing your shapes based on some factor like rotation or, surprise, depth. Perhaps you want to give the impression of fog or night. Shading faces white or black as those faces recede into the distance can give these effects. What about shading based on a light source like a spotlight effect. Fog, however, is fairly easy and can be beneficial if you want to prevent having to worry about objects being drawn far off in the distance.

Simple Fog

Given any shape in your 3D scene, you have a specific coordinate telling you where that object is in relation to the view in terms of z. Using this distance, you can apply a fog of some sort by tinting a shape or face directly proportionate to that z value helping you achieve a greater sense of depth. We'll bring back our two rows of figures and add fog to them.

Basically, the only difference here is the inclusion of the fog. This is a color addition using the BlurFilter class. It lets you apply a blur visual effect to a variety of objects in Flash. A blur effect softens the details of an image. You can produce blurs that range from creating a softly unfocused look to a Gaussian blur, a hazy appearance like viewing an image through semi-opaque glass. The blur filter is based on a box-pass blur filter. The quality parameter defines how many times the blur should be repeated. The fog.fla uses this set of filters.

Integration of Pre-rendered 3D Elements

Having balls and flat figures can be fine to a degree, but often, your scene may require more than that flat look. Using pre-rendered elements, either hand-drawn, or more commonly pre-rendered in an external 3D application imported into Flash can be used to enhance your 3D scene by adding a more realistic 3D impression.

Such elements would require a fully rendered frame-by-frame rendition with 360 degrees of rotation. That way, no matter what angle you are looking at the object, you will be able to see

Figure 11.14 *Fog applied to figures in the distance*

its correct side. Using these angles of view, we can stick that element into a 3D scene to give a better sense of realism though only requiring Flash to calculate position and scaling for one single movieclip.

Shapes and Fills

Wire frame, though cool and very 3D in effect, has its limitations. It is *just* a wire frame and can only go so far for you depending on what you want to do or make. A way to really add a 3 dimensional feel to your shape, whatever it is, is to make it have solid sides and not just lines outlining them. Luckily, the drawing API in Flash also allows us to create those lovely sides

Figure 11.15 *API rendered 3D shape in Flash 8*

with fills as well as draw lines. Using these fills we can add some real plasticity to our 3D shapes. The addition of fills in the drawings is initially, and in its basics, not too difficult to include. After all, it is just a matter of correctly throwing in the beginFill and endFill commands within the drawing operations. Adding these fills introduces a whole lot more of maths and is out of the scope of an animation book.

Chapter 12

Flash Professional Tips and Tricks

This chapter is all about those little snippets that can make the difference to an animation production. They are very loosely split into Animation, Flash 8 application and ActionScript. Sometimes the difference in the success is purely because you organized a large project well or you spell checked the title. It is unlikely that even the most ardent of Flash animators developer will not find something interesting in this chapter.

The features I cover in this chapter will save you countless hours by reducing mouse clicks. It has been compiled from best practices from a number of different sources and then worked on in real situations over a number of years and then finally adapted to Flash 8.

For me Code hints and Code completion were probably the biggest time-savers in Macromedia Flash 8. Its little features like these that add up to a substantial improvement.

Figure 12.1 *Code hints in use*

Animation Productivity

Here are a few things to keep in mind when considering image and animation formats. Joint Photographic Experts Group (JPEG), is a 24-bit file format and is generally the best choice for compressing photographs, naturalistic artwork, grayscale images and similar material. As a JPEG file is compressed, it throws-out data and is referred to as a "lossy" format. You can heavily compress your images but this will cause "artifacts", where portions of the image begin to cluster together.

Graphic Interchange Format (GIF) is the format of choice to compress lettering, simple cartoons and line drawings. GIF images are often made up of lines and curves, which are mathematically

defined. GIF files are often composed of few colors and compress well. Other common animation formats are Audio-Video Interleaved (AVI – a desktop video movie format from Microsoft), Moving Picture Experts Group (MPEG), MOV (Quicktime), SWF (the Flash Player format) and Shockwave.

Portable Network Graphics (PNG) is worth noting because it offers a 48-bit true color setting and a 16-bit grayscale setting. One advantage is that PNG is lossless, meaning that no matter how many times you save the file, you will not lose data. This is important for maintaining high-quality images. Another factor favouring PNG is gamma correction, a setting used by many image manipulation programs to measure brightness and contrast levels. PNG automatically adjusts the gamma setting and makes sure that images look correct across platforms. PNG files are almost always larger than JPEG images. Another issue involves file size and compression. PNG files tend to be 5 to 10 times larger than a standard JPEG file. Don't recompress JPEG files with PNG because artifacting can become a problem. And don't add alpha channels to opaque images because this can create large files unnecessarily.

The following animation tips are designed to help you make clear decisions about animation aesthetics, implementation, storyboarding and optimization, without sacrificing quality:

A single animation on a web page will overwhelm all static images, so placement is important. Before you place a finished animation on your site, be aware that if you have more than one animation on a single page, the effect can overwhelm the viewer, rather than draw them into your page.

Always start your animation with a storyboard. For a simple animation make a simple storyboard for a complex big budget production take more time. Your storyboard, must detail the animation in a precise fashion with sketches, scripts, transitions and timing. Refer to Chapter 2 for more information on storyboarding. Working out your difficulties on a storyboard is so much easier. A key issue in storyboard design is complexity. Often, we create animations that are striking in theory, but impossible to complete. Whenever possible, keep it simple. If necessary, you can always add detail later.

When a figure is in motion the eye is not able to discern information. This means that the details in a moving figure can be much reduced and put back in on the last frame.

One useful method for compressing image maps or bitmaps is "Weighted Optimization", available in Photoshop and ImageReady. Weighted Optimization uses an alpha channel to vary compression settings across an image. For areas where quality is important, you use a lower compression, and in areas such as sky, you use a higher compression. The end result is an image of a small size but certain areas are of a high quality. Weighted Optimization gives you control over GIF dithering, lossy GIF settings and JPEG compression.

Flash 8 Workflow Techniques

Macromedia Flash has a spell checker, you should use it, after all how many times have you had to go back and change things because of typos. Also the Find and Replace function like many unique Macromedia Flash features allows you to search not only for text but also for font usage or even for specific colors used in graphics. These features save you production time that can really add up.

Snap Align

You can now pick up and move objects and you'll see dashed lines appear to indicate alignment with other objects. This is very intuitive and useful.

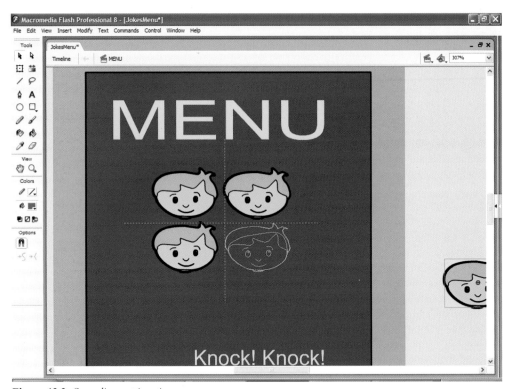

Figure 12.2 *Snap alignment in action*

Productivity and Performance

Create custom shortcut keys (Edit>Keyboard Shortcuts) to increase productivity.

Launch image editing applications directly from the Library palette to edit an imported bitmap.

Give layers of the Timeline intuitive names.

Use Shared Libraries to contain media elements common to several loaded movies.

When incorporating sound, use MP3 files, the smallest sound format, whenever possible.

Use symbols, animated or otherwise, for every element that appears more than once.

Limit the area of change in each keyframe, make the action take place in as small an area as possible.

Break larger movies up into smaller movies and join them together using the Load Movie action.

For better performance, avoid animating bitmap images. Use bitmap images as background or static elements.

Use the Bandwidth Profiler and the Show Streaming option to simulate the playback of a movie over different connection speeds.

Streaming performance of Flash movies can be enhanced by reducing the amount of information in the first few frames of the movie.

Using simple vector graphics will give better playback than bitmap images.

Use the "Generate Size Report" option in the Publish Settings dialog as a tool to help optimize movie playback.

Test your Flash movies early, often, and on all browsers and platforms that you anticipate visitors will use to view your site.

Use the lowest acceptable bit-depth and sample rate for imported sounds in order to achieve the smallest file size.

Minimize the number of alphas, gradients, masks and tweens you use at any given time to improve performance.

Publishing

The Property inspector has a built-in option to maintain aspect ratio so that when you type numbers to resize shapes, the proportions don't change.

If shapes or text appear jagged when playing a movie, check to see if the QUALITY attribute of the OBJECT and EMBED tags is set to HIGH.

Flash movies can scale to fill the entire browser window or can play within a specific area. Use the HEIGHT and WIDTH parameters in the Publish Settings dialog to choose one or the other. Bitmaps can distort if you allow the movie to scale within the HTML page. To avoid this, use an exact pixel HEIGHT and WIDTH for the dimensions rather than percentages.

The HTML Templates used by Flash can be modified to streamline and personalize the publishing process by adding HTML or other tags.

If you cannot view the Flash movies off a Web server then the server's MIME types might need to be set, so that it recognizes the SWF file format and loads the appropriate plug-in.

History Panel

This is more than just a glorified "undo" function, the code generated in the History panel uses the JavaScript Flash (JSFL) language that controls the Macromedia Flash workspace. JSFL lets you automate repetitive or intricate procedures. Almost any development task that you usually do by hand can now be recorded and played back using script that runs at author time. The History panel tracks your moves using the same language. The History panel shows a list

Figure 12.3 *The History Panel*

of the steps you've performed in the active document since you created or opened that document, up to a specified maximum number of steps. The slider in the History panel initially points to the last step that you have performed. By default, Flash supports 100 levels of undo for the History panel. You can select the number of undo and redo levels, from 2 to 9999, in Flash Preferences.

You can use the History panel to undo or redo individual steps or multiple steps at once. The History panel is a record of steps in the order in which they were performed. To remove deleted items from a document after you undo a step in the History panel, you use the Save and Compact command. Clearing the history list does not undo steps; it merely removes the record of those steps from the current document's memory. Closing a document clears its history.

To Open the History Panel: Select Window>Other Panels>History.

Shadows

Without shadows, a character may seem to "float" above the ground level. Since shadows give a visual clue of where a character or object touches the ground, shadows also help in adding

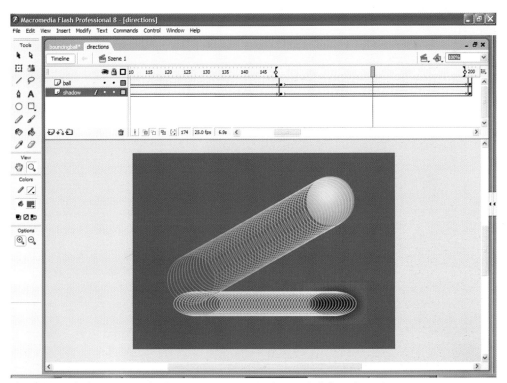

Figure 12.4 *Shadows suggesting height on isometric motion (see bouncingball.fla on the CD)*

depth to perspective drawings. For an interesting example of how shadow can even suggest motion in a stationary object look at these two files on the CD bouncingball.fla, directions.fla. I used the new filter feature in Flash 8 to blur the shadows. In the directions.fla you can see how shadows are especially helpful when drawing in an axonometric or an isometric perspective.

It's a good idea to use separate layers or folders for sound files, ActionScript, frame labels and frame comments. This helps you find these items quickly when you need to edit them.

Movie Explorer

It used to be impossible to find scripts hidden within movie clips until the advent of the Movie Explorer. Using the row of buttons along the top of the window you can activate only the scripts view. You'll see in the list all the scripts you've written, and probably a few that you thought had been lost forever. Typing a keyword in the find box further narrows the list of scripts, making it even easier to find. If someone's determined to hide their code there are lots of places in Flash to do so. The most useful and the only tool for detecting code at the limits is the Movie Explorer. Select Window>Movie Explorer for a bird's eye view of all the assets in the current scene including any scripts attached to frame, button or a MovieClip. This same window will allow you to search for text fields containing a certain word. There is no easy way to search the entire

Figure 12.5 *The Movie Explorer window with only ActionScript selected*

movie but you can search one scene at a time. To filter the display to show only scripts, select the show actions scripts icon under the show menu, and deselect all the other icons.

ActionScript for the Animator
ActionScript – The Language

Flash was born out of the lack of good animation capabilities for the web. With basic web capabilities limited to animated GIFs, Java applets and later DHTML, Flash provides much better animation support by an animation framework, mixed media (including vector graphics, bitmaps with multiple levels of transparency, anti-alias text and sound) and a single cross-platform scripting model. Creating animated clips and movies in Flash is much easier than creating similar effects in DHTML; there is less coding involved and Macromedia controls the Flash plug-ins for various platforms; making things work across different platforms is much easier. Support for vector graphics and the graphic transformation capabilities also decreases download size.

The Action Panel

Familiarize yourself with its features, because it's a panel you will use time and again. You want as much room as possible to see your scripting especially if you start to make long comments,

Figure 12.6 *The Action Panel*

so open it up as wide as possible. If you are using script assist, all the syntax can be chosen from the "+" button at the top left-hand-pane. Once you have a nice size window, don't keep opening and closing it: use its windowshade feature to collapse it into its title bar by double-clicking the title bar on Windows, and clicking the top right button on a Mac.

Using the Actions Panel

To add an action to a Flash document, you must attach it to a button or movie clip, or to a frame in the timeline. The Actions panel allows you to select, drag and drop, rearrange and delete actions. You can use the Actions panel in two different editing modes: script assist and expert. In script assist you write actions by filling in parameter text boxes. Script assist is especially helpful for users who are new to ActionScript because it prevents most typos and syntax errors. However, experienced scripters will most likely find it easier and faster to use Expert mode and simply typescripts directly. In expert mode you write and edit actions directly in a Script pane, much like writing scripts with a text editor.

To Display the Actions panel choose Window>Actions or press F2 (or F9). To activate the Actions panel select an instance of a button, movie clip or frame and the Actions panel title changes to reflect the selection.

Navigate through the Actions Toolbox (see Figure 12.7)

To select the first item in the Actions toolbox, press Home on your keyboard. To select the last item in the Actions toolbox, press End on your keyboard. If you want to select the previous item in the Actions toolbox, press the Up Arrow or Left Arrow key. Press the Down Arrow or Right Arrow key to select the next item in the Actions toolbox, to expand or collapse these folders, press Enter or Spacebar. To insert an item into a script, press Enter or Spacebar. To scroll up a page of items, press Page Up, to go down a page of items, press Page Down. To search for an Actions toolbox item by initial character, type the character, but remember this is not case-sensitive. You can type the character multiple times to cycle through all the items that start with that character.

Working in Script Assist

Flash opens the Actions panel in script assist. Flash 8 opens the action panel with the script help turned off). This is the point to start to build scripts by selecting items from the Actions toolbox, the list on the left side of the Actions panel. The Actions toolbox separates items into categories such as Actions, Properties, Objects and more. It also provides an Index category that lists all items alphabetically. When you click an item once, its description appears at the upper right of the panel. When you double-click an item, it appears on the right side of the panel, in the Script pane.

In script assist you can add, delete or change the order of statements in the Script pane; you can also enter parameters for actions in text boxes above the Script pane. The Actions panel also lets you find and replace text, view script line numbers and "pin" a script – that is, keep a script

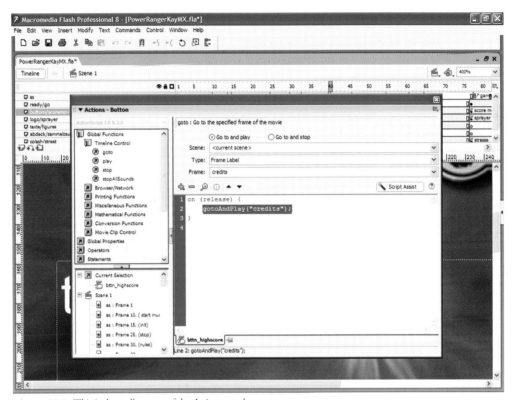

Figure 12.7 *This is the toolbox area of the Actions panel*

in the Script pane when you click away from the object or frame. You can also use the jump menu to go to any script on any object in the current frame.

To display the Actions panel in script assist you need to select Windows>Actions. Click the arrow in the upper right corner of the Actions panel to display the pop-up menu, and choose Script assist and click anywhere in the Actions panel.

Naming Strategies for Flash

Although Flash 8 offers flexibility in naming objects and freedom in coding practices, following some basic naming conventions will help to ensure proper playback. The use of naming conventions when coding also helps to make scripts easier to understand, troubleshoot and share with others. This document lists some common naming conventions, when programming in ActionScript and other languages.

Use unique names

Avoid giving two different objects the same variable name. For example, if a movie clip instance and a text field both have the same name, problems may arise when changing properties of one or the other. Giving each object a unique name can help avoid this issue.

Avoid spaces or special characters

Spaces, periods or special characters often have special meaning to the Flash Player, signifying the end of a statement or part of an expression. Names can include underscores, letters and numbers. Punctuation or other special characters should be avoided.

Start with a letter

Using a variable or object name that starts with a number can cause confusion. Instead of using the expression "*8frame*" to identify a frame label, use "*fram8*". Variable, function and object names can contain numerals, however the first character should be a letter.

Use multi-word descriptive names

For example: *firstNumber*, *myDate*, *timeCounter*, *lastName*. This naming practice is useful when troubleshooting or sharing scripts with others. Generally named variables such as *x*, *i* or *j* don't give much information as to their use and can be difficult to keep track of when troubleshooting. The variable *lastName*, however, instantly gives clues as to what the variable is for.

Match cases

Be sure to be consistent with capital and lower case letters. If an object is named *myTextFader*, be sure to refer to it throughout the movie as *myTextFader*, and not "mytextfader" or "MYTEXTFADER".

Avoid reserved words

Words like "date", "this" and "goto" have special meaning for the Flash Player. Using these words as variables may cause problems when the script is executed. One way to avoid this is by using multi-word descriptive names for variables, as suggested above. For example, use *birthDate* as the name for a variable holding a date. In addition to avoiding conflicts with the reserved word "date", the result is a more descriptive variable name.

Declare variables with *var* or *set variable*

Although Flash does not require using *var* or *set variable* to assign a value to a variable, it's a good practice. For example, it's perfectly acceptable to declare a variable and assign it a value in one step, as in the following:

```
userName = ``Mary'';
```

However, the code is more readable if the variable is declared before being assigned a value:

```
var userName = ``Mary'';
```

This clearly identifies the statement as a variable assignment.

Include a legend

This is especially helpful in complex projects. For example, if you use certain prefixes to identify different types of variables and objects, it is helpful to define your naming system. Use the comment statement in ActionScript, or create a "ReadMe" or "legend" symbol in the library with text that explains what each prefix means.

View a Description of an Action

To view a description, click a category in the Actions toolbox to display the actions in that category, and click an action. Select a line of code in the Script pane and the description appears

at the upper right of the Actions panel. To add or delete actions in the Script pane click a category in the Actions toolbox to display the actions in that category. Either double-click an action, drag it to the Script pane, or right-click (Windows) or Control-click (Macintosh) and select Add to Script. Click the Add (+) button and select an action from the pop-up menu. Deleting an action – select a statement in the Script pane. Click the Delete (−) button or press the Delete key. To Move a statement up or down in the Script pane you need to Select a statement in the Script pane, then click the Up or Down Arrow button or select the statement and drag it up or down.

Search for text in a script, do one of the following

To go to a specific line in a script, choose GoTo Line from the Actions panel pop-up menu; then enter the line number. To find text, click the Find button above the Script pane, choose Find from the Actions panel pop-up menu. Enter the text you want to find in the dialog box that appears.To find text again, press F3 or choose Find Again from the Actions panel pop-up menu.

To replace text, click the Replace button above the Script pane, choose Replace from the Actions panel pop-up menu. Enter the text you want to find and the text you want to replace it within the dialog box that appears.

In expert mode, Replace scans the entire body of text in a script. In script assist, Replace searches and replaces text only in the parameter box of each action. For example, in script assist you cannot replace all gotoAndPlay actions with gotoAndStop.

You can Navigate between scripts by using the jump menu at the top of the Actions panel and choose a script from the list.

Pining a Script to the Actions Panel

Click the Script Pin button. The Actions panel displays the script in the Script pane even when you click away from the object or frame.

To view line numbers in the Script pane, do one of the following

Select View Line Numbers from the View Options pop-up menu above the Script pane.
Select View Line Numbers from the Actions panel pop-up menu or you can
press Control+Shift+L (Windows) or Command+Shift+L (Macintosh).

To print actions

All the ActionScript from the Actions panel pop-up menu can be printed by choosing Print. The Print dialog box appears or choose options and click Print.

The printed file will not include information about the source Flash file, so it's a good idea to include this information in a comment action in the script.

Working in Expert Mode – The Default Mode

When switching from script assist to expert mode a few things change in the Actions panel. The most obvious change is the Reference field and the parameter field sections are removed. In expert mode you create scripts by entering ActionScript directly into the Script pane on the right side of the Actions panel. You edit actions, enter parameters for actions, or delete actions

directly in the Script pane, much as you would create a script in a text editor. You can also use the Actions toolbox (the left side of the Actions panel) and the Add (+) button to add actions to the Script pane, but the parameter text boxes don't appear. You cannot move statements with the Up Arrow and Down Arrow buttons or delete statements with the Delete (−) button. Like script assist, expert mode lets you use the buttons above the Script pane to find and replace text, set and remove debugging breakpoints, view line numbers and insert target paths; it also allows you to use the jump menu and the Script Pin button. In expert mode you can also check the syntax for errors, automatically format code, and use code hints to help you complete the syntax. In addition, the punctuation balance feature helps you pair parentheses, braces or brackets.

To display the Actions panel in expert mode, Select the Script Assist button in the ActionScript panel.

Checking Syntax

Click the Check Syntax button. Choose Check Syntax from the Actions panel pop-up menu. Syntax errors are listed in Output window.

Auto Formatting

ActionScript gives you flexibility in how you format your code. You can use any form of spaces, lines and indentions. In fact if you are an experienced programmer you will probably find that you have a style that can easily be replicated by the auto formatting tool. In Script Assist Flash enforces its own formatting, in expert mode it is up to you how you format your code. It is for this reason that creators of Flash have created the auto format button. Click the Auto Format button or choose Auto Format from the Actions panel pop-up menu. Then press Control+Shift+F (Windows) or Command+Shift+F (Macintosh). This functionality is useful if you are drawing on ActionScript from a number of different programmers.

The rules that the Auto Format feature follows are set in the Auto Format options dialog box. This can be accessed from the Actions panel pop-up menu (see Figure 12.8). In the dialog box you will find a number of check boxes from which you can alter the formatting style. Below the options is a preview which allows you to test all the formatting styles.

Automatic indentation is turned on by default. To turn it off, deselect Automatic Indentation in ActionScript Editor preferences. When automatic indentation is turned on, the text you type after (or {is automatically indented according to the Tab Size setting in ActionScript Editor preferences. To indent another line in the Script pane, select the line and press Tab. To remove the indent, press Shift+Tab.

Figure 12.8 *Auto format options box*

Switching between Editing Modes

While working in the Actions panel, you can switch between Script Assist and expert mode at any time. When you switch modes, Flash maintains your script's formatting unless you change the script. For example, if you write a script in expert mode with your own style of indentation and switch to Script Assist to view it, but make no changes, the formatting does not change. If, however, you modify the script in Script Assist, Flash removes your custom indentation and formats the script using the Auto format. Flash does warn you before changing any formatting.

To switch editing modes, do one of the following: Choose Script Assist or Expert Mode from the Actions panel pop-up menu or from the View Options pop-up menu above the Script pane. A check mark indicates the selected mode.

The Actions panel remains in the selected mode until you choose the other mode, even if you select a script on a different button, movie clip or frame.

You cannot use Script Assist to view an expert mode script that contains errors. If you try, you'll receive the message "This script contains syntax errors. It must be edited in Expert mode".

You can use Script Assist to view an expert mode script that uses ActionScript elements that are not supported by the current publish settings. If you export such a script, you'll receive a warning message.

Using the Reference Panel

You can use the Reference panel to view detailed descriptions of the actions listed in the Actions toolbox. The panel also displays sample code, which you can copy and paste into the Script pane of the Actions panel. You can also adjust the font size and print the contents of Reference panel.

The Reference panel is integrated in the Flash help. Just press F1 to open it. Now you can browse and search different types of information sources like tutorials for sample codes or just the references for descriptions.

Copy and paste sample code
>Highlight the code and right-click (Windows) or Control-click (Macintosh), then select Copy from the context menu.
>In the Script pane, right-click (Windows) or Control-click (Macintosh) and select Paste from the context menu or from the pop-up menu in the upper right.

Font size
>Select Large, Medium or Small Font from the pop-up menu in the upper right of the Reference panel.

Using an External Text Editor

You can use a text editor to write and edit ActionScript outside the Actions panel. You can export actions from the Actions panel to a text file, import a text file into the Actions panel, or use the include action to add an external script file at runtime.

In turn you can export actions as a text file. From the Actions panel pop-up menu (at the upper right of the panel), choose Export as File. Choose a location where the file will be saved, and click Save. You can then edit the file in an external text editor.

Importing a text file containing ActionScript can be done by the Actions panel pop-up menu, choose the Import from File command. Select a text file containing ActionScript, and click Open. Scripts with syntax errors can be imported only in expert mode. In Script Assist, you'll receive an error message.

Externalizing ActionScript Code

ActionScript can call external text files which use the .as extention or .swf files. Maintaining the code in external files, you can standardize your code using libraries and therefore make the code

easy to share. You can import external code into Flash using the import from file, the #include or the shared library.

Although it functions like an operator as it does not use parentheses to enclose its parameters, you must specify a location that can be either absolute c:\sprite.as or relative as in ..\sprite.as. The files must be local. So you cannot specify a non-local URL for the location of the .as file. The parameter, path and filename for the external file must always be enclosed in double-quotation marks. You must not use semicolon with this function as you will produce an error.

The .as extension is short for ActionScript. It is not necessary to name your files with this extension as you can use .txt but it makes standardizing code a whole lot easier if everybody is working to the same format.

Externalizing your code can be a good way of coping with complex movies. In reality it can also cause great confusion to the beginner who as a whole is unable to see what code goes with what objects. Working in this way will have a major effect in the way you work – not always to the better.

Adding an External Script to a Script Within Flash When the Movie is Exported

Click in the Script pane to place the insertion point where you want the external script to be included.

In the Actions toolbox select the Actions category; then select the Miscellaneous Actions category. (it is now in the category "compiler directives").

Double-click the include action to add it to the Script pane.
Enter the path to the external file in the Path box.
The path should be relative to the FLA file. For example, suppose your FLA file is sprite.fla and your external script is called externalfile.as. If sprite.fla and externalfile.as are in the same folder, the path is externalfile.as. If externalfile.as is in a subfolder called Scripts, the path is scripts/externalfile.as.
The text of the external script replaces the include action when the document is exported as a Flash movie (SWF) file. The included code is only considered at "compile time". In other words, the included .as files will not to be staged/posted to the live site along with the SWFs.

About Syntax Highlighting

In ActionScript, as in any language, syntax is the way elements are put together to create meaning. If you use incorrect ActionScript syntax, your scripts will not work.

In Script Assist, syntax errors are red in the Script pane. If you move the mouse pointer over an action with incorrect syntax, a tooltip displays the associated error message; if you select the

red highlighted action, the error message appears in the status bar at the bottom of the Actions panel. In both expert and script assist, ActionScript export version incompatibilities are yellow in the Script pane. For example, if the Flash Player export version is set to Flash 6, ActionScript that is supported only by Flash Player 7 is yellow.

Using Code Hints

Flash can detect what action you are entering and display a code hint – a tooltip containing the complete syntax for that action or a pop-up menu listing possible method or property names. In expert mode, code hints appear for parameters, properties and events when you enter certain characters in the Script pane. In Script Assist, code hints appear for parameters and properties, but not events. They appear in the parameter text boxes when the Expression box is selected.

Code hints are enabled by default. By setting preferences, you can disable code hints or determine how quickly they appear. When code hints are disabled in preferences, you can turn them on manually.

Code Hints and Tool Tip-style Hints

Click the Show Code Hint button so that code hints always appear. To enable automatic code hints choose Preferences from the Actions panel pop-up menu. On the ActionScript Editor tab, select Code Hints.

For tool tip-style hints, type an open parenthesis [(] after an action name.

The code hint appears. Enter a value for the parameter. If there is more than one parameter, separate the values with commas. To dismiss the code hint, do one of the following:

Type a closing parenthesis [)].
Click outside the statement.
Press Escape.

You can have manual code hints in expert mode by clicking the Show Code Hint button above the Script pane and from the Actions panel pop-up menu, choose Show Code Hints.

The menu-style code hints display by doing one of the following:

Type a dot after the suffix of an object name.
Type an open parenthesis [(] after an event handler name.
To navigate through the code hint, use the Up and Down Arrow keys.
To select an item in the menu, press Return or Tab, or double-click the item.

To dismiss the code hint, do one of the following:
Choose one of the menu items.
Click outside the statement.
Type a closing parenthesis [)] if you've already typed an open parenthesis.
Press Escape.

Many ActionScript objects require you to create a new instance of the object in order to use its methods and properties. In a piece of code like myMc.gotoAndPlay(6), the gotoAndPlay method tells the instance myMc to go to a certain frame and begin playing the movie clip. The Actions panel doesn't know which code hints to display and what type of object the instance myMc is.

You can display code hints that help you choose the correct syntax and structure for your code, but your must add a special class suffix to each instance name. To display code hints for the class MovieClip, you must name all MovieClip objects with the suffix _mc, as in the following examples:

```
Car_mc.gotoAndPlay(1);

Ball_mc.stop();

Stamp_mc.duplicateMovieClip(''NewStamp_mc'', 100);
```

The following table shows the suffixes and their corresponding object classes:

Suffix	Object class
_mc	MovieClip
_array	Array
_str	String
_btn	Button
_txt	TextField
_fmt	TextFormat
_date	Date
_sound	Sound
	(Continued)

Continued

Suffix	Object class
_xml	XML
_xmlsocket	XMLSocket
_color	Color
_camera	Camera
_mic	Microphone
_stream	NetStream
_connection	NetConnection
_so	SharedObject
_video	Video

You can also use ActionScript comments to specify an object's class for code hinting. The following example tells ActionScript that the class of the instance theObject is an Object. If you were to enter the code mc after these comments, a code hint would display the list of MovieClip methods and properties; if you were to enter the code theArray, a code hint would display a list of Array methods and properties.

```
//Object theObject;

//Array theArray;

//MovieClip mc;
```

Setting Actions Panel Preferences

To set preferences for the Actions panel, you use the ActionScript Editor section of Flash preferences. You can change settings such as indentation, code hints, font and syntax coloring, or restore the settings to their defaults. To set Actions panel preferences you need to choose Preferences from the Actions panel pop-up menu,

Then choose Edit>Preferences and click the ActionScript Editor tab.

You can set any of the following preferences:

For Editing Options, select Automatic Indentation to automatically indent ActionScript in the Script pane in expert mode, and enter an integer in the Tab Size box to set an indentation tab size for expert mode (the default is 4).

Select Code hints to turn on syntax, method and event completion tips in both expert and Script Assist. Move the Delay slider to set the amount of time. Flash waits before displaying a code hint (the default is 0).

For Text, select a font or size from the pop-up menu to change the appearance of text in the Script pane.

For Syntax Coloring, choose a color for the Script pane's foreground and background and for keywords (for example, new, if, while and on), built-in identifiers (for example play, stop and gotoAndPlay), comments and strings.

To restore the default ActionScript Editor click the Reset to Defaults button.

For large imported sounds use the Stream Sync setting and stretch the sound over a number of frames.

Use bitmap images sparingly. To reduce the file size added by bitmap included in the Flash movie, change the JPEG Quality setting in the Publish Settings dialog.

To retain definition and clarity of imported bitmaps, disable smoothing for that image only.

To perform shape effects on text, use the Modify>Break Apart command to change the text from a font to a shape outline.

Leave a few empty frames at the beginning of all your movies, to make adding frames before your content easier.

Shared Library Assets

Allow a Flash movie to share library assets with other Flash documents, while authoring, or when a movie is played with the Flash Player. Shared runtime libraries help you create smaller files and easily make updates to multiple documents simultaneously by letting your document show library symbols and shared objects that are stored on an intranet or the Internet. It can improve your work pace by letting you track, update and swap symbols in any Flash document available on your computer or network.

Using Shared Library Assets

Shared library assets enable you to use an asset movie to feed content like logo's and pictures to multiple destination movies. You can do this in two different ways:

Runtime Shared Assets

Assets from a source movie are linked as external files in a destination movie. These assets are loaded into the destination movie during movie playback at runtime. The source movie containing the shared asset does not need to be available on your local network when you author

the destination movie. The destination movie must be referencing the content in the source movie at run time.

Author-time Shared Assets

You can update or replace any symbol in a movie you are authoring, with any other symbol on your local network. The symbol in the destination movie retains its original name and properties, but its contents are updated or replaced with those of the symbol you select, which you may have updated through the source file.

Using shared library assets can optimize your workflow and movie asset management in numerous ways. We will go through an example demonstrating how you can use shared library assets to share a font symbol across multiple sites, provide a single source for elements in animations used across multiple scenes or movies. The shared library is best used as a central resource library to use for tracking and controlling revisions.

How Runtime Shared Assets Work

Two process are involved in working with shared library assets:

You as the author must define a shared asset in the source movie, and enter an identifier label for the asset and a URL where the source movie will be posted.

The author of the destination movie defines a shared asset in the destination movie and enters an identifier string and URL identical to those used for the shared asset in the source movie. You can drag the shared assets from the posted source movie into the destination movie library. Whichever approach you take the source movie must be posted to the specified URL in order for the shared assets to be available for the destination movie.

Defining Assets in a Source Movie

You use the Symbol Properties dialog box or the Linkage Properties dialog box to define sharing properties for an asset in a source movie, to make the asset accessible for linking to destination movies. The following example takes you through the stages:

1. Open the source movie, choose Window>Library to display the Library panel.
2. Select a movie clip, button or graphic symbol in the Library panel and choose Properties from the Library options menu. Click the Advanced button to expand the Properties dialog box.
3. For Linkage, select Export for Runtime Sharing to make the asset available for linking to the destination movie.
4. Enter an identifier for the symbol in the Identifier text field. Do not include spaces. This is the name Flash will use in identifying the asset when linking to the destination movie.

Figure 12.9 *The Linking Properties dialog box*

The Linkage Identifier is also used by Flash to identify a movie clip or button that is used as an object in ActionScript.

5. Enter the URL where the SWF file containing the shared asset will be posted.
6. Click OK.

The URL value is a relative path, all movies that use this asset must be located in the directory above the shared folder. If the movies are located across several directories, you need to use an absolute URL http://www.sprite.net/shared/sharedLib.swf. If you specify a path as/shared/sharedLib.swf which specifies a shared folder located at the root of the current URL used by the destination Flash Movie. In the above example when you publish the movie, you must post the SWF file to the URL specified in step 5, so that the shared assets will be available to destination movies.

Linking to Shared Assets from a Destination Movie

You use the Symbol Properties dialog box or the Linkage Properties dialog box to define sharing properties for an asset in a destination movie, to link the asset to a shared asset in a source

movie. If the source movie is posted to a URL, you can also link a shared asset to a destination movie by dragging the asset from the source movie to the destination movie.

You can turn off sharing for a shared asset in the destination movie, this allows you to embed the symbol in the destination movie.

Linking a shared asset to a destination movie by entering the identifier and URL:

In the destination movie, choose Window>Library to display the Library panel.

Figure 12.10 *Source Symbol dialog window*

Select a movie clip, button or graphic symbol in the Library panel and choose Properties from the Library options menu. Click the Advanced button to expand the Properties dialog box.

Select a graphic symbol and choose Linkage from the Library options menu.
For Linkage, select Import for Runtime Sharing to link to the asset in the source movie.
Enter an identifier/name for the symbol in the text field that is identical to the identifier used for the symbol in the source movie.
Enter the URL where the SWF source file containing the shared asset is posted.
Click OK.

Linking a Shared Asset to a Destination Movie by Dragging

In the destination movie, choose File>Open or Open as Library. In the Open or Open as Library dialog box, select the source movie and click Open. Drag the shared asset from the source movie Library panel into the Library panel or onto the Stage in the destination movie.

To Turn off Linkage for a Symbol in a Destination Movie

In the destination movie, select the linked symbol in the Library panel and do one of the following: If the asset is a movie clip, button or graphic symbol, choose Properties from the Library options menu. If the asset is a font symbol, choose Linkage from the Library options menu.

In the Symbol Properties dialog box or the Linkage Properties dialog box deselect Import for Runtime Sharing.

Click OK.

Updating or Replacing Symbols using Author-time Sharing

You can update or replace a movie clip, button or graphic symbol in a movie with any other symbol in a FLA file accessible on your local network. The original name and properties of the symbol in the destination movie are preserved, but the contents of the symbol are replaced with the contents of the symbol you select. Any assets that the selected symbol uses are also copied into the destination movie.

To Update or Replace a Symbol

With the movie open, select movie clip, button or graphic symbol and choose Properties from the Library options menu.

1. Select a new FLA file, under Source in the Symbol Properties dialog box, click Browse.
2. In the Open dialog box, navigate to a FLA file containing the symbol that will be used to update or replace the selected symbol in the Library panel, and click Open.
3. To select a new symbol in the FLA file, under Source, click Symbol.
4. Navigate to a symbol and click Open.
5. In the Symbol Properties dialog box, under Source, select Always Update Before Publishing to automatically update the asset if a new version is found at the specified source location.
6. Click OK to close the Symbol Properties or Linkage Properties dialog box.

Shared Library (Runtime Import)
Shared ActionScript

Runtime import offers the most flexible approach to sharing code across movies because it does not require recompilation of the movies that import the shared code. The following example creates a simple test from a movie called ScriptLibrary.swf to a movie called myMovie.swf.

First you need to create the ScriptLibrary.swf movie. Create a new Flash document.

Create a new movie clip symbol named sharedScript.

On frame 1 of the sharedScript clip, add the following code:

```
Function demo(){

  Trace(''this is a text, demo'');

}
```

Select the sharedScript clip in the Library.

From the Library panel, select Linkage from the pop-up options menu.

Select export for Runtime Sharing.

In the indentifier box type sharedScript.

In the URL box, type codeLib.swf.

Click OK.

Save the document as codeLib.fla.

Export Movie to create codeLib.swf from codeLib.fla

Close all the files.

We now need to create a file that executes the code imported from the codeLib.swf.

Save a new Flash document as NewMovie.fla in the same folder as codeLibrary.fla.

Create a layer and call it sharedCode

In File>Open choose codeLib.fla and open it as Library (File>Import>Open External Library).

Find the instance of the sharedScript and drag it on to the stage at frame 1.

Name the instance sharedScript.

Create a new layer on newMovie.fla Timeline and call it code.

Add a key frame at frame 2.

Add new frame to the sharedCode layer.

On frame 2 of the code layer, attach this code:

```
Stop();

SharedScript.demo();
```

Export the movie.

The following text should appear in the output window "this is a text, demo".

Do not forget, if you change the location of either file you will need to select the symbol in the library, choose linkage and under URL you need to set the new location.

Showcase

Showcase

The convergence of the media world has not only affected the way we see things but also the way we have things delivered visually to our chosen device. My phone has a number of animated themes. Because of their brand association, I expect these animations to be of a high quality even though I had not seen some of them. This is quite typical of the cross-pollination between platform and content. This rich and productive cross-pollination between design and animation mediums is one of the forces that keeps animation vital, and the web interesting. We will see more of these transitions from design, print to animation, since one of the great trends of the past decade is the conglomeration and merger of media companies. Comic strips can gain a second round of profits in animated form from print to PC to mobile. This represents an economic windfall that will become increasingly irresistible to cartoonists and animation studios alike.

The printed comic strip and animated cartoons have shared a long mutual history; in many cases, the former has given birth to the latter. Bill Melendez did a terrific job of bringing Charles Schultz' Peanuts strip to life, putting Charlie Brown and crew into some of the coolest cartoon specials of the 1960s and 1970s.

So ... what's out there that might carry on the grand old tradition and reinvent a genre?

I have selected a few of the many sites that I feel are inspiring in one way or another; ultimately they have all been selected because of their animation or illustration qualities. I will start by looking at snips of code-driven animations that I have found useful. I will then move on to some of the games from the CD and then finally I will feature my work and Sprite Interactives work and web site because that is who I work for and one way or another the existence of this book and all its examples are a credit to the team at Sprite. The Zak and Ellen characters have been taken from a 3D world to TV to mobile phone and pocket organizers, an exhausting journey of convergence – Enjoy the trip.

ActionScript driven animation, and the techniques that go into building code-driven effects can be very programming intensive and beyond the scope to this book. However, this section consists of seventeen examples, all of which can be plugged into your movies to create animation effects but at the same time taking a minimum of file size. Use this movie clips to learn how to add a whole new range of effects and interaction to your movies.

ActionScript-driven Animation Techniques

The Flash Timeline allows you to create very sophisticated animations without having to deal with the code that lies behind them. However, sometimes there are benefits to getting in there and using code to generate your animations. ActionScript-driven animation is fundamental to Flash games, and can generate some amazing text effects and dynamic animations that the user can control! The animator can also benefit from ActionScript, using code to automate repetitive tasks.

The team at Sprite Interactive have created useful movies that can be easily pulled into your project.

The development of code-driven animation, particularly in Flash, has opened up whole new realms of possibility for designers and programmers alike, and we have recently seen a move away from the conventional tweening techniques towards code-based techniques. Code-based techniques can produce a wide range of results, ranging from the artistic to the mechanical; the results are always computer generated but with a little imagination can be stunning. Traditional frame-by-frame animation can also be combined with code-driven animation to make your animations run more smoothly and create unique effects, and you can also easily model physical behaviours, such as gravity. Using code-driven animation animators are now not limited to traditional animation techniques, and can create complicated effects with just a basic knowledge of the methods used. Code-driven animation can be as small as 3% when compared to a similar frame-driven animation. This is great for delivery over a telephone line or playback on a mobile device.

Before Flash, code-driven animations had to be written in lower-level languages such as C and Java, which needed a lot more programming expertise, were less robust (particularly Java) and took a lot longer to write. With the development of ActionScript, a high level language, a lot of the hard work is already done for you, for example, you do not have to tell it how to move an asset, you just have to tell it where to put it. ActionScript 2 also has a robust structure to code around (the Flash Interface) which makes it much easier to get to grips with.

Code-driven animation consists of a number of static elements that use a function to move over a mathematically generated path. The beauty of code-driven animation lies in its flexibility, and the parameters of the animation can easily be changed to manipulate your animation without having to re-draw it. Code-driven animation is also very memory-friendly, and only needs the space needed to store the lines of code. You can also re-use lines of code in other code-driven animations, making them very efficient. The fact that you can re-apply your code also means that you can easily use a favourite technique over and over without having to re-draw all the frames. Our examples are a source of extra functionality for your animations, and give sophisticated results with minimum fuss and effort. You can experiment with the examples and remember you can edit these in any way you would like to fit them into your movies. Have fun!

The ActionScript-driven Animation Movies

Preloader – learn how to add a preloader to your movies, invaluable if you are creating large animations.

Cursor – we show you how to change the appearance of the cursor in your animations.

Magnifying Glass – a great magnifying glass example to magnify the background of your movies.

Starfield – a classic space starfield effect that you can plug into your movies.

Parallax Scrolling – we demonstrate how to create parallax effects.

Collision Detection – learn how to build collision detection into your movies and animations.

Disney Sparkle – the classic Disney Wand sparkle, attached to your cursor.

Sparkler Effect – create fireworks that follow your mouse pointer around the screen.

Dancing Lights – a nice animated effect to generate fading lights all around your screen.

Snow – a plug in and play snow effect.

Bubbles – plug this effect into your animation to create bubbles rising to the top of your screen.

Gravity Footballs – real gravity created by ActionScript.

Wobble Buttons – make your buttons wobbly.

Spiral – a piece of ActionScript code that makes objects spiral around a set point.

Orbit – a simple way to create complex orbit effects.

Preloader

Most Flash movies contain actions, sounds and images, which means a large file size. A preloader is essential if you are creating large Flash animations, and is very easy to create. A preloader is a separate scene at the start of your movie (usually a looped animation) that uses a simple piece of ActionScript to check if the rest of the movie is loaded, once it has detected that the movie is loaded it begins playing the rest of it.

You can check whether your movie needs a preloader by selecting the View > Show Streaming command when you test your movie from within Flash, and then turning on the Bandwidth Profiler, by selecting View > Bandwidth Profiler. If there are bars, which denote content in each individual frame, over the red line, which denotes the streaming threshold, then the movie will not stream properly and will need a preloader so that it does not skip or hold-up when it is playing.

The script to power a preloader is very simple. To make a basic preloader all you need to do is create a 20 frame animation loop (this can be longer or shorter), and at the beginning of this loop insert a script telling the preloader to check whether the last frame in the last scene of the movie is loaded, if it has then it tells the preloader to begin playing the next scene. At the end of this loop, you insert ActionScript to tell the playhead to loop back to the start of the preloader. This has the effect of looping the animation while the rest of the movie is streaming behind it. When the last frame in the movie has streamed through, the preloader goes on to play the next scene.

The example we have written can be easily plugged into your movie, and contains a progress bar. This checks how much of the movie has been loaded, by using the getBytesTotal command, and then shows that much progress on the bar. All you need to do to plug this into your movie is to create a new scene at the start of your movie and drop the Preloader movie clip in.

Cursor – Standard Change of Cursor

Changing the appearance of the cursor is a great way to make your movies and animations more visually appealing. It is also very simple. All you need to do is drop the "Change Cursor" movie clip into your movie, and the cursor will change. Updating the graphic is also easy, all you need to do is change the graphic in the "Change Cursor" movie clip.

The ActionScript in this example first of all hides the mouse, and then locks the "cur" movie clip onto the mouse, it then uses the startDrag command to drag that movie clip around the screen.

Magnifying Glass

A magnifying glass is a fun tool that you can feature in your animations. It could, for example, be used for a game where the user has to find certain hidden objects around a picture using the magnifier. In the example we have provided, you can magnify the Ellen and Zak web site homepage.

The magnifier works by taking the picture you are magnifying, and then through the lens, which acts as a mask over the first image, blows the image upto twice its size, creating a magnified effect. It is quite a simple process, but is hard to get the picture positioning exact, so you can't move the picture around. To update the picture being magnified all you need to do is go into the Library, select the image, which in this case is image.jpg and bring up its Properties Dialog Box, then select the Import button and choose the image you would like to magnify, the size of the image should be 640 × 480.

The ActionScript featured in the movie is very simple, and consists of a small piece of script to tell the movie to make the cursor invisible and to make the lens draggable, and then actions in the lens movie clip to set two variables that tell it to magnify the picture by two times, however, if you want to change this you will have to re-scale the picture, which is a complicated procedure.

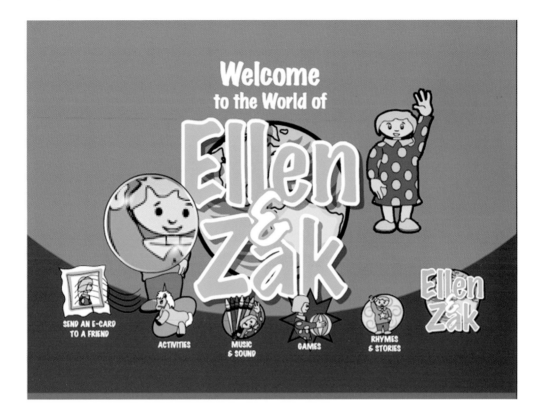

Starfield

A starfield is a nice effect that can add a great sense of depth to your movies if you are building space animations. The "Star Field" movie clip can be dropped straight onto your movies, and only requires a small amount of tweaking to work in any size of movie. To see the ActionScript that drives the movie, open the "Star Field" movie clip in editing mode and then select key-frame, one of the actions layer. Here you need to set the width and height of the movie you will be dropping the starfield into, and the rest of the calculations are done for you.

The star graphic is a tweened animation that is called "Moving Star", which can be found in the "Star Field Assets" folder in the library. You can change the graphical assets in this animation to make the stars in the starfield appear however you would like.

Parallax Scrolling

Parallax scrolling is the effect one sees when looking at a scrolling series of "layers" scrolling at different speeds. Each layer represents a distance from the viewer (the foreground, the background, far in the distance, etc.) As the entire view "scrolls" or moves in a two-dimensional direction (no depth movement), the layers scroll at a different speed. The farther away from the viewer a layer is supposed to be, the slower it will scroll. This creates the illusion of depth. Parallax scrolling is used extensively in computer games and animations.

The beauty of parallax is that you can place a static character in the foreground, and then change how fast it moves simply by speeding up or slowing down the speed of the scrolling. The example in this chapter uses a desert scene that can easily be modified, all you need to do is change the graphics in each movie clip that makes up the scene. There are four movie clips, Background, Far, Middle and Near, and you do not have to change the code to change the background, just the graphics. You will notice that the three levels of the scene all move at different speeds, this variable is set in the first frame of the Parallax Background movie clip. The movie clips are tiled across the screen, and the second frame of the movie clip sets each level of the scene to start its movement again if it has moved half way across the main scene.

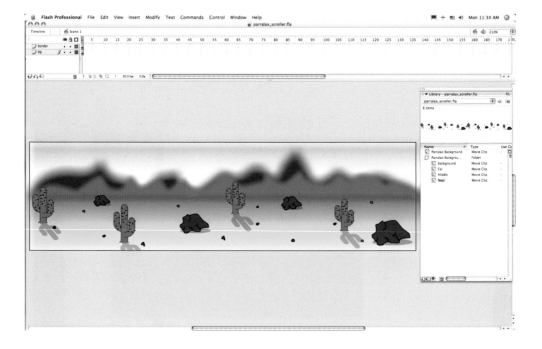

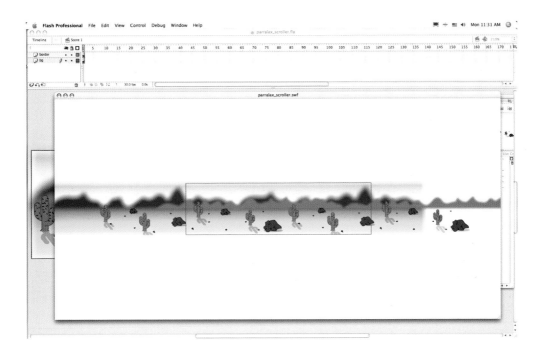

Collision Detection

Collision detection is particularly useful if you are building games or animation where you want the movie to be able to detect collisions between objects. There are several ways to detect collisions, the most common use the hitTest() method to detect whether one movie overlaps another and therefore collides. More advanced trigonometry can also be used to accurately detect collisions between particular parts of an object. The demonstration here is not a plug-in-and-play type example, it demonstrates the principle of collision detection, so that you can learn how to integrate it into your movies.

Our example uses the hitTest() method to check whether two movie clips, a square and a circle, have collided. The ActionScript to drive the example is stored on the "object 1" movie clip (the circle) and it simply uses the hitTest() method to check whether "object 1" has collided with "object 2", if it has then it tells the "status_text" text box to display the "They've hit text". This example is very simple, but clearly demonstrates the basics of collision detection.

Animating with Flash 8

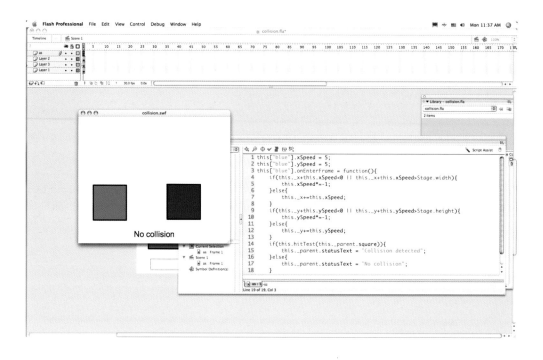

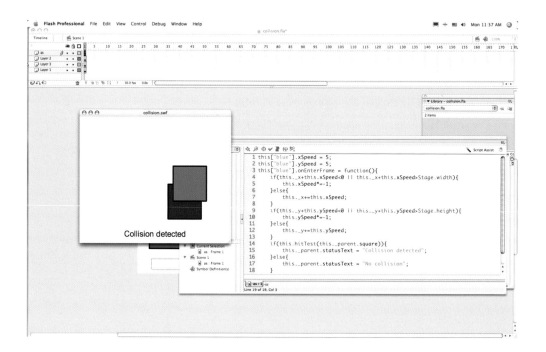

Sparkler Effect

This animation creates a sparkler effect around the mouse pointer that follows it around and slowly dissipates towards the bottom of the screen. The sparkles generated are of random size and fall away from the pointer at a random speed, which are both fully customizable. To change the sparkle graphic, open the "Sparkle Graphic" movie clip, and make any graphical changes you want. The sparkles appear at a set rate, which is not updatable, and they fall at a set speed. To integrate the sparkler with your movie all you need to do is drag the "Sparkler" movie clip from the library onto the stage and it will automatically work.

The ActionScript in the movie duplicates the firework movie clip and sets it to play at a random angle, therefore creating the "sparkling" type effect. This ActionScript can be edited, but it is so simple and so effective that it is not really necessary.

Animating with Flash 8

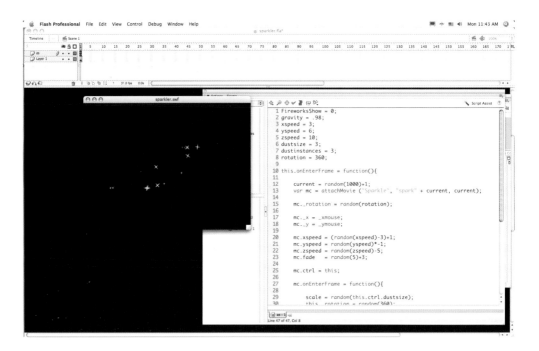

```
 1 FireworksShow = 0;
 2 gravity = .98;
 3 xspeed = 3;
 4 yspeed = 6;
 5 zspeed = 10;
 6 dustsize = 3;
 7 dustinstances = 3;
 8 rotation = 360;
 9
10 this.onEnterFrame = function(){
11
12     current = random(1000)+1;
13     var mc = attachMovie("Sparkle", "spark" + current, current);
14
15     mc._rotation = random(rotation);
16
17     mc._x = _xmouse;
18     mc._y = _ymouse;
19
20     mc.xspeed = (random(xspeed)-3)+1;
21     mc.yspeed = random(yspeed)*-1;
22     mc.zspeed = random(zspeed)-5;
23     mc.fade   = random(5)+3;
24
25     mc.ctrl = this;
26
27     mc.onEnterFrame = function(){
28
29         scale = random(this.ctrl.dustsize);
30         this._rotation = random(360);
```

Snow

This handy snow effect can be plugged into any movie simply by dragging the Snow Generator movie clip onto the stage, its great for giving your movie a Christmas feel! The snow falls down the screen randomly, and follows a sin wave to give a wavy snowing effect.

The ActionScript that controls how the snow falls can be updated depending on the movie size and how much snow you want to fall. The actions for the Snow Generator can be found in the first keyframe of the actions layer of the Snow Generator movie clip. You can affect the amount of snow by entering a value for the amount_of_snow variable and the snow_speed variable controls how fast the snow falls, handy for if you want to whip up a snowstorm! The movie dimensions in the ActionScript should be set to the height and width of the movie you are putting the effect into and you can change the sin values to affect how the snow falls.

Bubbles

The bubble effect is very similar to the previous snow effect, but creates bubbles that rise up the screen and increase in size and fade out as they approach the top of the stage. Like the snow effect, you can drag and drop the Bubble Generator from the library onto the stage to integrate the effect into your movie.

The ActionScript that drives the bubble effect works in the same way as the snow effect, and you can change the variables in the same way, the ActionScript to control the bubbles can be found in the first keyframe of the actions layer of the Bubble Generator movie clip. The number_of_bubbles variable sets the number of bubbles that appear on the screen at once, the buble_speed controls how fast the bubbles move up the screen, and you need to set the dimensions of the movie you are inserting the bubbles into to make the effect work properly. You can also change the sin values to affect how the bubbles travel up the screen.

Wobble Button

The wobble button is a unique function that creates wobbly buttons. Buttons are essential if you are building interactive movies, where the user can either navigate around or make decisions on screen. The wobble button is a fun tool that would be perfect for creating fun buttons on a web site or on a kid's game. You will see the effect of the wobble button when you run your mouse pointer over it.

The script that runs the wobble buttons is fairly simple, it sets a number when you roll over the button that it increases its size to, and then sets another number as you move the mouse pointer away from the button to decrease the size of the button. The numbers to set the size of the button as the mouse rolls over it can be found in the "Wobbler" movie clip in the actions for the button, and you can experiment with changing them here. The actions on the "Wobbler" button are also where you put the interactivity for the button, and you can see the comments in the script explaining how to add interactivity to the on(release) handler, the most important thing to remember is that you have to reference the _root of the movie if you are adding interactivity, as the Wobbler button is a button within a movie clip within another movie clip and therefore is not on the top level of the main movie. You can also easily change the graphics that make up the button by just going into the actual button and changing the graphical assets.

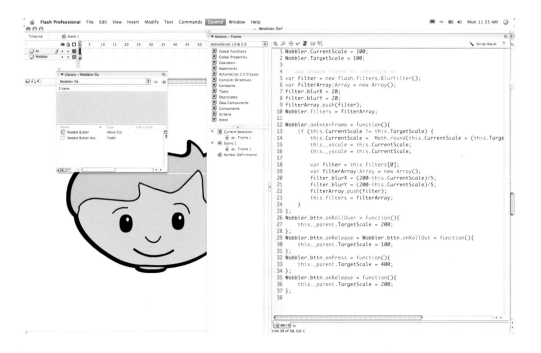

Spiral

The spiral example is a nice piece of ActionScript code that you can use to create a spiral effect (such as water draining down a plughole) without having to line up awkward tweens. The spiral movement is actually generated by ActionScript, all you need to do is attach the movie clip that you want to spiral in the code.

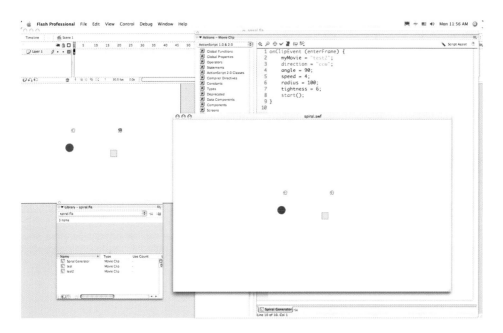

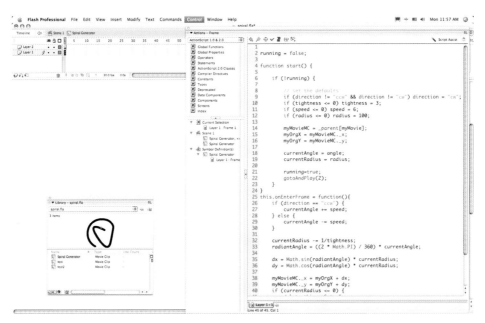

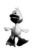

To change the settings for the spiral you need to click on the spiral movie clip (represented by a small spiral graphic) on the top level of the movie and open the ActionScript panel. You can then change five different settings, you can set the angle of the spiral, the speed of the object spiralling (the higher the faster), the radius of the spiral, which sets how far out the spiral actually starts, and how tight the circular motion is (from one to ten), which sets how many times it will spiral before stopping. In this section you also set which movie clip is attached to the spiral, the default movie clip is "test", but this can easily be changed simply by taking the movie you want to attach into the library and referencing it from this point.

Orbit

The orbit example is a simple way to create complex orbit effects. The example file contains the "sun" with the "earth" orbiting around it, and the "moon" orbiting around the earth. To set up an orbit first of all drag the "Orbit Generator" onto the stage and open its actions panel. You will see a number of areas that can be changed to affect how the orbit function works, the movie clip that is referenced in the "movclip" field is the movie clip that is being orbited around, and the "movclip2" field is the movie clip that is orbiting. You can then set a number of variables in the same actions panel, you can set the angle of the orbit, which is the angle that the orbiting object starts at, the speed of the orbit (the higher the faster) and the radius of the orbit, which sets how far out the orbit begins. As you can see in the example movie you can set objects to orbit around others that are moving across the screen, which can lead to some stunning effects, and you can put as many orbits on the screen as you like.

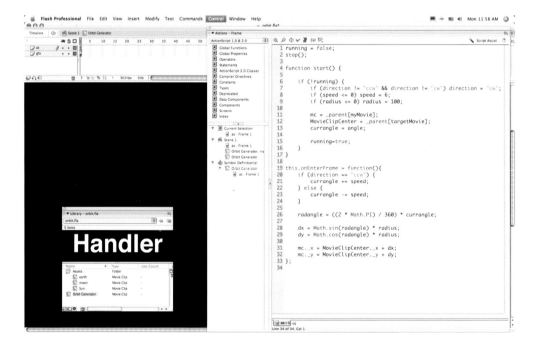

Animated Bug

This fun code-driven animation allows you to put bugs into your movies that move around the screen in a random manner. The bug graphic is a simple two-frame animation of the bug moving, and the ActionScript in the "crazy bug" movie clip makes the bug move around the screen in a random way. It is easy to update the bug graphic, just open the "bug" movie clip in editing mode and make any changes you would like. The ActionScript that powers the bug can be found in the "crazy bug" movie clip, in the "actions" layer. The first keyframe controls the random movement of the bug, and you can set the speed, which controls how fast the bug moves, the craziness, which controls how crazy the bug's movement is (how often it changes direction) and the movie width and height, which controls the bounding box for the bugs' movement.

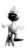

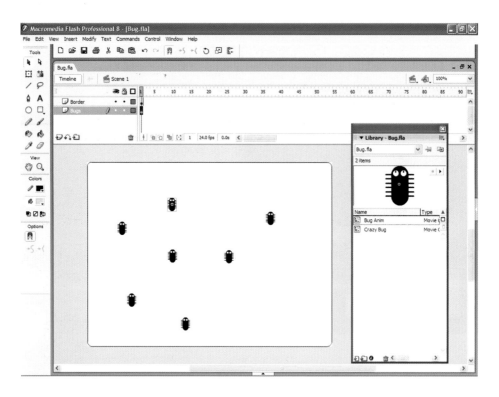

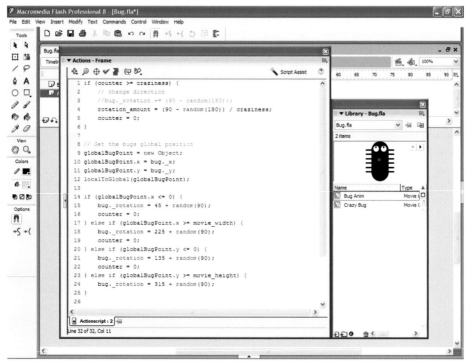

Moving Eyes

A fun pair of moving eyes that follow your mouse pointer around the screen. These eyes are part of a whole face, which can be edited in any way you like simply by editing the "face" graphic. The eyes are a movie clip, called "creepy eyes" that can be dropped into your movie to make them work. The ActionScript that drives the example is quite complicated, and can be found on the actions layer of the "creepy eyes" movie clip. It uses trigonometry to track the cursor and point the pupil of the eye towards the pointer, whilst at the same time keeping it inside the boundary of the eye.

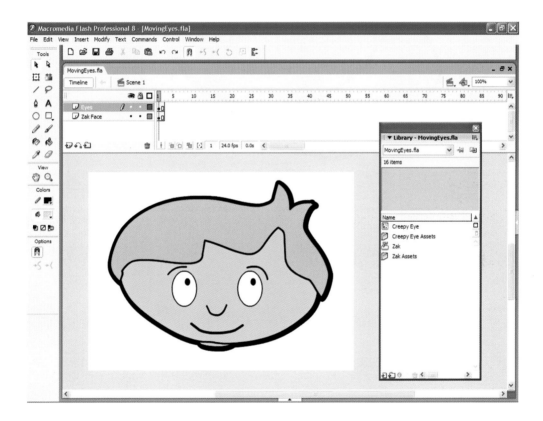

Dancing Lights

This is a great piece of code-driven animation that generates a pre-set number of lights that dance and fade into the distance, this could be used as an introduction for an animation, or to add a visually appealing effect to your animation. To use the dancing lights as an effect all you need to do is drag as many instances of the "Dancing Lights" movie clip onto the stage as you want, they will then play when the playhead passes over the movie clip.

The graphics of the dancing lights can easily be changed by opening the movie clip in editing mode and substituting the "dust" graphic for your own. The ActionScript that drives the lights can also be edited, you will find this script in the actions layer of the "Dancing Lights" movie clip, the first keyframe sets the direction of the light, the x and y values, and also sets the lifespan of the lights, the higher number you enter here, the longer it takes to "die". The rest of the script in the other two keyframes of the actions layer generates random behaviours for the lights, so there is no need to edit these as the results are random anyway.

Games Available on the CD

The following is a series of commercial games available for your use for both on the web and mobile. The mobile games are geared towards mobile phones, however, with a little tinkering in the code shifting stroke commands from the mobile soft keys in Flash Lite 2 to PC-based playback. By including these games, I am not giving the purchaser of this book the rights to use the graphics but only the code. So please edit or replace the graphics for your use.

Streetfighter PC Game – Streetfighter.fla

All the code is here but you will need to finish this game. Finishing a game does not merely mean you get it to a point where it is playable, and then move on, this is not a finished game. A finished game will have an opening screen, a closing screen, menu options, introduction screens to playing, reward screens and a score board.

There is a big difference between a game that is a "skeleton", and a game you have put all the finishing touches on. This difference will be a matter of a couple of days to two weeks. The result, though, will be very important, both to terms of your understanding game development, and your own pride in your work and satisfaction/fulfilment.

By analyzing this game you will learn all the details that go into really finishing a game. If you stop at just working game play, you will still miss out on the details of wrapping things up, which will leave a blank spot in your mind when trying to plan larger projects in the future.

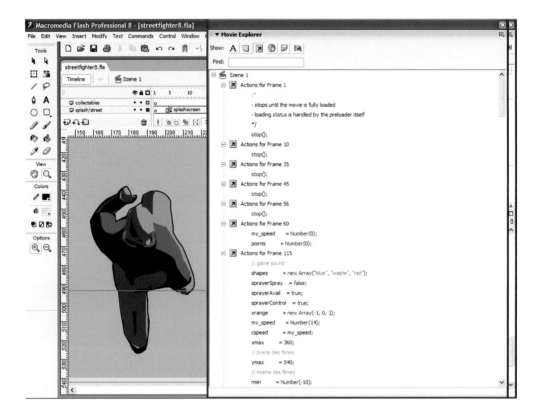

Arcade Heroes 1

The Invaders game itself was an adaptation of the popular shooting gallery games that were a mainstay of carnivals. In this electronic version of the game, the player controlled the motions of a movable laser cannon that moved back and forth across the bottom of the video screen. Rows and rows of video aliens marched back and forth across the screen, slowly advancing down from the top to the bottom of the screen. If any of the aliens successfully landed on the bottom of the screen, the game would end. The player's laser cannon had an unlimited supply of ammunition to shoot at the aliens and destroy them before they hit the bottom of the screen.

Meanwhile, the aliens would shoot back at the player, raining a hail of deadly rays and bombs that the player would have to dodge lest his cannon be destroyed. The player's cannon could be destroyed three times, and the game would end after the player's last life was lost. Occasionally, a bonus spaceship would fly across the top of the screen which the player could shoot for extra points.

As the player destroyed an increasing number of aliens, the aliens began marching faster and faster, with the lone remaining alien zooming very rapidly across the screen. Shooting the last alien in the formation rewarded the player with a new screen of aliens, which began their march one row lower than the previous round.

The other game on the CD is similar to the old PacMan. The game was developed primarily by Namco employee Toru Iwatani. After receiving inspiration from a pizza with one slice missing, game designer Iwatani spent approximately seventeen months on a game that revolved around eating. Iwatani's efforts to appeal to a wider audience – beyond the typical demographics of young boys and teenagers – would eventually lead him to adding in elements of a maze. The result was a game he entitled *PUCK MAN*, derived from the Japanese phrase *pakupaku*, meaning he eats he eats. When first launched in Japan in 1980 by Namco, the game received a lukewarm response, as *Space Invaders* and other games of similar ilk were far more popular at the time.

If you have a Flash Lite 2 device these files will run fine, otherwise you will need to tweak the code. You can install the swf files directly or if you are running a symbain device you can load the sis file.

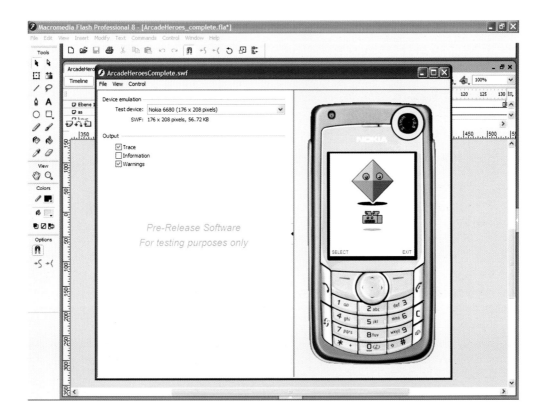

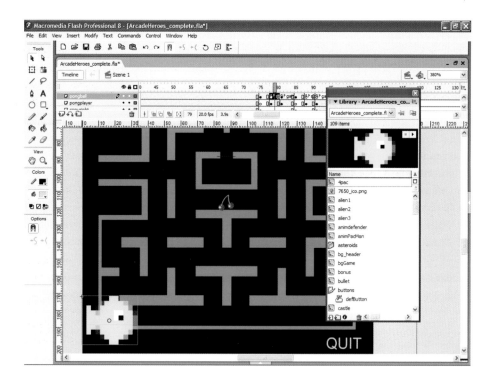

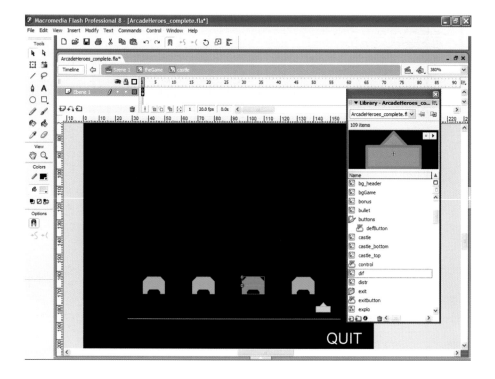

Arcade Heroes 2

In this game, a layer of "bricks" lines the top third of the screen. A ball travels across the screen, "bouncing" off the top and side walls of the screen. When the ball hits a brick, the ball bounces off and the brick disappears. The player loses a life when the ball touches the bottom of the screen, and to prevent this from happening, the player has a movable paddle to bounce the ball back into play.

The maximum score that one player can achieve is 896, by eliminating two screens of bricks of 448 points each. Once the second screen of bricks is destroyed, the ball in play harmlessly bounces off empty walls until the player finally relinquishes the game, as no additional screens are provided. Once the third screen is eliminated, the game is over.

If you have a Flash Lite 2 device these files will run fine, otherwise you will need to tweak the code. You can install the swf files directly or if you are running a symbain device you can load the sis file.

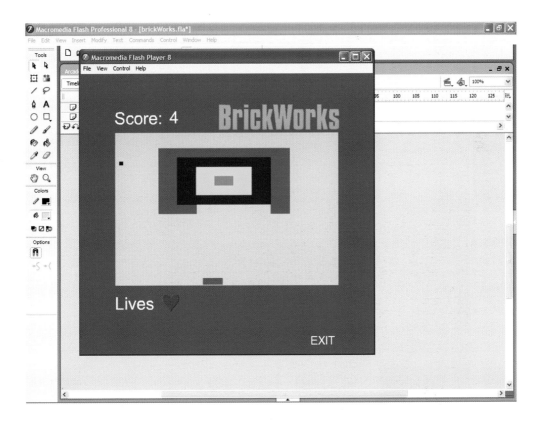

Arcade Heroes 3

Tetris has been embroiled in a large number of legal battles since its inception. In June 1985, Alexey Pajitnov created *Tetris* on an Electronica 60 while working for the Academy of Sciences at their Computer Center in Moscow, and Vadim Gerasimov ported it to the IBM PC. From there, the game exploded into popularity, and began spreading all around Moscow.

The Spriteris game is based on the *Tetris* game which is seven randomly rendered tetrominoes or tetrads – shapes composed of four blocks each – fall down the playing field. The objective of the game is to manipulate these tetrominoes with the aim of creating a horizontal line of blocks without gaps. When such a line is created, it disappears, and the blocks above (if any) fall. As the game progresses, the tetrominoes fall faster, and the game ends when the stack of tetrominoes reaches the top of the playing field.

The seven rendered tetrominoes in *Tetris* are referred to as *I*, *T*, *O*, *L*, *J*, *S* and *Z*. All are capable of single and double clears. *I*, *L* and *J* are able to clear triples. Only the *I* tetromino has the capacity to clear four lines simultaneously, and this clear is referred to as a "Tetris".

If you have a Flash Lite 2 device these files will run fine, otherwise you will need to tweak the code. You can install the swf files directly or if you are running a symbain device you can load the sis file.

Arcade Heroes 4

This game is only a little like the classic Duck Hunt which was a best-selling NES game combining the games Super Mario Bros. and Duck Hunt on one game cartridge. When a player turned the game on they could pick which one to play. It was best-selling largely due to the fact that it was packaged with the "NES Action Set", which also included the Zapper Light Gun for Duck Hunt. Developed and published by Nintendo, it was released in November 1988.

In December 1988, another combination pack was packaged with the "NES Power Set" which included the two games plus World Class Track Meet. The package also contained the Power Pad for World Class Track Meet.

If you have a Flash Lite 2 device these files will run fine, otherwise you will need to tweak the code. You can install the swf files directly or if you are running a symbain device you can load the sis file.

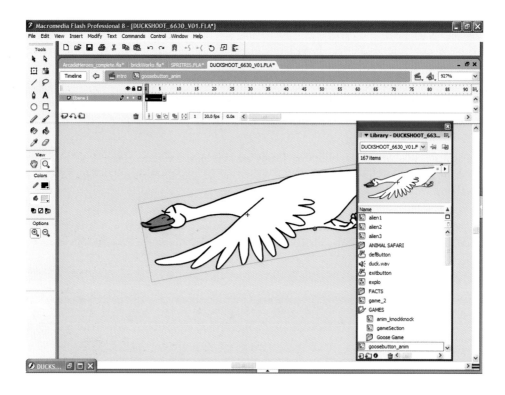

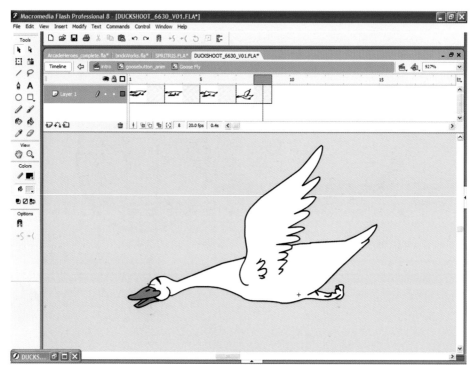

Ellen & Zak Kid's Magazine – Flash Lite 2

Keep your kids entertained with the Ellen & Zak kid's magazine on your phone – the most fun and interactive magazine available! There are five sections of the magazine – Jokes, Games, Animal Safari, Word Games and Facts – each will challenge and educate your child in a safe, colorful environment. The magazine uses Flash Lite for cutting edge content and usability. It's also a great fun for big kids too!

This magazine was originally built for FlashCast. FlashCast requires Flash Lite, the mobile profile of Flash, to render certain content types on the mobile device. The FlashCast client

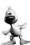

application, similar to a browser, provides the necessary services to the Flash Lite library, enabling playback of Flash Lite content. See more about FlashCast on the Macromedia site.

If you have a Flash Lite 2 device these files will run fine, otherwise you will need to tweak the code. You can install the swf files directly or if you are running a symbain device you can load the sis file.

Sprite Introduction

I have selected a few of the many sites that I feel are inspiring one way or another, ultimately they have all been selected because of their animation qualities. I started with Sprite Interactive's web site because that is who I work for and one way or another the existence of this book and all its example is a credit to the team at Sprite. The Zak and Ellen characters have been taken from a 3D world to TV to mobile phone and pocket organizers, an exhausting journey of convergence.

Sprite Interactive is a new media company that specializes in providing a wide range of web and mobile-based solutions. Current clients include Vodafone, Orange, T-Mobile, ESPN, Paul Smith, Toni&Guy. To see Sprite's portfolio of mobile games, applications and mobile pets visit www.Handyx.net, our product showcase site.

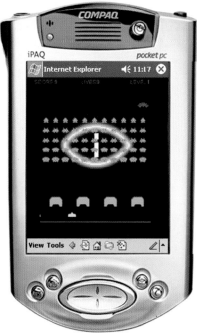

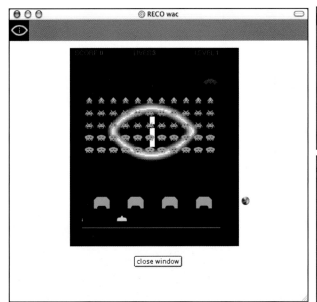

www.scottsmind.com

I love the evil clown generator on this site. When it comes down to it, I really cannot define this site other than it's probably not complete, but it's definitely worth a visit. The cartoons may one day turn into something that animates.

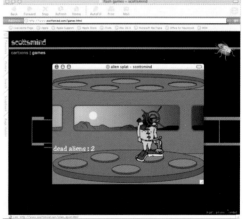

www.presstube.com

This is an interesting experimental site by three guys who have a love for things experimental. This site combines skilled drawings and advanced Flash scripting to produce a thought provoking animation genre. I love the preloaders for all the Flash content.

www.animationfactory.com

Animation Factory's dedicated artists and staff members continue to produce thousands of the best and most useful animated and web designs on the Internet each month and have been doing so since 1996. I often look at Animation Factory for inspiration. Animation Factory owned by Jupiterimages has the largest collection of royalty-free animated clipart on the Internet. Animation Factory features over 400,000 animations, video backgrounds, PowerPoint templates, backdrops and web graphics. ©2006 Jupiterimages Corporation

www.cartoons-online.com

The chat rooms bring avatars to the world of cartooning. It is a great community site, but, most of all, my favourite is the chat room built and designed in Flash, it's fun.

www.cartoonsaloon.ie

The Cartoon Saloon is dedicated to the production of high-quality animation. There work is both innovative and highly creative. They have recently developed quite a reputation for their work internationally. The team members are skilled in traditional animation and illustration. This site has great links to some very interesting content. Check out the character design and illustration sections.

www.identikal.com

In addition to 12 original font families this site is a visually compelling presentation and provides layers of information. It's a simple interface with a great window on to Indentikal's work. A simple design, with a simple and clear navigation. Great fonts.

www.markclarkson.com

To quote mark clarkson "I write, I draw, I animate, I play computer games ... it's sad, but at 42 I still haven't decided what I want to do when I grow up". Mark's site is fun, check out Fishin' ain't so bad. Everybody should have their own personal site.

www.aardman.com

The site is pleasant, welcoming and packed with information about all their projects. In particular, the GIF of Morph and friends is worth seeing. I particularly liked the film A1 Dente at the Steak Barn Meat Restaurant. The head–waiter takes an order for the "vegetarian option", which creates havoc in the kitchen.

www.bechamel.com

This is one of those projects that designers dream about. It gives us the opportunity to explore and rethink many aspects of Internet publishing. A perfect escape from the land of the left navigation, this site is proof that Internet publishing and community can live in harmony with design.

www.ultrashock.com

This compilation of animation, comprehensive tutorial, serves all the loyal fans of Flash. This site contains all of the standard portal site inclusions, the interface encourages exploration and involvement. Some very interesting tips in the tutorial section of this site. Beautifully executed with interesting sound effects on the buttons.

www.wmteam.com

Fantastically minimal. Color and animation in a simple format with great navigation based around a few characters on a building site. The use of ActionScript in Flash is understated and the whole thing is carried through eloquent animation. This site is probably the model for all the major entertainment sites

Appendices

Appendix A: Fonts

Appendix B: Flash Lite 2 Scripting

Appendix C: Shooting Terms

Appendix D: Animation Terms

Appendix E: Animation Software

Appendix F: TV Organizations

Appendix G: CD Content

Appendix A: Fonts

The period of stagnation for type design was in the sixteenth and seventeenth centuries. Many presses overlooked the rules of type design and mixed many sizes and styles of type into single pages, fliers and playbills. These 100–150 years witnessed very little in the progression of typography. Some histories of type start from ancient Egyptians and their hieroglyphs, but we are going to examine the type of fonts that you're likely to encounter in your everyday work. If we do not take into account some really exotic faces, the modern history of type begins in the fifteenth century, when the first examples of the fonts now called Old Style appeared.

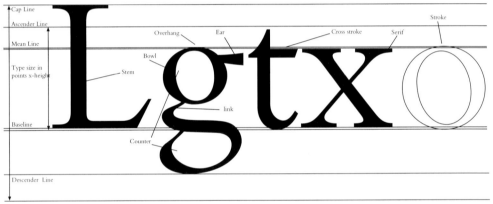

Figure A.1 *Letters in detail*

During centuries prior to that time, the prevalent style of letterforms was the blackletter, or "Old English". Complex, whimsical blackletter shapes were difficult to write and read; what's worse, they were clashing with the ideology of then Renaissance movement and its admiration of classic Roman and Greek art. New, humanist writings required creating a new type of font – more secular, more legible and more elegant.

The first time craftsmen looked into the past in order to create better typefaces for the present, they encountered a few problems. The ancient Romans only had uppercase, capital letters. While adopting their designs for capitals, Renaissance typographers had to spend more time working on lowercase lettershapes. As a basis, they took scripts that were common in the early Middle Ages, but changed them significantly to match the Roman uppercase letters and to better adopt to Gutenberg's printing technology that had just appeared.

One of these new fonts was Antiqua, i.e. "Ancient" (later, the term Antiqua was used for all typefaces that appeared after the blackletter era, and the original Antiqua fonts came to be named

AaBbCcDdEeFfGgHhIiJjKkLlMmNnOoPpQqRrSsTtUuVvWwXxYyZz

AaBbCcDdEeFfGgHhIiJjKkLlMmNnOoPpQqRrSsT

AaBbCcDdEeFfGgHhIiJjKkLlMmNnOoPp

AaBbCcDdEeFfGgHhIiJjKkLlMmN

Figure A.2 *Garamond, based on the Roman font of Griffo*

"Old Style" or "Humanist Antiqua"). Antiqua fonts provide the most up-to-date and fashionable look for the modern eye. Their light, spruce, stylish outline conveys the humanist spirit, and these fonts are now very popular for all sorts of design jobs.

The Old Style typefaces are made up of fairly constant width of all strokes and serifs. They are described as having low contrast, complex non-linear shapes of strokes, and so-called "cove" serifs that form curves where they join the main strokes (the ends of serifs are also sometimes rounded). The thick parts of strokes do not necessarily go vertically; where the thickest parts of the outline are at bottom left and top right. This feature, called diagonal stress, is an attempt to imitate the handwriting of the scribes, who held their pens at some less-than-90° angle to the direction of the line.

Authors of modern Old Style revivals had to artificially match independent designs, often created by different typographers and in different centuries, to compose a complete font family with roman and italic faces. Early italic faces had a more handwritten look and a small slant, while later, sixteenth century italics have a more pronounced slant and peculiarly narrowed letterforms. In roman faces, the late Old Style design fonts like Garamond lose their diagonal stress, the contrast of strokes is increased, and strokes become more linear. By the end of seventeenth century, a new type of font design was emerging. This new type design, belonging to the eighteenth century, is now called Transitional because of its intermediate position between the Old Style and Modern styles. It was during this period that the font faces such as the Times

AaBbCcDdEeFfGgHhIiJjKkLlMmNnOoPpQqRrSsTtUuVvWwXxYyZz

AaBbCcDdEeFfGgHhIiJjKkLlMmNnOoPpQqRrSsT

AaBbCcDdEeFfGgHhIiJjKkLlMmNnOoPp

AaBbCcDdEeFfGgHhIiJjKkLlMmN

Figure A.3 *Times New Roman is the most widely used of all Transitional fonts*

Roman and Baskerville emerged; their features include higher level of contrast (vertical strokes are noticeably thicker than the horizontal ones), mostly vertical stress and a more linear, austere design. Serifs in these fonts are not too long, sometimes pointed, and connected to main strokes through outspoken coves (so the serifs seem to have a triangular shape). The shapes and proportions of letters, the prominence of strokes and serifs, the contrast level – all these features are nearly transparent to the eye, adding minimum, if any, distinctive or "personal" features to a font. The Transitional design could be described as a generic serif font.

The Modern Font

The new font design created at the very end of the eighteenth century and dominating throughout the nineteenth century was, quite naturally, called Modern or New Antiqua. This style has further developed some of the Transitional trends, but abandoned some others.

Modern fonts have drastically increased contrast, leading almost to the edge of legibility and technical feasibility. Giambattista Bodoni had to improve the printing machinery available to him in order to reproduce the new fonts. The long, hairline serifs and horizontal strokes are the first things we notice about this font style.

Due to the high contrast and the lack of almost any coves and rounded corners, the Modern fonts can be very dry, rigid, elaborate and unnatural. Although Modern has an easily recognizable style of its own, the fonts were described as a revolutionary improvement and are called "modern".

AaBbCcDdEeFfGgHhIiJjKkLlMmNnOoPpQqRrSsTtUuVvWwXxYyZz

AaBbCcDdEeFfGgHhIiJjKkLlMmNnOoPpQqRrSsT

AaBbCcDdEeFfGgHhIiJjKkLlMmNnOoPp

AaBbCcDdEeFfGgHhIiJjKkLlMmN

Figure A.4 *Use Modern typefaces such as Univers to create an old-fashioned look (pun inevitable)*

Modern has in fact served as a base for several design variations created throughout the nineteenth century. The most notable Modern offsprings are slab serif fonts where serifs were as wide as main strokes or even wider. Later, Clarendon fonts reintroduced cove serifs and lowered contrast while preserving the overall style of Modern letterforms. Both classic Modern faces and their derivatives pretty much dominated the typography scene in the nineteenth and well into the twentieth centuries.

It was not some new fashion that replaced Modern faces in mass book production. Instead, the century drawing to a close was marked by a wave of revivals, fonts created from ancient prototypes of the Old Style, Transitional and early Modern ages. Now the spectrum of digitized serif typefaces is wider than ever; dominated by revivals, it also contains numerous original faces, for both body text and display setting, combining modern trends with the best features of all previous ages of typography. The first half of twentieth century is the end of the Modern era, the moment when revived typefaces were flooding the typography mainstream. But it was also the time when a completely different font design was booming, called sans serif (French for without serifs). It wasn't totally original at that time, since the first sans serif faces had appeared at the beginning of the nineteenth century; but the trend claimed importance in the 1920s and 1930s.

It is amazing that the simple idea of dropping serifs at the ends of strokes didn't occur to the great many typographers who experimented with their shapes and sizes so much. This is due to the inertia of scribes' tradition who, with their quills, simply could not produce a reasonably clean cut of a stroke. Old typographers also knew the fact that was later confirmed by experiments: serifs help the eye to stick to the line and thus facilitate reading.

AaBbCcDdEeFfGgHhIiJjKkLlMmNnOoPpQqRrSsTtUuVvWwXxYyZz

AaBbCcDdEeFfGgHhIiJjKkLlMmNnOoPpQqRrSsT

AaBbCcDdEeFfGgHhIiJjKkLlMmNnOoPp

AaBbCcDdEeFfGgHhIiJjKkLlMmN

Figure A.5 *Futura In The Past, or A Triumph of Geometry: developed by Paul Renner in 1928*

When the first examples of sans serif fonts finally appeared, they seemed so controversial that the first name given to them was "grotesque", and they were very rarely used except in advertising. And so it remained until the newest trends in art and industrial design, most notably the German Bauhaus movement of 1920s, required adequate means of typographic expression. These movements stressed utilitarian aspects in design, claiming functionality and denying any attempts to artificially adorn the face.

The Futura font, created in Germany in 1928, displayed the core of the Bauhaus ideology: strictly geometric outline, without any embellishments and just barely conforming to the historical shapes of letters. Now we're much more accustomed to the look of Futura and its many derivatives, but the inborn radicalism of the font still shows through and has become the source of many techno fonts.

The Radical Sans Serif

As all radical movements, the "new sans serif" typography of the 1920s was taken by designers to mean the imminent death of all serif fonts. This didn't happen. Futura itself didn't manage to become so neutral and familiar in the mass perception as to become a standard sans serif font. The standard sans serif position was taken by Helvetica, a font that became ubiquitous almost to the point of being misused. However, it cannot be denied that Futura played an important role in sans serif becoming a mainstream type style, and a contrasting pair for the time-proven serif fonts.

Sans serif proliferation was also due to the higher demand for display typefaces in all media, the demand which is much more severe than at any time in the past. The most natural use of a sans serif font is still for display purposes (ads, titles, logos, labels of all sorts), although it can be successfully used for body text as well.

The Humanist Sans Serif

One of the first such designs was Frutiger developed in 1976; at first sight similar to Helvetica, on a closer look this font reveals some "anti-geometric" features, such as uneven width of strokes (especially in bold variants), non-perpendicular cuts and slightly bent-off tips of strokes (e.g. the bottom of the vertical stroke in "d"). All these subtleties were intended to smooth out the too harsh edges of the generic sans serif design and improve legibility of characters, and their net result is a relatively warm and friendly-looking typeface – especially when compared to Helvetica or Futura.

The trends that were hinted at in Frutiger were later fully developed in a family of fonts extremely popular both on the web and in print design. The original typeface of this family, called Meta, was developed in 1984 by German designer Erik Spiekermann. In Meta and its offsprings, strokes have slightly varying width, the creator's goal was that in small sizes, thinner strokes should

AaBbCcDdEeFfGgHhIiJjKkLlMmNnOoPpQqRrSsTtUuVvWwXxYyZz

AaBbCcDdEeFfGgHhIiJjKkLlMmNnOoPpQqRrSsT

AaBbCcDdEeFfGgHhIiJjKkLlMmNnOoPp

AaBbCcDdEeFfGgHhIiJjKkLlMmN

Figure A.6 *Officina Sans is another Meta-like font designed by Spiekermann*

not "drop out", but become undistinguishable from the thicker ones and, in compensation for the missing serifs, bent-off tips of vertical strokes in letters like "d" or "n". Both uppercase and lowercase characters are narrower than in most other sans serif fonts. Here we can see how we can have an example showing how far can we go in "humanizing" sans serifs and borrowing serif-specific features, while remaining within the sans serif paradigm.

Interestingly, the problems that the designer tried to resolve with the new typeface were purely practical – Spiekermann's goal was to create an economic font readable in a wide variety of sizes and conditions.

But, let's say you really need two fonts for your work (for example, one for headings and the other for body text), and you're not satisfied by using variations of the same font. Which pair to choose? The basic answer is: serif fonts work fine with sans serifs, and vice versa. These two types of fonts are different enough for their contrast to be immediately obvious, resulting in a harmonious and well-balanced page. As serif and sans serif were not developed in parallel, we cannot base our decisions on historical acceptance; most, if not all, of today's serif faces are rooted in past ages, while the majority of sans serifs were created in the current century. More useful is matching the level of looseness versus rigidness and artificiality.

A personal favourite font site is www.fontsforflash.com it provides top quality creative fonts in both Pixel and Super Pixel fonts, check it out.

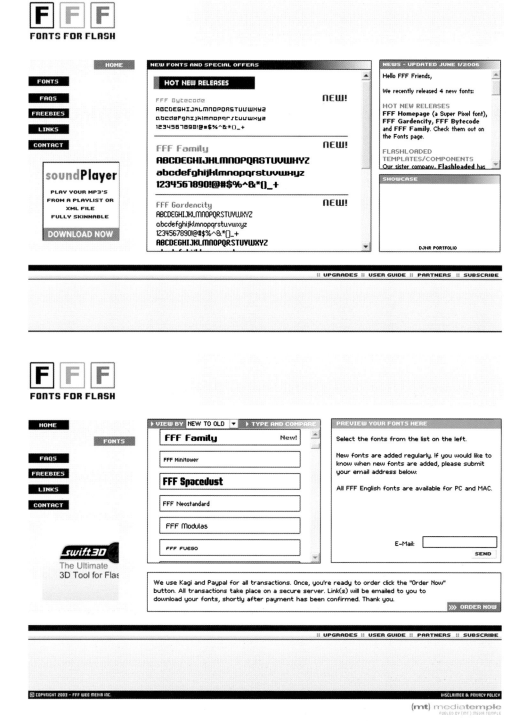

Figure A.7 *Home Page of fontsforflash*

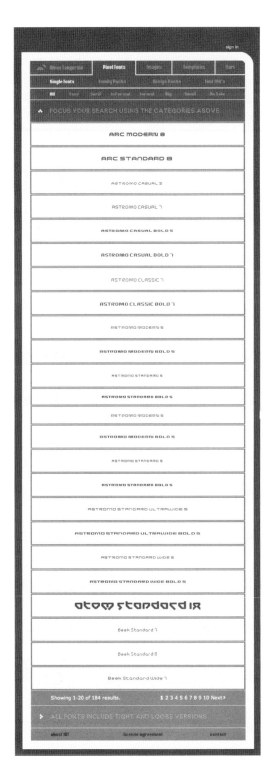

Figure A.8 *Home Page*

Figure A.9 *Font library*

Another personal favourite is Mean Tangerine pixel fonts which are great not only for Flash applications, where every font will remain sharp and clear, but for any design delivered on screen or in print. Use them in buttons, navigation bars, site logos – even on mobile phones fonts. A good selection well worth a visit at http://www.meantangerine.com.

Mean Tangerine pixel fonts for Flash and general creative design. Interactive or static delivery. Big type or small, avant-garde or traditional. There's something for everyone in the MT library.

Appendix B: Flash Lite 2 Scripting

Before you start developing a Flash Lite application, you need to know the following:

The Device or Devices on which the Content will Run

Identify your target devices and Flash Lite content type as different devices have different screen sizes, support different audio formats, and have different screen color depths, among other factors. These factors may influence your application's design or implementation.

The Flash Lite Content Types that the Target Devices Support

Some devices use Flash Lite to enable Flash-based screen savers or animated ring tones. Others use Flash Lite to render Flash content that is embedded in mobile web pages. Not all content types support all Flash Lite Scripting features. For example, a Flash application that is running as a screen saver is not able to make network connections or download data.

You can determine if your application uses features that aren't available for the type of content that you are developing by testing features in Macromedia Flash Professional 8 Flash Lite emulator against multiple devices. You can use the Flash Lite emulator to refine your application design and fix any problems before you test it on a mobile device. However, the emulator doesn't emulate all aspects of the target device, such as its processor speed, color depth or network latency. An animation that runs smoothly on the emulator might not run as quickly on the device, because of its slower processor speed. The procedure is an iterative development and testing process. After you test your application on a device, you may find that you need to refine the application's design in the Flash authoring tool.

Flash Lite Authoring Features in Flash Professional 8 Only

The Flash Lite emulator and test window lets you test your content as it will run and appear on an actual device. A settings panel in the Flash Lite test window lets you select a different test device, view information about your application, and set emulator debug output options.

The Device Settings dialog box lets you select the test devices and Flash Lite content type that you want to test against in the Flash Lite emulator. When you preview your application in the Flash Lite test window, the emulator mimics the features available to the selected test device running as the selected content type.

The Property inspector contains a section that provides information about your current device settings, as well as a button that lets you open the Device Settings dialog box. This button is active

only when your document's Version setting on the Flash tab of the Publish Setting dialog box is set to Flash Lite 1.0 or Flash Lite 2.

Document templates provide a starting point for you to create different types of Flash Lite content for different categories of devices.

Commands Issued through fsCommand and fsCommand2

The fsCommand and fsCommand2 commands let the SWF file communicate with either Flash Player or the program that is hosting Flash Player, such as a web browser.

Flash Lite 2.0 modifies the standard Flash Player 7 commands, and adds commands that are specific to embedded devices. Flash Lite 2.0 also supports fsCommand2, which provides similar functionality to fsCommand, with the exception that the command is executed immediately.

When the application is started I always set it to full screen mode using the following script:

```
success = fscommand2(``FullScreen'', true);
```

Then I set the quality to high quality:

```
success = fscommand2(``SetQuality'', ``high'');
```

Figure B.1 *Picture of script formatting in the ActionScript window*

To trigger soft key events you need to tell the Flash Player. Otherwise it triggers soft key events with its default methods. To do so you can use another fscommand2:

```
success = fscommand2(''SetSoftKeys'', ''Select'', ''Quit'');
```

The strings "Select" and "Quit" are visible if the application doesn't run in full screen mode.

In Flash Lite 1.x the soft keys return the key codes of PageDown and PageUp on a computer keyboard and you could trigger it with simple buttons:

```
on (keyPress ''<PageUp>''){

        //left soft key

}

on (keyPress ''<PageUp>''){

        //left soft key

}
```

In Flash Lite 2 this doesn't work. The soft keys return extended key codes and you have to create a key listener to trigger key events:

```
MyKeyListener = new Object();

MyKeyListener.onKeyDown = function() {

    if (Key.getCode() == ExtendedKey.SOFT1) {

      //left soft key

    }else if (Key.getCode() == ExtendedKey.SOFT2) {

      //right soft key

    }

};

Key.addListener(MyKeyListener);
```

You can trigger all other key events with simple buttons:

Joystick events:

```
on (keyPress ''<Up>''){
```

```
    //joystick pressed up

}

on (keyPress ''<Down>''){

    //joystick pressed down

}

on (keyPress ''<Left>''){

    //joystick pressed left

}

on (keyPress ''<Right>''){

    //joystick pressed right

}

on (keyPress ''<Enter>''){

    //joystick select/fire

}
```

Keypad events:

```
on (keyPress ''1''){

    //key 1 pressed

}

...

on (keyPress ''9''){

    //key 9 pressed

}
```

To quit an application you have to use another fscommand2:

```
success = fscommand2(''Quit'');
```

Every call of an fscommand2 method returns a value. In the examples above this value is stored into a variable named "success". It can sometimes be helpful to check if a fscommand2 was successfully executed.

Other useful fscommands are:

```
success = fscommand2(''StartVibrate'', 3000, 2000, 10);
```

This forces the phone to vibrate (if supported). In that case, it vibrates 10 times for 3 seconds with 2 seconds pauses between the vibrations.

```
success = fscommand2(''StopVibrate'');
```

It stops the vibration if there is any.

All the other fscommands aren't very interesting for animators.

fscommand2 Commands

Command	Description
ExtendBacklightDuration	Extends the length of a backlight for a specified period of time.
FullScreen	Sets the size of the display area to be used for an image.
GetBatteryLevel	Returns the current battery level.
GetDevice	Sets a parameter that identifies the device on which Flash Lite is running.
GetDeviceID	Sets a parameter that represents the unique identifier of the device (for example, the serial number).
GetFreePlayerMemory	Returns the amount of heap memory, in kilobytes, currently available to Flash Lite.
GetMaxBatteryLevel	Returns the maximum battery level of the device.
GetMaxSignalLevel	Returns the maximum signal strength level as a numeric value.
GetMaxVolumeLevel	Returns the maximum volume level of the device as a numeric value.
GetNetworkConnectionName	Returns the name of the active or default network connection.
	(Continued)

Continued

Command	Description
GetNetworkConnectStatus	Returns a value that indicates the current network connection status.
GetNetworkGeneration	Returns the generation of the current mobile wireless network 2G or 3G mobile wireless.
GetNetworkName	Sets a parameter to the name of the current network.
GetNetworkRequestStatus	Returns a value indicating the status of the most recent HTTP request.
GetNetworkStatus	Returns a value indicating the network status of the phone (i.e. whether there is a network registered and whether the phone is currently roaming).
GetPlatform	Sets a parameter that identifies the current platform, which broadly describes the class of device.
GetPowerSource	Returns a value that indicates whether the power source is currently supplied from a battery or from an external power source.
GetSignalLevel	Returns the current signal strength as a numeric value.
GetTotalPlayerMemory	Returns the total amount of heap memory, in kilobytes, allocated to Flash Lite.
GetVolumeLevel	Returns the current volume level of the device as a numeric value.
Quit	Causes the Flash Lite Player to stop playback and exit.
ResetSoftKeys	Resets the soft keys to their original settings.
SetFocusRectColor	Sets the color of the focus rectangle to any color.
SetInputTextType	Specifies the mode in which the input text field should be opened.
SetSoftKeys	Remaps the softkeys of a mobile device.
StartVibrate	Starts the phone's vibration feature.
StopVibrate	Stops the current vibration, if any.

Appendix C: Shooting Terms

A

Ambient sound: This term generally refers to any sound that is used to establish location and is usually unintelligible background noise.

Aperture: A device that controls amount of light admitted. On a camera it is the opening of the camera lens, controlling and allowing the light to pass through.

Assemble edit: A video editing procedure which records new video audio and control track information concurrently. Also can be a method for building a videotape in which a series of clips are placed one after the other to create, or assemble, a program.

Available light: The light that's normal in a scene, although the term is generally used when the light level is low. Available light shooting usually involves fast film, low shutter speeds and apertures, and/or the use of a tripod. Light from a natural source or commonly used lamp, as opposed to light added to a scene by using powered lighting.

B

Background light: A light used to illuminate the background of a set or scene, but not intended to illuminate the subject.

Backlight: Light striking a subject from the direction opposite to the camera. Illumination of a subject from behind, facing the camera. May be done intentionally for a special effect however this is a production mistake, making the main subject difficult to see.

Base light: Even, non-directional (diffused) light necessary for the camera to operate optimally. Normal base light levels are about he 2000 lux (150–200 foot-candles).

C

Close-up: An object or any part of it seen at close range and framed tightly. The close-up can be extreme (ECU) or rather loose (medium close-up).

CU: Close-up.

Cut: The transition from one picture or audio source to another. Rough cut first assembly of a film which the editor prepares from selected takes, in script order, leaving the finer points of timing and editing to a later stage.

Cutaway: A shot added between two edit points.

D

Depth of field: The amount of distance between the nearest and farthest objects that appear in acceptably sharp focus in a picture. Depth of field depends on the size of the aperture, the distance of the camera from the subject and the focal length of the lens.

Depth of focus: A zone of focus in the camera. If an image is focused on a ground glass screen in a camera, depth of focus makes it possible to move the screen slightly backward or forward and still have the image in acceptable focus.

Dolly: A device with wheels for rolling the camera on a specially designed trolley that runs on rubber wheels attached to a tripod to allow smooth movement of a camera.

E

Edit: The process of adding pictures and sound and making changes to one source.

Establishing shot: A cinematic shot that establishes a certain location or area. It can introduce a scene, usually a wide angle view.

F

Fade: In video the gradual change of a picture to black or vice versa, and in audio the gradual change from sound to silence or vice versa. In stage lighting, a fade is a gradual increase or decrease of the intensity of light projected onto the stage. The term fade-in refers to gradually changing the lighting level from complete darkness to a predetermined lighting level.

Fill light: Illumination from a source less bright than the key light, used to soften deep shadows in a scene.

Flare: Lens flare is a phenomenon that may occur in images or views through optical systems when they are pointed at bright sources of light. It is caused by the scattering and internal reflection and refraction of bright light.

Flood light: Lighting fixture that emits a broad field of light with a soft edge illumination with diffused shadows such as a borderlight.

Focal length: The distance between the film plane and the focal point when the lens is focused at infinity. The focal length of the lens is marked in millimetres on the lens mount. The principal focal point is the position of best focus for infinity.

Focus: A sharp image from a lens to be projected onto the focal plane of a camera.

Frame: In film, video production, animation and related fields, a frame is one of the many still images which compose the complete moving picture. Historically, these were recorded on a long strip of photographic film, and each image looked rather like a framed picture when examined individually, hence the name. A complete television picture consists of two interlaced fields of video. The frame rate for PAL is 25 frames per second and for NTSC is thirty frames per second.

Freeze frame: The continuous repetition of a single frozen frame of video.

Fresnel: The lens invented by Augustin Fresnel in 1821 which consists of concentric ridges radiating outward from the central lens (bullseye), with prisms positioned at the top and bottom of the ridges to refract the light from the light source placed behind the central lens. Originally used in lighthouses, now also used in high-quality studio and theatrical lights.

f-stop: The size of the aperture in a lens, given in f-numbers. The lower the f-number, the more light passes through the lens. Measured in stops for example f2.8, f4, f5.6, f8, f11, f16, f22 each have one stop between them, so f2.8 to f16 will be 5 stops.

G

Gaffer: On a film set, the head electrician, now more commonly called the "Chief Lighting Technician". In film, the head of a crew, e.g. the "gaffing mixer" would be the re-recording mixer-in-charge, formerly known as the gunner.

Gaffer's tape: A strong adhesive tape used in film and television production.

Gain: This is the degree of amplification. The difference between the signal level at the input of a device and the level at the output, usually expressed in dB.

Grip: Crewmember who moves the dolly and is responsible for the transportation, maintenance and mounting of the camera.

H

Head room: This is for video or film and is the space between the top of a subject's head and the top of the frame.

I

Incident light: The light actually falling on a subject, which may not be the same as the amount of light being reflected by the subject.

Insert: A shot or sequence inserted into an existing edit.

Insert edit: An edit in which a clip is added to the track at a specified point, moving clips that follow it out in time. An insert edit does not replace existing material. It can also mean a video or audio edit which is recorded on a tape which already has a reference on it or over a previously prepared "base" of video black and control track.

J

Jump cut: A mismatched edit that creates a visual disturbance when replayed. Usually occurs when cutting between two images which share an identical subject but place the subject at different positions in the frame.

K

Key light: A studio light used to control the tonal level of the main area of the subject.

L

Lavalier: A microphone worn on the body and held in place either with a lanyard worn around the neck or a clip fastened to clothing. The frequency response of a lavalier microphone is skewed toward the higher frequencies to compensate for the low frequency sound transmitted directly to the microphone by contact with the body. This microphone is very common in interviews.

Lens hood: An accessory that attaches as a collar to the front of a lens to prevent stray light from striking the surface of the lens, and thereby causing flare.

Live: Not pre-recorded. Real-time transmission or instant as it is seen on the television.

Live on tape: Recorded exactly as occurring with no compression of time or alteration of any sequence of events.

Long shot (LS): A shot taken from a considerable distance. Often the LS serves as an establishing shot.

M

Master: The tape where the edit is recorded on.

Master: The finished copy of a movie from which copies are made for distribution.

Medium shot (MS): A shot showing a single subject, rather than an overall scene, but not in detail. For example, a shot of a person including the body from the waist to slightly above the top of the head.

N

Neutral density filter: Filter for use in front of the lens that absorbs all visible wavelengths to a more or less equal extent. ND filters can be used with both monochrome and color films, since they have no effect on color balance.

Nose room: The space between the nose of a subject's head in profile and the edge of the video frame the subject is facing.

O

One-hundred eighty degree rule: A rule which states that when dealing with two or more subjects, shots may only be cut together if they are taken from the same side of a line drawn through the subjects. The visual continuity is used to maintain proper direction on the screen.

Original: First generation videotape or film. This is also usually the tape which is recorded in the camera.

P

Pan: A movement in which the camera is rotated in the horizontal axis. The proper commands are "pan right" and "pan left".

Profile: Side view of a person or object.

R

Reflected light: Light not falling on a subject but bounced.

Reflector flood: A sealed floodlight with a self-contained reflector.

Reflector spot: A sealed spotlight with a self-contained reflector.

S

Safe area: The portion of the picture area, usually marked so in the camera's viewfinder, where important material, action or text titles should be confined to. The purpose is to make sure that everything important can be seen even when the TV set has a significant overscan, or to create movie and video programs that can be acceptably cropped into a choice of two or more picture aspect ratios.

Slow motion: Movements on the screen appearing slower than they would in actual life. For example, a diver will seem to float to the water gently rather than fall at the speed dictated by gravity. A filmmaker achieves slow motion by running film through his camera at a speed faster than the standard 24 frames per second; subsequent projection at 24 frames per second slows down the action.

Superimposition: A process in TV projection where an image, word or phrases are imposed over another image and are visible simultaneously.

T

Telephoto lens: A lens that makes a subject appear larger on film than does a normal lens at the same camera-to-subject distance. A telephoto lens has a longer focal length and narrower field of view than a normal lens.

Thirty-degree rule: This is a principle of visual continuity which states that the relative angle of view of any two similarly framed shots of the same subject which are to be cut together should vary by at least thirty degrees.

Tilt: A camera movement in the vertical axis which rotates the camera either over or under the subject. The commands are "tilt up" and "tilt down".

W

Wide angle: In photography and cinematography, a wide-angle lens is a lens whose focal length is shorter than the focal length of a normal lens. For a 35 mm camera with a 24 by 36 mm format, the normal lens is 50 mm. A lens of focal length 35 mm or less is considered wide-angle. For 35 mm still cameras and one inch television cameras, the standard length is 50 mm.

Wide shot (WS): A shot that shows a great deal of the area where the scene is taking place. It usually looks as if the camera is placed far back from the subject. A picture showing a subject in the context of the surroundings to establish a relationship between the subject and the surroundings.

Z

Zoom: Enlarges the view of an object enabling you to see more detail. In photographic terms, 'Telescopic' and 'Wide' are general expressions used to describe the varying extremes of the zoom function.

Zoom lens: A lens with a focal length that can be changed during a shot. A shift toward the telephoto range enlarges the image and flattens its planes together, giving an impression of moving into the scene's space, while a shift toward the wide-angle range does the opposite.

Zoom ratio: The ratio of the starting focal length (wide) to the ending focal length (telephoto) of a zoom lens. A 10X zoom will magnify the image at the wide end by 10 times. Examples of a 10X zoom lenses; 8mm~80mm, 12mm~120mm.

Appendix D: Animation Terms

Alpha: A fourth color channel in the RGB color model that represents transparency. Alpha values can range from completely transparent to completely opaque. Not supported by all file formats.

Animatic: A storyboard that has been put onto video or film with a soundtrack to give a better idea of the finished product.

Animated GIF: Solid-color animated graphic file format that doesn't include audio. It's best suited for small frame sizes, and ideal for low-impact animations on the web.

Animation Path: A line that objects follow during the course of an animation, also called a motion path.

Anti-aliasing: A rendering technique to reduce the jagged lines produced by the low resolution of computer screens. It determines the color value of a pixel by averaging the color value of the pixels around it and softening the hard lines.

Anticipation Movement: A rule of animation that dictates that an object has to have an opposite movement before it can travel in the desired direction.

Application: A software package that allows the user to perform some kind of work function. Also called a program.

Aspect Ratio: The ratio of width to height of a screen. Standard television aspect ratio is 4:3. Some motion picture sizes are 16:9.

AVI: Audio–Video Interleaved. A standard compressed video file format for Windows.

Background: Normally painted or drawn artwork that is scanned into the computer and used as a static backdrop for animations.

Back-up: A way to store files on some kind of storage device in case they are lost or destroyed.

Bézier: A way to define curved lines invented by Pierre Bézier, a French mathematician.

Bi-linear Interpolation: A texture display mode used to minimize aliasing.

Bitmap: A grid of pixels assigned a color and X and Y locations to make up an image. Bitmap images are resolution dependant, and are also known as raster images.

Byte: A unit of computer data consisting of eight bits.

Camera: The viewpoint through which a scene is viewed.

Cel: A clear cellulose sheet used for traditional animation. Drawn with black ink on one side, and then colored on the reverse.

Cel Animation: Traditional form of animation. Images are drawn by hand, transferred to acetate, colored and photographed one frame at a time.

Client: A computer workstation connected to a server on a network.

CMYK: Cyan, magenta, yellow and black. A process of identifying the colors used by printers.

Collision Detection: The process whereby the boundaries of objects are detected by other objects in a scene. This prevents objects from passing through each other, used extensively in games.

Color Depth: The number of bits per pixel used to define color. Different monitor systems and software can display colors in 1 bit (black and white), 4 bits (16 colors), 8 bits (256 colors), 16 bits (65,536 colors), 24 bits (16.4 million colors), and 32 bits (16.4 million colors with 256 levels of transparency).

Color Index: A single value that represents a color by name, rather than by value.

Color Wheel: A representation of the color spectrum in the form of a circle.

Cursor: The on-screen pointer that shows the position at which you're working. It can take a variety of forms.

Cycle: A sequence of drawings, creating a movement by repeating themselves continuously, for example a walk cycle.

DAT: Digital Audio Tape, a format used for string audio material or computer data.

Desktop: The main work area on a computer screen.

Disk: A magnetic storage medium for data.

DPI: Dots Per Inch. The display resolution of devices such as monitors or printers.

Direct3D: Microsoft's standardized 3D programming interface.

Dithering: Simulates unavailable colors using patterns that intersperse pixels from available colors. Dithered colors often look coarse and grainy.

Dope Sheet: A chart used in traditional animation that contains notes for a cameraperson to follow while they are filming the animation artwork.

Drag: To move an object around the screen by holding a mouse button and "dragging" the mouse around.

Driver: A software program that is used by the computer to give instructions to hardware devices.

Email: Electronic mail. A system of communication that allows the user to send messages to other users as long as they too have an email address.

EPS: Encapsulated Postscript file. A standard graphics format.

Exposure Sheet: A dope sheet.

FAT: File Allocation Table. A hard disk storage and retrieval method used by computers.

Filter: A process applied to an image to create an effect, e.g. blurring.

Follow Through: An action in animation drawings that obeys the law of motion that when an object is stopped, a part of the body continues to follow the direction it was going.

Fps: Frames per second. The speed at which a computer renders each frame.

Frame: A single image on a roll of film. In an NTSC video signal, one frame is 1/30 of a second. In a PAL video signal one frame equals 1/25 of a second.

Frame Rate: The rate at which a computer renders each frame of an animation.

Geometry: The 3D structure of an object.

Grab: The technique of acquiring a still graphic from the screen of a computer or a video.

Graphics Engine: Software that generates interactive 2D and 3D graphics. Examples of graphics engines are Direct3D and OpenGL.

Hardware: The components of a computer system, for example, the hard disk or the motherboard.

Hold: Frames within an animation sequence where an object does not move, but maintains its position.

HSB: Hue, Saturation, Brightness. Based on the human perception of color, the HSB model describes three fundamental characteristics of color.

Icon: A small picture that represents an application, file type or other computer related items.

In-betweening: In animation, the process of adding frames between keyframes to produce smooth motion. Also known as tweening.

Interface: The display and presentation of information on the computer screen.

Interpolation: Literally: filling in the empty space between existing parts. Interpolation is used in graphics to describe the process of upscaling graphics. It's used in animation to describe the process of tweening.

JPEG: Joint Photographic Experts Group. A commonly used graphics file format that compresses graphics. It supports up to 24-bit color. Its small size makes it ideal for web graphics.

Keyframe: In animation, a frame that marks the position of an object at a point in time. A series of keyframes show the object at key positions during the course of motion. In-between frames then represent the actual movement.

Lathing: Creating a 3D surface by rotating a 2D spline around an axis.

Layout: A drawing of the background and animation characters created as a plan to visually describe the main features of a scene.

Level of Detail: A series of models representing the same object and containing increasing levels complexity and detail. The less detailed models are displayed when the viewer is far away. The more detailed models are displayed as the viewer gets closer.

Lip Sync: Synchronizing a character's mouth movements to a spoken soundtrack.

Luminance: The perceived brightness of a surface.

Memory: Computer hardware that is used for short-term storage, also known as RAM.

MOV: Movie. Apple's QuickTime movie format.

Motion Capture: The process of digitizing a motion and applying it to a model.

Monitor: A computer screen.

Mouse: A pointing device that has one or more buttons.

MPEG: Motion Picture Experts Group. A compressed video file format.

Network: A connected group of computers, each sharing information.

NTSC: National Television Standards Committee. Created the standards for American televisions. This acronym also refers to the standard formulated by the committee. This format has approximately 30 frames (60 fields) per second.

OpenGL: An open graphics API originally developed by SGI. It's used with many video adapters for many 3D applications, from games to high-end CAD.

Operating System: The basic software that defines how a computer operates.

PAL: Phase Alternate Line. A video format used in Europe and England. There are approximately 25 frames (50 fields) per second in this format.

Pan: The movement of a camera across a scene.

Parenting: The process of assigning hierarchy to objects.

PCX: Commonly used by IBM PC-compatible computers. It supports RGB, indexed-color, grayscale and bitmap color modes. It does not support alpha channels. PCX supports the RLE compression method.

PICT: Apple graphic file format. It can include bitmapped or vector images, and can use different compression schemes. It's available only for Apple.

Pixel: Picture element. The smallest element that can be independently assigned color.

Polygon: A near-planar surface bounded by edges specified by vertices.

Quicktime: A compressed video file format developed by Apple.

RAM: Random-Access Memory.

Rasterize: The process of converting a projected point, line, polygon or the pixels of a bitmap or image to fragments, each corresponding to a pixel in the framebuffer.

Rendering: The process of producing images or pictures. Rendering techniques such as shading, light modelling or depth cueing are sometimes used to make an image look realistic.

Resolution: For a CRT, the maximum number of displayable pixels in the horizontal and vertical directions. For a printer or plotter, the number of pixels per inch.

RGB: Red, Green, Blue. A color model. A large percentage of the visible spectrum can be represented by mixing red, green and blue (RGB) in various proportions and intensities. Where the colors overlap, they create cyan, magenta and yellow. RGB colors are used for lighting, video and monitors.

Rotation: A geometric transformation that causes points to be re-oriented about an axis.

Saturation: The amount of color.

Server: A computer that controls other users' access to a network.

Scaling: Changing the size of an object without changing its location or orientation.

SCSI: Small Computer Systems Interface. A standard connection that allows hardware devices to be attached to a computer.

Shading: The process of interpolating color within the interior of a polygon or between the vertices of a line during rasterization.

Squash and Stretch: A rule of motion applied to animated drawings. An object will stretch and then squash as soon as it stops against a surface.

Texture: A 2D bitmap image applied to 3D surfaces.

Texture Mapping: The process of applying a texture to 3D surfaces. It's used to add visual detail to 3D surfaces without increasing the geometry.

TIFF: Tagged Image File Format. An industry standard bitmap image format supported by many applications.

TGA: Targa. Graphic file format that supports any bit depth, and includes features such as alpha channels, gamma settings and built in thumbnails.

Timeline: A scale measured in either frames or seconds.

Transformation: Translation, scaling and rotation of a geometric object.

TWAIN: Technology without an interesting name. An industry standard for exchanging information between applications and devices.

Tweening: In animation, the process of adding frames between keyframes to produce smooth motion. It's also known in-betweening.

VCR: Video Cassette Recorder.

Viewing Coordinates: A coordinate system that defines the positions of objects relative to the location of a viewer or camera.

VTR: Video Tape Recorder.

Window: A rectangular area in which information is presented on the screen.

Wireframe: The process of drawing a model by tracing features such as edges or contour lines without attempting to remove invisible or hidden parts, or to fill surfaces. The result is a model "frame".

Xsheet: The Xsheet is the final application where the completed scene is put together.

Zoom: The enlargement or reduction of the image created by adjusting the lens on a video camera.

Appendix E: Animation Software

2D Animation Software:

Animo

http://www.animo.com

A comprehensive toolkit to create animated productions in digital format that takes the animator through the whole process: from the scanner to outputting on film or video. Many of the digital techniques featured in the package emulate traditional methods.

Archer

http://www.yogurt-tek.com/

Archer is a modular-based software painting package designed to create high-quality 2D animation that can be configured according to different working environments and preferences. This bitmap system offers scanning, Bgmaker, Analyser, Painter, Xsheet and Composer modules.

Axa Team 2D Pro

http://www.axasoftware.com

A program designed specifically to do 2D cel animation in a Windows environment; easy to use, affordable and expandable.

CelAction

http://www.celaction.com/

Professional 2D animation software for films, TV series and commercials. It is a cheap package, but very easy to use and allows animators to design 2D character models on computer as resolution-independent vector graphics or scanned bitmaps.

Crater Software

http://www.cratersoftware.com

Cartoon television program (CTP) is a PC compatible computer program specifically designed for broadcast quality animated series production. To run the CTP, you only need a standard PC, a simple scanner and any video input/output board.

Creatoon

http://www.creatoon.com

PC software that allows the animator to create 2D animation in the cut-out style that shows your animations on screen in real time as you are creating them.

Flash

http://www.macromedia.com

A vector-based software system to allow you to create high-impact animations specifically for the Internet. Its purpose is too limited for general film and video production, however.

Linker Systems

http://www.linker.com

Animation stand is a computer assisted 2D character animation system, available for all major platforms.

MediaPegs

http://www.mediapegs.com/

A system that digitizes the entire post-paper animation process from scanning to delivery, can run on Silicon Graphics stations and Windows NT machines. The package is intended for all animated media, including animated series, commercials and web content.

Retas!Pro

http://www.retas.com

A 2D digital animation production system which puts all the power and flexibility of professional creativity at your fingertips: digital drawing, pencil test, line trace, ink and paint, composting and special effects.

Softimage Toonz

http://www.softimage.com

Toonz is a complete 2D animation system used extensively in high-profile film, video and interactive media productions. It includes a flexible automated workflow, palette management and ways to eliminate the labour intensive processes involved with animation.

Toonboom

http://www.toonboom.com

A 100% vector-based, resolution-independent system for producing 2D animations from the web to film, featuring an animator-tested interface.

2D Drawing Tools:

CorelDRAW

http://www.corel.com

CorelDRAW® delivers vector illustration, layout, bitmap creation, image-editing, painting and animation software. CorelDRAW supports development for both print and the web, and also now features a bundled application for creating Flash animations.

Fireworks

http://www.macromedia.com

Fireworks allows you to create, edit and animate web graphics using a complete set of bitmap and vector tools and export them into a number of HTML editors. Links in seamlessly with Flash and Dreamweaver.

FreeHand

http://www.macromedia.com

FreeHand creates vector-based illustrations, web site storyboards and features a unique multipage workspace. The package can be used to generate both web-and print-based material.

Adobe Illustrator

http://www.adobe.com

Illustrator produces vector graphics alongside creative options and powerful tools for efficiently publishing artwork on the web and in print. The package features innovative slicing options, live distortion tools and dynamic data-driven graphics.

3D Packages:

3DS Max 4.2/Character Studio 3

http://www.discreet.com

Discreet 3DS Max is used by animators across the board, from video games to TV and film animation. It is one of the best character animation packages on the market, and handles complex textures easily. Character Studio 3 is one of the most popular add-ons that anyone doing character animation in 3DS will have in their toolset.

Cinema 4D XL7

http://www.cinema4d.com

This package is notable due to the ability to create poseable figures as easily as creating crude cubes or spheres. This means the animator can easily create primitive figures to set up a scene quickly and simply. The package can be extended with add-ons, and provides a lot of tools for the character animator to play with at a good price.

Hash Animation Master

http://www.hash.com

Hash animation master is a stand-alone package with some unconventional tools. It is a low-cost, but heavy-weight package that allows you to simplify and reuse animation once you have built up a library of poses; what it does it does well and with a minimum of fuss.

Lightwave 7

http://www.newtek-europe.com

This package runs on a 3D-based system, unlike the 2D systems in many other packages, allowing the animator to produce more realistic results. Lightwave 7 handles 3D well, and is a tried and tested tool for the 3D animator.

Maya 4

http://www.aw.sgi.com

Perhaps the most sought-after 3D animation tool, Maya has been used on a wide range of television programmes, video games and films, and is used for everything from cartoon animation to ultra-realistic character animation. Maya makes complex animation tasks a lot less tricky and has the power to animate down to the finest detail.

Poser/Poser Pro

http://www.curiouslabs.com

A low cost, but effective, package for creating and animating 3D characters. Poser has a user-friendly interface and an extensive set of character animation tools, letting you animate characters through a set of poses quickly and easily. Poser sacrifices rendering quality for speed and ease of use, but this can be solved by taking your models into another 3D package.

Project Messiah:animate 3.0

http://www.projectmessiah.com

Once a Lightwave plug-in, Project Messiah has been designed for those who work on character animation full-time. Featuring advanced morphing and blending to allow you create animations quickly, Project Messiah is a strong package that gives you a wide range of tools for character animation.

Softimage XSI 2.0

http://www.softimage.com

The package is one of the top players in the 3D animation world, and contains a special meta-clay feature that lets you mould organic shapes from a soft, sticky material. Strong texturing and rendering makes this a very desirable package.

Strata Pro

http://www.strata3d.com/

Strata 3D pro is a versatile application for 3D modelling, rendering and animation. The package has a range of features, including light sourcing, a wide range of modelling capabilities and a number of rendering options, including .swf Flash format.

Swift 3D

http://www.swift3d.com/

A low cost, easy to use vector-based animation package that is a useful choice for 3D Flash animation as it can export files in .swf and a range of other formats, and has other features such as light sourcing and a powerful rendering engine.

Lip Syncing Applications:

Magpie Pro

http://www.thirdwishsoftware.com

Magpie Pro is a powerful lip sync and animation timing tool for the professional animator. It was created in such a way that allows the animator to approach the task in different ways according to his or her personal taste, and includes automatic speech recognition, a curve editor and multiple animatable channels.

Ventriloquist

http://www.lipsinc.com

Ventriloquist is a plug-in designed to ease and radically speed up the creation of talking characters for individual animators and production houses using 3DS Max™ R3 and R4. Ventriloquist automatically generates the entire animation through a sophisticated – and hands-off – analysis of the voice file.

Face2Face

http://www.f2f-inc.com

This program lets you capture full facial movement and motion, allowing you to create facial expressions, head and lips movements and near-perfect lip sync.

Appendix F: TV Organizations

Advanced Television Systems Committee (ATSC)

The ATSC works to coordinate television standards among different communications media. Specifically in digital television, interactive systems and broadband multimedia communications.

http://www.atsc.org

Advanced Television Forum (ATV Forum)

Non-profit organization that provides an open forum for commercial deployment of dynamic, interactive content.

http://www.atvforum.com

Advanced Television Enhancement Forum (ATVEF)

A cross-industry alliance of companies representing the broadcast and cable networks, television transports.

http://www.atvef.com

Association for Interactive Media (AIM)

A non-profit trade organization devoted to helping marketers use interactive opportunities to reach their respective marketplaces.

http://www.imarketing.org/

Cable and Telecommunications Association for Marketing (CTAM)

The CTAM is dedicated to the development of consumer marketing standards in cable television, news media and telecommunications services.

http://www.ctam.com

Corporation for Public Broadcasting (CPB)

Public broadcasting's largest single source of funds for analog and digital program development and production.

http://www.cpb.org

Digital Video Broadcasting (DVB)

A consortium of over 300 broadcasters, manufacturers, network operators, software developers, regulatory bodies and others in over 35 countries committed to building global standards of the delivery of digital television and data services.

http://www.dvb.org

National Association of Television Program Executives (NATPE)

An organization committed to furthering the quality and quantity of content in television.

http://www.natpe.org

National Cable Telecommunications Association (NCTA)

The principal trade association of the cable television industry in the United States.

http://www.ncta.com

National Center for Accessible Media (NCAM)

A research and development facility dedicated to the issues of media and information technology for people with disabilities.

http://ncam.wgbh.org

Society of Motion Picture and Television Engineers (SMPTE)

The leading technical society for the motion imaging industry.

http://www.smpte.org

Women in Cable and Telecommunications (WICT)

The oldest and largest organization serving women professionals in cable and telecommunications.

http://www.wict.org

World Wide Web Consortium (W3C)

Develops interoperable technologies (specifications, guidelines, software and tools) to lead the web to its full potential as a forum for information, commerce, communication and collective understanding.

http://www.w3.org

Appendix G: CD Content

The cover CD will work on the Mac or the PC. The navigation system allows you to browse around the tutorials for every chapter. All .fla's files need to be accessed through Windows Explorer and they are saved in the main chapter folders. Each chapter folder is split into two directories, one that contains all the files for each tutorial and another that contains any other relevant files for that chapter. The tutorials are organized into their own sub-folders, each containing all the assets necessary for that tutorial. The following screen grab shows a breakdown of the CD structure.

I have included a PC Flash 8 game and three further PC games compiled from an MX version. I have also included five (mobile) Flash Lite 2 applications in the Showcase and on the CD. The purposes here is not to take you through streams of code but to allow you to practice your animation skills in a multi-platform environment animating very basic button through to full character design. In addition to the games, I have also featured a number of useful code-driven animation that you might find useful as effect.

The Flash Lite 2 games will not run unless you have the correct publisher version, which is the Flash Lite 2 player. You can learn more about this on the Macromedia site in the mobile section.

In the ShowcaseEffects folder, on the CD I have compiled 17 ActionScript-driven animations, and have provided commentary on the code, so that you can plug them into your Flash projects and customize them to play in any way you would like. I hope you find them as useful as I do almost everyday.

The applications Macromedia Flash 8 Professional, Adobe After Effect, Swish and Poser are all available on the Developer sites as 30-day free trail. These can be easily plugged into the current demonstration material so you can take full advantage of the techniques covered in this book. For updateability reasons we have not included the apps on this CD.

For more information and updates for the CD, you can visit www.sprite.net/anim or email alex.michael@sprite.net.

Figure G.1

Figure G.2

Index

2D chart, 270
3D
 calculations, 271
 chart, 270
 effects, 270
 modelling
 animation, 262
 rendering, 262
 sound effect, 116
3DS Max 4.2, 412

A

Accent, 97-8
Actions toolbox, 291, 293-5, 297-8
ActionScript, 290, 291-5, 297-8, 307
ActionScript tab, 47
Actual body and head motion, 97
Adobe After Effects (Windows and
 Macintosh), 228
Adobe Illustrator, 210
Adobe PostScript, 149
ADPCM, 113
Advanced television enhancement forum
 (ATVEF), 415
Advanced television forum (ATV forum), 415
Advanced television systems committee
 (ATSC), 415
Advantages of streaming video, 233
AIFF, 103, 179
Aldus PageMaker, 150
Alpha, 244, 403
Alpha video, 244
 8-bit alpha channel, 244-5
 chroma keying, 244-7
 keying, 244-5, 248-53
 luma key value, 245
Ambient sound, 397
Animated GIF, 403
Animatic, 403

Animating pixel fonts, 155
Animation
 birds, 75
 character, 61
 facial animation, 81-2, 86, 97-8
 four-legged animals, 75
 library, 263-4
 lip syncing, 81, 83-6, 414
 methods
 frame, 40
 sprite, 40
 swing, 5, 11, 18, 20, 63-4, 69, 73
 tween, 10, 169, 269, 318, 408
Animo, 410
Anti-aliasing, 150, 403
Anti-aliasing modes, 141
Aperture, 204, 214, 397-9
Apple Final Cut Pro, 220, 245
 Macintosh, 229
Apple QuickTime Pro
 Windows and Macintosh, 229
Archer, 410
Artifacting, 247, 285
Aspect ratio, 200, 216, 236, 257, 402
Assemble edit, 397
Association for interactive media
 (AIM), 415
Attachsound, 109, 118
Audio options, 205-6
Audio-video interleaved (AVI), 403
Author-time shared assets, 304
Auto formatting, 296-7
Available light, 397
Avid suite, 245
Avid xpress DV (Windows and Macintosh),
 229
Axa team 2D pro, 410

B

Back-up, 403
Back arm, 6, 16, 20–1
BackAndForth function, 275
Background, 403
Background light, 397

Bandwidth
 limitations, 101
 Profiler, 287, 314
Basic shading, 279
Bézier, 403
Bezier curve masks, 253
Bi-linear interpolation, 403
Bitmap, 403
Bitmap (pixel) font, 150
Blend between the phonemes, 99
Blocking, 40
Blocks of text, 155, 159
Bounce card, 245-6
Bouncing, 246, 341
BPM, 134
Broadcast format
 NTSC, 195-6
 PAL, 196-7
 SECAM, 197-8
Broadcasting live video
 audio and video encoder, 256
 broadcast application, 256
Bubble wrap, 246
Buttons, 171-2
Byte, 404

C

Cable and telecommunications association for
 marketing (CTAM), 415
Camcorder, 198, 226-7, 248
Camera
 angles, 28-30
 offset, 275
Capture card, 257
Cartoon television program (CTP), 410
Cel Animation, 404
CelAction, 410
Central bar, 111
Channel displays, 113
Character studio 3, 412
Checking syntax, 296
Cinema 4D XL7, 412
Client, 404
Clipping, 136
Close-up, 74, 227, 397
CMYK, 404

Code, 298
Code completion, 284
Code hints, 284, 300-2
Codecs
 on2 VP6, 229
 sorenson spark, 229
Collision detection, 314, 321-2, 404
Color
 depth, 172, 391, 404
 index, 404
 wheel, 245, 404
Column width, 144
Commands issued
 fsCommand, 392
 fsCommand2, 392
Component
 based audio, 134
 for Flash video, 229, 238
Compress
 lettering, 284
 photographs, 284
 settings, 113
Consonants, 82, 97, 99-100
Contact position, 12-8, 69
Control sound, 104, 111, 114
CorelDRAW, 411
Corporation for public broadcasting (CPB),
 415
"Cove" serifs, 382
Crater software, 410
Creating the walk cycle, 266-7
Creatoon, 410
CU, 34, 397
Curious labs, 265
Custom shortcut keys, 286
Customize, 4, 48-9, 109, 178, 225, 233,
 418, 442
Cut, 34, 397
Cutaway, 397
Cycle, 404

D

DAT 404
Degree rule
 thirty-degree rule, 401
 one-hundred eighty degree rule, 402

Delivery options, 225, 234
Depth
 of field, 246-7, 398
 of focus, 398
 scale, 271
Desktop, 404
Device fonts
 types, 160
 limitations, 161
Dialects, 82-3
 BBC-English, 83
 NBC-English, 83
Diffused lighting, 245
Digital theatre sound (DTS), 206, 208
Digital versatile disc (DVD), 201
 comparison with video, 202
 DVD-video quality, 203
 MPEG-2 video stream, 202-3
Digital video broadcasting (DVB), 416
Direct3D, 404-5
Direction of your lighting, 247
Directional sound, 114-5
Disk, 104, 227, 233-4, 404
Dithering, 285, 405
Dolby digital, 202, 205, 207
Dolly, 34, 398-9
DPI, 158, 404
Drag, 405
Drawing settings, 45
Drawing tab, 45-6
Driver, 405
Drop phonemes, 95
Duplicate, 10, 42, 48, 52, 93
DV chroma key, 248
Dynamic and input text, 155-8
Dynamically loaded MP3, 131

E

Earth tones, 248
Edit, 398
Editing options, 47
Email, 405
Embedded fonts, 157, 159-60, 171
Embedding cue points, 254-6
 crop-and-trim, 254

cue point, 254
default frame rate, 254
event cue point, 255
frame numbers, 254
milliseconds, 254
navigation cue point, 255
parameters, 256
Enable simple buttons, 53
End, 110
Envelope
 handle, 113
 line, 113
EPS, 405
Establishing shot, 398
Event sound quality, 100
Expert mode, 295
Export, 229
Exporting movie, 213
Exposure sheet, 89-90, 405
Expression, 82-4, 87-9, 96, 98, 143, 294,
 300, 385
External text editor, 298
Eye expressions, 87
 blink L and blink R, 89
 eyebrow down L and eyebrow
 down R, 89
 eyebrow up L and eyebrow up R, 89
 frown, 87
 grin L and grin R, 87
 sneer L and sneer R, 87
 squint, 89
Eye movement, 62, 74, 98

F

Face2Face, 414
Facial animation, 81-2, 86, 97-8
Fade, 34, 398
FAT, 405
Features of the Fash Lite player, 169-70
Federal communications commission
 (FCC), 195, 202
Fill light, 398
Filter, 141, 405
Find and replace function, 286
Fireworks, 151, 314, 323, 412

Flare, 398, 400
Flash
 environment, 4
 for Video (FLV), 429
 Lite, 165
 authoring features, 391-2
 content types, 391
 media server, 222-3, 229-30, 233, 240,
 244, 256, 429
 player, 112
 player 8, 141
 professional 8, 2
 project, 3
 tutorials, 9
 video import wizard, 228
 video streaming service, 240-1
Flash 8: 3, 4, 9, 28, 40
Flood light, 398
FLV playback component, 244
Focal length, 398
Focus, 398
Font library, 389
Font selection, 144
Fonts
 antiqua, 380-1
 arial, 161
 avant-garde, 390
 baskerville, 383
 clarendon fonts, 384
 courier, 161
 frutiger, 143, 385
 futura, 385
 garamond, 143, 382
 humanist antiqua, 382
 old english, 380
 old style, 383
 times roman, 161
 types
 sans serif, 142
 serif, 142
 univers, 56
 variants
 bold, 142
 italics, 142
Fps, 204, 254, 405
Frame, 405

Frame backward, 145
Frame forward, 115
Frame motion, 230
Frame rate, 405
FreeHand 10, 266
Freeze frame, 399
Fresnel, 399
F-stop, 390

G
Gaffer, 399
Gaffer's tape, 399
Gain, 399
Game, 161-3
Game function, 43
Gamma correction, 285
Gantt chart, 28-9
Garamond, 140, 143, 382
General tab, 45
Generate size report, 287
Geometry, 405, 408
GIF dithering, 285
Globalsound, 126
Goto line, 295
Grab, 4, 405, 418
Gradient keys, 245
Graphic interchange format (GIF), 284
Graphics engine, 405
Grip, 399
Grotesque, 385
Guide layers, 8, 11-2, 16-7, 23, 25, 174-5

H
Half frames (delta frames), 232
Hand animating, 98
Handlers, 112
Hardware, 405
Harmonized vocal riffs, 136
Hash animation master, 412
HDTV, 198, 202
HeadMovements, 74
Head room, 399
Highlight color, 45
History panel, 288-9
Hold, 13, 51, 92, 117, 190, 232, 405

Horizontal
 sliding, 129
 volume slider, 128
HSB, 406

I

Icon, 406
Identify assets
 ALIEN, 4
 BOMB, 42
 CRAFT, 42
 MISSILE, 42
 PROJECTILE, 42
 SHIP, 41
 UFO, 42
Import
 wizard, 222, 228, 239-40, 254
 sounds, 106
In-betweening, 406
In and out point, 109, 112
In script assist, 292-3
Incident light, 399
Insert, 399
Insert edit, 400
Interactive
 and custom-like soundtracks, 134
 storyboarding, 35
 video, 208
Interface, 170, 406
Interpolation, 98, 153, 252, 403, 406

J

Java applets, 291
Java script Flash (JSFL), 288
Joint photographic experts group (JPEG),
 140, 227, 284-5, 303, 406
JPEG compression, 285
Jump cut, 400
Jump menu, 293, 295-6

K

Kerning, 145, 153, 157
Key frames, 30, 75
Key light, 398, 400

Keying in after effects, 248-53
 after effects filters panel, 249
 color tolerance, 249
 edge feather, 249
 edge thin, 249
 effects & presets panel, 250
 eraser, 56, 251
 Flash video encoder, 229, 231 251-2,
 254-5
 keying filters, 248

L

Lathing, 406
Lavaliere, 227
Lavaliere (lave) microphone, 227
Layer
 palette, 7, 9, 11-2
 scrolling, 269, 320
Layout, 406
LCD screen, 159, 199, 226
Legs, 9-11
Lens hood, 400
Level of detail, 79, 264, 406
Library of standard objects, 264-5
Lightwave, 7, 413
Limitations, embedded video,
 233
Line length, 144
Linear PCM, 205-7
Linkage identifier, 122-3, 305
Linkage properties identifier, 126
Linker systems, 411
Lip positions, 84, 93-4
Lip sync animation, 84, 98, 414
Listening, 34, 89, 91, 95, 176
Live, 400
Live on tape, 400
Live video streaming, 241, 244
Load
 movie, 186, 287
 sound, 113, 132-3
Long shot (LS), 34, 400
 medium LS (MLS), 34
 very LS (VLS), 34
Looping background sound, 126

Loops, 5, 116, 121, 129, 131, 134,
 136, 261
Lossless, 285
Lossy GIF settings, 285
Low frame rate for the web, 115
Lower-level languages
 C, 268, 313
 Java, 268, 313
Lower window, 111
Luminance, 245, 406

M

Mac, 13, 48, 151, 155, 215-6, 292, 418
Macintosh computer, 77, 156
Macromedia Flash player, 100, 178-9, 184,
 244
Magpie Pro, 90, 414
Manipulate, 115, 124, 126, 141, 154, 260-1,
 268, 313, 343
Mannequin, 260, 265-6
Master, 94, 400
Match cases, 294
Maya 4, 413
Mean tangerine pixel fonts, 390
MediaPegs, 411
Medium shot (MS), 34, 400
Memory, 406
Microphone, 227, 256, 302, 400
 microsoft project or excel, 28
MiniDV, 211, 246
Mirror, 91, 97-8
Mixed media, 291
Modern font, 383-5
Monitor, 407
Mono sounds, 104
Monotone, 248
Motion capture, 244, 406
Motion math, 253
Mouse, 407
MOV (Quicktime), 77, 285, 406
Movie Explorer, 177
MovieClip, 22-3, 104, 117, 121, 141, 290,
 301-2
MovieClipObjectName, 111
Moving picture experts group (MPEG), 407

Moving Star, 269, 318
MP3, 104, 111, 114, 132, 134
MPEG-2 audio, 205, 207-8
Multi-channel surround sound, 116
Multi-word descriptive names, 294
MusicBox, 117
MySound, 117, 122, 124-6

N

Naming convention, 49, 111, 293
National association of television program
 executives (NATPE), 416
National cable telecommunications
 association (NCTA), 416
National center for accessible media
 (NCAM), 416
Navigate, 105, 136, 236, 292, 295, 300,
 307, 327
Network connectivity, 169-70
Neutral density filter, 401
New encoding options, 222-4
New layer, 7, 9, 12-3, 16, 50-1, 79, 108,
 110, 119, 181, 309
New movie, 92, 126, 135, 267, 308
 frames of the animation, 92
 lip sync text as frame comments, 92
 sound clip, 91-3, 104, 106-7, 116,
 134, 136
Non-Flash file formats, 141
 GIF, 41, 153, 284-5, 303, 406
 JPEG, 141, 227, 284-5, 303, 406
 PNG, 141, 285
Non-linear editing (NLE), 227
NTSC, 407

O

On-demand video, 230, 256
On launch, 45
On2 VP6 videocodec, 245
OnEnterFrame event function, 275
Onion skinning, 10-3, 99
OnSoundComplete, 113, 130-2
OpenGL, 405, 407
Optimization techniques, 101

Original, 401
Outdoor filming, 245, 248
Outputting video from Flash, 214-7
Overlapping, 73-4, 84, 265, 271

P

PaintShop, 158
PAL, 196-7, 407
Pan, 34, 401, 407
Panel layout, 49-50
Panning the camera, 278-9
Parallax scrolling, 269-70, 314, 320
Parenting, 407
Passing position, 13-7, 21, 63-4, 68
Path to your object, 111
Pausing a sound object, 129-30
Pay attention to every frame, 98
PCX, 407
Perpetua and Gill Sans, 61, 143
Persistence of vision, 200-1
Phone capabilities, 169-70
Phonemes
 A, 85
 C K G, 85
 CH SH J, 85
 E, 86
 F V, 85
 I U, 86
 K, 100
 M B P, 84, 100
 N D T L, 86
 O, 86
 R, 86
 S Z, 86
 TH, 86
 W OO Q, 86
Physical movement of a camera, 34
 dolly, 399
 pan, 62
 tilt, 34, 70, 402
 truck, 34
PICT, 407
Pixel
 fonts, 149-51, 153, 155-9
 distoration, 257
 fonts in Flash, 152-4, 157

Placement, 28, 35, 255, 285
Planning, 29, 265
Plasma screens, 199
Playhead, 11, 94, 109, 115, 136, 314, 334
Polygon, 7, 9, 407-8
Portable network graphics (PNG), 285
Poser
 animation, 260
 Pro, 413
 still, 261
 WalkCycles, 265
Poser 6: 4, 265
PostScript font, 150, 153
Power rangers, 4
Predrawn assets, 7
Preloader, 313-4, 358
Preparing Flash movies for video, 211-2
Pre-rendered 3D elements, 279-80
Preset sound effect, 109
Primary color, 245
Product specification document, 35
Profile, 401
Program chain (PGC), 209
Progressive download, 224, 229-30, 233-6,
 239, 254
Project messiah:animate 3.0, 413
Project settings, 45
Property inspector, 106, 154, 171, 178, 287,
 391
Proportion, 38
Punctuation balance, 296
Puppet, 95-6
 mouth closed, 95
 mouth open, 95
 mouth tighten, 95

Q

Quality, 158, 211
Quicktime, 407
QuickTime Export/er, 215, 223, 228-9

R

Random-access memory (RAM), 407
Raster images, 403

Rasterize, 407
Raw, 113-4
Real-time, 4, 141, 189, 202, 253, 256-7
Record sound, 115
Reference panel, 298
Reflected light, 401
Reflector flood, 401
Reflector spot, 401
Rendered 3D model, 264
Replicate, 97, 296
Reserved words, 294
Retas, 411
RGB, 245, 403, 407-8
ROOSTER, 126
Root timeline, 125, 131
Rotoscoping, 76-9
Runtime shared assets, 303-4

S

Safe area, 198, 401
Sample rate, 104, 114, 206, 287
Sans serif
 radical sans serif, 385
 humanist sans serif, 385
Saturation, 199, 406, 408
Scaling, 408
Scrub, 40, 90, 94, 232
Secondary colors, 245
Server, 408
Setup lighting
 background, 246-7
 foreground, 246-7
SetVolume, 111-3, 123-9
Shading, 150, 279, 408
Shadows, 245, 247, 289-90, 398
Shape
 construction, 57
 movement, 275-6
Shapes and Fills, 280-1
Shared Library Assets, 303-4
Shockwave, 285
Show code hints, 300
Show streaming, 287, 314
Simple fog, 279
Slider movie clip, 128-9

Slider track, 128
Slow motion, 401
Small computer systems interface
 (SCSI), 408
Snap align, 286
Snapshots, 28, 30
Society of motion picture and television
 engineers (SMPTE), 416
Softimage toonz, 411
Softimage XSI 2.0, 413
Sonic foundry's acid, 134
Sony dynamic digital sound (SDDS), 208
Sorensen codec, 245
Sound
 clips, 93, 104, 134, 136
 event, 134-6
 files, 104, 115, 117, 180, 290
 objectName,111
 objects, 103-6
 panel, 109, 111
 track, 40, 137
 track looping, 137
Source quality, 230
Spell checker, 286
Spinning, 270, 277
Sprite Interactive, 40, 146, 187,
 312-3, 360
Squash and Stretch, 71-2, 408
Stages of storyboarding
 clean storyboard, 35
 rough pass, 35
 thumbnails, 35
Starfield, 269-70, 318
Start, 110, 121, 130
Static Text Fields, 159-60
Storyline, 31, 37, 74, 209
Strata pro, 413
Stream, 110
Streaming
 performance, 287
 service, 240
 sound, 106
 video, 224, 234
Study from life, 98
Subtle head motion, 98
Super pixel fonts, 386

Superimposition, 402
swapDepths, 271, 275
SWF, 232-3
Swift 3D material, 263
Switches, 105, 158
Symbol, 264, 307
Sync property, 100-1
Synchronize, 101, 109-10, 132, 153,
 222, 255
Syntax highlighting, 299-300

T

Tagged image file format (TIFF), 408
Tailored soundtracks, 134
Targa. graphic file format (TGA), 408
Telephoto lens, 402
Test shots, 248
Text animation, 146-8
 using SWiSH, 146-8
Text on a path, 253
Textfields, 271
Textual description, 41, 43
Texture, 62, 260-1, 264, 403, 408
Texture Mapping, 408
Thirty-degree rule, 402
Thumbnail, 35, 51, 106, 408
Tic-tac-toe pattern, 227
Time indexes of shots, 247
Time remapping, 253
Time-based, 100
Timeline, 408
Timing skills, 99
Toonboom, 411
Top, 7
Track Analysis, 89-96
 2D images, 91
 3D animation program, 91
 bitmaps, 437
 compression levels
 CD-ROM lower compression, 92
 web site higher compression, 92
 custom phonemes, 90
 digital exposure sheet, 90
 fcurves, 90
 real time, 90

waveform and timecode, 89-90
 X-sheet, 89-90, 96
Transfer software license, 52
Transformation, 409
 scheme, 40
 key and frame numbers, 40
 rotations values, 40
 scale, 40
 translation, 40
Transition, 34
 cut, 34
 fade, 34
 mix/dissolves, 34
 wipe, 34
Tricks of the trade, 98-100
Triggered, 109, 136, 229, 255
Tripod, 226, 397-8
Truetype font, 150-1
TWAIN, 409
Tweening Motion, 23-5, 409

U

Undo levels, 45
Upper window, 112
URL value, 305
Use unique names, 293

V

Vector line work, 30
Ventriloquist, 90, 414
Vertical slider, 129
Video cassette recorder (VCR), 195, 198,
 409
Video capturing formats
 AVI, 227
 Motion-JPEG, 227
 MPEG, 227
Video Information
 general, 204
 video image, 205
Video shooting tips, 225-6
Video tape recorder (VTR), 409
Viewing coordinates, 409

Visemes, 82
Voiceover, 30
Volume control, 105, 113, 126
Vowels, 82, 85, 87, 95, 97, 99-100

W

WAV, 90, 96, 104, 113, 180
Walk
 angry walk, 70
 anticipation, 70-1
 cycles, 63-4
 double bounce walk, 64
 push walk backwards, 67
 push walk forwards, 67
 slow lazy walk, 64
 sneak walk timeline, 66
 sneaky walk, 65
 timeline, 63
 tired/energyless walk, 65
Web display, 257
Web server, 186, 232-4, 239-40, 288

Webcam or digital video camera, 234
Weighted optimization, 285
Wide angle, 402
Window, 409
Wireframe, 409
Women in cable and telecommunications
 (WICT), 416
Word transitions, 94
World wide web consortium (W3C), 169,
 417

X

X-sheet, 89-90, 96

Z

Zoom, 402
Zoom lens, 402
Zoom ratio, 402
Zooming figures, 272

Also available from Focal Press

Understanding Macromedia Flash 8 ActionScript 2

Andrew Rapo and Alex Michael

- Benefit from explanations and examples of why and how ActionScript can simplify Flash production and expand your design potential
- Learn all the basics of strong scripting skills to produce professional results
- Example code is available and ready to use with either Flash MX 2004 or Flash 8 – at www.rapo.org/as2book

If you are a designer or new Flash programmer looking for a crash course in ActionScript 2 – then look no further!

Andrew Rapo and Alex Michael explain all the important programming concepts from a designer's point of view, making them completely accessible to non-programmers. Completely revised and rewritten this second edition will help you develop professional ActionScript 2 applications, and communicate knowledgeably about current, Object Oriented ActionScript 2 techniques.

'Learn the basics of strong scripting skills for truly professional results. Written from a creative viewpoint, this is a book that really talks your language!'
World Animation Journal

February 2006: 189 X 246 mm: Paperback: 0240519914

To order your copy call +44 (0)1865 474010 (UK) or +1 800 545 2522 (USA) or visit the Focal Press website: **www.focalpress.com**

Also available from Focal Press

The Focal Easy Guide to Macromedia Flash 8

Birgitta Hosea

If you need to get to grips fast with creating interactive graphics and animation in Flash – then look no further! Whether you are a new user or a professional, this highly visual book is all you need to get up and running with the latest powerful upgrade – Macromedia Flash 8.

Birgitta Hosea breaks down the software into its main components and offers simple, visual step-by-step instructions to explain the fundamental practical techniques you need to know to be able to create finished projects. The accessible style and structure lets you dip in and out when working on a project, or work straight through to explore more of the program's capabilities and develop your skills.

Written by a designer for designers *The Focal Easy Guide to Macromedia Flash 8* offers a thorough coverage of the basic features of Macromedia Flash 8, without going into in-depth coding with ActionScript.

January 2006: 148 X 210 mm: Paperback: 0240519981

To order your copy call +44 (0)1865 474010 (UK) or +1 800 545 2522 (USA) or visit the Focal Press website: **www.focalpress.com**

Focal Press

www.focalpress.com

Join Focal Press online
As a member you will enjoy the following benefits:

- browse our full list of books available
- view sample chapters
- order securely online

Focal eNews
Register for eNews, the regular email service from Focal Press, to receive:

- advance news of our latest publications
- exclusive articles written by our authors
- related event information
- free sample chapters
- information about special offers

Go to www.focalpress.com to register and the eNews bulletin will soon be arriving on your desktop!

If you require any further information about the eNews or www.focalpress.com please contact:

USA
Tricia La Fauci
Email: t.lafauci@elsevier.com
Tel: +1 781 313 4739

Europe and rest of world
Lucy Lomas-Walker
Email: l.lomas@elsevier.com
Tel: +44 (0) 1865 314438

Catalogue
For information on all Focal Press titles, our full catalogue is available online at www.focalpress.com, alternatively you can contact us for a free printed version:

USA
Email: c.degon@elsevier.com
Tel: +1 781 313 4721

Europe and rest of world
Email: L.Kings@elsevier.com
Tel: +44 (0) 1865 314426

Potential authors
If you have an idea for a book, please get in touch:

USA
editors@focalpress.com

Europe and rest of world
ge.kennedy@elsevier.com